✓ P9-DGI-477

An introduction to theories of popular culture

An Introduction to Theories of Popular Culture is a clear and comprehensive guide to the major theories of popular culture. Dominic Strinati provides a critical assessment of the ways in which these theories have tried to understand and evaluate popular culture in modern societies.

Among the theories and ideas the book introduces are mass culture, the Frankfurt School and the culture industry, semiology and structuralism, Marxism, feminism, postmodernism and cultural populism. Strinati explains how theorists such as Adorno, Barthes, Althusser and Hebdige have grappled with the many forms of popular culture, from Jazz to the Americanisation of British popular culture, from Hollywood cinema to popular television series, from teen magazines to the spy novel.

Each chapter includes a guide to key texts for further reading and there is also a comprehensive bibliography.

Dominic Strinati is a Lecturer in Sociology at the University of Leicester. He is the author of *Capitalism*, the State and Industrial Relations (1982) and co-editor of *Come on* Down? Popular Media Culture in Post-War Britain (1992).

LONDON AND NEW YORK

An introduction to theories of popular culture

Dominic Strinati

First published 1995 by Routledge 11 New Fetter Lane London EC4P 4EE

Simultaneously published in the USA and Canada by Routledge 29 West 35th Street, New York, NY 10001

Reprinted 1996 (twice) and 1997

© 1995 Dominic Strinati

Typeset in Sabon by Florencetype Ltd, Stoodleigh, Devon

Printed and bound in Great Britain by Biddles Ltd, Guildford and King's Lynn

All rights reserved. No part of this book may be reprinted or reproduced or utilized in any form or by any electronic, mechanical, or other means now known or hereafter invented, including photocopying and recording or in any information storage or retrieval system, without permission in writing from the publishers.

British Library Cataloguing in Publication Data

A catalogue record for this book is available from the British Library

Library of Congress Cataloguing in Publication Data

Strinati, Dominic.
An introduction to theories of popular culture / Dominic Strinati.
p. cm.
Includes bibliographical references and index.
1. Popular culture. I. Title.
HM101.S834 1995
306–dc20 94–37268

ISBN 0-415-12469-7 (hbk) ISBN 0-415-12470-0 (pbk) As always, this book is for Adam and Jonathan. It is also dedicated to the memory of my mother and father.

Contents

Acknowledgements	xi
Introduction	xiii

1

1 Mass culture and popular culture

Mass culture and mass society	5
The mass culture debate	10
Mass culture and Americanisation	21
Americanisation and the critique of mass	
culture theory	31
A critique of mass culture theory	38

2 The Frankfurt School and the culture industry

The origins of the Frankfurt School	53
The theory of commodity fetishism	56
The Frankfurt School's theory of modern capitalism	58
The culture industry	61
The culture industry and popular music	64
Adorno's theory of popular music, Cadillacs and	
Doo-wop	69
The Frankfurt School: a critical assessment	74
Benjamin and the critique of the Frankfurt	
School	81

51

87

129

3 Structuralism, semiology and popular culture

Structural linguistics and the ideas of Saussure	89
Structuralism, culture and myth	94
Structuralism and James Bond	102
Barthes, semiology and popular culture	108
Barthes, structuralism and semiology	109
Writing Degree Zero	110
Myths and popular culture	112
Bourgeois men and women novelists	116
Structuralism and semiology: some key problems	119
Lévi-Strauss's structuralism	120
Roland Barthes's semiology	123

4 Marxism, political economy and ideology

Marx and ideology	130
Marxism and political economy	136
The limits of political economy	142

viii

Althusser's theory of ideology and	
structuralist Marxism	146
Althusser's Marxism: economic determinism	2.10
and ideology	155
Gramsci, Marxism and popular culture	160
Gramsci's concept of hegemony	165
Conclusions: Marxism, Gramscian Marxism and	100
popular culture	171
1 1	1/1
5 Feminism and popular culture	177
The feminist critique	180
Women and advertising	184
The feminist analysis of popular culture	189
Feminism and mass culture	189
Feminist theory and the critique of content analysis	191
Feminist theory, patriarchy and psychoanalysis	196
Feminist theory and the study of ideology	201
Feminist analysis, semiology and ideology	206
Feminist analysis, ideology and audiences	209
Conclusion	215
6 Postmodernism and popular	
culture	221
What is postmodernism?	223
The breakdown of the distinction between culture	
and society	223
The breakdown of the distinction between art and	
popular culture	225
Confusions over time and space	226
The decline of metanarratives	227
Contemporary popular culture and postmodernism	228
Architecture	228
Cinema	229

Television	231
Advertising	232
Pop music	233
The emergence of postmodernism	235
Consumerism and media-saturation	235
New middle-class occupations and consumer markets	236
The erosion of personal and collective identities	238
The limits of postmodernism	239

7 Conclusions

Discourse and popular culture	249
The 'dialogical' approach to popular culture	252
Cultural populism	255
Notes	263
Bibliography	275
Index	291

Acknowledgements

This book has partly been written as a ground-clearing exercise to help me push my work on popular culture in new directions. It has also been developed from courses in popular culture and social and cultural theory that I have taught in the Sociology Department at Leicester University. A period of study leave granted by Leicester University has helped me develop my work, and has enabled me to complete this book much quicker than would otherwise have been the case. I acknowledge the opportunity provided. I wish to thank both former and present students and colleagues (at Leicester and elsewhere) for the help they have given, whether consciously or not, in the writing of this book. Amongst those I wish to thank are Ros Gill, James Fulcher, Roman Horak, Derek Lavder, John Scott, Sallie Westwood and John Williams. In particular, I would like to thank Graham Murdock, especially for the help and guidance he provided when this book was no more than a draft proposal, and Rebecca Barden at Routledge, for wanting to publish the book in the first place, and for her advice and tolerance during the time it took me to write it. I am also grateful to Sara Beardsworth for the highly efficient way she has copy edited this book. Needless to say, the ultimate responsibility for what follows is mine alone.

Introduction

This book basically represents an attempt to outline and critically assess some leading theories of popular culture. The study of popular culture is now in the process of becoming a part of the educational curriculum, just as it is beginning to attract more attention from theorists and researchers in the humanities and social sciences. In the course of its emergence, and its consolidation as a subject to be analysed and taught, popular culture has been subject to assessment and evaluation by a number of different theories. This book tries to examine some of these theories in order to see how far they have advanced the study of popular culture.

It is not only this development, however, which makes popular culture and its analysis a relevant topic of inquiry. More important is the increasing extent to which people's lives in western capitalist societies appear to be affected by the popular culture presented by the modern mass media. It is clearly important in other kinds of societies as well, both historical and contemporary, but in these societies the sheer volume of popular media culture which is made available gives it a specific significance which needs to be looked at. Again, this sheer volume must not be exaggerated.¹ Just as there are international inequalities in the distribution of the media, so in western capitalist societies there are domestic, economic and cultural inequalities which prevent people from sharing in the increased availability of popular media culture.² However, given this, the scale of popular culture in the modern world does suggest that looking at theories which have tried to explain and evaluate it, may have some relevance to the overall debate on popular culture and the mass media.

The focus of this book is theories and perspectives on popular culture. It does not try to discuss particular traditions of research, such as audience research and the methodological issues it raises.³ This is not because these traditions are not important. In fact, it seems to me that they are crucial to the development of the study of popular culture. However, one feature of this area of study is the way it has been dominated by different theoretical perspectives and the arguments and debates they have attracted. Therefore, any assessment of the development of the study of popular culture has to come to terms with these theoretical perspectives. Of course, not all theories and perspectives are underrepresented by research. Feminism, for example, has built up a strong body of research while still being involved in extensive and relevant theoretical debates. But this book, which is about theories, is not an appeal to do without theory. Rather it is based on the simple assumption that the importance of theories should be balanced more evenly by the importance of research. A good example of this lack of balance is to be found in the elaboration of postmodern theory which is considered below.

While this book introduces an outline and critique of theories of popular culture, it does not pretend to be exhaustive in its scope and coverage. The theories I do discuss have been chosen for a number of reasons. First, they are directly concerned with the analysis and evaluation of popular culture. Some theories, like Marxism and feminism, are about a lot more than this, but are discussed in terms of what they have to say about popular culture. Other theories, which may seem relevant, are not considered if they have not looked directly at popular culture. Variants of postmodernism and post-structuralism, for example, have not directed their attention to this area. So, whatever their potential, they are not explicitly addressed. This may explain why the version of postmodern theory considered below has to take the form of a composite picture drawn from differing sources. Second, it could be claimed that the theories covered in this book have all played an important part, at different times, in shaping debates over the interpretation of popular culture. They may not all have been equally associated with bodies of empirical research, but they have all represented a set of ideas which have formed an important point of reference for any attempt to analyse and evaluate popular culture. It has been the focus on popular culture, not more general developments in social and cultural theory, which has provided the rationale for the theories considered in this book.

Third, the theories chosen all tend to deal directly with popular culture rather than the mass media. It is clearly difficult to look at one without looking at the other, especially in view of how popular culture today is so closely bound up with the mass media. And there is no attempt to downplay these links in this book. Yet insofar as a difference has arisen between theories and studies which concentrate upon the mass media, and those which concentrate upon popular culture, this book will try to confine itself to the latter. Some of the theories considered, such as the political economy variant of Marxist theory, are as equally concerned with explaining the role of the mass media as they are with interpreting popular culture. None the less, in view of the focus I have chosen, approaches such as these will be outlined and assessed primarily in terms of the theory of popular culture they put forward, without necessarily under-estimating their theories of the mass media.

In addition, the theories and perspectives which are discussed in the following chapters are assessed in terms of their adequacy as sociological theories of popular culture. The development of the study of popular culture has been based upon the contributions of a number of different disciplines. These include literature, literary criticism, history and psychoanalysis, as well as sociology. The inter-disciplinary character of this process, and the intellectual cross-fertilisation it has entailed, have proved useful in establishing this area of study, and in fostering conceptual innovations, empirical research and theoretical debates. However, the study of popular culture still needs to strike a more even balance between the approaches of psychoanalysis and literary criticism, and the contributions offered by sociology and history. Different disciplines or sub-disciplines contain different ways of forming their arguments, and of providing some kind of empirical proof for what they say. The claim that the 'cultural studies' approach to the study of popular culture is truly inter-disciplinary, comes up against this point, the fact that different disciplines have different traditions, theoretical assumptions, empirical and historical concerns, methodologies, and so on, which prevent them from being easily and smoothly integrated into an over-arching 'interdisciplinary' perspective. Compare, for example, the divergent stances of psychoanalysts and historians over the role of empirical validation and the need for theoretical concepts. As such, this book will try to emphasise the importance of sociological approaches to the study of popular culture.

While this book attempts to outline and criticise some leading theories of popular culture, it is not written as a history of the study of popular culture. The theories selected are discussed in terms of their assumptions and arguments about how to explain and evaluate popular culture. They are not discussed, nor are they meant to be discussed, as stages in an introspective history of how popular culture has been studied. Books which do this, or which deal with specific aspects of this history, are already available. There is, for example, Turner's outline (1990) of the tradition of cultural studies which has emerged in Britain, and which has been most closely associated with the Centre for Contemporary Cultural Studies at Birmingham University. There is also McGuigan's critique (1992) of this cultural studies tradition for the way particular aspects of its work have engaged in, or encouraged, an excessive populism at the expense of asking questions about the wider dimensions of political and economic power.⁴ Or there is Ross's account (1989) of the changing relationship between intellectuals and popular culture in America. One problem with books like these is that they often seem as concerned with the internal mechanics of intellectual debates, or the uneven development of the discipline, as with the analysis and evaluation of popular culture.

This book does not, thus, pretend to provide an internal history of popular cultural study, but tries to assess the theories discussed in their own terms, as ways of accounting for popular culture. Nor does it pretend to present an alternative theory of popular culture. There are clearly hints and indications throughout of my own conceptual and analytical preferences and prejudices, but to have indulged in the presentation of an alternative, assuming it would be possible to put one forward, would have got in the way of the more modest aims of the book.

Although this is a book about popular culture, I shall not spend much time trying to define it in this introduction. If we are to have a working definition then a straightforward description of the sort of things that might be covered by this term will suffice here. The sense of popular culture I have in mind is indicated by Hebdige's definition: "popular culture" - e.g. a set of generally available artefacts: films, records, clothes, TV programmes, modes of transport, etc.' (1988; p. 47). Different societies, different groups within societies, and societies and groups in different historical periods can all have their own popular culture. It is therefore preferable not to hold to a strict and exclusive definition, so that provided by Hebdige will work for the purposes of this book. The range of artefacts and social processes covered by the term popular culture will emerge as the discussion of the book unfolds, and examples are used to illustrate the claims of the different theories considered.

I have avoided discussing the various conceptual attempts to define popular culture (and presenting my own version beyond indicating a straightforward description) for the simple reason that this is one of the things theories of popular culture in fact endeavour to do. However implicitly or explicitly they address the problem, these theories provide definitions of popular culture which are more or less consistent with their general conceptual frameworks. Any attempt to define popular culture inevitably involves its analysis and evaluation. It therefore seems difficult to define popular culture independently of the theory which is designed to explain it.

A few examples may help clarify this point. Popular culture

for the mass culture critics can either be defined as folk culture in pre-industrial societies, or as mass culture in industrial societies. For the Frankfurt School, popular culture is that mass culture. produced by the culture industry, which secures the stability and continuity of capitalism. The Frankfurt School thus shares with other versions of Marxist theory, such as those put forward by Althusser and Gramsci, a conception of popular culture as a form of dominant ideology.⁵ The Marxist political economy perspective also comes close to this understanding of popular culture, while variants of feminist theory define it as a form of patriarchal ideology which works in the interests of men and against the interests of women. While the main tendency of semiology is to stress the role of popular culture in obscuring the interests of the powerful - in Barthes's view the bourgeoisie - some structuralist theories see popular culture as an expression of universal and unchanging social and mental structures. Those writers who put forward a cultural populist approach tend to define popular culture as a form of consumer subversion which is precisely how they wish to evaluate and explain it (Fiske: 1989a; pp. 43-47). Lastly, according to postmodernist theory, popular culture embodies radical changes in the role of the mass media which efface the distinction between image and reality.

The conclusion which can be drawn from these examples is that popular culture is defined on the basis of the way it is explained and evaluated theoretically. There is no doubt, as I have suggested, that popular culture can be defined descriptively as covering a specific set of artefacts. But it is much more difficult to envisage the possibility of a conceptual and theoretically informed definition receiving widespread agreement, especially since the attempt to do this would involve competing conceptions of the nature of the social relationships within which these artefacts could be located. If it is the case that popular culture cannot be defined except in relation to particular theories, then the problem of definition is best left to the chapters which follow.

Chapter 1

Mass culture and popular culture

Mass culture and mass society	5
The mass culture debate	10
Mass culture and Americanisation	21
Americanisation and the critique	
of mass culture theory	31
A critique of mass culture theory	38

T HE SOCIAL SIGNIFICANCE OF popular culture in the modern era can be charted by the way it has been identified by the idea of mass culture. The coming of the mass media and the increasing commercialisation of culture and leisure gave rise to issues, interests and debates which are still with us today. The growth of the idea of mass culture, notably evident from the 1920s and 1930s, can be seen as one of the historical sources of the themes and perspectives on popular culture with which this book will be concerned.

This is not to say that the debate over mass culture represents something totally new. Lowenthal (1957), for example, has traced some of its central arguments back to the writings of Pascal and Montaigne in the sixteenth and seventeenth centuries, and linked their emergence to the rise of a market economy. Others argue that they have always been with us, pointing to the 'bread and circuses' function of popular culture in the Roman empire. More convincingly, Burke suggests that the modern idea of popular culture is associated with burgeoning forms of national consciousness in the late eighteenth century, and resides in the attempt by intellectuals, for example poets, to construct popular culture as national culture. The distinction, for example, between popular culture and 'high' or 'learned' culture is to be found in this period in the writings of the German poet Herder (Burke: 1978; p. 8).

The contrasting implications associated with the history of the idea of popular culture are clearly noted by Williams. Referring to a 'shift in perspective' between the eighteenth and nineteenth centuries, he writes:

Popular was being seen from the point of view of the people rather than from those seeking favour or power over them. Yet the earlier sense had not died. Popular culture was not identified by the people but by others, and it still carries two

older senses: inferior kinds of work (cf. popular literature, popular press as distinguished from quality press); and work deliberately setting out to win favour (popular journalism as distinguished from democratic journalism, or popular entertainment); as well as the more modern sense of well-liked by many people, with which, of course, in many cases, the earlier senses overlap. The recent sense of popular culture as the culture actually made by people for themselves is different from all these; it is often displaced to the past as folk culture but it is also an important modern emphasis.

(Williams: 1976; p. 199)

The development of the idea of popular culture is tied in with contests over meaning and interpretation which predate but become strikingly evident in the debates over mass culture. In particular, three related themes or arguments can be found in the work referred to above which, while not being exhaustive, have been central to theories of popular culture in the twentieth century.¹ The first concerns what or who determines popular culture. Where does popular culture come from? Does it emerge from the people themselves as an autonomous expression of their interests and modes of experience, or is it imposed from above by those in positions of power as a type of social control? Does popular culture rise up from the people 'below', or does it sink down from elites 'on high', or is it rather a question of an interaction between the two? The second concerns the influence of commercialisation and industrialisation upon popular culture. Does the emergence of culture in commodity forms mean that criteria of profitability and marketability take precedence over quality, artistry, integrity and intellectual challenge? Or does the increasingly universal market for popular culture ensure that it is truly popular because it makes available commodities people actually want? What wins out when popular culture is manufactured industrially and sold according to the criteria of marketability and profitability - commerce or quality? The third concerns the ideological role of popular culture. Is popular culture there to indoctrinate the people, to get them to accept and adhere to ideas and values which ensure the continued

dominance of those in more privileged positions who thus exercise power over them? Or is it about rebellion and opposition to the prevailing social order? Does it express, in however an imperceptible, subtle and inchoate manner, resistance to those in power, and the subversion of dominant ways of thinking and acting?

These are issues which are still very much alive in the study of popular culture today, but they (as well as others) received systematic and substantial attention in the debates over mass culture which started to gather pace from the 1920s onwards.² The 1920s and 1930s are significant turning points in the study and evaluation of popular culture. The coming of cinema and radio, the mass production and consumption of culture, the rise of fascism and the maturation of liberal democracies in certain western societies, all played their part in setting the terms of the debates over mass culture.³

The very fact that culture came to be almost infinitely reproducible due to the development of techniques of industrial production posed considerable problems for traditional ideas about the role of culture and art in society (Benjamin: 1973). Cultural products like films were not, of course, mass produced like cars since relatively few copies of a film need to be made to reach a mass audience. But the introduction of mass production techniques in the making of films, such as assembly line methods, clearly defined products, specialised divisions of labour, strict financial controls, etc., and the mass entertainment provided by cinemas, meant they could be viewed like any other commercial product.⁴ For many of the writers I shall look at in this chapter, this meant that cultural products like cinema could not be art because they no longer possessed the 'aura' of authentic and genuine works of art; nor could they be 'folk' culture because they no longer came from the 'people', and therefore could not reflect or satisfy their experiences and interests.

Apart from the popular press, cinema and radio were arguably the first archetypically modern mass media to emerge. And while they fed fears about the commercialisation of culture, they were equally central to concerns about the potential they conferred upon political regimes (particularly but not exclusively fascist ones) for mass propaganda. The existence of highly efficient means of reaching large numbers of people within societies with centralised, totalitarian political systems was seen by many as another way, along with coercion, of further entrenching such systems and suppressing democratic alternatives. Mass media like radio and film transmitted and inculcated the official ideology of the fascist state because they could be controlled centrally and broadcast to the population at large. The absence of counterveiling political organisations in totalitarian societies just added to the efficiency of this equation: mass media equalled mass propaganda equalled mass repression. This potential was also marked by the deliberate and conscious attempt by the Nazi party in Germany in the 1930s to establish official Nazi ideology in all areas of culture and art, and eradicate alternative political and aesthetic ideologies. The aim was to enlist the help of intellectuals, writers, novelists, poets, painters, sculptors, musicians, academicians, architects, etc., in order to ensure that Nazi ideology prevailed as Nazi aesthetics. Totalitarian societies, along with liberal democracies, have been viewed as types of mass society. The concept of mass society has formed one important perspective on the role of mass media and mass culture in modern capitalist societies. It has been the fears and anxieties of intellectuals, in societies like Britain and America, over the rise of what they have seen as a mass society and a mass culture which have served to organise and inform the debates over these developments.5

Mass culture and mass society

Although what follows may look something like an identikit picture which nobody can be identified with, I want to single out the main points advanced by mass society theory so as to illustrate its relevance to debates over the nature of popular culture as mass culture.⁶

The major claim of mass society theory refers to the disruptive consequences of the processes of industrialisation and urbanisation. The radical transformations associated with the rise

of large-scale and mechanised types of industrial production, and the growth of massive and densely populated cities as the forms in which people increasingly come to work and live are argued to have destabilised and eroded the previous social and value structures which held people together. The eradication of agrarian based work tied to the land, the destruction of the tightly knit village community, the decline of religion and the secularisation of societies associated with the growth of scientific knowledge, the spread of mechanised, monotonous and alienating factory work, the establishment of patterns of living in large anomic cities populated by anonymous crowds, the relative absence of moral integration (some of the things entailed for mass society theory by the processes of industrialisation and urbanisation) lie behind the emergence of a mass society and mass culture.

Defining precisely what is meant by the concept of a mass society, the theory argues that industrialisation and urbanisation serve to create what is called 'atomisation'. This means that a mass society consists of people who can only relate to each other like atoms in a physical or chemical compound. Mass society consists of atomised people, people who lack any meaningful or morally coherent relationships with each other. These people are clearly not conceived of purely and simply as isolated atoms but the links between them are said to be purely contractual, distant and sporadic rather than closely communal and well integrated. The individual in mass society is left more and more to his or her own devices. has fewer and fewer communities or institutions in which to find identity or values by which to live, and has less and less idea of the morally appropriate ways to live, because mass society, due to the processes which give rise to it, cannot provide adequate and effective solutions to these problems.

Central to this process of atomisation is the decline of mediating social organisations which results from industrialisation and urbanisation. These are organisations, like the village, the family and the church which once provided a sense of psychological identity, social conduct and moral certainty for the individual. In contrast, their modern counterparts like the city or science do not work in the same way; they cannot foster identity, define conduct and fashion morality. According to the theory, people in a mass society are atomised both socially and morally. Not only are the contacts between people purely formal and contractual, but they lack any deeper sense of moral integrity since moral order is in decline in a mass society. The point here is that if no appropriate framework of moral order is forthcoming, if people do not have a secure sense of moral value, then a spurious and ineffectual order will emerge instead, and people will turn to surrogate and fake moralities. This will thereby exacerbate rather than resolve the moral crisis of a mass society. Mass culture plays a part here in that it is seen as one of the major sources of a surrogate and ineffective morality. Without appropriate mediatory organisations, individuals are vulnerable to being manipulated and exploited by core institutions like the mass media and popular culture. There is no moral order to prevent this happening. Religious certainties and communal verities decline and give way to the amoral immediacy of rational individualism and secular anomie associated with the rise of mass consumption and mass culture, the moral placebos of a mass society.

Although it is not integral to every version of the theory, it is clear that mass culture theory can and has accommodated the idea that democracy and education have been harmful developments because they have contributed to the pathological constitution of a mass society. This point is particularly relevant to the debate about Americanisation which I shall discuss later in this chapter. The very fact that fears about Americanisation in the nineteenth century concerned the effects of democracy in breaking down traditional hierarchies of class and taste, in allowing the 'mass' or the 'mob' to determine political decisions, to be the majority in the polity and culture, in supposedly realising the tyranny of the ignorant majority over the cultivation of minority taste, and in ensuring the reduction of all questions of moment to the lowest common denominator, suggests that democracy and education are a particularly useful illustration of this point.

From this point of view, democracy means that not only is everyone entitled to full political citizenship, but potentially everyone's general cultural preferences are as valuable and as worthy

of being respected and fulfilled as those of traditional elites. Furthermore, education, as part of this process of democratisation, means that the capacity to be able to engage more fully in cultural activities – the abilities to read, write, discriminate, demand, know, understand – become more available, formally at least, to more and more people. Just as the mass or the population at large began to be seen as the prime determinant of the polity and the decisions it comes to as a result of the extension of political citizenship rights, so the further expression of this trend in the sphere of culture, combined with the effects of universal elementary education, has been said to result in the popular determination of the culture of mass societies.

This has not, however, been evaluated in a positive manner. Rather, culture has now been regarded as being open to debasement and trivialisation because the masses lack taste and discrimination. If their tastes are to be satisfied, everything has to be reduced to the lowest common denominator of the average or the mass. The people have to have a culture of their own, one which reflects their status and taste as a mass. At the very least, democracy and education entail the breakdown of cultural distinctions between art and folk culture on the one hand, and mass culture on the other, just as much as industrialisation and urbanisation entail the breakdown of traditions of community and morality. These fears have continued well into the twentieth century, and indeed could be argued to be present, in obviously differing forms, at subsequent points of major cultural change.

It should not be thought, however, that mass society theory holds a populist or democratic theory of power, or that if it does it thinks this is a good thing. In fact, it tends to argue that the consequence of the processes it describes is to invest power in the central institutions of the society, the commercial industries, the state and the mass media. Mass society theory is one attempt to indicate the potential opened up for mass propaganda, the potential for elites to use the mass media to cajole, persuade, manipulate and exploit the people in more systematic and allpervasive ways than had been possible before. What happens is that those who control the institutions of power pander to the tastes of the mass in order to control them. If traditional communal and moral frameworks, and consensually deferred to hierarchies of class and status, are breaking down, and there are no institutions left to mediate the relationships between the atomised individual and the centralised powers of mass society, the individual is open to the persuasive, manipulative and coercive force exercised by the joint or autonomous powers of capitalism, the state and the mass media. Alternatively, if a specific variant of the theory bemoans the advent of political and cultural democracy because they appear to work, and criticises mass culture in terms of elitist criteria of taste and discrimination, then it is the power of the mass, not its lack of power, which is emphasised, but it is not welcomed or celebrated.

Before going on to look directly at the theory of mass culture an important definitional point needs to be cleared up, which concerns the differences between elite culture or art, popular or folk culture, and mass culture. This need arises from the way theories of mass society and mass culture usually rest upon a clear division between the past and the present. The division is normally taken to refer to a process of social change which is conceived of as a transition from a 'better' or preferable past to a degenerating and uninviting present and future. The pre-mass society is viewed as a communal organic whole in which people accept and abide by a shared and agreed upon set of values which effectively regulate their integration into the community, and which recognise hierarchy and difference. There is a place for art, the culture of elites, and a place for a genuinely popular folk culture which arises from the grass roots, is self-created and autonomous and directly reflects the lives and experiences of the people. This authentically popular folk culture can never aspire to be art, but its distinctiveness is accepted and respected. With industrialisation and urbanisation this situation changes. Community and morality break down, individuals become isolated, alienated and anomic, the only relationships open to them being those of a financial and contractual kind. They are absorbed into an increasingly anonymous mass, manipulated by the only source of a surrogate community and morality available to them, the mass media. In this world,

MASS CULTURE

mass culture spreads like a deadly ether suffocating folk culture and threatening to stifle the very integrity of art.

To indicate the relevance of this to the themes of this chapter it is perhaps worth quoting a leading theorist of mass culture on the substance of the last paragraph:

Folk art grew from below. It was a spontaneous, autochthonous expression of the people, shaped by themselves, pretty much without the benefit of High Culture, to suit their own needs. Mass Culture is imposed from above. It is fabricated by technicians hired by businessmen; its audiences are passive consumers, their participation limited to the choice between buying and not buying.... Folk Art was the people's own institution, their private little garden walled off from the great formal park of their master's High Culture. But Mass Culture breaks down the wall, integrating the masses into a debased form of High Culture and thus becoming an instrument of political domination.

(MacDonald: 1957; p. 60)⁷

This statement provides a concise summary of how this perspective sees the differences between elite, folk and mass culture. We now have to consider more fully the implications of these differences, and the meaning of the idea of mass culture.

The mass culture debate

To put it as simply as we can, we could say that mass culture is popular culture which is produced by mass production industrial techniques and is marketed for a profit to a mass public of consumers.⁸ It is commercial culture, mass produced for a mass market. Its growth means that there is less room for any culture which cannot make money, which cannot be mass produced for a mass market, like art and folk culture. Although stated somewhat crudely, this picture would probably represent an accurate, if elliptical, description of the claims covered in this chapter. It indicates, moreover, how mass culture theory has been a response to the industrialisation and commercialisation of popular culture on a grand scale, a process which began to gather momentum in the 1920s and 1930s. The terms of the theory and its implications need to be made more precise before I go on to try to show how in this country it has been bound up with the debate about Americanisation. This will lead on to a critical examination of its claims.

First of all, we can note that it is industrialisation and urbanisation which give rise to an atomised and anonymous mass which is ripe for manipulation, a mass market for the mass media which can only be catered for by forms of mass culture. These processes entail mass production industries and mass markets which both encourage the spread of mass culture. For this approach, the main determinant of mass culture is the profit its production and marketing can make from its potential mass market. If it can't make money then it is unlikely to be produced. Together with this, the effects of the mass production of mass culture are also stressed by the theory. The use of mass production techniques are seen to have as harmful and debasing an influence on the culture produced in industrialised mass societies as the imperatives of commercial profit. It is argued that aspects of mass production like the assembly line, a highly specialised division of labour, the strict compartmentalisation of different stages of production, the large quantities which can be manufactured and so on (which could be said to have marked the Hollywood studio system between the coming of sound in the late 1920s and the disentangling of production, distribution and exhibition along with the decline in audiences in the late 1940s and 1950s) stamp mass culture with the particular kinds of characteristics which are associated with the products of mass production industries.

From this point of view, there is no real difference between material and cultural products, between the production of cars and the production of films. The standardised, formulaic and repetitive products of mass culture are the result of the manufacture of cultural commodities by means of routine, specialised, fragmented, assembly-line forms of production. Art, for example, cannot be produced in this way. The aesthetic complexity of true art, its

creativity, its experiments, its intellectual challenges, cannot be realised by the techniques which produce mass culture. They rather depend upon the complete opposite of mass production, the inspired genius of the individual artist working outside the constraints of the commercial market, and the tried and tested formulas and standard techniques of composiiton. Equally folk culture has to be produced by an integrated community which knows what it is doing, which has mastered the techniques of production, and which can guarantee the authenticity of its products.

Associated with this line of argument is a specific conception of the audience for mass culture, the mass or the public which consumes mass produced cultural products. The audience is conceived of as a mass of passive consumers, prone to the manipulative persuasions of the mass media, submissive to the appeals to buy mass produced commodities made by mass culture, supine before the false pleasures of mass consumption, and open to the commercial exploitation which motivates mass culture. The picture is of a mass which almost without thinking, without reflecting, abandoning all critical hope, buys into mass culture and mass consumption. Due to the emergence of mass society and mass culture it lacks the intellectual and moral resources to do otherwise. It cannot think of, or in terms of, alternatives. The cultural universe is reduced to one common mass. Art lies beyond its aspirations, and it has already lost its folk culture. Culture has to be mass produced for this audience in order to be profitable.

To sell to this mass consuming public, the bland and standardised formulas of mass culture are developed because they can be made to appeal to everyone since everyone, every atomised person, is open to manipulation. Equally, they are the kind of cultural products which can be made in large numbers by mass production industries. There is thus no point in making demands upon or challenging this audience in the way that art might do, or drawing it into genuine and authentic forms of communal participation as folk culture might do, since their conditions can no longer be guaranteed. Instead, the mass audience is there to have its emotions and sensibilities manipulated, to have its needs and desires distorted and thwarted, to have its hopes and aspirations exploited for the sake of consumption, by the meretricious sentiments, the surrogate fantasies, the false dreams of mass culture. In effect, mass society delivers up people to mass exploitation by mass culture.

This view of the mass audience, a view to be found in a range of theories of popular culture, is conveyed by a leading proponent of the theory of mass culture in the following terms:

in so far as people are organized . . . as masses, they lose their human identity and quality. For the masses in historical time are what a crowd is in space: a large quantity of people unable to express themselves as human beings because they are related to one another neither as individuals nor as members of communities - indeed, they are not related to each other at all, but only to something distant, abstract, nonhuman: a football game or bargain sale in the case of a crowd, a system of industrial production, a party or a State in the case of the masses. The mass man is a solitary atom, uniform with and undifferentiated from thousands and millions of other atoms who go to make up 'the lonely crowd' as David Reisman well calls American society. A folk or a people, however, is a community, i.e., a group of individuals linked to each other by common interests, work, traditions, values, and sentiments.

(MacDonald: 1957; p. 69)

Lest this argument be thought anachronistic, perhaps some more recent examples will suggest otherwise. Paul Johnson writing in 1964 described an unwelcome encounter with a TV pop show audience as follows:

Both TV channels now run weekly programmes in which popular records are played to teenagers and judged. While the music is performed, the cameras linger savagely over the faces of the audiences. What a bottomless chasm of vacuity they reveal! The huge faces, bloated with cheap confectionary and smeared with chain-store make-up, the open, sagging mouths and glazed eyes, the hands mindlessly drumming in time to the music, the broken stiletto heels, the shoddy, stereotyped, 'with-it' clothes; here apparently is a collective portrait of a generation enslaved by a commercial machine. Leaving a TV studio recently, I stumbled into the exodus from one of these sessions. How pathetic and listless they seemed: young girls, hardly any more than 16, dressed as adults and already lined up as fodder for exploitation.

(Cited in Frith: 1983; p. 252)

This is a famous if extreme example, one which clearly concentrates upon the seemingly most passive and exploitable of all mass consumer markets, the youth market for clothes, fashion and music.

Mass culture, for this theory, is a standardised, formulaic, repetitive and superficial culture, which celebrates trivial, sentimental, immediate and false pleasures at the expense of serious, intellectual, time honoured and authentic values. As MacDonald, lamenting what he calls the 'spreading ooze of Mass Culture', argues:

it is a debased, trivial culture that voids both the deep realities (sex, death, failure, tragedy) and also the simple, spontaneous pleasures, since the realities would be too real and the pleasures too *lively* to induce . . . a narcotized acceptance of Mass Culture and of the commodities it sells as a substitute for the unsettling and unpredictable (hence unstable) joy, tragedy, wit, change, originality and beauty of real life. The masses, debauched by several generations of this sort of thing, in turn come to demand trivial and comfortable cultural products.

(MacDonald: 1957; pp. 72-73)

Mass culture is therefore a culture which lacks intellectual challenge and stimulation, preferring the undemanding ease of fantasy and escapism. It is a culture which denies the effort of thinking and creates its own emotional and sentimental responses, rather than demanding that its audiences use their own minds, make an effort, and work out their own responses. In this sense, it begins to define

social reality for the mass public. It therefore tends to simplify the real world and gloss over its problems. If these problems are recognised, it usually treats them superficially by presenting glib and false solutions. It equally encourages commercialism and celebrates consumerism, together with the virtues of profit and the market, and, just as it denies intellectual challenge, it tends to silence other opposing voices because it is a stultifying and passifying culture.

The rise of mass culture would, on its own, be considered enough of a danger by those writers under consideration in this chapter; but it has not just been the effects so far described which have been at issue. If the eclipse of folk culture could not be resisted by the 'people', high culture has equally been at risk along with the role of the traditional intellectual elite. Here we come to the core of many of the anxieties, fears and hostilities expressed by these intellectuals about mass culture. Another elite culture has still remained available, along with the already doomed folk culture being deserted by the masses in favour of mass culture. Nevertheless, its place and security, its privilege to judge, arbitrate, voice its judgements and speak on behalf of those who could not otherwise have a voice, have been challenged both by the spread of mass culture and the general trivialisation of all culture it has entailed, and by the presumed loss of the skills and abilities required to appreciate and understand high culture.

For some, like MacDonald, this would not be that much of a problem if the people could keep to their own folk cultural pastimes, and leave art to the elite. For others, however, it served as a warning of just how pernicious the hold of mass culture could be. Writing in the early 1930s in an interesting study of the book market, the English literary and social critic, Q.D. Leavis (1906–1981), expressed her concerns as follows:

It is not perhaps surprising that, in a society of forty three millions so decisively stratified in taste that each stratum is catered for independently by its own novelists and journalists, the lowbrow public should be ignorant of the work and even of the names of the highbrow writers, while to the highbrow public 'Ethel M. Dell' or 'Tarzan' should be convenient symbols, drawn from hearsay rather than first-hand knowledge. But what close at hand is apparently trivial becomes a serious development when we realise that this means nothing less than that the general public – Dr. Johnson's common reader – has now not even a glimpse of the living interests of modern literature, is ignorant of its growth and so prevented from developing with it, and that the critical minority to whose sole charge modern literature has now fallen is isolated, disowned by the general public and threatened with extinction. Poetry and criticism are not read by the common reader; the drama, in so far as it ever overlapped literature, is dead, and the novel is the only branch of letters which is now generally supported.

(Leavis: 1932; p. 35)⁹

And her study is designed to show how the serious, high-brow novel is next.

According to MacDonald, mass culture poses a threat because of its homogeneity, its capacity to level down or debase all culture, and remake it in its own image. It is

a dynamic, revolutionary force, breaking down the old barriers of class, tradition, taste, and dissolving all cultural distinctions. It mixes and scrambles everything together, producing what might be called homogenized culture.... It thus destroys all values, since value judgements imply discrimination. Mass culture is very, very democratic: it absolutely refuses to discriminate against, or between, anything or anybody.

(MacDonald: 1957; p. 62)

This argument is clearly similar to those we hear today regarding the postmodern traits of contemporary culture. It also shows, as does Q.D. Leavis's argument, that the position of the elite intellectual as an arbiter of cultural taste has been seen to be open to the democratising threat posed by mass culture. The real problem sometimes appears to be that mass culture, unlike folk culture, refuses to stay in its place and stick with the masses, but has pretensions beyond its station or merits, and refuses to recognise traditional hierarchies of taste, and the cultural distinctions generated by those at the top. The threat of mass culture for these theorists resides in its ability to undermine the distinctions once established between elite and popular culture. In doing so, it co-opts, while at the same time debasing and trivialising, what high culture has to offer.

Q.D. Leavis makes this clear in her analysis of the fate of the then modern novel. Referring first to the growing taste for mass culture, she notes its effects as follows:

The training of the reader who spends his leisure in cinemas. looking through magazines and newspapers, listening to jazz music, does not merely fail to help him, it prevents him from normal development, partly by providing him with a set of habits inimical to mental effort ... whereas the eighteenth century and nineteeth century helped the reader, the twentieth century hinders.... This meant ... an inability to be bored and a capacity to concentrate, due in part, no doubt, to the fact that there that there was no competition of amusements provided. Life was not then a series of frivolous stimuli as it now is for the surburban dweller, and there was time for the less immediate pleasures. The temptation to accept the cheap and easy pleasures offered by the cinema. the circulating library, the magazine, the newspaper, the dance-hall, and the loud-speaker is too much for almost every one. To refrain would be to exercise a severer selfdiscipline than even the strongest-minded are likely to practise, for only the unusually self-disciplined can fight against their environment and only the unusually self-aware could perceive the necessity of doing so.

(Leavis: 1932; pp. 224-225)

This conclusion is confirmed for Leavis by the 'disappearance of poetry from the average man's reading', and by the fact that book clubs don't improve taste but rather standardise it (ibid.; p. 229). Thus, 'the general reading public of the twentieth century is no longer in touch with the best literature of its own day or of the

MASS CULTURE

past.' And this is because 'the idiom that the general public of the twentieth century possesses is not merely crude and puerile; it is made up of phrases and cliches that imply fixed, or rather stereo-typed, habits of thinking and feeling at second-hand taken over from the journalist' (ibid.; pp. 235, 255); and, we might add, from the other producers of mass culture as well.

The threat posed to high culture by mass culture is given a slightly different slant by MacDonald. According to him, in the 1920s the mass culture of Hollywood (which was mitigated to a limited extent by bits of avantgardism and folk art) and the high culture of Broadway were clearly and sharply distinguished from each other in terms of production - commercial versus artistic criteria; texts - popular pleasure versus intellectual stimulation; and audience - the masses versus the metropolitan upper class. It is, of course, questionable as to whether Hollywood could ever have contained types of popular art and vestiges of an avantgarde if MacDonald's argument is valid. Be that as it may, he goes on to suggest that with the coming of the sound film this differentiation began to break down. 'Plays are now produced mainly to sell the movie rights, with many being directly financed by the film companies. The merger has standardised the theatre expunging both the classical and the experimental.' He continues:

And what have the movies gained? They are more sophisticated, the acting is subtler, the sets in better taste. But they too have become standardised.... They are better entertainment and worse art. The cinema of the twenties occasionally gave us the fresh charm of Folk Art (e.g. Chaplin) or the imaginative intensity of Avantgardism (e.g. D.W. Griffith). The coming of sound, and with it Broadway, degraded the camera to a recording instrument for an alien art form, the spoken play. The silent film had at least the *theoretical possibility*, even within the limits of Mass Culture, of being artistically significant. The sound film, within those limits, does not.

(MacDonald: 1957; pp. 64-65)

Clearly, there are problems in making this kind of historical claim fit in with MacDonald's theorisation of the differences between mass culture, folk culture and high culture. The latter two are seen to be dependent upon the workings of a harmonious community which it may be difficult to find, given the claims of mass culture theory, in either the mass production of Hollywood cinema or its mass audiences.

If it is the case that mass culture has threatened to unseat high culture and take over, where does this leave art and the avantgarde? What role if any can they play in the era of mass culture? As with so many who hold to this understanding of popular culture, MacDonald adopts a position of cultural pessimism. For him, 'bad stuff drives out the good, since it is more easily understood and enjoyed' (ibid.; p. 61). But he does see the artistic avant-garde having a defensive role to play because it is, by definition, outside the market place, and can maintain artistic standards. It therefore represents the opposite of mass culture. The modernist avant-garde between the late nineteenth century and the 1930s (MacDonald cites Rimbaud, Joyce, Stravinsky and Picasso) tried to preserve an area outside the market and mass culture where 'the serious artist could still function'. In this it was 'remarkably successful', producing the only worthwhile art in this period (ibid.; p. 63).

But whether this intellectual community can sustain itself is open to doubt in MacDonald's eyes. His is a cultural pessimism in which the future is truly dark, and in which alternatives are being closed off. It is only the modernist avant-garde which seems to hold out a faint glimmer of hope. There is no sense here of the idea that mass or popular culture may not be the monolithic or homogeneous phenomena mass culture theory makes it out to be, and that therefore possibilities for difference, challenge and innovation may well exist within as well as outside this culture. Also, whether popular culture is in itself a bad thing is equally something which may be questioned. There are notable similarities in these respects between mass culture theory and the Frankfurt School's analysis of modern culture. However, the Frankfurt School does have a more systematic conception of the role an avant-garde can play as the guardian of truth and values in an age of mass culture.

Indeed, Q.D. Leavis puts forward a somewhat comparable argument in pointing to ways of preventing mass culture from

undermining literary standards and destroying the reading public. What she argues is that the cultural rot can only be stopped by the efforts of a committed intellectual elite: 'all that can be done, it must be realised, must take the form of resistance by an armed and conscious minority' (1932; p. 270). The role of this elite, this conscious minority, is two-fold. First, it must carry out research to show just how bad things have become, how far the literary standards and reading capacities of the general public have declined and how restricted a role the serious novel and writer have to play in cultural life. This will equip the elite with the information it needs to carry out its mission to reverse the decline produced by mass culture, rather than enlightening the people directly. The result of this research would not only be books to increase 'general awareness': 'it would also mean the training of a picked few who would go out into the world equipped for the work of forming and organising a conscious minority' (ibid.; p. 271).

This leads us to the second role of this minority, that of 'educational work in schools and universities' (ibid.). Thus, the function of the 'conscious minority' is, first, to constitute an elite avant-garde which will substantiate and disseminate its interpretation of the rise of mass culture, and warn the population about, and try to reverse, the decline of serious culture; and, second, to regain its position of authority in education, and hence its position of authority as the ultimate arbiter of cultural and artistic taste and values. The similarity between this and theories of the political vangard should be evident enough as to require no comment. 'In fact', as Leavis comments, 'the possibilities of education specifically directed against such appeals as those made by the journalist, the middleman, the bestseller, the cinema, and advertising, and the other more general influences discussed in this study. are inexhaustible; some education of this kind is an essential part of the training of taste' (ibid.). This minority may be the only hope Leavis holds out for the future, but she does not share MacDonald's ambiguity about the influence that an intellectual avant-garde can exercise. Her analysis is therefore instructive not merely for what it says about what she sees as the debasing effect of mass culture upon literary standards, but for her political

response to this situation which involves a coherent and consistent theory of the role of an intellectual and elite avant-garde.

So far in this chapter I have tried to outline my understanding of the idea or theory of mass culture. This I have done by relating it to the theory of mass society with which it shares much in common. I have tried to show how the concept of mass culture involves the mass production and consumption of culture, the threatened subversion of folk culture and high culture, and the relationship between cultural pessimism and the role to be played by an intellectual avant-garde. I have argued that what characterises the conception of mass culture is that it represents a debased, trivialised, superficial, artificial and standardised culture, one which saps the strength of folk and high culture, and challenges the intellectual arbitration of cultural taste. I realise that the account I have presented is somewhat schematic and exaggerated. It is always open to the charge that any such composite picture does not do justice to the work of X, or the ideas of Y, nor to the concept Z. While I accept something of this argument, I would still insist that what I have outlined above is implied in whole or in part in most accounts of mass culture as popular culture.

It might also be suggested that nobody thinks in terms of mass culture any more, that we now know how to appreciate popular as well as high culture. The respective merits of these positions still need to be argued out but, in my view, the idea of mass culture is still very much alive, even if it is not always presented in precisely this way. It has a prominent part to play in many theories of popular culture, although its role may be understood in different terms. The challenge in a way is to try to understand and appreciate popular culture without resorting to the theory of mass culture.

Mass culture and Americanisation

The theory of mass culture outlined above has also been concerned about the process of Americanisation. The fears and anxieties expressed by critics of mass culture have been equally aroused by

MASS CULTURE

the threat of Americanisation.¹⁰ The reason for this is that American popular culture is seen to embody all that is wrong with mass culture. Because mass culture is thought to arise from the mass production and consumption of cultural commodities, it is relatively easy to identify America as the home of mass culture since it is the capitalist society most closely associated with these processes. So much mass culture comes from America that if it is perceived as a threat then Americanisation becomes a threat as well. For critics of mass culture this represents a threat not just to aesthetic standards and cultural values, but to the national culture itself.

It is therefore interesting that in Britain intellectual concern about the harmful effects of American influence can be found in the nineteenth century, before the massive potential for the mass production and consumption of culture began to be fully realised. This is where American populism and the consequences of mass democracy and education become important. Q.D. Leavis, for example, cites Edmund Gosse, writing in 1889, as follows:

One danger which I have long foreseen from the spread of the democratic sentiment, is that of the tradition of literary taste, the canons of literature, being reversed with success by a popular vote. Up to the present time, in all parts of the world, the masses of uneducated or semi-educated persons, who form the vast majority of readers, though they cannot and do not appreciate the classics of their race, have been content to acknowledge their supremacy. Of late there have seemed to me to be certain signs, especially in America, of a revolt of the mob against our literary masters. . . . If literature is to be judged by a plebiscite, and if the plebs recognise its power, it will certainly by degrees cease to support reputations which give it no pleasure and which it cannot comprehend. The revolution against taste, once begun, will land us in irreparable chaos.

(Leavis: 1932; p. 190)

The similarity between this kind of argument and the theory of mass culture should be obvious. America is identified as the home

22

of the mass revolt against literary taste, the point being that what can happen there can happen here if the 'democratic sentiment' is allowed to spread.

It is not that difficult to find early examples of anti-American sentiment. In his book *Culture and Anarchy*, originally published in 1869, a mid-nineteenth-century precursor of much that was to follow in the general condemnation of mass culture, the English poet and literary critic Arnold (1822–1883) wrote: 'in things of the mind, and in culture and totality, America, instead of surpassing us all, falls short.' America here is 'that chosen home of newspapers and politics' (cited in Webster: 1988; p. 180). Arnold's fears about Americanisation were part of his overall concern that democratisation should not just give power to the masses, but should entail a polity guided and directed by the state and a properly constituted culture. This culture should involve the 'pursuit of our total perfection by means of getting to know, on all the matters which most concern us, the best which has been thought and said in the world' (Arnold: 1932; p. 6).

It would probably be correct to say that the equation Arnold draws is between Americanisation and mass democracy rather than Americanisation and mass culture. However, as a number of writers have suggested, the two – democratisation and mass culture – are not that easily distinguished from each other. As Johnson notes, for example:

Trilling described Arnold's fear [about Americanisation] in terms of a fear of vulgarity, loss of distinction and, above all, that eccentricity of thought which arises when each man, no matter what his training or gifts, may feel that the democratic doctrine of equality allows him to consider his ideas of equal worth with those of his neighbour. . . Arnold's apprehension about Americanization stemmed originally from de Tocqueville's warnings about democracy.... He used America as a case study to analyse the possible dangers and trends of democracy. Thereafter, in English thought America or 'Americanization' was often seen as the epitome of what was most dangerous in the development of modern industrial society.... [Americanisation] meant two things especially to Arnold, a tendency towards fragmentariness [the absence of a powerful central authority be it an aristocracy or the state to guide, educate, establish standards] and an addiction to the banal [the absence of standards of excellence and thus the cultural and moral degeneration of society which could be halted by the educational inculcation of a properly constituted culture].

(Johnson: 1979; p. 21; cf. Webster: 1988; pp. 180-181)

This seems to be a consistent line of argument, although obviously subject to subsequent changes in context and content. Another example thus worth considering is the work of the English literary and social critic F.R. Leavis (1895–1978), who was responding directly to a clearly emergent mass culture. Apart from anything else, he took it as axiomatic that Americanisation was an accomplished fact: 'it is a commonplace that we are being Americanised' (cited in Webster: 1988; pp. 180–181; originally published 1930).

Leavis was a critic of mass society and mass culture, and saw America as an embodiment of both of these dangers. As Hebdige has noted with respect to the anxieties expressed about Americanisation in post-1945 British society, one of the main processes which caused concern was the 'levelling-down' that Americanisation represented (Hebdige: 1988; chapter 3). This levelling-down, the apparent potential for greater economic and cultural equality, appears also to have worried Leavis. He saw mass society as involving mass production and standardisation. generating an almost irrepressible shift to a mass culture dominated by the mass media. This involved the soporific pleasures of a superficial culture, and the exploitation of a rootless and uneducated public, which thereby denied the standards of great art. Americanisation was thus the nub of the problem for Leavis because American society had the most developed mass culture. and thus represented the future towards which other comparable societies, including Britain, were heading: 'American conditions are the conditions of modern civilization, even if the "drift" has

gone further on the other side of the Atlantic than on this' (cited in Johnson: 1979; p. 96).

These fears about Americanisation have not been confined to a backward looking and elitist conservatism, but can be found on the left as well. In this context an interesting socialist writer on Americanisation is the English novelist Orwell (1903–1950), who voices many of the concerns of the more traditionally conservative critics. Perhaps something of the flavour of Orwell's stance is captured in the following quote on the 'decline of the English murder':

it is significant that the most talked of English murder of recent years should have been committed by an American and an English girl who had become partly Americanized. But it is difficult to believe that this case will be so long remembered as the old domestic poisoning dramas, product of a stable society where the all-prevailing hypocrisy did at least ensure that crimes as serious as murder should have strong emotions behind them.

(Orwell: 1965; p. 13. Originally published 1946)

This was Orwell's conclusion to a short and presumably partly comic essay on changes in the nature of murder in which he set the traditional English murder, one which 'can have dramatic and even tragic qualities which make it memorable and excite pity for both victim and murderer', against the newer 'Americanised' murder cited in which there is 'no depth of feeling': 'it was almost by chance that the two people concerned committed that particular murder, and it was only by good luck that they did not commit several others.' According to Orwell, the two murderers were an English woman who had said 'she wanted to do something dangerous, "like being a gun-moll", and an American Army deserter who had, untruthfully, 'described himself as a big-time Chicago gangster'. Moreover, 'the background' to the murder 'was not domesticity, but the anonymous life of the dance halls and the false values of the American film' (ibid.: pp. 11–12).

Orwell was equally critical of the moral cynicism of the 'Americanised' crime novel. The example he had in mind was No Orchids For Miss Blandish, which featured a gangster as its 'hero'.

This he compared with the less morally ambivalent 'Raffles' books which were also about the activities of a criminal hero figure. In contrasting these crime novels, the latter dating from the turn of the century, the former being published in 1939, Orwell was concerned with 'the immense difference in moral atmosphere between the two books, and the change in popular attitude that this probably implies' (ibid.: p. 63; *Raffles* is the actual title of the first book of a trilogy by E.W. Hornung). In view of the Americanised and popular character of the *No Orchids* novel Orwell argues that:

Evidently there are great numbers of English people who are partly Americanized in language and, one ought to add, in moral outlook. For there was no popular protest against *No Orchids...* The thing that the ordinary reader *ought* to have objected to – almost certainly would have objected to, a few decades earlier – was the equivocal attitude towards crime. It is implied ... that being a criminal is only reprehensible in the sense that it does not pay ... the distinction between crime and crime prevention practically disappears. ... Even a book like *Raffles* ... is governed by powerful taboos, and it is clearly understood that Raffles's crimes must be expiated sooner or later. In America, both in life and fiction, the tendency to tolerate crime, even to admire the criminal so long as he is successful, is very much more marked.

(ibid.: p. 73)

If such Americanisation is indeed a trend then, for Orwell, 'there would be good grounds for dismay'. Raffles may have been a criminal but he was also a 'gentleman' and therefore subscribed to a code of moral honour, even if this in the end turned out to be no more than 'the reflexes of a gentleman'. On the other hand, in books like *No Orchids*, 'there are no gentlemen and no taboos. Emancipation is complete. Freud and Machiavelli have reached the outer suburbs. Comparing the schoolboy atmosphere of the one book with the cruelty and corruption of the other, one is driven to feel that snobbishness, like hypocrisy, is a check upon behaviour whose value from a social point of view has been underrated'

(ibid.: p. 79). For, after all, according to Orwell, intellectuals, unlike the 'common people', had by then got used to reading 'serious novels' which no longer dealt in the 'world of absolute good and evil', and which no longer provided a clear division 'between right and wrong' (ibid.: pp. 77–78).

The substance of Orwell's position regarding mass culture and Americanisation is therefore fairly clear, and can be found throughout his work, including, for example, his discussion of 'boy's weeklies' written in 1939 (Orwell: 1957; pp. 193–195). Also clear is the fact that lying behind much of his work was a particular conception of England:

we are a nation of flower-lovers, but also a nation of stamp-collectors, amateur carpenters, coupon snippers, darts players, crossword puzzle fans. All the culture that is most truly native centres around things which even when they are communal are not official – the pub, the football match, the back garden, the fireside and the 'nice cup of tea'.

(ibid.: p. 66. Originally published 1940)

For writers like Orwell, Americanisation did not pose the threat to folk culture that it did for those critics of mass culture I discussed earlier. They have all, however, been concerned about its consequences for art and the national culture. Thus, for Orwell, it threatened his notion of Englishness, a notion which is evident in those writings of his I have mentioned above. But what it also posed a threat to, for him, was a particular understanding of the established working-class community. This conception of the working class shared many of the qualities ascribed by mass culture critics to the rural folk community – organic harmony, shared authentic values, a moral sense of communal and individual worth, autonomous leisure pursuits, genuine patterns of social integration – although it was a product, not of an agrarian society, but of an industrial and urban capitalism.

The better known and more extensive presentation of this position is that put forward by the English cultural critic Hoggart (b.1918). Hebdige links Orwell and Hoggart together in what he calls a 'negative consensus'. In taking the stance they did, he

argues, they knew what they wanted to preserve – the traditional working-class community – rather than what they wanted to change: 'Orwell and Hoggart were interested in preserving the "texture" of working-class life against the bland allure of post-war affluence – television, high wages, and consumerism' (Hebdige: 1988; p. 51; cf. pp. 50–52).

In his justly famous book *The Uses of Literacy*, first published in 1957 (a book which has been central to the development of the study of popular culture in Britain) Hoggart tried to document how the traditional and closely knit working-class community was being taken over by what he termed 'a shiny barbarism'. Writing about the background in which he grew up, he said his was not simply a critical attack upon mass culture and Americanisation, nor a statement of a particular set of preferences. He viewed what he was doing, in part, as providing a sociology of the uses of popular culture, and of the role of media in people's lives. As Passeron has noted, Hoggart's book draws 'attention to the fact that the reception of a cultural message should not be dissociated from the social conditions in which it occurs and thus from the *ethos* which essentially characterises a social group' (cited in Dyer: 1973; p. 40).

The 'shiny barbarism' Hoggart feared was for him associated with mass culture and Americanisation. In particular, he was concerned about the manipulative and exploitative influence exercised over the working-class community, most especially over its more vulnerable younger members, by the America of the Hollywood film, the cheap and brutal crime novel, 'milk bars' and juke-box music. As Webster has pointed out (1988; p. 187), Hoggart's view of the value and influence of American culture is not totally dismissive or negative. He recognises, for example, the vibrancy and relevance of the more realistic and straightforward qualities of the 'tough-guy' American crime novel in its appeal to working-class readers. However, there is little doubt that, in the end, Hoggart lumps together Americanisation and working-class youth in an elegantly argued moral warning about the debasement of workingclass life and the gradual wearing down of the traditional working-class community. Hoggart saw the 'newer mass arts' like

'sex-and-violence novels', 'the "spicy" magazines', 'commercial popular songs' and the 'juke-box', enticing working-class people to lose themselves and their culture in a mindless and trivial 'candyfloss world', the 'hollow brightness' of a 'shiny barbarism', a world brought to them from across the Atlantic.

Some of Hoggart's most extended condemnations of the impact of Americanisation are reserved for working-class youth. The 'juke-box boys', who frequented what were known in the 1950s and early 1960s as 'milk bars', get special attention. I therefore make no apologies for quoting the following once again:

the milk-bars indicate at once, in the nastiness of their modernistic knick-knacks, their glaring showiness, an aesthetic breakdown so complete that, in comparison with them, the layout of the living-rooms in some of the poor homes from which the customers come seems to speak of a tradition so balanced and civilized as an eighteenth-century town house ... most of the customers are boys aged between fifteen and twenty, with drape-suits, picture ties, and an American slouch. Most of them cannot afford a succession of milkshakes, and make cups of tea serve for an hour or two whilst - and this is their main reason for coming - they put copper after copper into the mechanical record-player. About a dozen records are available at any one time; a numbered button is pressed for the one wanted, which is selected from a key to titles. The records seem to be changed about once a fortnight by the hiring firm; almost all are American.... Some of the tunes are catchy; all have been doctored for presentation so that they have the kind of beat which is currently popular . . . the 'nickleodeon' is allowed to blare out so that the noise would be sufficient to fill a good-sized ballroom rather than a converted shop in the main street. The young men waggle one shoulder or stare, as desperately as Humphrey Bogart, across the tubular chairs.

(Hoggart: 1958; pp. 203-204)

The view Hoggart has of the influence exercised by Americanised imagery and consumerism over young working-class men is clear. The import of American mass culture leads the 'juke-box boys' away from the lived authenticity of their working-class backgrounds and into the empty fantasy world of Americanised pleasures.

During the period after the end of the Second World War in Britain, Americanisation had become an aspect of some more general fears and anxieties about the increasing capacity of the young and the working class to participate in the slowly emerging consumer society. Booker defined Americanisation, in his idiosyncratic social and cultural history of post-war Britain, as 'a brash, standardised mass-culture, centered on the enormously increased influence of television and advertising, a popular music more marked than ever by the hypnotic beat of jazz, and the new prominence, as a distinct social force, given to teenagers and the young' (Booker: 1969; p. 35). As Americanisation came to be associated with increased consumerism on the part of the young and the working class, America itself came to be an object of consumption. Frith makes this point as follows: 'The American dream became an inextricable part of mass cultural fantasies. In German film director Wim Wenders's words, "The Americans colonised our sub-conscious" ... America, as experienced in film and music, has itself become the object of consumption, a symbol of pleasure' (Frith: 1983; p. 46).¹¹ It is therefore not surprising that Hebdige can argue that invoking 'the spectre of Americanisation could be used to stand in for any combination of the following ideological themes: the rebellion of youth, the "feminisation" of British culture, the collapse of authority, the loss of Empire, the breakdown of the family, the growth in crime, the decline in attendance at places of worship, etc.' (1988; p. 58).

This set of themes informs Hoggart's arguments, but he was just as interested in what was being lost in the process. Hence, for example, his association of Americanisation and the milk bar with the loss of the communal sociability of the working-class pub:

compared even with the pub around the corner, this is all a peculiarly thin and pallid form of dissipation, a sort of spiritual dry rot amid the odour of boiled milk. Many of the customers – their clothes, their hair-styles, their facial expressions all indicate – are living to a large extent in a myth-world compounded of a few simple elements which they take to be those of American life.

(Hoggart: 1958; p. 204)

There is thus in Hoggart's work the idea that the 'genuine' working-class community is in the process of being dissolved into cultural oblivion by mass culture and Americanisation (ibid.; pp. 164–165 and 282–285).

Americanisation and the critique of mass culture theory

If we now begin to think about the critical problems which this particular understanding of Americanisation has to confront, then we can introduce a more general critique of mass culture theory. There are other ways of understanding the process of Americanisation in Britain, and I shall now look at some of these before proceeding to the general critical conclusions of this chapter.

Many nineteenth-century cultural critics were concerned about Americanisation because they identified it with mass democratic populism, and thus feared it would allow the masses to run the government and lower cultural standards. Others, however, associated America with democracy, modernity, rationality and science. The scientist T.H. Huxley, for example, saw America as representing the promise of a scientific and rational future. Huxley was an optimist for whom there was no real benefit in trying to preserve social and cultural forms which were in decline. Instead, he saw immense possibilities being opened up for everybody by the forward march of a progressive and scientific modernity. As Johnson notes:

Huxley was optimistic about the way in which society was developing, an attitude which he exhibited quite explicitly in his reaction to America. He was filled with optimism and exhilaration by his visit there. Describing his first sight of America, he remarked on the excitement he felt on seeing the towers and buildings of the post office and other

31

MASS CULTURE

communication centres, instead of the spires of churches. Huxley interpreted this first sighting as symbolizing the Americans' interest in knowledge rather than superstition.

(1979; p. 50)

The example of a scientist like Huxley is instructive since his views illustrate an alternative understanding of America and Americanisation which can be used to offer a critical commentary on mass culture theory.

In looking at this alternative we can begin with the reading public and the decline of literary standards focused upon by Q.D. Leavis and Orwell. Other arguments indicate how, sociologically speaking, the issues involved are significantly more complex than a simple decline of standards. In his discussions with working-class people about their past lives, part of an attempt to construct an oral history, Worpole found that a surprising number of the people he talked to said that one type of reading matter they had preferred had been American crime and detective fiction. On the basis of this evidence. Worpole tentatively speculates that, in the 1930s and 1940s, this kind of fiction gave male, urban, working-class readers access to a language, a style and a subject matter that was more realistic, more relevant to their own lives, their own conditions and circumstances, more like the way they spoke and thought and dealt with other people, and which were not available in the literature written by and for the English upper and middle classes. As he writes:

it was in American fiction that many British working class readers . . . found a realism about city life, an acknowledgement of big business corruption, and an unpatronising portrayal of working class experience and speech which wasn't to be found in British popular fiction of the period, least of all in the crime novel obsessed as it was with the corpse in the library, the colonel's shares on the stock market, and thwarted passion on the Nile.

(Worpole: 1983; p. 35. Cf. R. Chandler: 1980; p. 186)

This provides an interesting counterpoint to Orwell's complaints about the 'decline of the English murder' and the popularity of the

32

American crime novel. Perhaps one of the things which is opened up by this comparison is the difference between the critical arbitration of taste and a sociology of culture (cf. Bourdieu: 1984; especially pp. 11-57).

In any event, Worpole's speculations are given support by White's historical study of a working-class street in North London, near Finsbury Park. This area, Campbell Bunk, had a reputation as one of the roughest and toughest in London, and White presents a historical overview of its development and eventual demise. With respect to the theme of Americanisation he remarks:

The cinema forged ... links between the male youth of Campbell Road and outside. This was especially true of the American talkies . . . American films offered heroes and heroines who were less hidebound by class than their technically inferior British counterparts. The glamourised male (especially young male) violence of films like Little Caesar (with Edward G. Robinson, 1930), Public Enemy (with James Cagney, 1931), Scarface (with George Raft, 1932), helped workingclass youngsters see themselves as heroes rather than bystanders, the subject of life rather than its object. The adopted American accents, dress-styles and mannerisms, which many observers bemoaned as slavish emulation of a new trash culture, can be interpreted quite differently. This borrowed 'style' was a self-conscious identification with a more democratic discourse than anything British society (including its labour movement) had to offer them.¹²

(White: 1986; p. 166)

Thus looking at the influence of American popular culture 'from below', from the point of view of the people who actually consume popular culture, can offer strikingly different pictures from those which can be glimpsed 'from above', from the point of view of those who wish to pass aesthetic judgements upon popular culture.

The debate over the nature and effects of Americanisation in Britain can be traced back to the nineteeth century. But it seems to have become more significant and more contentious after 1945. In this context it is possible to contrast Hebdige's arguments with those put forward by Hoggart. For Hebdige, fears about Americanisation in the post-war period were linked to fears about the threat posed to traditional intellectual elites and their judgements about taste by the 'levelling-down process'. Ideas about America being more populist and democratic fed into concerns about increasing working-class affluence and consumption, things which threatened the intellectual arbitration of taste and middle-class consumption as forms of symbolic and positional power. As both Hebdige and Webster have indicated, these fears reflected, to some degree, worries on the part of the 'British Establishment' over the decline in Britain's world role and its increasing dependence upon the American state (Hebdige: 1988; p. 58. Webster: 1988; pp. 183-184 and the conclusion). But what Hebdige is at pains to question is whether the working class, and particularly young, white, working-class men living in the centres of large cities and involved in putting together their own sense of subcultural styles, could be described and understood in Hoggart's terms.

Hebdige's point is that Americanisation did not result in the greater cultural uniformity and homogeneity which the mass culture critics had predicted. On the contrary, he notes 'the sheer plethora of youth cultural options currently available . . . most of which are refracted through a "mythical America" (1988; p. 74). This is so because for him:

American popular culture – Hollywood films, advertising images, packaging, clothes and music – offers a rich iconography, a set of symbols, objects and artefacts which can be assembled and re-assembled by different groups in a literally limitless number of combinations. And the meaning of each selection is transformed as individual objects – jeans, rock records, Tony Curtis hair styles, bobby socks, etc. – are taken out of their original historical and cultural contexts and juxtaposed against signs from other sources.

(ibid.)

It is in keeping with Hebdige's more general interpretation of subculture (Hebdige: 1979) that he sees Americanisation in this light. For him, young working-class males – his version of the 'juke-box boys' – do not consume their imaginary America in a passive and unreflective manner. They construct it with the popular cultural materials available, rather than being constructed by them. In this sense, it does not matter that their America is 'imaginary' because that is the point – it possesses its 'magic' because it is 'imaginary'. They thus consume styles in images, clothes and music in an active, meaningful and imaginative fashion, one which transforms the meanings of Americanisation and converts them into distinct subcultural tastes. Hebdige suggests that these young, urban, working-class men have used the images, styles and vocabularies of American popular culture in their own distinctive and positive ways as a form of resistance, albeit not a radical one, to middleclass and upper-class culture, and as a spirited defence against their own subordination.

Moreover, this assimilation and transformation of a 'mythical America' has gone along with the adoption of European styles and fashions. For example, the 'mods', a young working-class subculture based in the central areas of large citics which emerged first in the early 1960s, borrowed as much from Italy (suits and scooters) as it did from black American popular culture (modern jazz and soul music). In fact, Hebdige quotes the anonymous workingclass spy hero of Len Deighton's first novel, *The Ipcress File*, in this context. 'Until the 1960s', he writes:

the romantic affirmation of American culture tended to be left to such unashamedly 'popular' weeklies as *Titbits* and to the undergrowth of literature – the novelettes, comics and Hollywood ephemera – which were aimed at a predominantly working-class market. And by 1960, this market – at least significant sections of it, particularly amongst the young – had swung again – away from the exuberant vocabularies of streamlining and rock.

(1988; p. 74)

This change was marked for Hebdige by the appearance of Deighton's novel in 1962. The following words of the novel's narrator and anti-hero, which are to be found early on in the book, and which are quoted more extensively in Hebdige's account,

identify the character of the transition: 'I walked down Charlotte Street towards Soho ... I bought two packets of Gauloises, sank a quick grappa with Mario and Franco at the Terrazza, bought a Statesman, some Normandy butter and garlic sausage' (Deighton: 1978; p. 22). 'What is so remarkable here', according to Hebdige, 'is the defection of a man like Harry Palmer not to Russia - still less to America – but to Italy ... to the Continent.' He continues: 'it is perhaps the final irony that when it did occur the most startling and spectacular revolution in British "popular" taste in the early 1960s involved the domestication not of the brash and "vulgar" hinterland of American design but of the subtle "cool" Continental style which had for so many decades impressed the British champions of the modern movement' (1988; p. 75). Thus, Harry Palmer 'is a fictional extension of mod' (ibid.).¹³ Moreover, 'the "spy masters", Burgess and Maclean (followed later by Philby) - motivated, or so the story goes, by a profound contempt and loathing for America, for American cultural, economic and military imperialism, for the "Americanization" of the globe, had flown the roost leaving men like Palmer to take care of things' (ibid.; p. 76).

The contrast between elitist and populist evaluations of Americanisation is made evident for Hebdige by the example of the spy novel which he also uses to show how 'foreign' cultural influences, other than those deriving from America, were crucial to subcultural constructions, and to the structuring of popular culture more generally. Indeed, if he had continued to trace out these differences in the spy novel, he would have noted that the motives which led the mole in John Le Carré's novel *Tinker, Tailor, Soldier, Spy*, to betray his country, arose from a deeply felt anti-Americanism. In his confession at the end of the novel, the mole, very much a Leavisite rather than a mod, lays bare his reasons for his secret defection to the Soviet Union:

'The political posture of the United Kingdom is without relevance or moral visibility in world affairs.... In capitalist America economic repression of the masses is institutionalised to a point which not even Lenin could have forseen'. ... He spoke not of the decline of the West, but of its death by greed and constipation. He hated America very deeply, he said, and Smiley supposed he did.... At Oxford, he said, he was genuinely of the right.... For a while, after forty five, he said, he had remained content with Britain's part in the world, till gradually it dawned on him just how trivial this was.... He had often wondered which side he would be on if the test ever came; after prolonged reflection he had finally to admit that if either monolith had to win the day, he would prefer it to be the East.

(Le Carré: 1975; p. 306)

However, it has also to be noted that the spy novel may not be as representative as Hebdige suggests, in that it is a genre of popular fiction which has tended to be dominated by British writers. Furthermore, as Hebdige notes himself, the influence of the Continent was experienced by a subculture which took its music from black American culture. The point of the cultural moment Hebdige talks about is the mixture of cultural influences rather than the predominance of one over the other. But it is not a point which is as easy to substantiate as he appears to suggest.

None the less. I hope that the kind of argument put forward by Hebdige contrasts effectively with that offered by Hoggart, and outlines some of the interesting problems associated with the analysis of the Americanisation of popular culture, including the difficulties confronted when doing this from the perspective of mass culture theory. Needless to say, the debate about Americanisation has continued on into the 1970s and 1980s and has focused, for example, upon the threats posed to national cultural identities by popular American television programmes. Ang (1989) has shown in her study of the Americanising influence of US soaps like Dallas, how they are open to interpretations by audiences both in terms of an ideology of mass culture, and, by contrast, an ideology of populism. I hope that the overall discussion of Americanisation has provided a relevant and useful illustration of some of the issues and problems raised by mass culture theory and its approach to the analysis of popular culture. It now

MASS CULTURE

remains to extend some of the critical points made above into a more general critique of this perspective.

A critique of mass culture theory

Nowadays it might be more difficult to find many people who would subscribe openly and consistently to the theory outlined above. Yet I think it is still popular amongst certain groups, for example those committed to the defence of what they conceive of as great literature and great art. And even if it is not believed in as a whole, some of its specific arguments, such as the insistence on maintaining a distinction between art and popular culture, or the claim that contemporary popular culture isn't as good as it used to be, are still widely shared. As a case in point, some theorists of postmodernism tend to lament what they see as the lowering of the standards of aesthetic taste associated with contemporary popular culture, echoing the fears expressed by mass culture critics about the threat posed by mass culture to folk and elite culture (Jameson: 1984, Collins: 1989; chapter 1). The concept of a manipulated and passified audience susceptible to the ideological appeals of advertising and consumerism can be found in variants of Marxist, feminist and structuralist theory. Even those perspectives which pride themselves on 'taking popular culture seriously' sometimes seem too apologetic and self-conscious about doing this themselves.

The first line of criticism I want to look at claims that mass culture theory is elitist. This was a charge F.R. Leavis rejected:

the word 'elitism' is a product of ignorance, prejudice and unintelligence. It is a stupid word, but not for that the less effective in its progressive-political use, appealing as it does to jealousy and kindred impulses and motives. It is stupid, and perniciously so, because there must always be elites, and, moblizing and directing the ignorance, prejudice and unintelligence, it aims at destroying the only adequate control for 'elites' there could be.

(Cited in Johnson: 1979; p. 98)

However, it can be argued that the term elitism is highly relevant to any critical assessment of mass culture theory.

In keeping with the fact that elitism can be used to refer to a set of unexamined values which give rise to opinionated judgements about popular culture, the first problem with it concerns the privilege conferred upon those positions from which popular or mass culture can be understood and interpreted. An elitist position assumes that popular or mass culture can only be understood and interpreted properly from the vantage point provided by high culture or 'high' theory, from the principles derived from the aesthetics and 'taste' of cultural and intellectual elites. This is a problem because the principles or values which underlie this position often remain unexplored and untheorised. Elite values and aesthetics are assumed to be valid and authoritative and therefore capable of assessing other types of culture, without any questions being raised about these assumptions and their ability to pass cultural judgements. The claim that mass culture theory is elitist can be made because elitism rests upon a set of unexamined values which shape the perceptions of popular culture held by their adherents. It is characteristic of elites to try to pass off their own tastes as the best, or the only ones worth having, and thus pass them off as analyses of popular culture.

Moreover, elitism fails to recognise that mass culture can be understood, interpreted and appreciated by other groups in distinct and 'non-elitist' social and aesthetic positions within societies. This raises the question of why the understanding and appreciation of popular culture by some groups is thought to be better or more valid than the standards of other groups. We have already seen in the discussion of Americanisation, how working-class evaluations of mass culture have, at times, differed markedly from those held by mass culture critics. Elitist judgements fail to take seriously both alternative interpretations of popular culture, those which can be developed from alternative vantage points outside the elite, and the value these alternatives possess. In part, this occurs because elitism usually lacks any kind of sociology, but it tends to deal with this problem by diminishing the importance of the mass consumers of popular culture because they do not share the assumptions and

MASS CULTURE

the aesthetics of the elite. This may be why mass culture theory views the consumers of mass culture as passive, manipulable, exploitable and sentimental 'cultural dopes'. It is the elite which holds the key to cultural truth and everyone else's tastes are dismissed accordingly.

It can likewise be argued that elitism, like mass culture theory, tends to ignore the range and diversity of popular culture, and the tensions and contradictions within it. It usually sees mass culture as necessarily and inevitably homogeneous and standardised. In the critiques offered of the Americanisation thesis. I tried to show how it is difficult to see popular culture as homogeneous or standardised. It offers diversity and difference, and these qualities become even clearer when it is reinterpreted and re-evaluated outside its original context. There are therefore two separable strands to this point. First, popular culture is diverse because it is open to diverse uses and interpretations by different groups in society. Second, popular culture itself has to be seen as a diverse and varied set of genres, texts, images and representations which can be found across a range of different media. If it is possible for popular culture to be accounted for by the conflicts and tensions within and between its genres, texts, images and representations, between its producers and its media, and between its audiences, then it is difficult to see how it can be understood in terms of the mass culture theorists' criteria of homogeneity and standardisation. For example, the representations of women in advertising differ from those to be found in soap operas in terms of the range and variety of roles portraved. while it is not easy to conceive of rap, soul, jazz, sampling, novelty songs and 'serious' ballads as constituting a standardised musical mass 'sound'. This point has been made by Collins who writes:

If mass culture were indeed identical, one could expect some uniformity in its representations of life within the center.... Television, the quintessential mass culture medium in regard to both its transmission power and similarity of program format, would necessarily produce homogeneous visions of that center. Yet on the same night of the week at exactly the same time, two programs on opposing national networks present decidedly dissimilar visions of the urban center. During the 1987-88 season, on St Elsewhere (a 'hospital' program), the perils of urban experience - street crime chief amongst them - are diseases that can be treated by humanist understanding. The Equalizer, on the other hand, presents the city as overridden with criminals who feed on the innocent, a form of vermin that must be exterminated by the title character. Within forty-eight hours, in the same slot, the third major network presents yet another vision of urban life on Max Headroom. Here the city appears to be controlled by television networks in corporate boardrooms, and crime, more often than not, is a prime media event - a point made rather drastically in one episode when a news 'packager' employs a terrorist group to commit mayhem on command, allowing him to sell the television rights to urban disasters in the making.

(Collins: 1989; pp. 10-11)

While mass culture, none the less, does at times make use of standardised formats, this is not unique to it but can equally be found in elite culture.¹⁴ Moreover, it is perfectly possible to appreciate some forms of popular or mass culture without accepting it all. Since popular culture is not homogeneous, it does not have to be consumed as a whole. Parts of it can be chosen selectively as a result of more precise social and cultural factors than are envisaged by mass culture theory. The type of cultural discrimination exercised by audiences in particular social conditions becomes an interesting sociological problem, the solutions to which cannot be defined in advance but have to be determined empirically.

To some extent the consumption of popular culture by the general population has always been a problem for 'other people', be they intellectuals, political leaders or moral and social reformers. These 'other people' have often held the view that this population should ideally be occupied with something more enlightening or worthwhile than popular culture. Q.D. Leavis's work suggests, for example, that readers would be better off with a novel from the great tradition of English Literature than a pulp fiction magazine, while

41

MASS CULTURE

for MacDonald audiences should confine themselves to the theatre or silent and avant-garde films rather than mainstream Hollywood cinema. There are at least three strands to this argument. The first is that mass culture takes up time and energy which is preferably devoted to other more constructive and useful pursuits – like art or politics or resuscitating folk cultures. The second is that mass culture has positively harmful effects on its audiences, making them passive, enervated, vulnerable and thus prey to manipulation and exploitation. The third strand to the argument, therefore, is that bad mass culture drives out good culture – both folk culture and art.

The doubts which can be raised about these points concern the set of criteria agreed upon from which it is possible to determine what people should consume, what popular culture they should like and dislike and what enables some people to pass judgement on the tastes of others. Taste and style are socially and culturally determined. It is the power to decide upon the definitions of taste and style which circulate within societies which is important, rather than the remote possibility of finding universal and objective reasons for validating aesthetic judgements. The power to determine popular culture and the standards of cultural taste is not restricted to the economic and political power exercised by the mass culture industries, although these are obviously crucial for any adequate assessment of the overall process. It also includes, even if only as a secondary phenomenon, those intellectuals, or producers of ideas and ideologies, with the power to attempt to set down guidelines for cultural discrimination, and the position from which to try to decide upon what people should like and dislike. It is clear, as Ang has pointed out, that the ideology of mass culture does influence the evaluations made by audiences of popular culture, including those forms of popular culture which give them obvious pleasure (1989; chapter 3). The production of aesthetic value judgements, and hierarchies of cultural taste, together with the conflicts they give rise to, have therefore to be understood in this context.

One way in which an objective basis can be claimed for the critique of mass culture is through the pretence of speaking on behalf of the people, and praising the authenticity of their culture in contrast to the artificiality of mass culture. Mass culture by definition cannot arise from and be relevant to the lives and experiences of people in the way that a genuine and authentic popular or folk culture can be. However, questions can be raised about the definitions which are at play in these arguments. What, after all, does 'authentic' mean, and how can we know that a culture is authentic? Is there such a thing as a 'pure' culture rooted in authentic communal values untainted by outside influences and commercial considerations?

Popular music is an area in which the roots and authenticity of particular styles are important topics of study and evaluation, and are used to champion the superior status of certain genres like folk, blues or country when contrasted with the artificial and manufactured character of mainstream, mass market popular music. Yet the criteria of originality, roots, community and authenticity can be deployed as marketing strategies to appeal to particular segments of the audience for pop music, while presumably most musicians have to make a living. Also, how do authenticity and inauthenticity affect the pleasures music can afford its audience? Is it not possible for popular music with a wide appeal to be 'good', 'quality' music? Is it really the case that only authentic music is 'good' music? Questioning the notion of authenticity not only shows just how difficult a term it is to define, but also indicates that it may derive from a particular set of cultural tastes and values, rather than from a considered analysis of popular music. We might be prompted to ask if there is any such thing as an authentic popular culture.

The notion of authenticity is clearly associated with how mass culture theory conceives of the past. It is a familiar complaint that this theory has a very idealised and romanticised view of the past, of a society and culture fated to be ruined by the rise of mass culture. This ideology of the past is vividly captured by F.R. Leavis:

What we have lost is the organic community with the living culture it embodied. Folk-songs, folk-dances, Cotswold cottages and handicraft products are signs and expressions of something more: an art of life, a way of living, ordered and patterned, involving social arts, codes of intercourse and a responsive adjustment, growing out of immemorial experience, to the natural environment and the rhythm of the year. (Cited in Johnson: 1979; p. 96)

It can be argued that this romantic conception of the past is not fanciful but merely an attempt to show us what has been lost, and the consequences for us today. Yet it is difficult to resist the conclusion that an idealised 'golden age', in which an authentic folk culture and a truly great high culture knew their places in an ordered world, is an intrinsic part of mass culture theory. If this is so, we can question the way the theory overestimates the past and underestimates the present. What about the standards of education and literacy in the kinds of community evoked by Leavis? What about the qualities and pleasures of contemporary popular culture? Are not the continuing economic, political and cultural inequalities to be found in the past and the present bound up, to some extent, with the differences between folk, elite and mass culture? Equally, this conception of the past brings out again the elitism of the theory, for the idealised past is one based upon a cultural hierarchy dominated by the standards of the elite, to which the people are expected to defer.

This sense of a decline from a past when things were better is by no means unique to mass culture theory. But the notion of the past it holds to is, on closer inspection, very unclear. At what precise period of time and in what specific locations could the communities and cultures it talks about once be found apart from the Cotswolds? Was it in its heyday in an age of mass illiteracy? Like most 'golden ages', it is very difficult to pinpoint historically and geographically. Moreover, when did its decline begin? With the emergence of a commercial market for popular culture? With the rise of the modern mass media? With the spreading ownership of the radio, the dominance of Hollywood cinema, or the location of a television set in most people's homes? Or is it all the fault of America? Quite apart from the fact that representations of the past may themselves be cultural constructions which tell us more about the present than the past, these questions again indicate the lack of clarity, the absence of a sense of history and an unfounded nostalgia which characterise the arguments of mass culture theorists.

Two further points emerge out of this problem. The first is that mass culture theory lacks an adequate understanding of social and cultural change. It registers and criticises the appearance of mass culture but fails to explain it. In this sense, it limits itself in not fully understanding something it attacks. Inevitably, this limits both its explanatory and its critical power. It is not enough to say mass culture is a consequence of industrialisation, since a more precise specification of the links between the two is required for an adequate explanation to be put forward. Second, the theory seems to imply a resentment on the part of certain groups of intellectuals to the threats posed by mass culture and mass democracy - popular culture, education, literacy, etc. - to their role as cultural educators and arbiters of taste. Within a strictly defined social hierarchy, the production and protection of cultural standards and the arbitration of taste are carried out by elite intellectuals; and their judgements apply both to those classes which share in a position of domination and privilege, and to those in subordinate positions who participate in their own popular culture, while respectfully deferring to elite culture. Mass culture threatens this hierarchy. Dominant classes engage in the production of mass culture, disregarding the standards set by intellectuals, and the people have access to a popular culture outside the bounds of the traditional hierarchy and the criteria of cultural taste and distinction it embodies. The symbolic power of intellectuals over the standards of taste which are applied to the consumption of cultural goods becomes more difficult to protect and sustain when people have made available to them a mass culture which does not depend on intellectuals for its appreciation and its definitions of pleasure.

The distinctions drawn by mass culture critics between mass and high culture are not in fact as clear cut or as static as they claim. What is interesting is the way the boundaries drawn between popular culture and art, or between mass, high and folk culture, are constantly being blurred, challenged and redrawn. These boundaries are not given, nor are they consistently objective and historically constant. Rather, they are contested, discontinuous and historically variable. Mass culture theory tends to condemn mass culture as a whole. F.R. Leavis, for example, is said to have dismissed cinema as a serious cultural form. Yet even some mass culture critics like MacDonald are prepared to count some examples of cinema, like Eisenstein's films, as art. Types of jazz are now appreciated and appraised as art, but jazz was condemned as mass culture in the earlier part of the century by mass culture theory and by the Frankfurt School. Alfred Hitchcock made commercial films within the Hollywood system but he has since come to be defined as an auteur or artist, as an original and creative genius. Early rock 'n' roll records, once condemned as mindless pap by music critics, are now accorded 'classic' status by changing critical standards. It would be possible to go on, but what this line of argument suggests here is that the assessment of evaluative distinctions between types of culture, like high and low, or elite and mass, needs to take account of the historically shifting character of the power relations between the groups involved and the categories of taste at stake in the making of these distinctions (Levine: 1988. DiMaggio: 1986).

Politics are central to the analysis of popular culture. The evaluations developed of popular culture embody different forms of politics. In this context, the anti-democratic potential of mass culture theory can be mentioned. It would be unfair to suggest that all writers in this tradition are unrepentant elitist reactionaries. None the less, there is a tendency for the critical stance of mass culture theory to lament the emergence of mass democracies, and mass cultural markets, and to see an elite avant-garde as the only potential saviour of cultural standards. I happen to think that this tendency can be found in theories which are ostensibly more democratic, but with mass culture theory there is clearly an anxiety about the equalitarian effects of democracy upon traditional hierarchies which can potentially allow the masses rather than elites to determine what counts as culture.

A problem which needs to be dealt with directly in this critique concerns mass culture theory's inadequate understanding of the role of the audience in popular culture. One way of beginning to clarify this problem is to look at the feminist critique of mass culture theory, which will be dealt with more fully in chapter 5 on feminism. Modleski (1986a), for example, has pointed out how this theory tends to 'feminise' mass culture. It attributes to mass culture qualities which are culturally equated with the feminine, like consumption, passivity and sentiment or emotion, and contrasts these with qualities like production, activity and intellect, which are culturally equated with the masculine, and defined as art or high culture. The hierarchical relationship between art and mass culture is analogous with, and reinforced by, the hierarchical relationship betweeen the masculine and the feminine. The power of men over women is reflected in the cultural distinction between art and mass culture. This means that one major reason for the critical dismissal of mass culture arises from its allegedly 'feminine' qualities. For example, mass culture, like the cinema or the soap opera, is denigrated because it is sentimental and plays on our emotions. Hence it can be dismissed because it evokes reactions associated with the feminine. Not only can we ask what is wrong with sentiment, but we can see that one of the threats posed by mass culture, according to its critics, is that it will feminise its audience. The very language used in some accounts of mass culture invokes a scenario of 'seduction' - the 'conquest' of a 'passive' and 'vulnerable' audience by 'fantasies' of 'romance' and 'escape' - and only serves to underline this point.

Another way of looking at this problem is to be found in Ang's analysis (1989) of the ideologies used by viewers of the American TV soap *Dallas* to account for their reasons for watching and evaluating the programme. She found that those who disliked or hated the series, and those who watched but laughed at it from a carefully cultivated and 'ironic distance', came across as being confident and secure about the judgements they made and the grounds upon which they could make them. However, those who liked the series (of whom there were many) tended to be far less confident about expressing their preference for the programme. Some dealt with this anxiety by bringing out what they saw as the positive and serious qualities of the series, indicating, for example, how its message is that money cannot buy happiness; but others seemed apologetic and diffident about deriving pleasure from such an obviously inferior, Americanised, mass cultural product.

Ang accounts for this contrast by suggesting that two distinct, discursive and publicly available ideologies are at work. Without necessarily succumbing to the evaluations these ideologies imply, she distinguishes between an ideology of mass culture and an ideology of populism.¹⁵ The first, very much in keeping with the theory I have outlined in this chapter, is the one the first set of viewers resorts to in accounting for their hostile and ironic responses to Dallas. This ideology of mass culture appears to be more prominent as a public discourse about cultural evaluations of what is good and bad, and thus underpins the confident critique of the series as yet another example of Americanised mass culture. From this point of view, Dallas serves as a resonant symbol of the Americanisation of Europe. This ideology is contrasted with the ideology of populism which those who liked the series appeared to refer to, although with much less confidence and vigour than those articulating the ideology of mass culture. The ideology of populism, which is based on an equalitarian tolerance of different kinds of cultural taste and a respect for people knowing what they like, is used to account for the pleasures this set of viewers derived from watching Dallas.

One important implication of this analysis, quite apart from its treatment of how viewers evaluated the television series, is that it conceives of the relationships between audiences and popular culture not in terms of mass culture theory, but in terms of the shifting connections between power and knowledge. Ideologies about popular culture may not be equally available as ways of evaluating popular culture, and the ones that predominate publicly, like the ideology of mass culture, may not accord with the preferences of large sections of the audience.

Mass culture theory tends to see the audience as a passive, supine, undemanding, vulnerable, manipulable, exploitable and sentimental mass, resistant to intellectual challenge and stimulation, easy prey to consumerism and advertising and the dreams and fantasies they have to sell, unconsciously afflicted with bad taste, and robotic in its devotion to the repetitive formulas of mass culture. What criticisms can be made of this depiction of the audience? First, is there any such thing as a mass audience anyway? This question applies as much to the time when the theory first emerged as it does now. From the point of view of the producers of popular culture, there may not be a mass audience but rather segments of a market differentiated and stratified in terms of tastes, values and preferences as well as money and power. If particular producers need to maximise their audience then this has to be analysed as a specific instance of cultural production and consumption, and not assumed to be a generalised feature of societies in which culture has become a commodity. This mass audience may not even exist at the point of consumption since evaluations, interpretations and appreciations of popular culture, together with its 'effects', will vary along with the social context and social location of its consumers. The kinds of conclusions reached by mass culture theory cannot in fact be substantiated in advance of knowing about the social positions occupied by consumers of popular culture in the wider society.

Second, when people are consuming popular culture can they be characterised in the way mass culture theory suggests? Can the view that the audience for popular culture is an undifferentiated mass of passive consumers any longer be sustained? To answer these questions adequately we need to see audiences as socially and culturally differentiated, and to recognise that cultural taste is socially constructed. But more than this, we need to acknowledge that audiences may be more knowing, more active and more discriminating in their consumption of popular culture than has generally been conceded in much popular culture theory. There has, in fact, been a tendency for this theory to speak on behalf of the audience rather than finding out what it has to say for itself. To make this point, it is not necessary to suggest that audiences are somehow as powerful, if not more powerful, than the producers of popular culture.¹⁶ This is something I shall return to in the conclusion when discussing the recent emergence of what has been termed 'cultural populism'.

49

Further reading

Ang, I. (1989) Watching Dallas, London, Routledge.

- Bennett, T. (1982) 'Theories of the media, theories of society', in M. Gurevitch et al. (eds), Culture, Society and the Media, London, Methuen.
- Brookeman, C. (1984) American Culture and Society since the 1930s, London and Basingstoke, Macmillan.

Frith, S. (1983) Sound Effects, London, Constable.

- Hebdige, D. (1988) Hiding in the Light, London, Routledge (chapter 3).
- Hoggart, R. (1958) The Uses of Literacy, Harmondsworth, Penguin.
- MacDonald, D. (1957) 'A theory of mass culture', in B. Rosenberg and D. White (eds), *Mass Culture*, Glencoe, Free Press.
- Modleski, T. (1986a) 'Femininity as mas(s)querade: a feminist approach to mass culture', in C. MacCabe (ed.), *High Theory/Low Culture*, Manchester, Manchester University Press.
- Strinati, D. (1992a) 'The taste of America: Americanization and popular culture in Britain', in D. Strinati and S. Wagg (eds), Come On Down?: Popular Media Culture in Post-war Britain, London, Routledge.
- Webster, D. (1988) Looka Yonder: The Imaginary America of Populist Culture, London, Routledge.
- Williams, R. (1963) Culture and Society 1780-1950, Harmondsworth, Penguin.

Chapter 2

The Frankfurt School and the culture industry

The origins of the Frankfurt School	53
The theory of commodity fetishism	56
The Frankfurt School's theory of	
modern capitalism	58
The culture industry	61
The culture industry and popular	
music	64
Adorno's theory of popular music,	
Cadillacs and Doo-wop	69
The Frankfurt School: a critical	
assessment	74
Benjamin and the critique of the	
Frankfurt School	81

51

T HOSE FAMILIAR WITH THE intellectual analysis of popular culture might well ask whether it is worth bothering any longer with the Frankfurt School. Surely its time has passed. Even if it still has something relevant to contribute, we now have better ways of recognising this. To persist with the Frankfurt School perspective is to stay with an approach which is both narrow and outmoded. This view is not quite so prevalent as it would have been a few years ago.¹ But works which are critical of elitist perspectives on popular culture often use the writings of Theodor Adorno, one of the key figures associated with the theories developed by the School, as a leading example of what they are opposed to. This stance is reinforced when it is realised how much common ground the School shares with mass culture theory.

The debate between the Frankfurt School and its subsequent theoretical heritage, which has moved from structuralism and semiology, through Althusserian and Gramscian Marxism, up to feminism and postmodernism, is itself indicative of the continuing significance of the School's ideas. These ideas can still serve as a bench-mark against which other theories of popular culture can measure themselves. Moreover, together with mass culture theory, the work of the Frankfurt School has set the terms of debate and analysis for the subsequent study of popular culture. As we shall see, the contemporary analysis of popular music still commences, however critically, on the basis of Adorno's theory, while his name is sometimes invoked as a symbol of a whole way of thinking about theory and culture. In any event, it is very difficult to understand the analysis of popular culture without understanding the work of the Frankfurt School.

In this chapter I shall, first of all, try to place the School in some kind of context, since this may help us understand some of its ideas. This context is not always relevant to the concerns of this book, so I shall confine my discussion to what I think is relevant

THE FRANKFURT SCHOOL

to the School's analysis of popular culture. Next, I shall look briefly at the School's general theory, going into more detail on its cultural theory and analysis. In doing this I shall, in the main, restrict myself to Adorno's work, although other representatives of the School, like Herbert Marcuse, will also be considered. The specific examples I shall use to illustrate and clarify the School's ideas, and to begin to develop a critique, will be Hollywood cinema and popular music, particularly the latter. I shall conclude with an evaluation of the School's contribution to the study of popular culture by looking at some of the arguments presented by Walter Benjamin, another member of the School but not one whose work is that representative of its approach.

The origins of the Frankfurt School

The Frankfurt School for Social Research was set up in 1923. Its founders tended to be left-wing German, Jewish intellectuals drawn from the upper and middle classes of German society. Amongst its functions was the development of critical theory and research. This involved intellectual work which aimed to reveal the social contradictions underlying the emergent capitalist societies of the time and their typical ideological frameworks in order to construct a theoretical critique of modern capitalism. Of the many prominent intellectuals who have been, at one time or another, associated with the School, amongst the most important are Adorno (1903–1970), Horkheimer (1895–1973) and Marcuse (1898–1978). An equally important figure, but one who, as I have said, is more marginal to the major tenets of the theory elaborated by the leading representatives of the School, is Benjamin (1892–1940), who will be considered more fully at the end of this chapter.

The rise of the Nazi party to power in Germany in the 1930s and its racist oppression of Jews together with its totalitarian repression of the left meant that members of the School were forced to flee to other parts of western Europe and North America.² The School was temporarily situated in New York in the early 1940s (although some members spent time in Los Angeles,

53

including Hollywood), and it eventually returned to Germany in the late 1940s, along with some of its leading figures like Adorno and Horkheimer. Some members stayed on in America after the war and renounced the School's theoretical and political perspectives, turning to liberalism and empirical social science instead. In contrast, others – Marcuse in particular – extended the School's analysis of modern society to post-war American capitalism. Thus in the fascist state of Nazi Germany and American monopoly, consumer capitalism formed crucial features of the context in which the Frankfurt School's analysis of popular culture and the mass media emerged and developed. In the eyes of the Frankfurt School, as Craib has identified these influences, 'it seemed as though the possibility of radical social change had been smashed between the twin cudgels of concentration camps and television for the masses' (Craib: 1984; p. 184).

In relation to these points, there are now a number of books which present a detailed history of the School and its work.³ Here it is merely useful to make a few general points which should allow us to appreciate the School's relevance to the study of popular culture. First of all, it is helpful to identify what the School was reacting against in developing its own theories. For a start, the School was engaged in a critique of the enlightenment. It thought that the promise of the enlightenment, the belief in scientific and rational progress and the extension of human freedom, had turned into a nightmare, the use of science and rationality to stamp out human freedom. This point has been effectively made by Adorno himself:

the total effect of the culture industry is one of antienlightenment, in which, as Horkheimer and I have noted, enlightenment, that is the progressive technical domination, becomes mass deception and is turned into a means of fettering consciousness. It impedes the development of autonomous, independent individuals who judge and decide consciously for themselves . . . while obstructing the emancipation for which human beings are as ripe as the productive forces of the epoch permit.

(Adorno: 1991; p. 92)

This critique of the enlightenment is obviously dependent upon the theory of modern capitalism and the culture industry that intellectuals like Adorno began to develop in the 1930s and 1940s.

This theory not only rejects the false hope of rational emancipation offered by the enlightenment but also involves a critique of Marxism. This critique is more complex because the School put forward an analysis which clearly draws extensively upon, while also criticising, Marxist theory. It is best viewed as a particular version of Marxism no matter how unorthodox it may appear to be. To put it simply, the School's distance from orthodox Marxism can be gauged by its attempt both to get away from the emphasis placed upon the economy as the major way of explaining how and why societies work as they do, and to elaborate and refine a theory of the cultural institutions associated with the emergence and maturation of capitalist societies. The very concept of 'the culture industry' captures the continuing adherence to Marxism (industry as the fundamental productive power of capitalism) and the innovative and original character of the School's contribution (culture as a basic causal factor in its own right). The School can be seen as trying to fill in an important part of the picture of capitalism Marx did not get round to, namely the position and importance of culture and ideology. However, in doing this it made a break with some of the major tenets of classical Marxism. In particular, the School seemed increasingly less optimistic about the prospects for a working-class, socialist revolution in the west as the twentieth century progressed. An important objective of their analysis has been to explain why such a revolution has not occurred and is unlikely to occur in the future.

In this, the critique of Marxism coincided with the critique of the enlightenment. The potential for massive and wide-ranging social control afforded by scientific rationality, which the critique of the enlightenment identified, came to be seen as undermining the political optimism formerly associated with Marxism. Historically, the School was confronted with a situation in which the erosion of the revolutionary momentum of the working class was accompanied by the rise of fascism. Fascism represented the political logic of rational domination unleashed by the enlightenment. The historical and political context for the work of the School thus led to a concern with the decline of socialism and working-class radicalism which resulted from the increased possibility for centralised control to be exercised over increasing numbers of people by the expanded 'totalitarian' power of the modern capitalist state.

We can already begin to see how the School's understanding of popular culture is dependent upon its theory of modern capitalism and its conception of the control the 'culture industry' can exert over the minds and actions of people. Before turning to this, however, the School's indebtedness to a particular aspect of Marx's work has to be noted.

The theory of commodity fetishism

Adorno once wrote that 'the real secret of success . . . is the mere reflection of what one pays in the market for the product. The consumer is really worshipping the money that he himself has paid for the ticket to the Toscanini concert' (1991; p. 34). Few statements could more graphically summarise the implications of Marx's theory of commodity fetishism for Adorno's own understanding of modern popular culture. Marx's theory lies behind Adorno's theory of the culture industry. Marx's discussion of commodity fetishism is, for Adorno and the Frankfurt School, the basis of a theory of how cultural forms like popular music can function to secure the continuing economic, political and ideological domination of capital.⁴

The immediate inspiration for Adorno's notion that money – the price of commodities or goods, including a ticket to a concert – defines and dominates social relations in capitalist societies is Marx's famous statement on the origins of commodity fetishism:

The mystery of the commodity form, therefore, consists in the fact that in it the social character of men's labour appears to them as an objective characteristic, a social natural quality of the labour product itself, and that consequently the relation of the producers to the sum total of their own labour is presented to them as a social relation, existing not between themselves, but between the products of their labour. Through this transference the products of labour become commodities, social things whose qualities are at the same time perceptible and imperceptible by the senses.... It is simply a definite social relation between men, that assumes, in their eyes, the fantastic form of a relation between things.... This I call the fetishism which attaches itself to the products of labour as soon as they are produced as commodities, and which is therefore inseparable from the production of commodities.

(Marx: 1963; p. 183)

According to Adorno, 'this is the real secret of success', since it can show how 'exchange value exerts its power in a special way in the realm of cultural goods' (1991; p. 34). Marx had made a distinction between the exchange value and use value of the commodities circulating in capitalist societies. Exchange value refers to the money that a commodity can command on the market, the price it can be bought and sold for, while use value refers to the usefulness of the good for the consumer, its practical value or utility as a commodity. With capitalism, according to Marx, exchange value will always dominate use value since the capitalist economic cycle involving the production, marketing and consumption of commodities will always dominate people's real needs. This idea is central to Adorno's theory of capitalist culture. It links commodity fetishism with the predominance of exchange value in that money is both the exemplar of how social relations between people can assume the fantastic form of a relation defined by a 'thing', that is money, and the basic means by which the value of commodities is defined for people living in capitalist societies. This is why we are supposed to venerate the price we pay for the ticket to the concert rather than the concert itself.

What Adorno has in fact done has been to extend Marx's analyses of commodity fetishism and exchange to the sphere of cultural goods or commodities. In the example cited, this concerns the market for music, and he accordingly elaborates a 'concept of musical fetishism'. Adorno argues that 'all contemporary musical

life is dominated by the commodity form; the last pre-capitalist residues have been eliminated' (ibid.; p. 33). This means that what Marx said about commodities in general also applies, for Adorno, to cultural commodities: they 'fall completely into the world of commodities, are produced for the market, and are aimed at the market' (ibid.; p. 34). They become tainted by commodity fetishism, and dominated by their exchange value, as both are defined and realised by the medium of money. What is, however, unique to cultural commodities is that 'exhange value deceptively takes over the functions of use value. The specific fetish character of music lies in this quid pro quo' (ibid.). With other commodities, exchange value both obscures and dominates use value. Exchange values not use values determine the production and circulation of these commodities. However, with cultural commodities like music, because they bring us into an 'immediate' relation with what we buy - the musical experience - their use value becomes their exchange value such that the latter can 'disguise itself as the object of enjoyment' (ibid.).

So we come back to the statement we started with, hopefully now more aware of its rationale. We are said to worship the price we pay for the ticket for the concert, rather than the performance itself, because we are victims of commodity fetishism whereby social relations and cultural appreciation are objectified in terms of money. This, in turn, means that exchange value or the price of the ticket becomes the use value as opposed to the musical performance, its real underlying use value. This is only part of a more general analysis of popular music to which I shall return below. What I have been concerned to show here is how the School's theory has been based on some of Marx's ideas despite its divergence from certain fundamental principles of classical Marxism. These ideas have played their part in the School's interpretation of the development of modern capitalism, and in Adorno's formulation of the concept of the culture industry.

The Frankfurt School's theory of modern capitalism

The School's theory of modern capitalism basically argues that it has managed to overcome many of the contradictions and crises it

once faced, and has thereby acquired new and unprecedented powers of stability and continuity. This theory has been very much a feature of the writings of the philosopher Marcuse, a member of the School who stayed in America after the Second World War, and witnessed its economic growth, affluence and consumerism, as well as its problems - continued inequality, poverty and racism.⁵ It also indicates the intellectual and political distance between the School and Marx's analyses of capitalism which usually defined it as a crisis-ridden and unstable system. The School obviously does not deny that capitalism contains internal contradictions identifying these contradictions is for Adorno part of the art of dialectical thinking. But insofar as capitalist societies are capable of generating higher and higher levels of economic well-being for large sections of their populations, including their working classes, their eventual overthrow and the rise of socialism appear less and less likely to occur. The School sees a durability in capitalism many others have doubted, and argues that this rests upon affluence and consumerism, and the more rational and pervasive forms of social control afforded by the modern state, mass media and popular culture.

Capitalist productive forces are capable, according to the School, of producing such vast amounts of wealth through waste production like military expenditure that 'false needs' can be created and met. People can therefore be unconsciously reconciled to the capitalist system, guaranteeing its stability and continuity. The rise of monopoly capitalist corporations, and the rational and efficient state management of economy and society, have served to entrench this process further. For example, monopoly has allowed corporations greater control over their markets and prices and thus their waste production, while state intervention could prevent the periodic eruption of economic crises and further extend the power of rational organisation over capitalist societies. Moreover, possible contradictions - and hence possible reasons for conflict between abundance (the productive potential of the economic forces of capitalism) and waste (consumer and military expenditure which could otherwise be used to alleviate poverty and inequality) are no longer integral to the capitalist system and the struggle between capital and labour, but instead become focused upon marginal groups (like ethnic minorities) or societies (like socalled 'third world' countries) lying outside the system. The affluence and consumerism generated by the economies of capitalist societies, and the levels of ideological control possessed by their culture industries, have ensured that the working class has been throughly incorporated into the system. Its members are more financially secure, can buy many of the things they desire, or think they desire, and no longer have any conscious reasons for wanting to overthrow capitalism and replace it with a classless and stateless society.

The idea that the working class has been pacified into accepting capitalism is central to the theory of the Frankfurt School and its analyses of popular culture. It links up with the critique of the enlightenment in that rational domination is the domination of the masses in modern capitalist societies. Its debt to the theory of commodity fetishism is also evident in that commodities of all kinds become more available and therefore more capable of dominating people's consciousness. This fetishism is accentuated by the domination of money which regulates the relationships between commodities. In keeping with these ideas is the School's concept of false needs, which connects what has been said so far with the concept of the culture industry.

The concept of false needs is identified particularly with the work of Marcuse, but is derived from the general theoretical framework of the School, and is implicit in the writings of some of its other members (Marcuse: 1972; p. 5). It is based upon the assumption that people have true or real needs to be creative, independent and autonomous, in control of their own destinics, fully participating members of meaningful and democratic collectivities and able to live free and relatively unconstrained lives and to think for themselves. It therefore rests upon the claim that these true needs cannot be realised in modern capitalism because the false needs, which this system has to foster in order to survive, come to be superimposed or laid over them. False needs which are created and sustained can in fact be fulfilled, like the desires elicited by

60

consumerism, but only at the expense of the true needs which remain unsatisfied.

This occurs because people do not realise their real needs remain unsatisfied. As a result of the stimulation and fulfilment of false needs, they have what they think they want. Take the example of freedom. People who live in capitalist societies think they are free but they are deluding themselves. They are not free in the sense that the Frankfurt School would use the term. They are not free, autonomous, independent human beings, consciously thinking for themselves. Rather their freedom is restricted to the freedom to choose between different consumer goods or different brands of the same good, or between political parties who look and sound the same. The false needs of consumer and voter choice offered by advertising and parliamentary democracy suppress the real needs for useful products and genuine political freedom. The cultivation of false needs is bound up with the role of the culture industry. The Frankfurt School sees the culture industry ensuring the creation and satisfaction of false needs, and the suppression of true needs. It is so effective in doing this that the working class is no longer likely to pose a threat to the stability and continuity of capitalism.

The culture industry

According to the Frankfurt School, the culture industry reflects the consolidation of commodity fetishism, the domination of exchange value and the ascendancy of state monopoly capitalism. It shapes the tastes and preferences of the masses, thereby moulding their consciousness by inculcating the desire for false needs. It therefore works to exclude real or true needs, alternative and radical concepts or theories, and politically oppositional ways of thinking and acting. It is so effective in doing this that the people do not realise what is going on.

In a reconsideration of the concept of the culture industry first published in 1975, Adorno reiterated his endorsement of these ideas. He clearly distinguished the idea of the culture industry from

THE FRANKFURT SCHOOL

mass culture, since the latter concept assumes that the masses bear some genuine responsibility for the culture they consume, that it is determined by the preferences of the masses themselves. More than the theorists of mass culture, Adorno saw this culture as something which has been imposed upon the masses, and which makes them prepared to welcome it given they do not realise it is an imposition.

Looking back to the book he and Horkheimer wrote entitled *Dialectic of Enlightenment* (originally published in 1944), Adorno defined what he meant by the concept of the culture industry:

In all its branches, products which are tailored for consumption by masses, and which to a great extent determine the nature of that consumption, are manufactured more or less according to plan. The individual branches are similar in structure or at least fit into each other, ordering themselves into a system almost without a gap. This is made possible by contemporary technical capabilities as well as by economic and administrative concentration. The culture industry intentionally integrates its consumers from above. To the detriment of both it forces together the spheres of high and low art, separated for thousands of years. The seriousness of high art is destroyed in the speculation about its efficacy; the seriousness of the lower perishes with the civilizational constraints imposed on the rebellious resistance inherent within it as long as social control was not yet total. Thus, although the culture industry undeniably speculates on the conscious and unconscious state of the millions towards which it is directed, the masses are not primary but secondary, they are an object of calculation, an appendage of the machinery. The customer is not king, as the culture industry would have us believe, not its subject but its object.

(Adorno: 1991; p. 85)

The commodities produced by the culture industry are governed by the need to realise their value on the market. The profit motive determines the nature of cultural forms. Industrially, cultural production is a process of standardisation whereby the products acquire the form common to all commodities – like 'the Western, familiar to every movie-goer'. But it also confers a sense of individuality in that each product 'affects an individual air'. This attribution of individuality to each product, and therefore to each consumer, serves to obscure the standardisation and manipulation of consciousness practised by the culture industry (ibid.; pp. 86–87). This means that the more cultural products are actually standardised the more they appear to be individualised. Individualisation is an ideological process which hides the process of standardisation. The Hollywood star system is cited as an example: 'The more dehumanised its methods of operation and content, the more diligently and successfully the culture industry propagates supposedly great personalities and operates with heart throbs' (ibid.; p. 87).

In response to the claims that modern mass culture is a relatively harmless form of entertainment, and a democratic response to consumer demand, and that critics like himself adopt elitist intellectual positions, Adorno stresses the vacuity, banality and conformity fostered by the culture industry. He sees it as a highly destructive force. As he puts it: 'the colour film demolishes the genial old tavern to a greater extent than bombs ever could. ... No homeland can survive being processed by the films which celebrate it, and which thereby turn the unique character on which it thrives into an interchangeable sameness' (ibid.; p. 89). To ignore the nature of the culture industry, as Adorno defines it, is to succumb to its ideology.

This ideology is corrupting and manipulative, underpinning the dominance of the market and commodity fetishism. It is equally conformist and mind numbing, enforcing the general acceptance of the capitalist order. For Adorno, 'the concepts of order which it [the culture industry] hammers into human beings are always those of the status quo' (ibid.; p. 90). Its effects are profound and far-reaching: 'the power of the culture industry's ideology is such that conformity has replaced consciousness' (ibid.). This drive to conformity tolerates no deviation from, or opposition to, nor an alternative vision of, the existing social order. Deviant, oppositional and alternative ways of thinking and acting become increasingly impossible to envisage as the power of the culture industry is extended over people's minds. The culture industry deals in falsehoods not truths, in false needs and false solutions, rather than real needs and real solutions. It solves problems 'only in appearance', not as they should be resolved in the real world. It offers the semblance not the substance of resolving problems, the false satisfaction of false needs as a substitute for the real solution of real problems. In doing this, it takes over the consciousness of the masses.

These masses, in Adorno's eyes, become completely powerless. Power lies with the culture industry. Its products encourage conformity and consensus which ensure obedience to authority, and the stability of the capitalist system. The ability of the culture industry to 'replace' the consciousnesses of the masses with automatic conformity is more or less complete. Its effectiveness, according to Adorno:

lies in the promotion and exploitation of the ego-weakness to which the powerless members of contemporary society, with its concentration of power, are condemned. Their consciousness is further developed retrogressively. It is no coincidence that cynical American film producers are heard to say that their pictures must take into consideration the level of elevenyear-olds. In doing so they would very much like to make adults into eleven-year-olds.

(ibid.; p. 91)

The power of the culture industry to secure the dominance and continuity of capitalism resides, for Adorno, in its capacity to shape and perpetuate a 'regressive' audience, a dependent, passive, and servile consuming public. I now want to illustrate some of these ideas further by looking at the example of popular music.

The culture industry and popular music

Adorno's theory of popular music is perhaps the most well-known aspect of his analysis of the culture industry. It is bound up with the theories of commodity fetishism and the culture industry. A trained musician, practising composer, music theory expert and champion of avant-garde and non-commercial music himself, Adorno had little time for the music produced by monopoly corporations and consumed by the mass public, except as a way of illustrating the power of the culture industry and the alienation to be found among the masses in capitalist societies.

According to Adorno, the popular music produced by the culture industry is dominated by two processes: standardisation and pseudo-individualisation. The idea here is that popular songs come to sound more and more like each other. They are increasingly characterised by a core structure, the parts of which are interchangeable with each other. However, this core is hidden by the peripheral frills, novelties or stylistic variations which are attached to the songs as signs of their putative uniqueness. Standardisation refers to the substantial similarities between popular songs; pseudo-individualisation to their incidental differences. Standardisation defines the way the culture industry squeezes out any kind of challenge, originality, authenticity or intellectual stimulation from the music it produces, while pseudo-individualisation provides the 'hook', the apparent novelty or uniqueness of the song for the consumer. Standardisation means that popular songs are becoming more alike and their parts, verses and choruses more interchangeable, while pseudo-individualisation disguises this process by making the songs appear more varied and distinct from each other.

The contrasts which Adorno draws between classical and avant-garde music on the one hand, and popular music on the other, allow him to extend this argument. According to Adorno, with serious music like classical or avant-garde music, every detail acquires its musical sense from the totality of the piece, and its place within that totality. This is not true of popular or light music. In popular music, 'the beginning of the chorus is replaceable by the beginning of innumerable other choruses . . . every detail is substitutible; it serves its function only as a cog in a machine' (1991; p. 303; originally published 1941). The difference is not so much between complexity and simplicity as such, for the key distinction in Adorno's view, which establishes the superiority of serious over popular music, is that between standardisation and nonstandardisation. An important reason for this is that 'structural standardisation aims at standardised reactions'. These features are not characteristic of serious music: 'To sum up the difference: in Beethoven and in good serious music in general . . . the detail virtually contains the whole and leads to the exposition of the whole, while at the same time it is produced out of the conception of the whole. In popular music the relationship is fortuitous. The detail has no bearing on a whole, which appears as an extraneous framework' (ibid.; p. 304). In Adorno's view, one of the few possible challenges to the culture industry and commodity fetishism comes from serious music which renounces the commodity form because it cannot be contained by standardised production or consumption.

One reason for this is that those who listen to popular music are taken in by 'the veneer of individual "effects" (ibid.; p. 302), which masks the standardisation of the music, and makes the listeners think they are hearing something new and different. Adorno distinguishes between the framework and the details of a piece of music. The framework entails standardisation which elicits 'a system of response-mechanisms wholly antagonistic to the ideal of individuality in a free, liberal society' (ibid.; p. 305). This means that the details must confer on the listener a sense of this suppressed individuality. People would not necessarily put up with musical standardisation for very long, so the sense of individualism within the process of musical consumption must be maintained. Hence, 'the necessary correlate of musical standardization is pseudo-individualization' (ibid.; p. 308). This involves 'endowing cultural mass production with the halo of free choice or open market on the basis of standardization itself. Standardization of song hits keeps the customers in line by doing their listening for them, as it were. Pseudo-individualization, for its part, keeps them in line by making them forget that what they listen to is already listened to for them or "pre-digested"'(ibid.). Examples of pseudoindividualisation include improvisation like that to be found with certain forms of jazz, and the 'hook' line of a song, the slight variation from the norm which makes the song catchy and attractive, and gives it the semblance of novelty.

It is clear from this that Adorno does not have too high an opinion of popular music, and his views on its audience are consistent with his general theory. He argues: 'the counterpart to the fetishism of music is a regression of listening' (1991; p. 40). The listeners drawn to popular music are conceived of in terms of their infantile or childlike characteristics: they are 'arrested at the infantile stage ... they are childish; their primitivism is not that of the undeveloped, but that of the forcibly retarded ... the regression is really from ... the possibility of a different and oppositional music' (ibid.; p. 41). Listeners really need this latter type of music, but due to their infantile mentality they continue to listen to popular music: 'regressive listeners behave like children. Again and again and with stubborn malice, they demand the one dish they have once been served' (ibid.; p. 45). Accordingly, they suffer from the delusion that they are exercising some degree of control and choice in their leisure pursuits. Adorno cites the example of the 'jitterbugs', groups

from the mass of the retarded who differentiate themselves by pseudoactivity and nevertheless make the regression more strikingly visible... They call themselves jitterbugs, as if they simultaneously wanted to affirm and mock their loss of individuality, their transformation into beetles whirring around in fascination. Their only excuse is that the term jitterbugs, like all those in the unreal edifice of films and jazz, is hammered into them by the entrepreneurs to make them think they are on the inside. Their ecstasy is without content. ... It is stylized like the ecstasies savages go into in beating the war drums. It has convulsive aspects reminiscent of St. Vitus' dance or the reflexes of mutilated animals.

(ibid.; p. 46)

According to Adorno, regressive listening, 'the frame of mind to which popular music originally appealed, on which it feeds, and which it perpetually reinforces, is simultaneously one of distraction and inattention. Listeners are distracted from the demands of

67

reality by entertainment which does not demand attention either' (1991; pp. 309–310). The capitalist mode of production conditions regressive listening. Higher pursuits like classical music can only be appreciated by those whose work or social position means that they do not need to escape from boredom and effort in their leisure time. Popular music offers relaxation and respite from the rigours of 'mechanised labour' precisely because it is not demanding or difficult, because it can be listened to in a distracted and inattentive manner. People desire popular music, partly because capitalists 'hammer' it into their minds and make it appear desirable. But their desire is also fuelled by the symmetry between production and consumption which characterises their lives in a capitalist society.

People desire popular music because their consumption of standardised products mirrors the standardised, repetitive and boring nature of their work in production. 'The power of the process of production', for Adorno:

extends over the time intervals which on the surface appear to be 'free.' They want standardized goods and pseudoindividualization, because their leisure is an escape from work and at the same time is moulded after those psychological attitudes to which their workaday world exclusively habituates them. Popular music is for the masses a perpetual busman's holiday. Thus, there is justification for speaking of a pre-established harmony today between production and consumption of popular music. The people clamour for what they are going to get anyway.

(ibid.; p. 310)

For these people, standardised production goes hand in hand with standardised consumption. Pseudo-individualisation saves them the effort of attending to the genuinely novel or original in their precious leisure-time. Both of these processes comprise the distraction and inattention which define regressive listening.

The last aspect of Adorno's theory that we need to look at concerns his claim that cultural phenomena like popular music act as a form of 'social cement', adjusting people to the reality of the

THE FRANKFURT SCHOOL

lives they lead. It seems to be Adorno's opinion that most people in capitalist societies live limited, impoverished and unhappy lives. They become aware of this, or are made to become aware of it, from time to time. Popular music and film do not actually function to deny this awareness, but they do act to reconcile people to their fate. The fantasies and happiness, the resolutions and reconciliations, offered by popular music and film make people realise how much their real lives lack these qualities, how much they remain unfulfilled and unsatisfied. However, people continue to be adjusted to their conditions of life since

the actual function of sentimental music lies rather in the temporary release given to the awareness that one has missed fulfilment... Emotional music has become the image of the mother who says, 'Come and weep, my child.' It is catharsis for the masses, but catharsis which keeps them all the more firmly in line... Music that permits its listeners the confession of their unhappiness reconciles them, by means of this 'release,' to their social dependence.

(ibid.; pp. 313–314)

We might wonder whether people are still distracted and inattentive when they are made to recognise the unhappiness of their lives by the medium of popular music, and we might want to question someone who judges the emotional and cultural quality of other people's lives in this way, but we can at least see how Adorno conceives of popular music as a kind of 'social cement'. Its comforts and catharsism enable people to resign themselves to the harsh and unfulfilling reality of living in a capitalist society. The popular song or Hollywood film dissuades people from resisting the capitalist system, and from trying to construct an alternative society in which individuals could be free, happy and fulfilled.

Adorno's theory of popular music, Cadillacs and Doo-Wop

In an extremely useful article entitled 'Theodor Adorno meets the Cadillacs' (1986), Gendron has tried to assess Adorno's theory of popular music by applying it to the example of Doo-Wop music. In doing this, he introduces a critical assessment of Adorno's theory. The Cadillacs mentioned in the title of the article is a reference to both the car and a Doo-Wop group.

Gendron in fact uses the example of car production in order to clarify what Adorno means when he argues that capitalism functions to standardise commodities. Standardisation involves the interchangeability of parts together with pseudo-individualisation. The parts of one kind of car can be interchanged with those from another due to standardisation, while the use of style or pseudoindividualisation - like the addition of a tail-fin to a Cadillac distinguishes cars from each other, and hides the fact that standardisation is occurring. According to Gendron, Adorno argues that what is true of cars is also true of popular music. Both are distinguished by a core and a periphery, the core being subject to standardisation, the periphery to pseudo-individualisation. The process of standardisation is bound up with the lives that people have to live in capitalist societies and the inferior status of popular music when compared with classical and avant-garde music. Gendron also makes the point that the standardisation of popular music, in Adorno's view, occurs diachronically (that is to say, over time as popular musical standards are set) as well as synchronically (the standards which apply at any particular point in time).

Gendron uses the example of Doo-Wop,⁶ as well as other styles of pop music, to critically assess Adorno's theory. He is not totally dismissive of Adorno's work. For example, he suggests that 'industrial standardization is an important feature of popular music, and must be taken seriously in any political assessment of the form' (1986; p. 25). He also argues that Adorno's theory has the potential both to combine political economy and semiological perspectives, and to provide a critique of the argument that consumers can draw from popular culture any meanings and interpretations they wish (ibid.; pp. 34–35). However, he equally feels that Adorno takes his claims about standardisation too far. And he uses the example of Doo-Wop to develop his critique. Doo-Wop is defined by Gendron as: a vocal group style, rooted in the black gospel quartet tradition, that emerged on inner city street corners in the midfifties and established a major presence on the popular music charts between 1955 and 1959. Its most distinctive feature is the use of background vocals to take on the role of instrumental accompaniment for, and response to, the high tenor or falsetto calls of the lead singer. Typically, the backup vocalists create a harmonic, rhythmic, and contrapuntal substructure by voicing phonetic or nonsense syllables such as 'shoo-doo-be-doo,' 'ooh-wah, ooh-wah,' 'sha-na-na,' and so on.

(ibid.; p. 24)

Gendron suggests this music was standardised both diachronically and synchronically, the former because it relied on the longestablished song patterns of either Tin Pan Alley or rhythm and blues, the latter because of the close resemblance between Doo-Wop songs and the interchangeability of their parts, for example the swapping of the shoo-be-dos of one song with the dum-dumde-dums of another.

One of the major difficulties with Adorno's work, according to Gendron, lies in its failure to distinguish between functional artefacts such as cars and Cadillacs, and textual artefacts such as pop music and a Doo-Wop group like the Cadillacs. The use of technological innovations in the production of functional artefacts usually furthers the process of standardisation since it can increase the extent to which the parts of, say, one type of car can be interchanged with those of another. However, with textual artefacts technological innovations can differentiate between, say, pop groups or music styles - for example, the use by The Beatles of experimental tape techniques - rather than making them more alike (ibid.; p. 26). The production of textual artefacts is also distinguished by the fact that what is initially produced is a single 'universal' statement, the song or a series of songs, and not a commodity which can be reproduced in large quantities by assemblyline techniques. What is produced is a particular or unique song in a recording studio by a group of singers, musicians, engineers, etc.

71

THE FRANKFURT SCHOOL

It only becomes a functional artefact when it is produced or reproduced in large numbers as a record. Functional and textual artefacts are the result of distinct processes of production. Thus music, like most popular culture, cannot be treated as if it were like any other commercial product.

Functional and textual artefacts, as Gendron goes on to note, are equally the object of different kinds of consumption. If functional artefacts are purchased and found to be useful, then they will be purchased again when required. This would even be true of commodities, like cars, which are only bought relatively infrequently. But if a textual artefact like a record is bought and liked, this doesn't mean that the very same one will be bought again. No matter how impressed you are with this book, you are unlikely to go out and buy a second copy. What you might do, however, is buy a similar kind of book (if you could find one). If you like Doo-Wop you might buy different examples of the style. but not the same record twice. This is one of the reasons for the emergence of 'genres' in popular culture, and for their importance in the organisation of pleasure. This means that, despite what Adorno argues, popular songs advertise both their individuality (it is this song, this example of Doo-Wop and not any other) and their interchangeability (if you like this song, this example of Doo-Wop then you might well like others in the same style or genre). In this sense, 'we might consider standardization not only as an expression of rigidity but also as a source of pleasure' (ibid.; p. 29). The pleasure people derive from popular music arises as much from their awareness of standardisation as it does from any perceived difference or individuality they attach to any particular song.

Gendron is equally critical of Adorno's notion of diachronic standardisation for its implication that popular musical styles never change. He suggests, of course, that they do change. Going back to the distinction between core and periphery he makes the following point: 'Adorno approached popular music from the point of view of western "classical" music; if we view popular music in terms of its own conventions, the line between core and periphery will be drawn quite differently' (ibid.; p. 30). For western classical music, songs share the same musical core if they share the same melodies, harmonies and chord progressions, while the sound, 'feel' and connotations of the song form its periphery. However, there is no reason to suppose that this hierarchy has universal relevance. Nor need it be closed to changes. 'Western classical music focused on melody and harmony, whereas contemporary pop music focuses on timbre and connotation', the connotation of Doo-Wop being 'fifties teen pop culture' and 'urban street corners' (ibid.; p. 31). It is by no means obvious what constitutes the core and periphery of textual artefacts; they may differ radically between different types of music.

This may be taken a step further since Gendron questions the extent to which the terms of core and periphery can be applied to pop music. He does this on the basis of the rapidity with which popular music styles change:

the constant shifts in musical genres constitute at least prima facie evidence that important transformations occur in the history of popular music. Before rock 'n' roll, people listened to ragtime, dixieland, swing, crooning, be-bop, rhythm and blues, among others. Whatever their harmonic and melodic similarities, these styles differed quite substantially in timbre, evocation, connotation, and expressiveness. With the coming of rock 'n' roll, the pace of change has accelerated. The thirty years of the rock era have seen the coming and going of Doo-Wop, rockabilly, the girl group sound, surf music, the British invasion, psychedelic rock, folk rock, heavy metal, and punk, to name just a few. While it might be argued that these have only been fashion changes, and hence merely surface changes, this sort of response simply fails to attend to the important differences noted earlier between textual and functional artefacts. In the latter the fashion can change while the mechanism remains the same; fashion is at the periphery, the mechanism at the centre. In the text, there is no mechanism to distinguish from the fashion, since a text is all style or all fashion.

(ibid.; p. 32)

Adorno's notion of diachronic standardisation has difficulties handling evidence of this kind. As Gendron indicates, for Adorno

73

it would probably be regarded as evidence of continuity rather than change, of how the inevitable standardisation of popular music has been neatly masked by the transient novelty of style. But as Gendron goes on to note, this response fails to appreciate how difficult it is to define the standardised core of popular music independently of its shifting fashions and genres. To introduce the latter into the analysis raises considerations of sound, context, pleasure, use and history.

The Frankfurt School: a critical assessment

As I indicated in my introduction to this chapter, I have tried to confine my discussion to those aspects of the Frankfurt School's work which appear relevant to the study of popular culture. Moreover, I can hardly claim my account is exhaustive. These qualifications apply equally to this critical assessment. While it is clearly rooted in a distinct theoretical tradition, the School shares much the same kind of view of popular culture and its audience as the mass culture critics. This may mean that certain points already made will be returned to in the following comments.

The Frankfurt School has commonly been singled out for two particular failings: its failure to provide empirical proof for its theories; and the obscure and inaccessible language in which its ideas have been expressed.7 From what I have outlined of his arguments, it is clear that Adorno makes few attempts to substantiate empirically the claims he makes. For example, his discussion of regressive listening makes no reference to real listeners. Rather it relies on an inferred subject defined by his theory. Therefore his ideas are confirmed by his analysis since there is no way in which they could be contradicted by empirical evidence. It would probably be Adorno's case that real listeners have regressed so far, have become so 'infantile', that their views are not worth bothering with. However, even his analysis of the culture industry is drawn from the features of its products as he conceives of them, and is not based on an empirical analysis of it as an historical type of industrial production (cf. Murdock and Golding: 1977; pp. 18-19). Of course,

if the society we live in is as Adorno envisages it, then nonfetishised, non-ideological forms of empirical knowledge and proof are not possible.

The same kind of defence can be mounted against the criticism that the ideas of the School are conveyed in an obscure and inaccessible language. A society dominated by commodity fetishism, exchange value and the culture industry, in which the language in common use is similarly tainted, can only be described by a language which resists fetishism, ideology and the market. For this task, only an obscure and inaccessible language will do. It is thus impossible to describe popular culture in its own terms. It has to be described by the language of a theory which protects itself against contamination by its obscurity. This is also why Adorno supports the cause of avant-garde music because, in rejecting popularity, standardisation and accessibility, it is rejecting commodity fetishism, exchange value and the culture industry. In fact, not all of the Franfurt School's work is that difficult or obscure. Certainly, Adorno's famous essay on popular music (1991) is not that hard to read, except where it discusses musical theory. But the almost impenetrable nature of much of the School's writings must put off most apart from the expert or the foolhardy.

This rejection of stylistic clarity is linked to the School's idea of the role of theory. Sometimes termed critical theory, the ideas of the Frankfurt School stress that theory is a form of resistance to the commercial impulses of capitalist production and the ideological hold of commodity fetishism. But it can only function in the way that avant-garde music does if it rejects the empiricism which demands that theories be based upon some kind of evidence, and protects itself behind an obscure and inaccessible language. The School's theory and language allow it to stand outside and criticise the 'one-dimensional' world of capitalist thought and culture. However, this stance is only possible if its theory is correct. But is it?

We could, of course, question the wisdom of trying to communicate if most people are thought to be incapable of understanding what is being communicated. The defences which can be made of the School's views of theory and language have a specious intellectual air about them. Critically assessing the School's theory can bring this out. Looking at empirical evidence can pin-point weaknesses in the School's analysis of popular culture as Gendron's article has shown.

To develop a critique of the School's theories, we can return first to the problem of elitism which was raised in the last chapter. Bearing in mind what was said there, elitism describes the role Adorno assigns to critical theory and avant-garde music. The select and enlightened few, by undertaking their intellectual and cultural practices, can cut themselves off from the mundane activites of the masses and thereby resist the power of the culture industry. Elitism describes the way Adorno assumes that other kinds of music can be judged and found wanting by the standards of western classical music. It is evident throughout his characterisation of the regressive listener. The standards which Adorno uses to discriminate between cultures are exemplified by his conception of the universal values of classical and avant-garde music. They derive from the position of the elite intellectual. Consider, in this respect, his following comment: 'a fully concentrated and conscious experience of art is possible only to those whose lives do not put such a strain on them that in their spare time they want relief from both boredom and effort simultaneously' (1990; p. 310). Art can only be appreciated properly by a privileged elite, an elite which is privileged either because its members don't have to work, or because their work is constantly stimulating and interesting, but never too physically strenuous. Elitism always encounters problems when it engages in social and cultural analysis because the standards upon which it bases itself turn out to be arbitrary not objective, a reflection of the social position of particular groups not universal values (cf. Bourdieu: 1984; pp. 11-57).

The School's analysis of capitalism appears to conceive of a society which has discovered the secret of eternal stability. Capitalism has found, in the culture industry, the means by which it can effectively contain the threats posed to it by radical and alternative social forces. This degree of stability and consensus is hardly consistent with the sociology and history of capitalist societies. Admittedly, these societies have not had to face a revolutionary proletariat, but there is little evidence that this was ever on the cards in the first place. On the one hand, it is arguable that capitalism is less stable than the Frankfurt School thought it would be. On the other hand, it has not been continually confronted by the implicit or explicit threat of a revolutionary working-class movement. If this reasoning is plausible, then popular culture cannot be understood in terms of its functional role in ensuring the continued stability of capitalism. In short, just how extensive and effective is the ideological domination exercised by the culture industry (cf. Abercrombie *et al.*: 1990)?

As we have seen, Adorno argues that the production and consumption of culture in capitalist societies are inevitably standardised. However, this not only ignores the differences between functional and textual artefacts, as Gendron suggests, but fails to recognise how much culture is standardised, including types of elite culture like classical music as well as pre-industrial forms like traditional folk music. Some element of standardisation is required for communication to take place at all. The emergence of popular cultural standards, like music or film genres, are not necessarily an outcome of the functions of the culture industry but arise out of the unequal relationship between the producers and consumers of popular culture. If the culture industry is so powerful why does it find it so difficult to determine where the next hit record or block buster film is coming from?

Popular culture may well be popular because of the pleasures its consumers derive from its standardisation. The existence of genres, for example, is as likely to be due to audience expectations about the organisation of pleasure as to the power of the culture industry. Genres are produced according to the criteria of profitability and marketability, and provide what audiences are familiar with, although not in ways which are completely predictable. The profitable market for genres is met by a product which balances standardisation and surprise, not standardisation and pseudo-individualisation. An historical analysis might reveal that changes in audience tastes have been a major cause of changes in film genres. Although, as Gendron suggests, it may not be possible to apply the core–periphery distinction to popular music, the core of film genres consists of a mixture of predictability and surprise which is realised by the style of the film. In any event, genres help audiences sort out what they want to see or hear from what they do not. Individual genres, and these include such forms as art-house films, are popular with their audiences to the extent to which standard themes and iconography are combined with variations and surprises within a recognisable narrative. If this outline of genres is at all plausible it suggests that genres are more prone to change than Adorno implies since they arise out of, and deal with, specific historical conditions.⁸

One of the major points of contention raised by Adorno's theory is his view of the audience which consumes the products of the culture industry. Studies have shown how audiences for popular culture are more discriminating and critical in terms of what they consume than the theories of mass culture or the culture industry allow.⁹ Indeed, this is true of other theories discussed in this book, and the critical reaction to this dismissive portrayal of the audience is particularly emphasised in chapter 5 below, on feminism. Audiences appear to be able to engage in active interpretations of what they consume which are not adequately described by Adorno's notion of the regressive listener. Obviously, audiences are by no means as powerful as the industries which produce popular culture, but this is no reason to conceive of them, in the way Adorno does, as 'cultural dopes'.

This problem is clearly one compounded by Adorno's elitism. In the last chapter I used Modleski's argument about the gendered character of the distinction between mass and high culture in my critical assessment of mass culture theory. The argument there made the point that the socially constructed inequalities between masculinity and femininity are reproduced by the distinction between high culture and mass culture, which associates the former with activity, production and the intellectual, and the latter with passivity, consumption and the emotional. Something similar can be found in Adorno's work. Witness his references to the consumer as 'the girl behind the counter', or 'the girl whose satisfaction consists solely in the fact that she and her boyfriend "look good"' (1991; p. 35). However, it is also possible to find in Adorno's work a similar kind of hierarchical distinction whereby adults are turned into children by the culture industry. This is evident in his use of the metaphor of infantilism to characterise the regressive listener and regressive listening. It is his case that infantilism results from consuming the products of the culture industry. But not only does the notion of infantilism fail to convey adequately what adults do when they consume popular culture, it does not even describe the popular cultural consumption of children.¹⁰ This metaphor, it could be argued, functions as a form of conceptual fetishism which hides the fact that the concept of regressive listening lacks any empirical foundation.

These difficulties are likewise to be found in the Frankfurt School's attempt to maintain a distinction between false and true needs, between the false needs for popular cultural goods which are imposed and met by the culture industry, and the true or real needs for freedom, happiness and utopia which are suppressed by the culture industry. This argument is most closely associated with the writings of Marcuse but, as we have seen, Adorno argues that 'the substitute gratification which it [the culture industry] prepares for human beings cheats them out of the same happiness which it deceitfully projects . . . it impedes the development of autonomous, independent individuals who judge and decide consciously for themselves' (1991; p. 92).

There are two related problems with this: how is it possible to distinguish between false and true needs?; and how can true needs be recognised? Why should the need for a consumer good like a washing machine be defined as a false need? In principle, a washing machine makes a household chore that much easier to perform. It may therefore be meeting a very real need. People may need intellectual self-fulfilment, but they also need clean clothes. Equally, consumer goods are being invested with more importance than they may actually possess. What may appear to be a sign of cultural decline from one point of view, may, from another, be merely a more efficient way of doing something necessary. As Goldthorpe *et al.* have insisted, 'perhaps Marcuse and like thinkers . . . need to be reminded that "a washing machine is a washing machine is a washing machine" (1969; p. 184). They continue in the same vein:

it is not to us self-evident why one should regard our respondents' concern for decent, comfortable houses, for laboursaving devices, and even for such leisure goods as television sets and cars, as manifesting the force of false needs; of needs, that is, which are 'superimposed upon the individual by particular social interests in his repression' [Marcuse: 1972; p. 5]. It would be equally possible to consider the amenities and possessions for which the couples in our sample were striving as representing something like the minimum material basis on which they and their children might be able to develop a more individuated style of life, with a wider range of choices, than has hitherto been possible for the mass of the manual labour force.

(ibid.; pp. 183-184)

The identification and criticism of false needs also seems to rest on the assumption that if people were not engrossed in satisfying these false needs, say watching television (for which they will have more time if they own washing machines), they would be doing something more worthwhile, satisfying their real needs. But what would this entail? What would the fulfilment of real needs consist of? Would it necessarily exclude owning washing machines and watching television? It is as if Frankfurt School theorists know what people should and should not be doing, but tell them so in a language they can't understand.

Similar criticisms can be made of the School's definition of real needs. This definition is as much the result of the School's ideological preferences as it is the outcome of a serious social analysis. It seems to imply a knowledge of what people should be doing and what they should really want. Although couched in vague and abstract terms, it assumes a particular model of cultural activity, one influenced by the example of art (e.g. classical music) and the social position of the elite intellectual, to which all people should aspire.

This argument can be extended to the School's understanding of the fate of the working class in western capitalist societies. For the School, this class's real need lay in the revolutionary overthrow of capitalism and its replacement by socialism. The fact that this revolution failed to materialise did not lead the Frankfurt School theorists to question the grounds upon which its predicted emergence had been based. What they did was to assume that it should have happened, and then tried to work out why it hadn't, a trait characteristic of much Marxist thinking in the twentieth century. They appeared to accept that a specifically working-class revolution was no longer possible, and accounted for this by means of the distinction between false and true needs, although the latter came to be necessarily expressed in more abstract and universal terms. They thus argued that it has been the dominance of false needs for the products of the culture industry which has securely incorporated the working class into the major institutions of capitalist societies.

In this scenario, true needs are seen as abstract, ahistorical and utopian aspects of human nature, and vet are located in specific, historical and social circumstances. This means that the attempt to distinguish between false and true needs in a way which has empirical relevance is never considered. Similarly, the difficulties involved in trying to define true needs in ahistorical terms are rarely raised. How can needs be defined without reference to their social definition, historical transformation and practical fulfilment (or non-fulfilment)? It would appear to be extremely difficult to define needs in ways which did not refer to their historical, social and cultural characteristics. Even if needs may be generally determined in some manner, they have to be socially constructed in order to be fulfilled or for their non-fulfilment to be recognised. For these and other reasons, it is difficult to find, in the work of the Frankfurt School, the conceptual foundations upon which to build a sociological analysis of popular culture.

Benjamin and the critique of the Frankfurt School

Another way of critically assessing the Frankfurt School's ideas is to look at the writings of Walter Benjamin who for a time was involved in the intellectual activities of the School, but whose cultural analyses appear to differ from those offered by Adorno.¹¹ For a while before the Frankfurt School was exiled from Germany in the 1930s by the Nazis' seizure of power, Benjamin was a member of the Institute, although one of its more marginal intellectual participants. In the mid-1930s he wrote what some regard as one of the most seminal essays on the popular arts in the twentieth century, 'The work of art in the age of mechanical reproduction' (1973; originally published in 1936).

In this essay, Benjamin aims to assess the effects of mass production and consumption, and of modern technology, upon the status of the work of art, as well as their implications for contemporary forms of the popular arts or popular culture. Benjamin argues that the work of art, due to its original immersion in religious rituals and ceremonies, acquired a kind of 'aura' which attested to its authority and uniqueness, its singularity in time and space. Since the work of art was placed at the centre of religious practices which culturally legitimated and socially integrated the prevailing order, it gained, through this ritual function, the aura associated with religion.

Once embedded in this fabric of tradition, art can retain its aura independently of its ritual role in religious ceremonies. This process was hastened by the changes associated with the Renaissance which extended the secularisation of the work of art and its subject matter. The focus of artistic attention began to shift from religious to secular subjects. The Renaissance initiated the struggle for artistic autonomy. This struggle concerned the notions that the work of art was unique in its own right, irrespective of any religious considerations, and that being an artist was a unique vocation, guided by a privileged insight into the truths of human existence, a kind of transcendent knowledge founded in the aura of the work of art.

These notions attained their most extreme manifestation in the 'art for art's sake' movement in the mid- to late nineteenth century. This was a reaction to the emergence of capitalist industrialisation and the commercialisation of culture, and the threats they posed to the aura of the work of art. It is these effects of 'the age of mechanical reproduction' with which Benjamin is most concerned. The example of photography may help us understand Benjamin's argument. He writes:

for the first time in world history, mechanical reproduction emancipates the work of art from its parasitical dependence on ritual. To an even greater degree the work of art reproduced becomes the work of art designed for reproducibility. From a photographic negative, for example, one can make any number of prints; to ask for the 'authentic' print makes no sense.

(1973; p. 226)

This is part of a general process which also includes another crucial modern development, foreshadowed by photography – the sound film:

that which withers in the age of mechanical reproduction is the aura of the work of art . . . the technique of reproduction detaches the reproduced object from the domain of tradition. By making many reproductions it substitutes a plurality of copies for a unique existence. And in permitting the reproduction to meet the beholder or listener in his own particular situation, it reactivates the object reproduced. These two processes lead to a tremendous shattering of tradition . . . their most powerful agent is the film.

(ibid.; p. 223)

In effect, art, as visualised by Adorno, has now 'left the realm of the "beautiful semblance" (ibid.; p. 232).

The point, however, for Benjamin, is that this should not be viewed in a negative manner. The work of art which is reproducible has not only lost its aura and autonomy, but it has become more available to more people. The ritual value of the work of art is replaced by its exhibition value. Not only do film and photography show us things we may never have seen before or realised existed (ibid.; p. 239), they also change the conditions in which they are received. 'Mechanical reproduction of art changes the reaction of the masses toward art' (ibid.; p. 236) by allowing them to participate in its reception and appreciation. This is so because

THE FRANKFURT SCHOOL

the new popular arts are more accessible to more people and afford them a role in their critical evaluation. For example:

painting simply is in no position to present an object for simultaneous collective experience, as it was possible for architecture at all times, for the epic poem in the past, and for the movie today. Although this circumstance in itself should not lead one to conclusions about the social role of painting, it does constitute a serious threat as soon as painting ... is confronted directly by the masses. In the churches and monasteries of the Middle Ages and at the princely courts up to the end of the eighteenth century, a collective reception of paintings did not occur simultaneously, but by graduated and hierarchized mediation. The change that has come about is an expression of the particular conflict in which painting was implicated by the mechanical reproducibility of paintings. Although painting began to be publicly exhibited in galleries and salons, there was no way for the masses to organize and control themselves in their reception. Thus the same public which responds in a progressive manner towards a grotesque film is bound to respond in a reactionary manner to surrealism.

(ibid.; p. 237)

In contrast to painting, the sound film is 'superior' in 'capturing reality', and in giving the masses the opportunity to consider what it has captured. Accordingly, Benjamin notes:

behaviour items shown in a movie can be analysed much more precisely and from more points of view than those presented on paintings or on the stage . . . the film, on the one hand, extends our comprehension of the necessities which rule our lives; on the other hand, it manages to assure us of an immense and unexpected field of action . . . with the closeup, space expands; with slow motion, movement is extended. . . . Let us compare the screen on which a film unfolds with the canvas of a painting. The painting invites the spectator to contemplation; before it the spectator can abandon himself to his associations. Before the movie frame he cannot do so. No sooner has his eye grasped a scene than it is already changed. It cannot be arrested. . . . The mass is a matrix from which all traditional behaviour towards works of art issues today in a new form. Quantity has been transmuted into quality. The greatly increased mass of participants has produced a change in the mode of participation.

(ibid.; pp. 237-238, 240, 241)

Therefore Benjamin stresses the democratic and participatory rather than the authoritarian and repressive potential of contemporary popular culture. This position, despite its striking originality, is, of course, not without problems of its own, which include the relationship between power and the new popular arts as well as an exaggerated technological optimism.¹² But my concern here is not with a detailed assessment of Benjamin's essay. Instead I wish to present it as a critical footnote to the work of the Frankfurt School so as to bring out the critical edge of his analysis of 'the work of art in the age of mechanical reproduction'.

Further reading

Adorno, T. (1991) The Culture Industry, London, Routledge.

- Benjamin, W. (1936) 'The work of art in the age of mechanical reproduction', in *Illuminations*, London, Fontana, 1973.
- Bennett, T. (1982) 'Theories of the media, theories of society', in M. Gurevitch et al. (eds), Culture, Society and the Media, London, Methuen.

Bottomore, T. (1989) The Frankfurt School, London, Routledge.

- Craib, I. (1984) Modern Social Theory, London and New York, Harvester Wheatsheaf (chapter 11).
- Gendron, B. (1986) 'Theodor Adorno meets the Cadillacs', in T. Modleski (ed.), *Studies in Entertainment*, Bloomington, Indiana, Indiana University Press.
- Jay, M. (1973) The Dialectical Imagination, London, Heinemann.

Marcuse, H. (1972) One Dimensional Man, London, Abacus.

Wolin, R. (1994) Walter Benjamin, Berkeley and Los Angeles, University of California Press (chapter 6).

Chapter 3

Structuralism, semiology and popular culture

	Structural linguistics and the ideas	
	of Saussure	89
	Structuralism, culture and myth	94
	Structuralism and James Bond	102
	Barthes, semiology and popular	
	culture	108
	Barthes, structuralism and semiology	109
	Writing Degree Zero	110
	Myths and popular culture	112
	Bourgeois men and women novelists	116
	Structuralism and semiology: some	
	key problems	119
	Lévi-Strauss's structuralism	120
82	Roland Barthes's semiology	123

87

I N THIS CHAPTER I shall discuss structuralism and semiology, both of which, since their rise to prominence from the 1950s, have had an important influence upon the study of popular culture. They have left their mark on other seemingly distinct perspectives like feminism and Marxism, and their concepts and procedures such as signs, signifiers, signifieds and decoding - have continued to be used in the analysis of popular culture. Unlike mass culture theory or the Frankfurt School, their legacy appears to be more assured and wide-ranging. In view of the way they emerged alongside the increasing concern with theory in social science in the 1960s, and the fact that they express an interest in societies increasingly inundated with popular culture images and representations, it may even prove to be premature to talk about their legacy since their role in the social analysis of culture is still very evident. I shall thus try to outline their basic ideas, and indicate some of their empirical applications and critical drawbacks. I shall also look at the major contentions of structural linguistics in order to show how they represent one of the sources for these approaches. But before doing this, there is one problem which has to be confronted, namely the difference between semiology and structuralism.

If one reads the literature extensively, it becomes apparent that these terms are often used interchangeably. So it might be possible to argue that they mean the same thing, and that there is no problem. However, things are not quite so simple. Structuralism has been defined as a theoretical and philosophical framework which is relevant to the social sciences as a whole. It is said to make general claims about the universal, causal character of structures. Semiology, in turn, has been defined as the scientific study of sign systems, like cultures. For example, the *Fontana Dictionary* of *Modern Thought* defines structuralism as 'a movement characterized by a preoccupation not simply with structures but with

STRUCTURALISM AND SEMIOLOGY

such structures as can be held to underlie and generate the phenomena that come under observation ... with deep structures rather than surface structures ... referable [according to Lévi-Strauss] to basic characteristics of the mind', while semiology is viewed as 'the general (if tentative) science of signs: systems of signification, means by which human beings - individually or in groups - communicate or attempt to communicate by signal: gestures, advertisements, language itself, food, objects, clothes, music, and the many other things that qualify' (Bullock and Stallybrass: 1977; pp. 566 and 607). Structuralism has been identified with claims about the universal character of mental and cultural structures, and their causal effects in giving rise to observable social phenomena. Neither of these claims need be entailed in the adoption of a semiological approach. This is roughly the usage I will keep to in this chapter. I realise it is not totally satisfactory since it could be argued that, in practice, structuralism and semiology have studied the same kinds of things in the same kinds of ways. Any distinction must therefore remain somewhat arbitrary, but perhaps this is better than a completely relativistic standpoint. It also allows me to suggest that semiology can be used as a method which does not carry the universalising implications of structuralism.

Structural linguistics and the ideas of Saussure

The Swiss linguist Saussure (1857–1913) attempted to establish and develop the discipline of structural linguistics, and on this basis suggested it was possible to found a science of signs.¹ In these respects, his ideas played a crucial role in the emergence of structuralism and semiology, and make their intentions and methods a lot clearer, while demonstrating their continuing relevance for the semiological study of contemporary forms of popular culture.

Saussure is concerned with establishing linguistics as a science, but in a particular kind of way. To do this he makes a number of distinctions and definitions which have come to be familiar to anyone acquainted with the academic study of culture.

89

Saussure's starting-point is the need to define the object of structural linguistics. For this reason, he draws a distinction between langue and parole, between language as an internally related set of differentiated signs governed by a system of rules (language as a structure) and language as it is made manifest in speech or in writing (language as an accomplished fact of communication between human beings). Langue is, according to Saussure, the object which linguists should study, forming both the focus of their analyses and their principle of relevance. Langue is the overall system or structure of a language (its words, syntax, rules, conventions and meanings). It constitutes all specific languages and it makes it possible for them to be used; it is given and has to be taken for granted by any individual speaker. Langue allows people to produce speech and writing, including words and phrases which may be completely new. It is, in the first instance, this notion of langue which has proved influential, since it is relatively easy to infer from this definition that all cultural systems like myths, national cultures or ideologies, may be described and understood in this way.

Parole, by contrast, is defined and determined by *langue*. It is the actual manifestation of language made possible by, and deriving from *langue*. *Parole* is the sum of the linguistic units involved in speaking and writing. These cannot be studied in and of themselves as discrete, atomistic and historical items. Instead, they provide evidence about the underlying structure of *langue*. The aim of linguistics, then, is to use speaking and writing as the ways in which the underlying structure of the language, the object of linguistics, can be constructed. This means that its rules and relations can be understood and used to account for the particular uses people make of their language. Linguistics, therefore, involves the study of *langue* as a system or structure.

This study involves the discovery and scrutiny of the system of grammatical rules governing the construction of meaningful sentences. These rules are not usually apparent to the users of the language who can none the less still utter or write such sentences. As Saussure himself states: 'In separating language from speaking, we are at the same time separating: (1) What is social from what is individual; and (2) what is essential from what is accessory and more or less accidental' (1974; p. 14). From a sociological point of view it may seem strange to regard speaking as a non-social act. But from the point of view of structural linguistics and its subsequent influence, Saussure is distinguishing between fundamental and derivative social and cultural structures, between those structures which explain and those which need to be explained.

The second distinction Saussure introduces is that between the signifier and the signified. According to Saussure, any linguistic sign such as a word or phrase can be broken down into these two elements of which it is composed, although this is only possible analytically, not empirically. It is a function of *langue* rather than *parole*, and accounts for the capacity of language to confer meaning, a feature which has made it attractive for analysing cultural structures other than language. For Saussure, the meaning of particular linguistic units is not determined by an external material reality which imposes itself upon language. These units do not have a direct referent in the external, material world. This world exists but the meanings which are conferred upon it by language are determined by the meanings inherent in language as an objective structure of definite rules. In this sense, the meanings conferred by language arise from the *differences* between linguistic units which are determined by the overall system of language.

If language can be understood in this way then so can other cultural systems, and we shall see how this notion has played an important part in the attempt by Barthes to develop semiology as the scientific study of sign systems. It is necesary to stress this in order to appreciate the significance of Saussure's distinction between the signifier and the signified. As I have said, the linguistic sign is made up of both these elements and its meaning is not determined by its external referent. Words like dog or god do not acquire their meaning from their equivalents in the world outside language but from the way language begins to differentiate between them in terms of the ordering of their letters. A letter change gives us an entirely different concept, and probably explains why philosophers of language are so fond of using the example of the word 'dog'. In the linguistic sign, the signifier is the 'sound image', the word as it is actually said or written down, and the signified is the concept of the object or idea which is being referred to by the sign. So with our examples of dog and god, the letters you see or the sounds you hear are the signifiers, and the object and idea evoked by these sounds and words are the signifieds. Language confers meaning on both of these words through their linguistic differences and their place in the differentiated categories of animals and supernatural beings.

Since the meanings of particular linguistic signs are not externally determined but derive from their place in the overall relational structure of language, it follows that the relationship between the signifier and signified is a purely arbitrary one. There is no definite reason as to why the notation dog should refer to that specific animal nor god to a supernatural deity. There is no intrinsic, natural or essential reason why a particular concept should be linked with one sound image rather than another. Therefore, it is not possible to understand individual linguistic signs in a piecemeal, ad hoc or empiricist fashion. They have, rather, to be explained by showing how they fit together as arbitrary signs in an internally coherent system or structure of rules and conventions. These signs cease to be arbitrary and become meaningful once they are located within the general structure of the language. Any item can only be understood in terms of this structure. This structure is, in fact, what Saussure calls langue, and it is not given but has to be reconstructed analytically.

This set of ideas is again higly relevant to the way semiology has been developed as a means of studying popular culture. But it is important to note that the relationship between signifiers and signifieds is not arbitrary in culture as it is in language. This is because, according to semiology and structuralism, there are definite factors associated with conventions, codes and ideologies which determine the association of specific signifiers with specific signifieds.

The arguments put forward by Saussure involve the idea that languages as systems – much like cultures as systems – can only be studied and understood in relational terms. For structural linguistics, and structuralism and semiology more generally, meaning can only be derived from a general objective structure of rules in which

92

particular items or units are differentiated from each other, and derive their meaningful character from their place in this general structure. This structure, be it language or another sign system like culture, is not given empirically but has to be discovered and defined in relational terms.

Saussure suggests a conception of langue can be constructed by studying the linguistic signs of *parole* not as discrete individual items but as pointers to, and signs of, the structure of langue. In this respect, there are two types of relationships which Saussure considers important: syntagmatic, that is the relationships between items in a linguistic sequence, say words in a sentence; and paradigmatic, the relationships between items which might replace each other in a sequence thus altering its meaning, say substituting one word for another in a sentence. To define any item, unit or sign in this manner is to specify its relation to other items, units or signs which can be combined with it to form a sequence, or which contrast with it and can replace it in sequences. In either case, it is the relational character of the structure which enables the item, unit or sign to acquire meaning. This notion helps explain why structural linguistics has influenced the study of culture more generally since it suggests that other cultural systems can be analysed as if they are structured like a language.

The attempt to establish structural linguistics as a science leads Saussure to make a final distinction between synchronic and diachronic analysis. He argues that if the task of linguistics is to reconstruct the *langue* which makes speech and writing possible at any particular point in time, then synchronic analysis has to be kept separate from diachronic analysis. Synchronic analysis refers to the study of structures or systems at a particular point in time, while diachronic analysis involves the study of structures or systems over time. In Saussure's linguistics, synchronic analysis also entails the reconstruction of the system of language as a relational whole which is distinguished from, but not necessarily subordinated to, the diachronic study of the historical evolution and structural changes of particular linguistic signs and items. To combine these two forms of analysis would undermine the attempt to define the relational structure of a language. Language is viewed

as a system of interrelated signs which are made meaningful by their place in the system rather than by their place in history. Freezing the system assimilated by speakers and writers at one point in time allows its structural and relational character to be clearly identified without being obscured by extraneous and incidental historical circumstances. Saussure seems to suggest that synchronic and diachronic analyses be kept separate from each other in order that the structure of *langue* can be determined. But he has been criticised, as have structuralism and semiology, for giving priority to synchronic analysis, and thereby neglecting the importance of historical and social change.

Saussure regards linguistics as a sub-branch of semiology. According to him, semiology is a science which studies the life of signs within society, showing what constitutes signs, and discovering the laws which govern them. Language can be studied as a semiological system of signs which express ideas, and can be understood properly by being compared with other systems of signs. Structural linguistics is one of the first examples of how semiology can be developed. In making this case, he laid the foundations for later attempts to extend the analytic potential of structuralism and semiology to other systems like popular culture.

Structuralism, culture and myth

The form of linguistics developed by Saussure has not, of course, gone unchallenged. Nor has it served as the uncontested paradigm for the study of language ever since. I have outlined some of Saussure's ideas because they have influenced the development of both structuralism and semiology. The importance of Saussure's linguistics will become clearer during this chapter, and is readily apparent in the structuralist concept of structure.

As far as the social study of language is concerned, Saussure's ideas have been heavily criticised.² His definition of *parole*, for example, has been rejected for a number of reasons. Speech and writing are in fact social rather than individual phenomena, *langue* is only ever manifest in *parole* anyway, and the social nature of

speech and writing make them open to change and transformation, unlike *langue*. Saussure only ever sees the latter as being social in character, and his overall theory tends to eschew social change. He also tends to regard human beings as mere mouthpieces for the rules of language which govern their speech and writing. Fairclough, for example, notes that 'language varies according to the social identities of people in interactions, their socially defined purposes, social setting, and so on. So Saussure's individualistic notion of *parole* is unsatisfactory' (1989; p. 21). Since Fairclough wishes to stress the links between language and power, he continues:

Saussure understood *langue* as something unitary and homogeneous throughout a society. But is there such a thing as 'a language' in this unitary and homogeneous sense? . . . When people talk about 'English' in Britain, for instance, they generally have in mind British *standard* English. . . . The spread of this variety into all the important public domains and its high status among most of the population are achievements of *standardization* . . . as part of the economic, political, and cultural unification of modern Britain. From this perspective, 'English' and other 'languages' [unlike Saussure's notion of *langue*] appear to be the products of social conditions specific to a particular historical epoch.

(ibid.)

While *langue* may be studied for its formal properties, it cannot in fact be understood outside of its particular uses, that is independently of *parole*. If this is so, it tends to undermine the rationale for the distinction Saussure draws between them.

Despite these and other problems, Saussure's work has formed an important influence upon the emergence of structuralism and semiology. Interestingly enough, Fairclough retains a reformulated sense of Saussure's distinction between *langue* and *parole* in that the former refers to 'underlying social conventions' and the latter to 'actual use' (ibid.; p. 22). In order to discuss structuralism, I shall begin with Lévi-Strauss's concept of structure.³

The French social anthropologist Lévi-Strauss (b.1908) is well known for introducing the concepts and methods of structuralism into anthropology, and using them for studying the myths circulating in pre-industrial societies. His version of structuralism is concerned with uncovering the common structural principles underlying all the specific and historically variable manifestations of culture and myth. These structural principles involve the logical and universal characteristics of the human mind whose mental structure lies behind, classifies and generates all the empirical examples of cultural myths which can be discovered. This means that, for Lévi-Strauss, his concept of structure is a theoretical and explanatory one which has, in the first instance, nothing to do with empirical reality. It is not directly available to the senses, and lies behind, while producing, what we can observe. It is thus non-observable but generates or 'causes' that which can be observed. The relationship envisaged here by Lévi-Strauss is similar to that implied by Saussure between *langue* and *parole*.

If this structure is unobservable and causal, then it follows that it must be unconscious. Human beings subject to its power are unaware or unconscious of its influences in much the same way that the speakers or writers of a language are unaware or unconscious of its rules. More than this, consciousness often involves the misrecognition of underlying structural causes and is a poor guide to their defining characteristics. The perceptions of human beings are as likely to mask as reveal these characteristics, and it falls to structuralist analysis to say what they are. Structuralism can do this because it is able to construct a relational model of what this underlying structure is like, even if it cannot be verified by the usual norms of empirical observation. According to the principles of structuralist analysis, it is a model of an underlying reality which has to be constructed. All the parts of this structure are systematically related to each other in the same way that all the units of a language are related to each other, and acquire their distinctive meanings due to their being part of a relational whole. Structuralism refers us to a relational structure like language which is more than the sum of its parts, and it argues that things cannot be studied in their empirical isolation but only in their structural unity.

This model of an underlying, unobservable, generative, relational and unconscious but real universal structure is defined by Lévi-Strauss as a logical grid of binary oppositions, combining rational modes of classification. It consists of a determinable number of related elements or oppositions which can be combined or classified as belonging together in a finite number of ways. It thus implies that all cultural forms represent different empirical combinations or symbolic reconciliations of inherent logical oppositions. Empirical examples, in this sense, merely represent secondary expressions or temporary reconciliations of the basic elements to be found in the underlying mental structure of binary oppositions. All cultures represent the logical transformations of the fundamental workings of the structure of oppositions inherent in the human mind. As Lévi-Strauss states in an essay on language and kinship:

If the general characteristics of the kinship systems of given geographical areas, which we have tried to bring into juxtaposition with equally general characteristics of the linguistic structures of those areas, are recognised by linguistics as an approach to equivalences of their own observations, then it will be apparent . . . that we are much closer to understanding the fundamental characteristics of social life than we have been accustomed to think.... We shall be in a position to understand basic similarities between forms of social life, such as language, art, law, and religion, that on the surface seem to differ greatly. At the same time, we shall have the hope of overcoming the opposition between the collective nature of culture and its manifestations in the individual. since the so-called 'collective consciousness' would, in the final analysis, be no more than the expression, on the level of individual thought and behaviour, of certain time and space modalities of the universal laws which make up the unconscious activity of the mind.

(1963; p. 65; cf. p. 21)

There is a lot more to Lévi-Strauss's view of structuralism than I can do justice to here. Moreover, what I have said so far may appear to be too abstract, so perhaps a few examples may clarify what he has to say. In his study of totemism, Lévi-Strauss shows

97

very clearly how he conceives of his method of working. Totemism refers to the way types of animals or other 'natural' phenomena may be taken to represent a particular social group, say a clan or a tribe, within certain types of societies. Now, according to Lévi-Strauss, totemism cannot be explained in terms of any specific example since there is no necessary reason why certain totems should represent certain groups. He rejects utilitarian, functional and integrative explanations and says, in effect, that the relationship between the group, the signified and the totem, the signifier, is, at this level, arbitrary. What he argues instead is that the empirically observable phenomenon is only one possible combination which exists alongside other logical possibilities. These can be discovered if the overall relational structure of possibilities and transformations is constructed. This overall procedure will, in turn, make the phenomenon of totemism intelligible.

Lévi-Strauss therefore constructs a grid of binary oppositions and possible permutations on the assumption that the phenomenon of totemism is an empirical manifestation of the more fundmental and universal tendency of societies to classify socio-cultural things, like groups or tribes, by means of things which are natural, like animals or plants. If totemism is seen as a phenomenon which provides a non-social (natural) representation of the social (cultural), and which can have both an individual and collective existence, and if the natural can thereby consist of categories and particulars, and the cultural of groups and persons, then totemism can be located within these possible combinations of the logically related oppositions between collective and individual existence, and culture and nature. Totemism is made intelligible as a way of transforming the elements contained in the following grid (from Lévi-Strauss: 1969; pp. 84–85):

Nature	Category	Particular
Culture	Group	Person

These collective and individual expressions of the binary opposition between culture and nature can be combined and transformed into a number of distinct relational types as follows (from ibid.):

	1	2	3	4	
Nature	Category	Category	Particular	Particular	
Culture	Group	Person	Person	Group	

Totemism can thus be understood not as a distinct empirical phenomenon to be found in certain cultures, but as a number of different types which emanate from this classificatory structure of logical oppositions and possible transformations. Lévi-Strauss identifies totemism empirically with types 1 and 2, and says it is only indirectly related to types 3 and 4. It is a phenomenon which consists of certain relations and forms which can be explained only when the complete structure, of which these relations are amongst the other possible combinations, has been reconstructed. For it is this universal and underlying structure, rooted in and articulating the opposition between culture and nature, which causes or gives rise to the phenomenon of totemism, and which allows other possible transformations of the elements involved to occur. Equally, totemism provides a symbolic reconciliation of the opposition between culture and nature in that both are united by being represented through the totem. It is an empirically manifest way in which societies and their cultures mediate the universal relation between culture and nature. Other myths such as those to be found in folklore could in principle be analysed in terms of other universal oppositions, like that between good and evil, or the sacred and the profane.⁴ Similarly, structuralist analyses have been extended to contemporary forms of popular culture. Before going on to look at this, another illustrative example of the way Lévi-Strauss uses structuralism to study myths may be useful.

In Structural Anthropology Lévi-Strauss cites a myth to be found amongst the Iroquois and Algonquin indians of North America which he suggests bears a close resemblance to the 'Oedipus legend'. The story concerns incest between brother and sister rather than mother and son, and murder, although not the unwitting slaying by a son of his father; but it does contain the moral that attempts to prevent incest making its occurrence inevitable. In looking at elements of these two myths he asks the questions: 'Is this a simple coincidence – different causes

99

explaining that, here and there, the same motifs are arbitrarily found together? Or are there deeper reasons for the analogy? In making the comparison, have we not put our finger on a fragment of a meaningful whole? (1977; p. 21). His answer to the last question is yes. However, he does provide a test of his theory since the native north American myth lacks the puzzle or riddle to be found in the Oedipal legend. If these myths are fragments, cultural manifestations, of a meaningful whole, an underlying and causal logical structure, then this element should also be there even if it has been transformed.

This is indeed what Lévi-Strauss discovers. He points out that puzzles and riddles, like that associated with the Sphinx episode in the Oedipus myth, are almost entirely absent among the 'North American Indians'. So if such an element could be found it would demonstrate that he has uncovered 'a fragment of a meaningful whole', and that 'it would not, then, be the effect of chance, but proof of necessity' (ibid.; p. 22). He says that amongst native North American myths only two types of riddles can be found: one where they are told to audiences by clowns whose birth is the result of incest; and one, to be found amongst the Algonquins, where owls ask riddles 'which the hero must answer under pain of death' (ibid. - this is the dilemma Oedipus finds himself in when confronted by the Sphinx). In the story we started with, the incestuous brother, the hero of the myth, murders his double whose mother is a sorceress, a mistress of the owls. This means that not only do we have a transformation of the basic structure of incestuous relations, sister-brother, mother-son, but also of puzzles or riddles which 'present a double Oedipal character, by way of incest on the one hand, and on the other hand, by way of the owl in which we are led to see, in a transposed form, an American Sphinx' (ibid.).

Again Lévi-Strauss has discovered meaningful relations between elements and oppositions – incest and riddles – which are transformed from one myth to another. They are, in turn, suggestive of other possible relations, and arise from an underlying and universal mental structure which 'thinks' these relations and oppositions. Thus he then pursues, for example, the possible permutations of riddles with each other, those questions which have no answer and those answers which have no question. This takes him on to the death of Buddha and the Holy Grail cycle, where questions which should be asked are not. He also looks at the relations between sexuality as expressed by incest, and chastity as represented by the actions of the heroes of myths, and tries to locate Oedipal type myths within a wider structure of possibilities. The point of these examples is to unravel the meaningful and logically based mental whole which lies behind them.

This argument is given additional force since it uncovers a structure which manages to prevail irrespective of the influences exerted by specific historical, social or cultural conditions. As Lévi-Strauss concludes: 'it seems that the same correlation between riddles and incest exists among peoples separated by history, geography, language and culture' (ibid.; p. 24). Comparable transformations of myth can be found in societies as far apart from each other, and as structurally distinct, as native north American tribes and the city states of Ancient Greece. If this is so, then the specific features of these societies cannot explain the character of myths. However, the logical structure of the human mind can explain the similarities and transformations detected by structuralism in cultural myths. In a fitting conclusion to his discussion of these myths, Lévi-Strauss writes: 'we have only sketched here the broad outlines of a demonstration . . . to illustrate the problem of invariance which, like other sciences, social anthropology attempts to resolve, but which it sees as the modern form of a question with which it has always been concerned - that of the universality of human nature' (ibid.). This is related to his view that:

today, no science can consider the structure with which it has to deal as being no more than a haphazard arrangement of just any parts. An arrangement is structured which meets but two conditions: that it be a system ruled by an internal cohesiveness and that this cohesiveness, inaccessible to observation in an isolated system, be revealed in the study of transformations through which similar properties are recognized in apparently different systems.

(ibid.; p. 18)

101

Structuralism and James Bond

An analysis of contemporary popular culture which shares much in common with the structuralist approach, while not committing itself to all the presuppositions held by a writer like Lévi-Strauss, is Umberto Eco's study of the James Bond novels written by Ian Fleming. A critical consideration of this study can show us how structuralism works as a way of studying contemporary popular culture, as well as the limitations it confronts. A leading contemporary Italian intellectual and semiologist, Eco (b.1932) is well known as a popular novelist, and as one of the first intellectuals to take a serious interest in popular culture at a time when it was not academically fashionable to do so. His study of the Bond novels is perhaps the best known example of his attempts to apply the methods of structuralism to a form of popular culture.⁵

Eco's concern is to uncover the invariant rules governing the narrative structure of these novels which ensure both their popular success and their appeal to a more restricted and culturally literate audience. The novels are a form of popular culture based upon an underlying structure of rules which ensures their popularity. For Eco these rules are comparable to 'a machine that functions basically on a set of precise units governed by rigorous combinational rules. The presence of those rules explains and determines the success of the "007" saga – a success which, singularly, has been due both to the mass consensus and to the appreciation of more sophisticated readers' (1979; p. 146). This 'narrative machine' presumably connects at some unconscious level with the desires and values of the popular audience, for each cog or 'structural element' of which this machine is composed, is assumed to be related to 'the reader's sensitivity' (ibid.).

First of all, Eco constructs the series of oppositions upon which the novels are based. These oppositions, which are very similar to Lévi-Strauss's binary oppositions, can be combined and recombined with each other, and are 'immediate and universal' (ibid.; p. 147). Their 'permutation and interaction' means that the combination, association and representation of each opposition can be varied, to some extent, from novel to novel. None the less they form an invariant structure of oppositions which defines the narratives and ensures the popularity of the novels. These oppositions involve the relations between characters in the novels (for example, between Bond and the villain or the woman), the relations between ideologies (for example, between liberalism and totalitarianism, or the 'free world' and the 'Soviet Union') and a larger number of relations between distinct types of values (for example, 'cupidity-ideals, love-death, chance-planning ... perversion-innocence, lovalty-dislovalty' (ibid.)). These relationships are worked out by particular characters, the relations between characters and the unravelling of the story as a whole. For example, Bond, in his relations with the villain, represents the ascendancy of the free world over the Soviet Union, and the victory of chance over planning. But whatever the specific transformation of relations between oppositions in particular novels, the underlying structure of oppositions remains the same. Eco traces the nature of this structure and its transformations across the stories to be found in the James Bond novels.

This argument is linked to the idea that there is an invariant *sequential* structure underlying the novels. Eco compares this to 'play situations' or 'games' in which each initial 'move' gives rise to a countermove and so on, pushing the story forward. The prevalence of games of chance in the novels occurs 'because they form a reduced and formalized model of the more general play situation that is the novel. The novel, given the rules of combination of oppositional couples, is fixed as a sequence of "moves" inspired by the code and constituted according to a perfectly prearranged scheme' (ibid.; p. 156). Abbreviating slightly, this 'invariable scheme' can be detailed as follows:

- A M moves and gives a task to Bond;
- B Villain moves and appears to Bond . . .;
- C Bond moves and gives a first check to Villain or Villain gives first check to Bond;
- D Woman moves and shows herself to Bond;
- E Bond takes Woman . . .;
- F Villain captures Bond . . .;

G Villain tortures Bond . . .;

H Bond beats Villain . . .;

I Bond, convalescing, enjoys Woman, whom he then loses. (ibid.)

This scheme is invariant in that each novel must contain all these elements or 'moves'. It is demanded by the narrative structure of the novels and explains their popular success. However, these basic elements need not appear in this sequence. In fact, Eco goes to great lengths to show the range of variations possible. In this sense, paradigmatic relations are more fundamental to the structure which articulates the novels than syntagmatic relations. The sequence may change but the structure remains the same. And it does so, as Eco tries to demonstrate, irrespective of the many 'side issues' or incidental features which may be introduced to add colour and variety to any particular novel.

It is the coming together of these two structures of binary oppositions and premeditated moves which, for Eco, accounts for the popular attractions of the novels. The incidental features or 'collateral inventions' play their part in this success, especially amongst more 'sophisticated' readers. According to Eco:

The true and original story remains immutable, and suspense is stabilized curiously on the basis of a sequence of events that are entirely pre-determined ... there is no basic variation, but rather the repetition of a habitual scheme in which the reader can recognize something he has already seen and of which he has grown fond ... it, in fact reconfirms ... [the reader] in a sort of imaginative laziness ... by narrating ... the Already Known.... The reader finds himself immersed in a game of which he knows the pieces and the rules – and perhaps the outcome – and draws pleasure simply from following the minimal variations by which the victor realizes his objective.

(ibid.; p. 160)

This passage is interesting in that it combines the concepts of structuralism with a picture of the audience consistent with that

104

presented by the mass culture critics and the Frankfurt School. As Eco continues: 'the novels of Fleming exploit in exemplary manner that element of foregone play which is typical of the escape mechanism geared for the entertainment of the masses' (ibid.; p. 161). A theory which relies for its explanatory power upon the concept of an underlying and unconscious structure is clearly liable to underestimate the significance of the role of the audience in understanding popular culture.⁶ This view is evident in Eco's account of Fleming's use of ideology. He argues that the ideologies to be found in the novels are determined by the demands of mass culture. Fleming's reliance on cold war ideology, for example, derives simply from his endorsement of 'the common opinions shared by the majority of his readers' (ibid.). Eco suggests that 'Fleming seeks elementary oppositions; to personify primitive and universal forces, he has recourse to popular standards' (ibid.; p. 162).

Another aspect of Eco's structuralism, one consistent with that of Lévi-Strauss, concerns the universal character of the structure which lies behind and explains the popularity of the Bond novels. Eco sees the narrative structure of these novels as representing a modern variation on the universal theme of the struggle between good and evil. This struggle, which for Eco defines Fleming's Manichaean ideology even if it is the result of opportunism, forms a fundamental binary opposition. The Bond novels are comparable to fairy tales in which a knight (Bond), under the orders of a King (M), goes on a mission to destroy the monster, such as a dragon (the Villain), and rescue the Lady (the Woman). Both types of story involve transformations of the basic elements embodied in the binary opposition between good and evil. They express a universal structure of basic oppositions which, because it is universal, will ensure popular success. Both the Bond novels and fairy tales are successful because they are universal in their underlying connection with the eternal conflict between good and evil.

The popular success of the Bond novels is accounted for by the idea that the mass audience is unknowingly in tune with the universal themes which are evoked. However, there are more discerning readers who are very aware of why the novels appeal to them. These readers are conscious of the mechanics of the novels, and capable of grasping the more subtle and esoteric allusions in Fleming's writing (ibid.; p. 163). Eco is in fact identifying a culturally stratified audience for the Bond novels, one divided between the mass popular readership on the one hand and a highly sophisticated cultural elite on the other. He thus elaborates upon the kinds of references to be found in the novels which appeal to the tastes and temperament of the culturally literate reader. He notes, for example, the resemblance between the physical description of James Bond and that of a typical Byronic hero (ibid.; pp. 171–172; see also pp. 169–170). 'By now', he writes,

it is clear how the novels of Fleming have attained such a wide success: they build up a network of elementary associations to achieve something original and profound. Fleming also pleases the sophisticated readers who here distinguish, with a feeling of aesthetic pleasure, the purity of the primitive epic impudently and maliciously translated into current terms and who applaud in Fleming the cultured man, whom they recognize as one of themselves, naturally the most clever and broadminded.

(ibid.; p. 163)

Structuralism therefore leads Eco to argue that the structure of the novels positions particular kinds of readers, masses and elites in terms of particular kinds of attraction, elemental primitivism and cultural sophistication. In view of this, it is curious that Eco finally comes to recognise the importance of readers who are not determined in their reading by the structure of the text. He argues that 'since the decoding of a messsage cannot be established by its author, but depends on the concrete circumstances of reception, it is difficult to guess what Fleming is or will be for his readers' (ibid.; p. 172). But without this 'definitive verification' what is the point of the analysis Eco has carried out? If it is the reception of the novels by their readers which determines their meaning, then what is the point of uncovering their invariant structure of binary oppositions? What value do structuralist analyses have if cultural meanings are derived from the 'society that reads', from 'the concrete

circumstances of reception'? These circumstances tend to involve socially and historically specific patterns of cultural production and consumption, and are certainly not defined by the invariant structure of narrative or the logic of binary oppositions. To suggest that the influence exerted by the universal structure does not determine how and why people read the texts which it generates, is to call into question the value of structuralist analyses. This is all the more surprising since Eco starts from the assumption that by identifying this structure it is possible to account for the popularity of the texts being studied.

There is an obvious confusion here over the role of readers or audiences. Are audiences determined in their 'readings' by a universal structural principle, or are these 'readings' determined by the social, cultural and historical circumstances of their audiences? This problem is one which, I think, can be found throughout the work of structuralists and semiologists. Another way of thinking about it is to ask the questions: do audiences themselves decide upon their understandings of cultural forms?; or does the analyst or theorist decide for them?; and do the latter take account of the former in arriving at their interpretations of popular culture?

This problem is compounded by the ahistorical nature of Eco's structuralist analysis. His explanatory principle is, after all, an invariant, static and eternal structure. As Bennett and Woollacott argue, there are in fact no fixed, universal and ahistorical codes; readings of popular culture are always organised in historically specific contexts. They point out how difficult it is to make sense of the James Bond novels without taking into consideration their 'intertextuality' (Bennett and Woollacott: 1987; chapter 3). By this they mean that the popular cultural phenomenon of James Bond has to be assessed in the context of a range of 'texts', or cultural forms and media, including, most significantly, the series of James Bond films as well as the novels. They also indicate how readers come to novels with some prior cultural knowledge, and suggest that the codes developed in the context of reading the British imperialist spy thriller formed an important aspect of the cultural knowledge readers would have brought to their interpretations of the Bond novels.

They even speculate that some working-class readers would have read them in terms of the codes associated with detective fiction. Similarly, Denning argues that the emergence of codes associated with tourism and pornography in the 1960s was a crucial referencepoint for audiences of both the novels and the films (Denning: 1987; chapter 4).

According to Bennett and Woollacott, Eco is talking about genre. They argue, however, that he tends to conceive of it as a structure of relatively fixed, textual conventions, whereas they would rather see it as a social and textual set of culturally variable expectations, orientations and values which circulate between producers and consumers, and which change over time (1987; pp. 76–90). Eco's study contains no sense of history and very little sense of the society in which the James Bond novels have been produced and read, and then made into films. Yet texts never exist in splendid isolation. They become significant when they are located within the social relationships which produce and consume them. It could equally be concluded that the vocabulary of readers, texts and readings is misplaced as a way of analysing popular culture.⁷

Barthes, semiology and popular culture

The semiological study of popular culture probably owes much of its reputation and importance to the writings of the French literary critic and semiologist Barthes (1915–1980), and in particular to his book *Mythologies* (originally published in 1957). In the studies and theoretical arguments which make up this book, Barthes sets out a way of interpreting popular culture which has, with some notable revisions, been much discussed and highly influential ever since.⁸ Although it will not be the only work of Barthes's that I shall refer to here, it is arguably the most significant. Before I do consider it, I need to make some general points about Barthes's semiology, and outline some of the points made in *Writing Degree Zero*, the book he wrote before *Mythologies*, since it clarifies a great deal of his subsequent work.

Barthes, structuralism, and semiology

The general points which need to be made here tend to echo those made about structuralism, except that semiology does not rely upon the idea that there is a universal structure underlying sign systems. In view of this, it is more capable of analysing social change. The signs and codes it refers to can be regarded as historically and culturally specific. It does, however, insist that it is these codes and signs which make meaning possible and thus allow human beings to interpret and make intelligible the world around them.

The wider significance of semiology can perhaps be gauged by the way Barthes later clarified his aims in writing the pieces which make up his book *Mythologies*: 'I was dazzled by this hope: to give my denunciation of the self-proclaimed petit-bourgeois myths the means of developing scientifically; this means was semiology or the close analysis of the processes of meaning by which the bourgeoisie converts its historical class-culture into universal nature; semiology appeared to me, then, in its program and tasks, as the fundamental method of an ideological critique' (1988; p. 5). This serves as a useful indication of the intentions of his book, and the general premises upon which it was based, even if it also hints at Barthes's subsequent reluctance to conceive of semiology as a systematic science.

As with structuralism, the first point which needs to be noted is that semiology is defined as a science of signs, in keeping with Saussure's original suggestion. It not only possesses a notion of ideology against which the truth of science can be measured, but it promises a scientific way of understanding popular culture. This allows it to be distinguished from the arbitrary and individualistic impressionism of liberal humanist studies of culture, as well as from those approaches which rely upon aesthetic discrimination and 'good taste'.

Semiology argues that material reality can never be taken for granted, imposing its meanings upon human beings. Reality is always constructed, and made intelligible to human understanding by culturally specific systems of meaning. This meaning is never 'innocent', but has some particular purpose or interest lying behind it, which semiology can uncover. Our experience of the world is never pure or 'innocent' because systems of meaning make sure that it is intelligible. There is no such thing as a pure, uncoded, objective experience of a real and objective world. The latter exists but its intelligibility depends upon codes of meaning or systems of signs, like language.

These codes and signs are not universally given, but are historically and socially specific to the particular interests and purposes which lie behind them. It is in this sense that they are never innocent. Meaning is not something which is given or which can be taken for granted. It is manufactured out of historically shifting systems of codes, conventions and signs. Semiology is concerned with this production of meaning, with what Barthes calls 'the process of signification'. Just as culture cannot be seen as being universal, neither can it be seen as being divorced from the social conditions in which it is to be found. Rather, it tries to present itself in this way when it is really historically and socially fixed. As Barthes writes in Mythologies, the function of myth is to 'transform history into nature' (1973; p. 140). This will become clearer when we look at his analyses of myth, as will his general assumptions if we look briefly at his book Writing Degree Zero (1967; originally published in 1953).

Writing Degree Zero

In this, his first book, originally published in 1953, Barthes was concerned with the French classical style of writing. This style, which emerged in court society in the seventeenth century, prided itself upon clarity and preciseness of expression, and set itself up as a universal model or standard for all writing. This French classical style of writing came to be considered, by the nineteenth century, as the only correct and rational way to write, an inevitable and 'natural' style which simply and unambiguously served to reflect reality. During this period, this model of lucidity came to be legitimised as a universal paradigm of human communication.

This is not, however, how Barthes wishes to view it. For a start, despite its claims to universal validity as a model of clarity

and as a natural way of representing reality, it begins to disintegrate from the mid-ninteenth century onwards. In this process, it is challenged by a multiplication of styles, for example writing as a craft or job, self-conscious literariness, and 'writing degree zero', to which we shall return. The reasons for this disintegration underpin Barthes's critique of the French classical style. He argues that it is wider social forces and class interests which govern the formation and transformation of writing styles. The emergence of new class interests and conflicts result in the breakdown of the classical style. Barthes interprets this style, despite its pretensions, as an aspect of the rise of bourgeois hegemony, and thus as a 'class idiom'.

For Barthes, French classicism, irrespective of its pretensions, is neither neutral and universal nor natural and inevitable. Instead, it has to be located in its historical and social contexts. As such, it is central to the rise of bourgeois hegemony between the seventeenth and nineteenth centuries, and to the emergence of challenges to this hegemony from the 1850s onwards. According to Barthes, the classical style is rhetorical in character, motivated by the 'permanent intention to persuade'. It is the style of the law courts and the political campaign, aimed at changing opinions and ensuring the acceptance of the bourgeois view of the world. It has thus not simply been a reflection of reality but an attempt to shape conceptions of reality. It has not been neutral and universal, nor natural and inevitable, but historically specific and socially constructed, rooted in a particular set of class interests. Its meaning has not been given but produced, not 'innocent' but 'guilty'. French classicism is another 'myth' which tries to transform the historical into the natural in the interests of the bourgeois class.

This is, for Barthes, a feature of all writing. Writing degree zero' is a style developed in order to reject the idea of politically committed writing. It values writing which is colourless, transparent and neutral, blank and impersonal. It pretends to be as asocial and ahistorical as possible. In a way, it is not a style at all. But this is not in fact possible according to Barthes. For him, all writing is a form of fabrication, a way of making things up, which therefore cannot avoid these signs of fabrication or style.

Furthermore, all writing is ideological and cannot avoid being so. Writing is never just an instrument of communication, an open way of addressing people. It is rather a product of certain social and historical circumstances and certain power relations, and cannot escape their influence. Non-ideological writing, writing which presents itself as being beyond ideology, is for Barthes shown to be an illusion by his investigation of French classicism and 'writing degree zero'.

Myths and popular culture

Barthes carried these ideas further in his book *Mythologies*, which contains both a series of short essays on various examples of popular culture, originally published in magazines, and an outline of the concepts and methods of semiology which he uses to analyse the examples. It is the latter we shall consider first. Myths are forms of popular culture, but they are also more than this according to Barthes. We have to find out what is really going on, and to do this we have to turn to semiology.

'Myth is a system of communication, that is a message', Barthes writes, 'a mode of signification, a form', 'a type of speech ... conveyed by a discourse. Myth is not defined by the object of its message, but by the way in which it utters this message' (1973; p. 117). This means that the concepts and procedures of semiology can be applied to the study of myths. To understand this we need to remind ourselves of the claims semiology makes. Barthes notes that 'any semiology postulates a relation between two terms, a signifier and a signified' (ibid.; p. 121), a distinction elaborated by Saussure as we have seen. There is also a third term in this, the sign itself (be it linguistic or mythological), which contains the signifier and the signified. Barthes wishes to use this argument to study myth, and he gives an initial and preliminary example of how this might be done.

The case he has in mind is a bunch of roses which can be used to signify passion. 'Do we have here, then', Barthes asks, 'only a signifier and a signified, the roses and my passion? Not even that: to put it accurately, there are here only "passionified" roses. But

on the plane of analysis, we do have three terms [even if empirically there is only one thing, the roses]; for these roses weighted with passion perfectly and correctly allow themselves to be decomposed into roses and passion: the former and the latter existed before uniting and forming this third object, which is the sign' (ibid.; pp. 121-122). In other words, the roses are a signifier of a signified which is passion, something signified by the roses sent to a loved one. The bunch of roses can thus be analytically if not empirically broken down into a signifier, the roses, a signified, passion, and a sign which combines and is not separate from these two components, the roses as a sign of passion. Here, passion is the process of signification. The fact that this attribution of meaning - the roses signify passion and not, say, a joke or a farewell cannot be understood simply in terms of the system of signs, but has to be located in the context of the social relationships in which the attribution of meaning occurs is a problem which semiology finds it difficult to deal with. It is similar to the problem Sassurian linguistics has in dealing with language independently of the contexts in which people actually use language.

Because the mythic process of signification is not totally comparable with that associated with language, Barthes uses other concepts to analyse myths. According to Barthes, myth '*is a second-order semiological system*' (ibid.; p. 123). This means it relies upon signs in other first-order systems like language (and horticulture, as with roses?) in order to engage in the process of signification. A sign in a first-order system, a word, a flower or a photograph, becomes a signifier in the second-order system of myth. Myth uses the *language* of other systems, be they written or pictorial, to construct meanings. Myth thus becomes a *metalanguage* because it can refer to other *languages*, and so necessitates the use of new if comparable concepts.

These concepts are established by Barthes through his most famous example, and it is worth quoting him at length:

I am at the barber's, and a copy of *Paris-Match* is offered to me. On the cover, a young Negro in a French uniform is saluting, with his eyes uplifted, probably fixed on a fold of the tricolour. All this is the meaning of the picture. But ... I see very well what it signifies to me: that France is a great Empire, that all her sons, without any colour discrimination, faithfully serve under her flag, and that there is no better answer to the detractors of an alleged colonialism than the zeal shown by this Negro in serving his so-called oppressors. I am therefore ... faced with a greater semiological system: there is a signifier, itself already formed within a previous system (*a black soldier* is *giving the French salute*); there is a signified (it is here a purposeful mixture of Frenchness and militariness); finally, there is a presence of the signified through the signifier. ... French imperiality.

(ibid.; pp. 125-126 and 128)

While retaining the analytical value of the distinctions made by structural linguistics, Barthes suggests that for studying myths it is more appropriate to avoid confusion. Therefore, the signifier becomes *form*, the signified *concept* and the sign *signification*. In the example cited, we have the form of the black soldier saluting the French flag, the concept of French military strength and the signification of the grandure and impartiality of French imperialism all embodied in the photograph, and revealed by semiological analysis.

Using these concepts and this example, Barthes argues that myth works through the particular relationships between form, concept and signification. The form of this specific myth of French imperiality, the black soldier, is taken from one system, his real history, which gave him his meaning, and placed in another system, that of the myth, which is precisely designed to deny his history and culture, and thus the real history of French colonial exploitation. What motivates this 'impoverishment of meaning' is the concept of French imperiality which gives another history to the soldier, that of the grandure and impartiality of French colonialism. The soldier is now made to function as a sign of French imperiality. As Barthes puts it, emphasising the process of signification: 'The French Empire? It's just a fact: look at this good Negro who salutes just like one of our boys' (ibid.; p. 134). For Barthes, 'signification is the myth itself' (ibid.; p. 131), the coming together of form and concept in the cultural sign. But the form does not hide the concept, or make it disappear as some theories of ideology tend to insist. Barthes writes: 'myth hides nothing: its function is to distort, not to make disappear ... there is no need of an unconscious in order to explain myth ... the relation which unites the concept of the myth to its meaning is essentially a relation of *deformation* ... in myth the meaning is distorted by the concept' (ibid.; pp. 131–132). Unlike the linguistic sign, the 'mythical signification ... is never arbitrary; it is always in part motivated' (ibid.; p. 136), and this motivation of form by concept brings us to the social and historical characteristics of myth.

Barthes notes that 'if one wishes to connect a mythical schema to a general history, to explain how it corresponds to the interests of a definite society – in short, to pass from semiology to ideology' (ibid.; p. 138), it is necessary to become a semiologist and to understand 'the very principle of myth: it transforms history into nature' (ibid.; p. 140). As with his analysis of French classical writing, Barthes argues that myth has to be understood in terms of the way it functions to transform that which is socially particular (the interests of the bourgeois class) and historically specific (the structure of capitalist societies) into something which is natural and inevitable, about which nothing can be done because it has always been the case (for example, '*The French Empire? It's just a fact*'), when it is in fact an historically specific structure of imperial power.

I shall try to illustrate this point about the function of myth in a moment. What has to be noted here is that one consequence of Barthes's idea that myth serves to naturalise history is how this process is seen to influence consumers by naturalising their reactions to the myth:

what allows the reader to consume myth innocently is that he does not see it as a semiological system but as an inductive one . . . the signifier and the signified have, in his eyes, a natural relationship . . . any semiological system is a system

of values; now the myth-consumer takes the signification for a system of facts: myth is read as a factual system, whereas it is but a semiological system.

(ibid.; p. 142)

Although myth is not an unconscious process, its consumers, according to Barthes, take it at face value, and accept it as natural and inevitable. They need semiology to tell them that myth is a system of meaning which cannot be taken for granted. The semiological interpretation of myth proceeds on the assumption that readers will understand myth in the way the theory presumes they will. It does not therefore take account of how people actually interpret myth, for if myths are so effectively mystifying, how can they be so easily demystified?

Bourgeois men and women novelists

In a later work, *Elements of Semiology*,⁹ Barthes refined his understanding of the relationship between the signifier, the signified and myth by drawing a distinction between denotation and connotation. On one level, the meaning of popular cultural signs is selfevident. They are what they are or what they appear to be, an advert, a photo of a black soldier, a bunch of roses and so on. In other words, they denote something to us, they present it to us as a matter of fact: this is a photo of a soldier, an advert, a bunch of roses. Denotation refers to those things which appear to us as natural and which we can take for granted.

But the task of semiology is to go beyond these denotations to get to the connotations of the sign. Doing this reveals how myth works through particular signs. In this way, the constructed, manufactured and historical location of the myth can be discovered. The connotations of myths can thus be identified: this may appear to be a bunch of roses but it connotes passion; or this may appear to be a photo of a black soldier saluting the French flag, but it really connotes the grandure and impartiality of French imperialism. The methods of semiology reveal the ideologies contained in cultural myths. Barthes is concerned with the role of myth in modern society, how it is constructed and sustains meaning as a systematic force. His intention is to get behind the process of mythical construction in order to reveal the real meanings which are distorted by myth. This involves moving from meanings that are taken for granted, which make things appear natural and inevitable, to meanings that are rooted in historical circumstances and class interests, moving, as he puts it, 'from semiology to ideology' (1968; p. 139). Although there is a great deal of novelty and interest in Barthes's notion of semiology, his conception of ideology seems to be more consistent with cruder Marxist versions of the concept in that the myths of popular culture are viewed as serving the interests of a bourgeois class. I shall look at this theory in the next chapter, but it is useful to see what Barthes has to say about the issue.

It is characteristic of bourgeois ideology, according to Barthes, to deny the existence of a bourgeois class. He writes: 'as an ideological fact, it completely disappears: the bourgeoisie has obliterated its name in passing from reality to representation, from economic man to mental man' (1973; p. 150). This is a class with no name because myth functions as ideology to ensure that it is not named. For example, the myth of the nation guarantees the anonymity of the bourgeoisie by representing everyone as citizens. This is part of the more general tendency for bourgeois ideology to focus upon the figure of universal 'man', thereby dissolving the reality of social classes: 'the fact of the bourgeoisie becomes absorbed into an amorphous universe, whose sole inhabitant is Eternal Man, who is neither proletarian nor bourgeois ... the whole of France is steeped in this anonymous ideology ... is dependent on the representations which the bourgeoisie has and makes us have of the relations between man and the world' (ibid.; pp. 153 and 152).

Barthes is therefore led to the conclusion that the function of myth as ideology is defined by the fact that bourgeois ideology lies at the very heart of myth in modern society. 'The flight from the name "bourgeois", Barthes writes:

is not therefore an illusory, accidental, secondary, natural or

insignificant phenomenon: it is bourgeois ideology itself, the process through which the bourgeoisie transforms the reality of the world into an image of the world, History into Nature. And this image has a remarkable feature: it is upside down. The status of the bourgeoisie is particular, historical: man as represented by it is universal, eternal.

(ibid.; p. 154)

This allows Barthes to fill out his understanding of myth. Myth transforms history into nature, which is exactly the function of bourgeois ideology. Myth thus facilitates the tasks of bourgeois ideology. It becomes 'possible to complete the semiological definition of myth in a bourgeois society: *myth is depoliticized speech*' (ibid.; p. 155). Politics is here understood in its wider sense of the totality of power relations, and myths are said to vary in the extent to which they are political. None the less, Barthes sees politics as being central to the understanding of myth because it accounts for the transformation of the historical into the natural. Since this is precisely what bourgeois ideology does, myth has to be conceived of as the outcome of the interests of the bourgeois class.

Barthes conducts a similar analysis of gender, and we can use this example to conclude our exposition of semiology. Yet again he takes as an example a photo in a magazine. Since the signs of popular culture are, at first sight, self-evident and all around us, we don't have to look very far for examples of how myths work. For Barthes, it is partly because modern bourgeois society is flooded with cultural signs that semiology is so important. This time his example is of a photo of seventy women novelists. What is interesting from Barthes's point of view is the fact that these women are also identified by the number of children they have. The photograph and its caption denote a group of women writers who are also mothers. The connotation is, however, what interests Barthes and he identifies this as the attempt, by the conjunction of women novelists and mothers, to make the role of women as mothers appear to be primary, natural and inevitable, whereas it is in fact historically and culturally specific. Women may succeed in being novelists, but the connotations of the photo and caption distort

this to imply that women are much more fundamentally and naturally concerned with motherhood. Equally the photo and caption can be seen as the signifier, the signified of which is the natural role of women to be mothers, irrespective of whatever else they do or aspire to, such as being novelists.

Barthes interprets this myth in terms of

the eternal statute of womanhood. Women are on the earth to give children to men; let them write as much as they like; let them decorate their condition, but above all, let them not depart from it... Let women acquire self-confidence: they can very well have access, like men, to the superior status of creation. But let men be quickly reassured: women will not be taken from them for all that, they will remain no less available for motherhood by nature.

(ibid.; pp. 56-57)

Myth is again seen by Barthes to function by transforming history into nature. This time the role of women as mothers is made to appear natural and inevitable, the related connotation being that the power and dominance of men is equally natural and inevitable. The myth exhorts women as follows: 'Love, work, write, be business-women or women of letters, but always remember that man exists, and that you are not made like him; your order is free on condition that it depends on his; your freedom is a luxury, it is possible only if you first acknowledge the obligations of your nature' (ibid.; p. 58).

Structuralism and semiology: some key problems

I have already hinted at some of the problems these perspectives face, particularly in my outlines of the arguments of Saussure and Eco. I now want to clarify these problems by looking at some of the criticisms that can be made of Lévi-Strauss's structuralism and Barthes's semiology.

Lévi-Strauss's structuralism

A familiar complaint about Lévi-Strauss's ideas concerns their lack of empirical validity.¹⁰ A number of related criticisms can be made here. It can be claimed that Lévi-Strauss's theories are supported by a highly selective and very partial use of examples, that they are simply not based upon sufficient evidence or that they are so constructed as to be impervious to any kind of empirical refutation. These claims may appear strange in that Lévi-Strauss's work is full of examples, but critics insist that these are only admitted if they are favourable to his case, and if they divert attention away from cases which might refute his theories. For example, his analysis of totemism is only possible because he confines this phenomenon to the study of myth, and does not consider how it works in relation to kinship systems. Also, his analysis of Oedipal myths is only successful because he selects those features of the stories which suit his case, and ignores others which contradict the notion that they are expressions of a universal mental structure. Related to this is the criticism that the myths he refers to cannot be interpreted in the logical manner he suggests, but must be understood in terms of the way they function in specific historical societies.

The claim that Lévi-Strauss ensures his theories are closed to empirical refutation is closely linked to the criticism that his ideas are overly abstract and theoretical. His concern with the mental structure which lies behind the myths he studies leads him to engage in cerebral exercises rather than empirical research. More than this, his notion of structure can be regarded as too abstract, its very abstractness allowing him to reach the conclusions he does. The more abstract an idea is, the more vague it is, and thus the more closed it is to empirical refutation. The abstractness of his notion of structure is equally related to its definition as a mental or psychic phenomenon. Lévi-Strauss's structuralism is marked by idealism and reductionism in that the variety and complexity of myths are reduced to the mental structure of the human mind. There are said to be two problems with his argument. First, it neglects the material processes of production whereby societies reproduce themselves, and thereby reproduce their cultures. Second, it neglects the complexity and historical and social specificity of cultural phenomena because it reduces it all to a simple mental structure. It thus fails to provide an adequate explanation of this complexity and specificity, and cannot account for the things which it is trying to explain except by ignoring their specific character.

Another way of appreciating this problem is to look at the claim that structuralism presents an ahistorical approach to the study of culture. We have already seen how Saussure distinguishes between synchronic and diachronic analysis. We have also seen how difficult it is to maintain this distinction in practice: it is difficult both to disentangle the uses of language over time from the formal rules which are used by speakers at any particular point in time, and to treat such rules as simply static and fixed norms. With Lévi-Strauss's work we confront this problem more directly in that he does not appear to recognise this distinction. His almost exclusive concern appears to be with synchronic analysis, uncovering the hidden and unconscious mental structure which gives rise to the myths we can observe. Insofar as his work dispenses with history, it confronts the same kind of difficulties experienced by Saussurian linguistics. Downplaying the importance of history means that the problems posed for any analysis of popular culture by historical variations in societies and cultures are simply not addressed. Indeed, it could be argued that it is impossible to understand the formal structures of language or myth outside of their social and historical contexts.

These problems are linked to the deterministic view structuralism has of the role of the subject or human agency. The major determinant of cultural myths is the logical structure of the human mind, and this exerts its power irrespective of any particular social or historical context. This means it must also exert its power irrespective of the efforts of human subjects to impose their meanings on their social world, and to attempt to alter them in different ways. Just as it is impossible to understand culture without taking its history into account, so it is equally impossible to understand it without taking account of human agency. Culture is produced, consumed and interpreted in definite social and historical circumstances, and these processes involve human agency and human intentions, the attribution and transformation of meaning, which cannot be spirited away at the mere mention of a universal structure. The variations in meaning entailed in the production and consumption of culture tend not to support the contention that fixed and immutable universal oppositions make cultural myths possible. The very fact that meanings can be contested suggests that the importance of the human subject cannot be so easily dismissed as structuralism argues. Rather, human agency has a leading part to play in any attempt to develop the study of popular culture. This may not aspire to the systematic qualities demanded by structuralism, but it is more in keeping with the empirical character of popular culture.

The problems structuralism has in dealing with the role of human agency can equally be detected in the importance Lévi-Strauss ascribes to the unconscious in his explanations. As we have seen, the mental structure exerts its power irrespective of the role of subjects who are unaware of what is happening. This raises questions about the empirical validity of this argument. How is it possible to validate the causal influence of something which is unconscious? If the mental structure remains unconscious we must presumably remain unaware of it, and cannot therefore talk about it in any meaningful empirical sense? Alternatively, if we can claim to demonstrate its existence how can it be unconscious?

Lastly, we can indicate the analytical difficulties associated with Lévi-Strauss's understanding of the binary opposition between nature and culture. He sees this as a basic logical opposition lying behind, and causing, the temporary reconciliations between nature and culture to be found in myths like totemism. Yet how clear and basic is this opposition? How can it be conceived of as a component of a universal mental structure lying outside specific societies and cultures, when it can only be defined in cultural terms? The concept of nature within particular societies is not 'natural' but something which is culturally defined. Lévi-Strauss does refer to the ways in which the distinction between nature and culture varies between societies, for example with respect to definitions of edible and inedible food (1970). However, rather than trying to account for this in comparative historical and sociological terms, he reduces it to an invariant mental structure. Clearly all societies are confronted by a nature which they have to deal with. Therefore their cultural definitions of nature can be seen as the ways they understand nature and make it meaningful. Nature can never therefore be 'innocent'; it exists as a reality which is interpreted by a society's culture. This proposition is in keeping with the arguments of semiology, which does not appear to deny the importance of culturally specific definitions of categories like nature and culture.

Roland Barthes's semiology

It can be suggested that the version of semiological analysis developed by Barthes is preferable to structuralism since it is historical in scope, and tries to relate the signs of popular culture to social forces and class interests. Barthes's approach has had a crucial influence upon popular culture studies, and yet it faces certain problems which I wish to consider in closing this chapter.¹¹

For a start, it is hard to say whether Barthes's analyses of myth fare any better than those of Lévi-Strauss when it comes to the problem of empirical validation. While semiology, like structuralism, is presented in principle (at least in Barthes's earlier work) as a rigorous scientific method, this is not carried over into its practice. What validity does Barthes's interpretation of a particular cultural item possess? He does not attempt to indicate why his interpretation is to be preferred to others. For example, he suggests that roses signify passion. But how can he validate this conclusion, and say they should be understood in this way, and not as a way of signifying a joke, a farewell, or a platonic thank you? How do we discriminate between these interpretations? What evidence could a semiologist call upon to back up Barthes's interpretation? Similarly, semiologists are fond of referring to the codes which lie behind, or are embodied in, a particular sign or myth, but rarely if ever produce evidence of this code independently of the sign or myth under consideration. The fact that, later on, Barthes argues that texts are polysemic in being open to different interpretations hardly gets us very far.¹² He is not presumably

arguing that texts are open to an infinite number of interpretations, nor that all interpretations are equally accceptable. So why should one interpretation be preferred to another? And why should some interpretations of signs be rejected?

This lack of attention to empirical validation is evident in another problem with semiology, which concerns the attribution of meaning to myths. Reading Barthes, it is difficult not to be persuaded by the style and polish of his arguments. Yet there is little effort on his part to be empirically persuasive, so it is necessary to be sceptical about the claims he makes. One of the aims of semiology is to show how the meaning attributed to a particular myth is systematic and not arbitrary. But it can be argued that the opposite is the case. Semiology wants to demonstrate that the meanings uncovered by its approach are systematic in that they possess a comprehensive structural form and are prevalent within the society in which the myth is found. However, if the analysis is confined to the sign itself and the problem of empirical validation is ignored, it is difficult to see how this claim can be substantiated. How do we know, for example, that the conclusions offered by semiology are not the result of the subjective impressions of the analyst but an objective uncovering of the systematic structure of meaning? Indeed, is semiology better viewed as a form of textual appreciation or literary criticism than as an objective social science?

Perhaps a brief example will clarify this point. Williamson has tried to apply semiology to the analysis of magazine advertisements, and in her first analysis of an advert in her book, one for car tyres showing a car on a jetty, she writes:

the jetty is supposedly here as a test of braking power; it provides an element of risk.... However, the significance of the jetty is actually the opposite of risk and danger ... the outside of the jetty resembles the outside of a tyre and the curve is suggestive of its shape ... the jetty is tough and strong ... because of the visual resemblance, we assume that this is true of the tyre as well. In the picture, the jetty actually encloses the car, protectively surrounding it with solidity in the middle of dangerous water; similarly, the whole safety

124

of the car and driver is wrapped up in the tyre, which stands up to the elements and supports the car.

(Williamson: 1978; p. 18)

This analysis is dependent upon the idea that the jetty represents a place which is strong and safe, and that this is an expression of a wider cultural code. How else could the signification of the jetty work? But why should we assume that people will regard a jetty as a place of safety no matter how strong and secure it may appear? In fact, Williamson's attribution of meaning, which equates the jetty with safety, is totally arbitrary. Accordingly, the implication that it is indicative of a cultural code is unfounded.

There are some related problems associated with the semiological analysis of popular culture. Much is made of Barthes's distinction between denotation and connotation. It is argued that myth works because we see the denotations of a particular sign or myth but its connotations remain hidden until they are revealed to us by a semiologist. Yet is there such a thing as pure denotation? Are not the connotations of a sign as clear, if not sometimes more clear, than its denotations? It can be argued that significations like adverts, photos or roses never exist as simple denotations but are always overlain by some kind of cultural interpretation. In this sense, they never lack meaning. Formally it is possible to define signs in a technical or denotative manner; but signs always exist in some kind of social context and are always available to some kind of interpretation. Moreover, in so far as interpretations of signs are offered in terms of their connotations, without being backed up by independent evidence, there is no reason why the connotations of a particular sign should not be readily apparent. After all, Barthes sits down in the hairdressers, sees the photo of the soldier on the cover of a magazine and quickly works out its connotations. The connotations of myths are more contestable than Barthes realises, but what we are concerned with here is the fact that the connotations of cultural signs and myths may not be so hidden or as difficult to discern as semiologists argue.

As I indicated above, a major problem with the semiological study of signs is the way it neglects the contexts in which signs are

used as forms of communication. The question raised here is whether signs can be adequately understood if they are divorced from the contexts in which they are used and interpreted. For example, how can we know that a bunch of roses signifies passion unless we also know the intention of the sender and the reaction of the receiver, and the kind of relationship they are involved in. If they are lovers and accept the conventions of giving and receiving flowers as an aspect of romantic, sexual love, then we might accept Barthes's interpretation. But if we do this, we do so on the basis not of the sign but of the social relationships in which we can locate the sign. Moreover, if we accept the interpretation of the sign Barthes proposes, and he makes no attempt to indicate the social relationships in which it is to be found, how do we know that intentions and relationships are involved which do not concern passion? The roses may also be sent as a joke, an insult, a sign of gratitude, and so on. They may indicate passion on the part of the sender but repulsion on the part of the receiver; they may signify family relations between grandparents and grandchildren rather than relations between lovers, and so on. They might even connote sexual harrassment. The point here is that it is impossible to interpret signs adequately unless their contexts of use, and the social relationships which confer meaning upon them, are taken into consideration. Semiology does not recognise that meaning is not a quality of the sign itself but of the social relationships in which it can be located.

This point about the social context of signs can be taken further if it is defined a bit more precisely. For a start, signs are implicated in social relationships in that they have to be produced in order to be culturally available as signs. It is a familiar complaint about semiology that it ignores the context of production. Cultural signs, like magazines, are produced by industries on the basis of their marketability and profitability. They are among the commodities which are produced, circulated and consumed in a capitalist society. In view of Barthes's understanding of the bourgeois interests served by the ideology to be discovered in cultural signs, it might appear to be the case that his semiology is not incompatible with this Marxist perspective. However, for the latter it is the way production generates meaning which is crucial rather than the decoding of signs, which ignores the context of industrial production. This problem is, in part, dealt with by introducing the concept of encoding. The idea here is that cultural producers consciously or unconsciously (usually the latter) instill meanings into cultural products which are then decoded or interpreted by audiences in relatively diverse and independent ways which are none the less, in the final analysis, in keeping with some general dominant ideology. The concepts of semiology are used to render the Marxist theory of ideology less deterministic and instrumental. However, this still tends to underestimate the ways in which what is produced is itself subject to conflicts and negotiations, and how the meanings produced may not be uniform, consistent, unambiguous or reducible to a coherent dominant ideology.¹³

This, in turn, raises the issue of the decodings made of signs by the people at which they are directed. The basic question here is why should the interpretation of signs and myths offered by semiology be accepted if they take no account of the interpretations placed upon them by their audiences? On what grounds can semiologists argue that their understanding of popular cultural signs is adequate if it neglects those groups who consume these signs. In part, this relates back to the fact that semiology fails to tackle the problem of justifying empirically its interpretations. In part, it also relates to the fact that semiology neglects the social relationships in which signs are produced and consumed. But it equally concerns how the meaningful character of popular culture can be determined. It would seem to me to be the case that this cannot be done without researching the part that audiences play in arriving at interpretations of forms of popular culture. These forms cannot possess any level of social meaning unless the meanings generated by audiences are taken into account. If a text has no audience, how can it have any meaning? It is only the fact that popular culture attracts audiences which gives it sociological importance.

I have indicated how, in my view, Barthes has a fairly crude view of ideology. He sees it as functioning in the interests of the bourgeoisie. It is this theory which introduces the concept

STRUCTURALISM AND SEMIOLOGY

of ideology into semiological analysis since the connotations and signifieds of signs are, in the end, reduced to bourgeois ideology.¹⁴ To appreciate the problematic character of this concept of ideology it is necessary to take into consideration the arguments of the next chapter.

Further reading

- Barker, M. (1989) Comics: Ideology, Power and the Critics, Manchester, Manchester University Press (chapters 6 and 7).
- Barthes, R. (1968) Elements of Semiology, New York, Hill and Wang.
- ----- (1973) Mythologies, London, Paladin Books.
- Craib, I. (1984) Modern Social Theory, London and New York, Harvester Wheatsheaf (chapter 7).
- Culler, J. (1983) Barthes, London, Fontana.
- Dyer, G. (1982) Advertising as Communication, London and New York, Methuen (chapter 6).
- Fiske, J. and Hartley, J. (1978) Reading Television, London and New York, Methuen.
- Leach, E. (1970) Lévi-Strauss, London, Fontana.
- Lévi-Strauss, C. (1969) Totemism, Harmondsworth, Penguin.
- Sturrock, J. (ed.) (1979) Structuralism and Since, Oxford, Oxford University Press.
- Woollacott, J. (1982) 'Messages and meanings', in M. Gurevitch et al. (eds), Culture, Society and the Media, London, Methuen.

Chapter 4

Marxism, political economy and ideology

Marx and ideology	130
Marxism and political economy	136
The limits of political economy	142
Althusser's theory of ideology and	
structuralist Marxism	146
Althusser's Marxism: economic	
determinism and ideology	155
Gramsci, Marxism and popular	
culture	160
Gramsci's concept of hegemony	165
Conclusions: Marxism, Gramscian	
Marxism and popular culture	171
	Marxism and political economy The limits of political economy Althusser's theory of ideology and structuralist Marxism Althusser's Marxism: economic determinism and ideology Gramsci, Marxism and popular culture Gramsci's concept of hegemony Conclusions: Marxism, Gramscian

129

I N THIS CHAPTER I want to assess critically the contribution that contemporary Marxism has made to the sociology of popular culture. This will involve looking at the approaches suggested by writers working with differing ideas about the value of Marxism.¹ In particular, I will consider those perspectives on the study of popular culture which have emerged from within the Marxist tradition in the last thirty years or so. These include the Marxist theory of political economy, the Marxist structuralist theory of ideology associated with the work of Althusser, and the concept of hegemony derived from the writings of Gramsci.

Before going on to look at these approaches, it may be useful to say a few words about Marx's ideas on ideology.² This may help us to recognise those aspects of Marx's work which appear to have influenced the subsequent attempt to develop a Marxist analysis of ideology, for it is in terms of the notion of ideology that Marxism usually tries to understand popular culture.

Marx and ideology

Marx (1818–1883) does not appear to have laid down a very clear definition of ideology, just as he never really defined social class, and he does appear to have had different conceptions of ideology as his ideas progressed and changed. This does not mean, however, that his work cannot be used to analyse ideology. There are a number of ways in which Marx talked about ideology. One of these, based on the theory of commodity fetishism, has already been outlined in the chapter on the Frankfurt School. The first approach I want to consider here rests upon the notion that the dominant ideas in any society are those which are formulated by the ruling class in order to secure its rule. In one of his earliest treatments of ideology in *The German Ideology* (originally published in 1845/46), Marx wrote as follows:

The ideas of the ruling class are, in every age, the ruling ideas: i.e. the class, which is the dominant *material* force in society, is at the same time its dominant *intellectual* force. The class which has the means of material production at its disposal, has control at the same time over the means of mental production, so that in consequence the ideas of those who lack the means of mental production are, in general, subject to it ... the individuals composing the ruling class ... rule also as thinkers, as producers of ideas, and regulate the production and distribution of the ideas of their age. Consequently their ideas are the ruling ideas of the age.

(1963; p. 93)

This passage clearly suggests that the predominant ideas common to a capitalist society, including its popular culture, are those of the ruling class. These ideas have to be produced and disseminated by the ruling class or its intellectual representatives, and they dominate the consciousness and actions of those classes outside the ruling class. Whatever other ideas the latter may have or profess to, it is the ideas of the ruling class which are the ruling ideas, although they may not be the only ideas in circulation. It also implies that if the working class is to oppose the ruling capitalist class successfully it must develop its own ideas and its own means of producing and distributing them. This will enable it to combat the ideas of the ruling class, a notion which feeds into the concept of hegemony. This perspective on ideology stresses the role of human agency and struggle. The ruling class constructs and circulates ideas which secure its power because they dominate the minds of the working class. However, this class, as a result of its material conditions of exploitation and oppression, will engage in struggles against the ruling class by producing its own ideas, as well as its own industrial and political organisations. This position holds to the theory that a dominant ideology, the ideology of the ruling class, enables the ruling class to rule by controlling the consciousness of the working class and those other groups outside the ruling class who are subject to its ideas.

Murdock and Golding attempt to adapt Marx's view of ideology for a political economy approach to the analysis of the mass media (1977). They argue that Marx's statement in *The German Ideology* entails three empirical propositions which they show can be satisfactorily validated: that the production and distribution of ideas is concentrated in the hands of the capitalist owners of the means of production; that therefore their ideas receive much greater prominence and hence dominate the thoughts of subordinate groups; and that therefore this ideological domination serves to maintain the prevailing system of class inequalities which privileges the ruling class and exploits the subordinate classes.

However, quite apart from the theory of commodity fetishism, Marx seemed also to have a distinct and deterministic conception of the place of ideology in the overall structure of capitalist societies. This is commonly known as the base–superstructure model. The base of a society is its mode of material production, the ways, usually economic, whereby it reproduces itself materially, and the source of exploitative class relations. It determines the superstructure of a society, its political and ideological institutions, the social relations and sets of ideas that lie outside the base, like the family, the state, religion, education and culture.

In what has been taken as one of the most succinct and programmatic statements of his approach (*Preface to a Contribution* to the Critique of Political Economy, originally published in 1859), Marx writes:

I was led by my studies to the conclusion that legal relations as well as forms of State could neither be understood by themselves, nor explained by the so-called general progress of the human mind, but that they are rooted in the material conditions of life ... that the anatomy of civil society is to be sought in political economy.... The general conclusion at which I arrived and which, once reached, continued to serve as the guiding thread in my studies, may be formulated briefly as follows: In the social production which men carry

132

on they enter into definite relations that are indispensable and independent of their will; these relations of production correspond to a definite stage of development of their material powers of production. The totality of these relations of production constitutes the economic structure of society – the real foundation, on which legal and political superstructures arise and to which definite forms of social consciousnesss correspond. The mode of production of material life determines the general character of the social, political and spiritual processes of life. It is not the consciousness of men that determines their being, but, on the contrary, their social being determines their consciousness. At a certain stage of their development, the material forces of production come in conflict with the existing relations of production, or . . . with the property relations within which they had been at work before.... Then occurs a period of social revolution. With the change of the economic foundation the entire immense superstructure is more or less rapidly transformed ... the legal, political, religious, aesthetic or philosophical - in short, ideological - [become the] forms in which men become conscious of this conflict and fight it out.

(1963; pp. 67–68; my emphasis)

This would appear to be a fairly straightforward statement of a theoretical position, even if it is a bit abstract and assertive. It rests upon a distinction between the real material, economic foundations of a society, and its secondary and derivative superstructure of ideological forms which arise upon and are determined by the foundations. Yet it has long occupied the attention of Marxists and their critics alike.

While there are evident differences between this perspective on ideology and that offered in *The German Ideology*, Murdock and Golding none the less incorporate it into their conception of a political economy of the mass media. Since Marx offers this statement as an outline of a political economy of civil society, it can be taken to include the modern media. Murdock and Golding therefore find no difficulty in combining Marx's ruling ideas and base-superstructure models of ideology. In referring to the passage I have just cited, they argue:

Marx is concerned to emphasize the fact that the system of class control over the production and distribution outlined in *The German Ideology* is itself embedded in and conditioned by the fundamental dynamics underpinning the capitalist economy. Hence, an adequate analysis of cultural production needs to examine not only the class base of control, but also the general economic context within which this control is exercised.

(1977; p. 16)

They take the view that Marx is not an economic determinist. They suggest, first, that his sense of causation is not rigidly deterministic but one 'of setting limits, exerting pressures and closing off options', a notion of autonomy within the general limits set by 'the economic relations of capitalism'. Second, they argue that Marx's understanding of the relation between the base and superstructure is a dynamic one, necessitating concrete and historical analyses of capitalism (ibid.; pp. 16–17).

It seems to me, however, that these points do not resolve the problem as suggested. To say the relation between base and superstructure is dynamic does not prevent it from being defined in rigid and deterministic terms. The dynamic can be continually determined by the economic base. Moreover, if the historical nature of capitalism cannot be theorised in advance of its concrete examination how can we, on the one hand, know that cultural autonomy must always operate within, and never go beyond, economic limits; and, on the other hand, accept the base–superstructure distinction as a theory of sociological causation in advance of historical research.

As Murdock and Golding note, there is clear evidence that Marx may not have wished to put forward an overly deterministic view of the relation between the economic base of societies and their political and ideological superstructures. Compare the above statement from Marx, for example, with this one taken from the third volume of *Capital*:

134

The specific economic form in which unpaid surplus labour is pumped out of the direct producers, determines the relation of domination and servitude, as it emerges directly out of production itself and in turn reacts upon production. . . . It is always the direct relation between the masters of the conditions of production and the direct producers which reveals the innermost secret, the hidden foundation of the entire social edifice. . . . This does not prevent an economic basis, which in its principal characteristics is the same, from manifesting infinite variations and gradations, owing to the effect of innumerable external circumstances, climatic and geographical influences, racial peculiarities, historical influences from the outside, etc. These variations can only be discovered by analysing these empirically given circumstances.

(1963; p. 113)

This passage clearly adds substance to Murdock and Golding's interpretation of Marx's theory, but it could equally be seen as a sign of the difficulties and inconsistencies which his theory has to confront. It argues that the economic relations of capitalism determine the other social relations to be found in these societies. They provide the foundations or the base for the rest of society. Yet innumerable, incidental and seemingly small-scale (from a Marxist viewpoint) influences can give rise to 'infinite variations and gradations' although the economic form remains the same. This hardly attests to the rigour of the base-superstructure model. The superstructure, assuming it includes 'innumerable, external circumstances', is now argued to be subject to infinite variations which do not derive from the base. The last statement cited is not even talking about 'autonomy within limits', since the possibilities for superstructural variations with the same economic base are infinite.

If the base-superstructure model is to be plausible the limits set by the base must be real and definite in terms of the superstructure it gives rise to. This means, in turn, that superstructural variations must be limited and finite, otherwise why argue that they are determined by the economic base? However, this defence can only be made from a position of economic determinism. If the economic base does not determine the superstructure then what significance can the distinction have? Even if the relationship is conceived of in terms of the limits set by the economic base upon the superstructure, how can it be the case that what is fundamentally the same economic base be associated with innumerable and infinite variations? This suggests that the theory is in effect bound to lose its explanatory power. Moreover, far from encouraging the study of economic relations, Marx appears to endorse the study of everything under the sun, for how else can we understand the infinite variations undergone by the superstructure in capitalist societies?

This, it seems to me, identifies the fundamental problem with Marxism. It either adopts an economic determinist position which is theoretically consistent but sociologically dubious and historically inaccurate. Or it claims that the economic base sets limits to the superstructure, or suggests that there is some sort of reciprocal interaction between the two. The latter responses are more realistic, although they no longer need the concepts of base and superstructure. However, they lose any distinctiveness Marxism may possess. As Williams points out, the base–superstructure model is limited as an approach to the study of culture:

What is fundamentally lacking ... is any adequate recognition of the indissoluble connections between material production, political and cultural institutions and activity, and consciousness ... [these] are in practice indissoluble: not in the sense that they cannot be distinguished for purposes of analysis, but in the decisive sense that these are not separate 'areas' or 'elements' but the whole, specific activities and products of real men.

(1977; p. 80)

Marxism and political economy

While I have already expressed some of my misgivings about Marx's ideas, there is little doubt that his work can be used to

136

develop a political economy approach to the analysis of the mass media and popular culture. One example of this which I wish to consider is the political economy perspective put forward by Murdock and Golding.³ As we have seen, they try to combine the ruling ideas and base–superstructure models with empirical research in attempting to argue the case for this perspective.

One of the starting-points for their argument is the contention that the sociology of class has failed to come to grips with the role of the mass media. Sociology is concerned with the persistence of class inequalities but does not realise how significant the mass media are in legitimating inequalities in wealth, power and privilege. The media make inequalities appear natural and inevitable to those who suffer the deprivation and oppression they entail. The subordinate classes gain most of their knowledge of the world from the mass media. Since control of this flow of knowledge, information and social imagery is concentrated in the hands of those who share in the power, wealth and privilege of the dominant class, this ruling class will ensure that what is socially circulated through the mass media is in its interests and serves to reproduce the system of class inequalities from which it benefits. The mass media are crucial in relaying information, knowledge and imagery throughout contemporary capitalist societies. Their structure of ownership and control is thus equally crucial.

Murdock and Golding are equally critical of those approaches, like the Frankfurt School or semiology, which exaggerate the autonomy of cultural forms. According to Murdock and Golding, this neglects the fundamental influence exerted by the material production of popular culture, and the economic relations within which this production takes place. They argue that these approaches analyse cultural forms in isolation from the social relations in which they operate, and so fail to carry out concrete historical analyses of the economic production of culture. They cite Adorno's assumption that the popular music industry in America could be studied and understood simply by investigating its products without looking at how capitalist industry actually produces music (1977; pp. 18–19). Likewise, the same kind of criticism can be levelled at semiology. Of course, Murdock and Golding share with Adorno the view that capitalist societies are held together, and the dominance of their ruling classes guaranteed, by the ideology spread by the mass media, which ensures social and political acquiescence on the part of their populations.

The primary concern of Murdock and Golding's approach lies in the ownership and control of the mass media and cultural production. They start from the questions raised by Marx, and launch upon a 'concrete analysis of the economic formations and process that underpin the contemporary communications industry' (ibid.; p. 20). The mass media serve to reproduce class inequalities. If it can therefore be shown that the ownership and control of the mass media is concentrated in the hands of a ruling class, then this will account for the fact that the media function in this way. They argue that empirical research shows that the ownership and control of the mass communication industries is concentrated in the hands of relatively small groups of powerful economic and financial interests. It thus tends to support the ruling ideas model put forward by Marx in *The German Ideology*.

While Murdock and Golding wish to substantiate empirically Marx's ruling-class ideas model, they are equally critical of tendencies within Marxist and radical theory. In particular, they oppose what they see as 'crude and oversimplified' accounts of the relationship between the ruling class's ideology, the ideas and values of the owners and controllers of the mass communications industries, and what appears in the products of the mass media. the ideas and values that circulate as popular culture. Crude and simplistic versions tend to view this relationship as a very direct and immediate one. They suggest that the mass media act simply as vehicles and outlets for ruling-class ideology which automatically ensures the desired acquiescence of subordinate groups to ruling-class domination. This sort of theory is usually supported by evidence based either on ownership and control or on textual analyses of media output. However, Murdock and Golding wish to see the relationship between ownership and control, and mass media output, that is between class power and popular culture, or between ruling class ideas and the dominant ideology, as an

indirect and mediated one. Mass media 'institutions do play important roles in legitimizing an inequalitarian social order, but their relationship to that order is complex and variable and it is necessary to analyse what they do as well as what they are' (ibid.; p. 34).

'By concentrating on the economic base', Murdock and Golding argue, 'we are suggesting that control over material resources and their changing distribution are ultimately the most powerful of the many levers operating in cultural production. But clearly such control is not always exercised directly, nor does the economic state of media organizations always have an immediate impact on their output' (ibid.; p. 20). In keeping with this aim of avoiding a crude and simplistic economic determinism, the case for a political economy of the media and culture is advanced in three main ways: by looking at instances in which, at first glance, the logic of economic determinism does not appear to be important, but in which it can in fact be shown to operate; by demonstrating empirically the extent to which the ownership and control of the mass communication industries has become concentrated in the hands of a capitalist class; and by assessing the consequences of this for the consumer markets in media and cultural products. Let us take each of these in turn.

One type of media institution which does not appear to obey the logic of economic determinism is public sector broadcasting. This is represented in Britain by the BBC which is supposed to provide a media culture which enlightens and educates as well as entertains. Because this service is funded by a licence fee and not by the prices its products can command on the market, it is not obviously subject to capitalist economic pressures. Public service not private profit is said to determine what gets produced. However, Murdock and Golding argue that state media institutions like the BBC have in practice to operate as if they were commercial enterprises and not public services. They have to go to Parliament in order to persuade governments to maintain or raise their licence fee. To do this, they have to be able to demonstrate that they are being run efficiently. In the absence of evidence on profits or markets, they have to show that they are cost effective and do not run huge deficits or waste money. They also have to prove they are providing a service which people want, while catering for various minority interests. Like commercial television and radio, they have to compete for larger audiences and become involved in ratings wars. For Murdock and Golding, this underlines 'the importance for an understanding of cultural production of its material base and economic context' (ibid.; pp. 22–23). They do not refer to production or ownership and control in making this case, but rather stress the role of political and market forces.

The central point of their argument, however, is the changing structure of the ownership and control of the mass media. They argue that the ownership and control of the means of production have become concentrated into the hands of a relatively small number of very large corporations. The evidence thus tends to support Marx's ruling ideas model. Murdock and Golding indicate this increasing level of concentration empirically by the proportion of the market controlled by the largest five firms in different industrial sectors, including the communication and leisure industries. This concentration also occurs across sectors, in that the largest concerns hold controlling positions in several sectors of the culture industry simultaneously. Increasing concentration therefore occurs alongside increasing conglomeration. They argue that the evidence indicates that the owners of the means of production continue to exercise high degrees of control over both production and distribution. The culture industry conglomerates are found to be associated with wider industrial and financial concerns, and they contend that these groups form a coherent class with key interests in common.

They therefore conclude that their overall theroretical perspective and the theory put forward by Marx in *The German Ideology* are vindicated.

Taken together, [the existing studies] suggest not only that control over the key processes of resource allocation is still significantly tied to ownership but that the owning group continue to constitute an identifiable class with recognizable interests in common. This in turn suggests that Marx's definition of the situation in *The German Ideology* continues not only to pose relevant questions but also to provide a pertinent general framework within which to begin looking for answers. Indeed, far from having been overtaken by history, Marx's propositions have, if anything, been rendered more relevant by recent developments in the structure of capitalism.

(ibid.; pp. 32–33)

This is finally related to a brief account of cultural production.

Stressing what they call a 'sequential logic' which insists on 'examining economic structures prior to their cultural products' (ibid.; p. 36), they note the lack of studies which examine the dominant ideology lying behind media imagery in terms of an analysis of economic forces. They argue that the emphasis upon consumerism within popular culture tends to mask the realm of production and class inequalities, and they see their own analysis of changes in the structure of ownership and control as indicating certain consequences for cultural production. First, 'the range of material available will tend to decline as market forces exclude all but the commercially successful' (ibid.; p. 37). Second, this exclusion will be systematic since it will tend to cover those 'voices lacking economic power or resources' (ibid.). Those with most economic power will be able to improve their market position, and ensure that the media products least critical of the class structure will survive, and those most critical will not. This, in turn, will make it more difficult for alternative viewpoints, politics and cultures to enter the market because they will lack the necessary economic resources. The pressure of rising costs means that all media have to try to reach as large an audience as possible. They can do this by aiming either at a large mass audience, or at smaller but affluent groups. Equally, they cannot afford to lose audiences. It therefore becomes necessary to rely upon tried and tested formulae, rather than trying to be different and experimental. Those forms of popular culture which have proved successful in the past, and which embody those 'values and assumptions which are most familiar and most widely legitimated' (ibid.; p. 37), will

be encouraged at the expense of all other forms. This leads Murdock and Golding to the following conclusion:

In general, then, the determining context for production is always that of the market. In seeking to maximize this market, products must draw on the most widely legitimated central core values while rejecting the dissenting voice or the incompatible objection to a ruling myth. The need for easily understood, popular, formulated, undisturbing, assimilable fictional material is at once a commercial imperative and an aesthetic recipe.

(ibid.; p. 40)

The limits of political economy

If we compare the political economy perspective with some of the other theories considered in this book, it can be seen that the latter do not readily take account of the production, circulation and consumption of ideas, knowledge and culture, nor of how they are circumscribed by systems of class power and control. As we have seen, there are approaches which neglect both the production of popular culture and the economic constraints under which it occurs. The political economy approach highlights certain aspects of the structural conditions under which popular culture is produced, distributed and consumed. While these arguments are clearly important and need to be retained, how far do they take us in understanding popular culture?

The political economists might well want to say that these are not the only important features we need to study, even though this in itself would question the value they place on analysing economic forces. In a recent update of their position, Golding and Murdock say that the distinguishing feature of their approach 'is precisely its focus on the interplay between the symbolic and economic dimensions of public communications. It sets out to show how different ways of financing and organizing cultural production have traceable consequences for the range of discourses and representations in the public domain and for audiences' access to them'

142

(1991; p. 15). The difficulties which this raises are similar to those associated with the base-superstructure model. To say that we are interested in the interplay between the economic and symbolic aspects of popular culture and the mass media, and the 'traceable consequences' of the former for the latter, are not necessarily contentious arguments. But if we are interested in this interplay, why don't we also need to look at the 'traceable consequences' of 'discourses and representations' for the 'financing and organizing of cultural production'? Presumably we cannot know this is a question not worth considering unless we have studied it?

The difficulty involved in this argument arises from the attempt to equate an emphasis upon the interplay between economic and cultural structures with an emphasis upon the greater explanatory importance of the economy. These emphases contradict one another, but if political economy were to accept this it would face a dilemma. Without this contradictory set of emphases, it would either lose the distinctiveness of its approach if it chose to stress the interplay between economic and cultural structures, or it would be putting forward an economic determinist position if it chose to stress the greater importance of the economy, which is precisely what it is trying to avoid. If it is the economy which determines and sets limits upon the cultural sphere (what about the political?), how can the real focus of interest be the interplay between the two?

In the end, political economy opts for economic determinism, as Golding and Murdock acknowledge: 'we can think of economic dynamics as defining the key features of the general environment within which communicative activity takes place, but not as a complete explanation of the nature of that activity' (ibid.; p. 19). There is little sense here of the interplay between economic dynamics and communicative activity. Also, it seems to be assumed that the two exist in isolation from each other; that communication is never about economics, and that economic activity, including cultural production, is carried on without the intervention of communication or other symbolic activities.⁴ It also makes little sense of their later claim that they wish 'to trace detailed connections between the financing and organization of cultural production and changes in the field of public discourse and representation in a nonreducible way' (ibid.; p. 27). Furthermore, if economic dynamics cannot offer a complete explanation of communicative activity, then what are the other factors which would need to be included for an explanation to be complete? We can specify in advance of empirical research the nature and importance of economic factors. So why can't we do the same with other non-economic factors? Thus, the idea that economic dynamics set the context for communicative activity does not allow for much interplay between the two. Communicative activity is always something to be explained; it is never able to be an explanatory force in its own right.

This point raises the question of whether political economy can tell us why popular culture is popular? As we have seen, Golding and Murdock refer to the tried and tested formulae of cultural production which capitalist media corporations resort to in order to maximise their audiences, and their profits. The drive to maximise profits involves the drive to maximise audiences. Therefore, despite the stress placed upon production, the consumption of popular culture is an equally important economic factor in the search for profits. If the mass communication industries failed to take it into consideration, they would not make profits. Often it will be a perceived or actual pattern of consumption which will stimulate production. Furthermore, can this profit motive account for the popularity of popular culture? What determines the tried and tested formulae which can be used to maximise audiences? How does the structure of ownership and control explain the popularity of popular culture? Is popular culture merely an expression of the ideas of the ruling class, and if so how can this be identified? Either popular culture can be read off from the ideas of the ruling class which has the power to impose them on the rest of the population, or there are other factors which, even within the limits of class power, can account for the popularity of popular culture, but which escape the attention of the political economy perspective. It may be necessary to resort to more directly cultural forms of analysis to explain the popularity of popular culture, but these do not fit easily with the emphasis upon political economy. If there is indeed a desire to avoid reductionist explanations, then it should surely no longer be possible to simply read off cultural forms from economic processes as Golding and Murdock attempt to do (ibid.; p. 27).

The political economy perspective sees the mass media conveying dominant values and assumptions which derive from and serve the interests of the ruling class, and which reproduce the prevailing structure of class power. However, little or no direct evidence is presented to suggest that the ideologies broadcast by the mass media have these desired effects. It seems to be assumed that if the power of the dominant ideology is asserted as the theory predicts, then its success in moulding the thoughts and actions of audiences is more or less automatically guaranteed. The political economy approach does not fare much better than many other perspectives in providing the basis for an understanding of the audiences for popular culture. This perhaps would be no bad thing if it were recognised that different approaches might be providing different parts of the overall picture. Therefore, political economy's inadequacies in analysing popular audiences would not matter in view of the strengths of its economic studies. But political economy, like many theories, has pretensions to being a total theory in keeping with its Marxism. This means that it obscures its limits as a theory only by remaining committed to the principle of economic reductionism.

Indeed, this problem has been recognised more recently by Murdock in an important and interesting essay on the relationship between modernism and communications. In fact Murdock's argument presents a useful way of thinking about this issue, and of furthering the analysis of culture. He writes:

the collapse of Marxism's claim to offer a totalizing theoretical system does not abolish the need to engage with its core concerns and concepts. We may wish to relinquish Marxism as a meta-narrative but 'still want to argue that class divisions are persistent and determinant'... and to continue the search for better ways of theorizing their relations to the structural inequalities of gender and ethnicity.

(1993; p. 525)

In making their general case, Golding and Murdock say that they do not wish to argue that the mass media are mere conveyor belts for the interests of the dominant class. Equally, they wish to stress the autonomy that professionals, working in media organizations. exercise in producing culture, within the limits set by class power. the profit motive and the economic structure of ownership and control. Political economy does not want to see the mass media as agents in a ruling class conspiracy, but neither does it want to accord them too much autonomy from economic and class power (1991; p. 25). However, it is difficult to see how far it can take this argument and remain committed to the ruling ideas model. The mass media propagate ideas which underpin the power of the ruling class, and yet the organisations and groups which do this can act with a certain level of autonomy. How then can the propagation of ruling-class ideas be ensured if media organisations and professionals are not mere mouthpieces for these ideas? Political economy wants to study media organisations as institutions which mediate between the economic structure of the media and their cultural output, but finds it difficult to square this with its claim that what they do is highly restricted by the need to produce and disseminate ruling-class ideology. It thus finds itself caught between models of conspiracy and autonomy, neither of which it wants to accept. This seems to be a general problem with Marxist theories of culture.

Althusser's theory of ideology and structuralist Marxism

The emergence of a political economy perspective on the mass media could be seen as a polemical response to other current developments within Marxism. The political economy approach accepts some idea of economic determinism in the sense that the economy sets limits upon all other forms of social relations. It does not directly analyse culture in isolation from these limits, nor does it accord it much significance in its own right. For the rest of this chapter, I want to consider those other developments within modern Marxism which have placed more emphasis upon the importance of culture and ideology. First of all, I want to look at Althusser's efforts to develop a theory of ideology on the basis of what could be termed a structuralist interpretation of Marxism.⁵

Althusser (1918-1990) was a French philosopher whose major work was published in the 1960s and 1970s in the context of the then widespread intellectual interest in Marxism and structuralism, although Althusser himself denied that he was a structuralist. Althusser's real concern lies with Marxist theory, and the need to secure its philosophical foundations. At their simplest, Althusser's objectives could be said to be to establish Marxism as a science and to rid it of economic determinism. In trying to reach these goals, Althusser holds to a highly distinctive view of science which argues it is abstract, logical and proceeds from first principles - in Althusser's version, the works of Marx, Engels, Lenin and Gramsci. Althusser sees himself carrying on the tradition of Marxist science established by Marx, and trying to resolve theoretical problems left unresolved, such as the absence of a theory of ideology. The solutions for these problems are to be found in the Marxist classics even if in undeveloped or barely recognised forms. The classics contain the solutions to problems thrown up by the development of Marxist theory and the history of capitalism, but much theoretical labour has to be expended before these conceptual solutions can be expounded. This means Althusser presents his arguments in a highly abstract and overly assertive manner which, of course, makes sense if you feel that the texts you are relying on constitute the truth, but can be difficult to take if you have a more sceptical view of their veracity.

It is not my concern to delve into the details of Althusser's definition of science, and his notion of why Marxism is a science. However, it is useful to bear in mind how important this is to the way he develops his concepts and theories. So when we come to his theory of ideology, which has had an important influence on analyses of popular culture, it is as well to be aware of the fact that the theory is put forward in an assertive manner as a series of steps in the logical resolution of a problem in Marxist theory left unresolved by Marx himself. It is also useful to appreciate this idea of science since it forms one of Althusser's guiding assumptions in his critique of economic determinism within Marxist theory.

We have seen that while political economy rejects what it sees as crudely reductionist theories of economic determinism, it does admit to economic determinism in the sense that the economy forms the most fundamental constraint or limit upon all other types of social activity. It thus thinks of economic determinism as a kind of empirical proposition which can be validated by research. According to Althusser, economism is a problem which has to be eradicated from Marxist theory. Basically, it is seen to represent a kind of 'essentialism'. The economy is an essence which gives rise to and shapes all other social institutions which therefore become merely expressions of this inner essence. It is therefore not scientific. Fortunately for Althusser, Marx's position can be interpreted in a non-essentialist manner which confirms its scientific status.

According to Althusser, economic determinism is not a problem which can be resolved empirically, despite his references to the material history of societies and to the class struggle. Real scientific solutions must be theoretical. Althusser accepts that Marxist theory can be interpreted as being economic determinist in character but insists that economic determinism works only in 'the last instance'. The meaning of this idea is central to Althusser's theory of ideology. For what he wants to do is to argue that ideology is a force within societies in its own right, while retaining Marx's emphasis upon economic determinism.

Althusser's point is that societies have to be thought of in terms of relations between structures rather than an essence and its expressions. The economic base or mode of production, and the superstructure or politics and ideology, form structures which are related to each other in definite ways. The political and ideological superstructures are not mere expressions of the essence of the economic base. In the last instance, which is a logical not a chronological concept, the economic base will be determinant due to its effects upon other structures and the dynamics of the society overall. But this does not prevent the superstructure from being 'relatively autonomous' from the base, or from exercising power and influence in its own right upon the base and upon the pace and direction of social change. In the real world, economic determinism never exists in a pure form, so its existence and effects are always difficult to decide upon and to disentangle from other influences. This is how Althusser interprets Marx's idea that the superstructure is not only determined by the base but by numerous secondary, incidental and contingent factors of a local and external kind.

Marxism has to take account of these possibilities while retaining its logical coherence as a theory which stresses economic determinism in the last instance. In the final analysis, the economy is paramount. It limits, influences and shapes the other structural levels of societies like ideology. These other levels, however, are not completely determined by the base; they are only determined by the economy in the last instance. They are autonomous from or independent of the base, even if this autonomy or independence is relative. They have some influence over the economic base and how it changes no matter how limited they are by the economic base. Althusser argues that Marxist science is not subject to economism, and that ideology is 'relatively autonomous' and exercises its own 'specific effectivity'. This means that ideology needs to have its own theory.

While Althusser can be criticised, unlike political economy, for not taking seriously the need for empirical research, he does attempt to pay more attention to superstructural factors like ideology. He makes this clear in his major work on ideology, the essay 'Ideology and Ideological State Apparatuses'. In this piece, Althusser tries to work out a Marxist theory of ideology in terms of the reproduction of what Marxists call the social relations of production. Putting forward his reasons for the elaboration of such a theory, Althusser makes clear his view of the base–superstructure model. He writes:

Marx conceived the structure of every society as constituted by 'levels' or 'instances' articulated by a specific determination: the *infrastructure*, or the economic base (the 'unity' of the productive forces and the relations of production) and the *superstructure*, which itself contains two 'levels' or 'instances': the politico-legal (law and the State) and ideology (the different ideologies, religious, ethical, legal, political, etc).

(1971; p. 129)

This formulation allows the specific powers of the superstructure, as well as the base, to be defined. It suggests a 'metaphor' in which the base provides the foundation on which rest the 'floors' or 'levels' of the superstructure. In this sense, the base determines the superstructure: 'in the last instance' it is the foundation which keeps the superstructure 'up in the air'. Given this, the theory suggests that the superstructure can be conceived of as possessing 'relative autonomy' from the base, and as having the capacity to reciprocally influence it. According to Althusser:

The great theoretical advantage of the Marxist ... spatial metaphor of the ... base and superstructure is ... that it reveals that questions of determination are crucial; ... that it is the base which in the last instance determines the whole edifice ... [which] ... obliges us to think what the Marxist tradition calls conjointly the relative autonomy of the super-structure and the reciprocal action of the superstructure on the base.

(ibid.; p. 130)

This 'thinking' about the relative autonomy and reciprocal action of the superstructure is conducted by Althusser in terms of the idea of reproduction, and we can follow this up by concentrating upon the example of ideology.

Althusser's essay is concerned with the problem of how the social relations of production are reproduced. Particularly important from our point of view is what Althusser has to say about the reproduction of labour power. In part, this reproduction is ensured by the payment of wages, but the worker has to be 'competent' in the work tasks he or she performs. This entails both technical competence, having and being able to use the right skills required by the work task, and 'good behaviour' or the 'right attitude', being respectful of authority, being a diligent and conscientious worker, etc. Under capitalism, these technical and cultural skills are acquired through the school system. As Althusser argues:

To put this more scientifically, I shall say that the reproduction of labour power requires not only a reproduction of its skills, but also ... a reproduction of its submission to the rules of the established order, i.e. a reproduction of submission to the ruling ideology for the workers, and a reproduction of the ability to manipulate the ruling ideology correctly for the agents of exploitation and repression, so that they, too, will provide for the domination of the ruling class 'in words' ... the school (but also other State institutions ...) teaches 'know-how', but in forms which ensure *subjection to the ruling ideology* or the mastery of its 'practice'. All the agents of production, exploitation and repression, not to speak of the 'professionals of ideology' (Marx), must in one way or another be 'steeped' in this ideology in order to perform their tasks 'conscientiously'.

(ibid.; pp. 127-128)

This understanding invokes a 'new reality', that of ideology, and suggests that the problem of reproduction can be theorised in terms of 'forms of ideological subjection' (ibid.).

This line of reasoning eventually reaches the claim that the superstructure secures the reproduction of the relations of production, the social relations between capital and labour grounded in the capitalist mode of production. Althusser identifies certain agencies of the state which perform this task and whose work is in essence ideological. These are called by Althusser the ideological state apparatuses which 'function massively and predominantly by ideology' (ibid.; p. 141), by the ruling ideology, which is the ideology of the ruling class. They are distinguished from the repressive state apparatuses which function 'massively and predominantly by repression' (ibid.). This is comparable to Gramsci's distinction between coercion and hegemony. Examples of the repressive agencies are the military, the police, the prisons and the courts, while the ideological agencies include religion, education, the family, trade unions, the mass media and popular culture.

Althusser sees the reproduction of the relations of production being secured by the superstructure, the repressive state apparatuses carrying out this function through the use of force or coercion, and the ideological state apparatuses by the use of ideology. It is also worth noting that he conceives of the mass media, education and popular culture as ideological state apparatuses. Thus if Althusser has a theory of popular culture and the mass media it is one which sees them as being constituted by ideology, and as functioning to secure the reproduction of the relations of production.

Althusser rarely refers to empirical or historical phenomena except in the most vague and abstract terms, and he merely gestures in the direction of what he thinks about popular culture and the mass media. But he does say a little more about education since for him this is the dominant ideological state agency within modern capitalism. It is the school which instils into people the technical and cultural skills required by their work in the relations of production. The school, he writes:

takes children from every class at infant-school age, and then for years, the years in which the child is most 'vulnerable', squeezed between the family State apparatus and the educational State apparatus, it drums into them ... a certain amount of 'know-how' wrapped in the ruling ideology ... it is by an apprenticeship in a variety of know-how wrapped up in the massive inculcation of the ideology of the ruling class that the relations of production in a capitalist social formation [society], i.e. the relations of exploited to exploiters and exploiters to exploited, are largely reproduced.

(ibid.; p. 148)

But what is ideology according to Althusser? He gives us some idea with respect to education and also makes a number of general theoretical points about the concept as well. So far we have seen that, for Althusser, ideology functions to secure the reproduction of capitalist relations of production by instilling the necessary skills into the minds and behaviour of the population. This is a function of the state which is performed, in the modern era, by its educa-

152

tional agencies, primarily by the school. But we do not have much sense of what ideology actually is apart from the ruling ideas (the know-how wrapped up in ruling-class ideas) which ensure the continuity of capitalism. This may partly be a result of Althusser's tendency to define ideology in terms of its functions, which makes it difficult to understand what its content might be except for that which can be guaranteed to be functional.

Althusser does therefore get round to providing an abstract account of ideology which, for our concerns here, involves three points: that 'ideology is a "Representation" of the imaginary relationship of individuals to their real conditions of existence' (ibid.; p. 152); that it is a material force in societies; and that it 'interpellates' individuals as subjects within particular ideologies. Let us take each of these in turn. The first point is probably the most difficult to grasp. As we can see, it is raised in his ideology essay, but Althusser also defines it in a similar fashion in his glossary of useful terms for Marxists of his persuasion, which is included at the end of his book For Marx: 'Ideology is the "lived" relation between men and their world, or a reflected form of this unconscious relation' (1969; p. 251). He goes into more detail in his essay, distinguishing his position from those which either see ideology as something directly imposed upon the powerless by powerful groups in order to maintain their power, or as a reflection of the alicnation prevailing in the wider society. According to Althusser, what people represent to themselves in ideology is not their real world as such but their relationship to the real world. This relationship is an imaginary one and 'underlies all the imaginary distortion that we can observe ... in all ideology: what is represented in ideology is therefore not the system of the real relations which govern the existence of individuals, but the imaginary relation of those individuals to the real relations in which they live' (1971; p. 155).

This is linked up with the other two points we have to consider. In suggesting that 'ideology has a material existence', Althusser is again distinguishing his position from those mentioned above since both depend on the notion that ideology exists merely as an illusory set of ideas in the minds of people, and is thus less real than the material base of society and the class power and alienation it generates. The imaginary relation Althusser refers to is a material relation. Ideology is not just about ideas or a question of mental states or consciousness, but a material practice carried out by groups and institutions. The school, for example, cannot be understood in ideological terms as a set of illusory ideas. It has to be analysed as a form of institutional practice. Ideology entails actions on the part of people living the imaginary relation it defines for them (for example, praying or voting), and these actions, for Althusser, are in effect practices which are 'governed by the *rituals* in which these practices are inscribed, within the *material existence of an ideological apparatus*, be it only a small part of that apparatus: a small mass in a small church, a funeral, a minor match at a sports' club, a school day, a political party meeting, etc.' (ibid.; p. 158).

This leads Althusser on to what he sees as his main point, the claim that 'ideology interpellates individuals as subjects' (ibid.; pp. 162–163). As well as being a state institution which reproduces capitalism, ideology is also a material force which embodies people's imaginary relationship to their real world. Ideology ensures that people live an imaginary relation to reality precisely because it forms them as subjects. From Althusser's point of view, people have little control over this process, and no chance of avoiding it. One way of trying to understand this idea is to think of what sociologists call socialisation, the process by which individuals gradually learn the cultural norms, or ways of behaving, of the society in which they are brought up.

For Althusser, the subject is the defining feature of all ideology, and all ideology works or functions by taking individuals and placing them, that is interpellating them, as subjects within the framework of ideology. For example, a religion will place all individuals who participate in its material practices as subjects, or believers, who are subject to one subject, God. Similarly, the ideology of political democracy will place individuals as subjects in terms of their becoming citizens subject to the sovereignty of parliament. Patriarchal ideology will interpellate individuals as more powerful men or less powerful women. Popular culture in contemporary societies might be argued to function by taking individuals and placing them as consumers, their subject status being defined by their consumption patterns. Likewise, it could be argued that the educational system serves first to place individuals as students in order to place them as workers and as members of social classes. Not all of these examples are cited by Althusser himself but they hopefully indicate the point he is trying to make, that ideology functions because it turns individuals into subjects.

Althusser's Marxism: economic determinism and ideology

Althusser's work can be seen as an attempt to establish Marxism as a science in terms of the revolution in knowledge ushered in by the concepts and theories developed in Marx's writings. This work involves both the eradiction of errors from the Marxist canon and the formulation of new theories to deal with outstanding problems. Althusser's ideas represent a major attempt to outline a Marxist theory of ideology, and his work is relevant to the analysis of popular culture and the mass media even if it does not touch directly on these issues. Nowadays, the academic consensus tends to reject Althusser's ideas, but – as we have seen – his work does confront the problem of economic determinism head on, recognises what he calls the 'specific effectivity' of ideology and tries to find a place for it within Marxist theory.

Althusser, of course, did not rid Marxism of its dogmatism given his own tendency to assert, rather than argue, his points on the basis of the authority conferred by Marx's texts. However, in dealing with the problem of economic determinism, he did manage to show, almost despite himself, the limitations as well as the potential offered by a Marxist inspired analysis of the mass media and popular culture. Althusser, along with Gramsci, helps us identify the critical limits of this perspective, although no account of popular culture could do without some of its insights concerning cultural production and the ideological nature of social struggles.

The importance of Althusser also lies in the influence he has had on the development of the academic study of ideas, knowledge and culture. This in part derives from the association of his work with structuralism and semiology and 'French theory' more generally. But equally Althusser's work seemed to hold out the promise of resolving the problem of economic determinism by constructing a novel Marxist theory of ideology. One way of gauging this is to point to the significance of Althusser for the perspectives and studies developed by the Centre for Contemporary Cultural Studies at Birmingham University as well as his impact on the theoretical output of a journal like *Screen* in the 1970s, concerned as it was with cultural theory and film studies.⁶ Althusser's work in this context helped foster the increasing interest in Gramsci's ideas on which he drew himself, although his overall theoretical framework and preferences appear different.

Having said all this, profound problems remain with Althusser's approach to the study of ideas and culture.⁷ The most intractable seems to be the problem of elaborating a Marxist theory of culture and ideology which is not economic determinist in character. This is a key issue for Althusser, as we have noted, but it is not one he manages to resolve. It is difficult to see how the sets of ideas which prevail in a particular society can be determined by the economic base and yet, at the same time, be able to influence the structure and direction of the society, including its economic base, in a relatively independent manner. Althusser's claim that the base itself determines the power and autonomy exercised by the superstructures does not help much in this regard since it is merely a restatement, not a resolution, of the problem. Either something like ideology is economically determined or it is influenced and shaped by economic processes that, because it is a material force, it can influence and shape in its turn. Reciprocal influence and relative autonomy are not the same thing; the latter is a vain gesture towards saving Marxist theory whereas the former is not.

Either economic determinism is accepted with all the problems it entails. Or autonomy is conceded to the superstructures (assuming it is necessary to think in these terms at all), in which case the connections between economic and ideological processes need to be established empirically. In short, if ideas and culture can have a causal impact upon the economic base then how tenable is a theory based upon economic determinism? To say that the latter limits the former is of no real help in that it still remains something to be determined empirically. Furthermore, it merely restates the problem, while it can no longer be assumed that the base is determinant in the first or last instance. How much impact can ideas actually have if they always work within some necessary but undefinable limits? Moreover, why are these limits never transgressed by ideological and cultural forces?

This argument can be seen more clearly if we look briefly at the example of education discussed by Althusser. He is concerned to develop a theory of ideology which recognises its 'relatively autonomous effects' and which does not rely upon economic determinism. Yet what he has to say about education as an institution (and he does not say a lot) fails to conform to either of these conditions. First, the function of ideology arises from the mode of production. Ideology secures the reproduction of the relations of production. This means that ideology is accounted for in terms of the economic base, and it has what autonomy it is supposed to have as a consequence of the function assigned to it by the mode of production. The concept of relative autonomy does not resolve the problem of economic determinism. Likewise, very little can be said about education from this position, aside from the function it performs for the economic base or mode of production. Education is reduced to a mechanism for the enforced inculcation of technical skills and respectful attitudes, the indoctrination of the dominant ideology, and for distributing people into the realm of production. Apart from the fact that this may not present a very accurate account of the educational systems of specific capitalist societies. it means that the so-called 'specific effectivity' of education gets lost in the tasks it is constrained to perform for the mode of production. How this would differ from accounts of education or ideology premised upon economic determinism is not that apparent.

Althusser's attempt to understand ideology in terms of the reproduction of the relations of production not only fails to steer Marxism away from economic determinism, but manages to turn it, or at least Althusser's theory of ideology, in the direction of functionalism. The basic problem with functionalist explanations is that they account for the causes of social phenomena in terms of their consequences. So a theorist can decide that a specific institution, like education, serves to distribute people into the mode of production, and can therefore conclude that this explains the emergence of education and its continued survival. An independent historical account of the emergence of an institution like education is thus ruled out because we know what its functions are, and need not take account of its origins. We can find this sort of functionalist explanation in Althusser's theory of ideology. Ideology, or in the specific case cited the 'educational state apparatus', is defined solely by the functions it performs for the mode of production, and there is not much else we can say about it.

In Althusser's hands, this functionalist theory of ideology means that (as with economic determinism) very little is said about education as a relatively autonomous institution with its own specific effectivity. In one instance, it is evaluated purely in terms of its relation to the mode of production, in another in terms of its functions. Also, ideology as education appears to be so functional as to be capable of ensuring the indefinite perpetuation of capitalism. Functionalist arguments often suggest, almost despite themselves, the eternally guaranteed continuation of the system which the institution is supposed to serve.

This is surprising in view of the fact that Althusser sees himself working in the Marxist tradition. This is not to say that Marxism as such is hostile to functionalist explanations (these explanations easily find their place in Marxist theories of the superstructure), nor indeed that functionalist explanations are intrinsically wrong. But it is hardly characteristic of Marxism to see no end to capitalism, or to understand its central institutions in the way Althusser does. It is open to Althusser's defenders to say that he places his major explanatory emphasis upon the class struggle. Marxism can be seen as theory which accounts for all other social phenomena in terms of the class struggles which are rooted in the history of different societies, and which explain the directions and transformations undergone by these societies. However, it is difficult to reconcile this theory with any simpleminded functionalism. The functions of any institution, be it the mass media, education or whatever, cannot be assumed to persist undisturbed, and to be performed efficiently, if they are always confronted by fundamental and wide-ranging class struggles. Conflicts, if they are important, must undermine functions at various points in time, no matter how powerful the institution charged with carrying out these functions. Althusser does try to pay due attention to class struggles, mentioning them profusely in his short postscript to his ideology essay (1971; pp. 170–173).

He incorporates the idea of class struggles into his discussion of education as an ideological state apparatus, by arguing both that education arises as a result of class struggles (no historical evidence of this is provided) and that the educational apparatus is internally riven by class struggles. These comments sit uneasily with his functionalist theory of ideology, and look more like vague gestures rather than reasoned arguments. If ideological institutions like education or the mass media are riven by internal class struggles how are they able to perform efficiently and consistently the functions entrusted to them by the mode of production? These struggles must introduce elements of indeterminacy and contingency into the way these institutions operate, limiting if not undermining their supposedly smooth and efficient performance of their functions. If these institutions are the result of class struggles over their structure and direction, where have these struggles, and the interests, aspirations and issues they entailed, actually gone? Tracing the origins of these institutions to the effects of class struggles may appear to offer a non-functionalist understanding of their causes. But Althusser does not relate these struggles to his account of ideology except to imply that ideology has resolved the problem of the class struggle by instilling in the dominated classes the ideology of the ruling class, "know-how" wrapped up in the ruling ideology'. It is no wonder that the significance of all kinds of social conflicts are lost sight of in Althusser's theory. They are buried by the functional operations of ideological institutions. Althusser does not frame his theory of ideology on the basis of class struggles, but it can be suggested that a Marxist theory of ideology and culture based upon the primary importance of social and class struggles is what is provided in the writings of Gramsci.

MARXISM

Gramsci, Marxism and popular culture

As we have seen, Althusser's theory comes up against some severe problems which limit its application to the study of popular culture. These include its abstractness, its functionalism, its determinism and its neglect of conflict, not to mention its failure to escape from the straight-jacket of economic determinism. In the end, these undermine its potential as the way forward for the Marxist analysis of culture and ideology. However, more recently Gramsci's work has been seen to offer this promise, and as a result his ideas have become widely influential. Indeed, the critique within cultural studies of Althusser and structuralist Marxism more generally comes that much easier if the potential offered by Gramsci (who had anyway influenced Althusser's theory without having to bear any responsibility for its worst excesses) can be fixed upon as the star for the Marxist perspective on popular culture to follow.⁸

The major reason for Gramsci's influence and importance lies in his concept of hegemony, the details of which we shall discuss in a moment. The extensive use of the concept itself indicates this, but it also now defines a particular approach to the study of popular culture. It tends to attract the prefix 'neo' to indicate the holding of certain reservations about the full-blooded use of the concept, although this should not detract from Gramsci's significance. Bennett (1986), for example, in introducing a reader on popular culture deriving from the research and teaching carried on at the Centre for Contemporary Cultural Studies at Birmingham University, underlines what he calls 'the turn to Gramsci', and firmly locates the progress of this subject in the concepts provided by Gramsci's writings. The emergence of the idea of 'Thatcherism' and the analysis of its fortunes throughout the 1980s by members of this centre clearly owes a great deal to Gramsci's notion of hegemonic and counter-hegemonic struggles, and the importance he placed upon the role of intellectuals.9

These examples underline the importance of Gramsci's ideas in defining a particular perspective on popular culture. In a paper calling attention to what its author sees as the absence of a guiding theory in cultural studies, McRobbie (1991b) argues that what is needed to resolve this situation is a neo-Gramscian theory of hegemony. The idea that Grasmci shows the way forward for cultural studies is also aired in a recent book surveying a wide range of cultural theories. Its author, Storey, says that on the whole he supports McRobbie's position: 'McRobbie's response to the so-called paradigm crisis in contemporary cultural studies is to argue for a return to neo-Gramscian hegemony theory. This is more or less my own position.... I still want to believe that hegemony theory is adequate to most of the tasks of cultural studies and the study of popular culture' (1993; pp. 199-200). Storey, however, qualifies this conclusion by indicating how he is equally attracted by the idea of 'the critical plurality of cultural studies - the different ways of working, the different contexts, the different conclusions - as equally valid (if differently weighted) contributions to the multidisciplinary field of cultural studies and the study of popular culture' (ibid.; p. 200). The reasons for arriving at these kinds of conclusions about the future of the study of popular culture will have to be left for the moment. We have first to discover just what it is that Gramsci has argued, and then assess whether the importance he is accorded is justified.

Before I consider this it would be helpful to say one or two things about Grasmci's relation to Marxism. This will serve to introduce his main ideas and begin to determine their significance, while locating Gramsci within this theoretical tradition. It almost goes without saying that, in a book such as this, I cannot go into great detail about Grasmci's wider theoretical inspirations, claims and legacies. Nor can I deal with his political career though it cannot pass without comment.¹⁰ Anyone at all acquainted with Gramsci will know he was a political activist. Born in Sardinia in 1891, he went to Turin in 1911 as a student and was eventually engaged in journalism and political activism before his arrest by the fascist state in 1926. He worked on radical and socialist newspapers in close association with the militant working-class movement in Turin which was centred on the Fiat car factories. He was also an active member of the Italian Socialist Party, and he eventually became one of the founder members of the Italian

Communist Party. He was imprisoned in 1926, and died in prison in 1937. It was during this eleven-year period in prison that most of the work for which he is famous was written, often when he was ill, and always under the vigilant, censorious eye of the prison authorities. This meant he had to write in a way which would escape the notice of the prison censors. As a result of these conditions, it took much longer for his writings to reach the outside world, and to be translated into foreign languages. This has led to a situation in which Althusser influenced cultural studies before Gramsci did, although the latter was an important influence on the former.

This career of political activity and struggle, as Anderson (1979; p. 50; cf. p. 45) has noted, makes Gramsci something of a unique figure as a theorist. Usually the writers, including Marxists, whose work is assessed for its theoretical importance are based in universities and follow intellectual careers, although they sometimes dabble in a bit of political journalism. But Gramsci is very different, even if he, too, saw himself as an intellectual, an 'organic intellectual' of the working class. Gramsci's politics shaped his ideas directly in that they grew out of his political experiences and the political repressions and hardships he suffered. For Gramsci, Marxism is not simply a science whose concepts have to be defined and developed in a rigorous and logical manner, nor merely a perspective well equipped to make sense of the world, but a political theory focused upon the emancipation of the working class. Marxism in this sense is above all a theory which guides, motivates and inspires, while monitoring and building, the socialist workingclass revolution.

Gramsci, like Althusser, is concerned to eradicate economic determinism from Marxist theory, and to develop its explanatory power with respect to superstructural institutions. Yet Gramsci's interest in doing this does not arise from a desire to establish Marxism's credentials as a science, but from the need to realise its significance as a theory of political struggle. In fact, Gramsci is very much opposed to scientistic and deterministic interpretations of Marxism. Instead, he prefers an interpretation which stresses the fundamental role performed by human agency in historical change,

162

one which is more voluntaristic in the view it takes of social life, and which concentrates upon the structure and direction of class and other social struggles. The concept of hegemony, and others formulated by Gramsci in the course of his writings, are designed precisely to advance this interpretation. Gramsci is opposed to economism not just because it reduces everything to the economy, but because it involves a strict determinism, whereas Althusser is prepared to accept some variant of determinism because it conforms to his conception of science (Gramsci: 1971; pp. 378–419).

A couple of brief examples should make this issue clear. The theory of class consciousness and political action characteristic of some schools of Marxist theory traces the history of the working class within capitalism in terms of the 'class in itself, class for itself' distinction. They argue that the working class is first formed objectively in the mode of production by being exploited and excluded from property rights, and by performing wage labour. Gradually it begins to develop itself subjectively as a result of its objective class situation, forming its own industrial and political organisations, and its own ideology and culture, which eventually equip it to seize state power, and usher in the socialist overthrow of capitalism. It can be infered from Gramsci's writings that this argument both ignores the uneven and contingent nature of class struggle, and traces its emergence directly to the economic base. It thus neglects the fact that class struggle is not a smooth evolutionary process, but one subject to reversals and setbacks as well as victories. Neither is it possible, according to Gramsci, to ever see class struggle as a purely objective or economic struggle since it must always involve ideas and ideologies.

This point is also made by Gramsci with respect to the French Revolution. Gramsci argues that Marxist interpretations of this revolution rely too heavily on the significance of the economic class struggle between the aristocracy and the bourgeoisie, and underestimate the significance of the role of intellectuals and ideas in ensuring the success of the revolution. For Gramsci, the same point can be made about the Marxist theory of the socialist workingclass revolution: that it should not devalue the importance of the role of ideas and culture in the making of this revolution, any more

MARXISM

than it should underestimate the importance of the role of bourgeois ideas and culture in preventing it from happening. This role of ideas and culture is what Gramsci understands as hegemony, which is produced by the activity of intellectuals, and feeds into the class struggle (ibid.; pp. 5–7, 77–82, and 452–453).

During his imprisonment, Gramsci began to understand his own political experiences in these terms (Anderson: 1979; Buci-Glucksmann: 1980). As he saw it, capitalism during and after the First World War experienced profound and severe economic and political crises. The bolshevik revolution had occurred in Russia, and working-class insurrections had broken out in various parts of Europe, where governments faced hostile political opposition on several fronts. In Turin, for example, there had been a series of factory occupations, while the national government appeared corrupt and unstable. This situation would have seemed favourable to socialist revolutions, yet it resulted, outside the Soviet Union, in either fascist seizures of power or the retrenchment of liberal democracy. Gramsci responded to this outcome partly by stressing how it underlined the need to build a Marxist political party directly involved in the struggles of the working class. He wanted to translate Lenin into Italian, and he argued that in part the factory occupations failed because they lacked political direction.

More importantly from our point of view here, he also noted the failure of economic crises to give rise to political and ideological crises favourable to the cause of socialism and the working class. This suggested that economic crises by themselves would not subvert capitalism, and that it was just as important for class struggles to be political and cultural, to be struggles over hegemony, as well as economic and industrial. The failure of the working-class insurrections is traced by Gramsci to the fact that bourgeois hegemony remained intact, and the counter-hegemony of socialism had not been made strong enough to ensure that the economic crises of capitalism would also become political and ideological crises. We can thus see two related aims lying behind Gramsci's theoretical writings which derive from his political experiences and which feed into his attempt to develop Marxism as the socialist political theory of the emancipation of the working class: to combat economism and determinism in Marxist theory; and to provide a theory of the superstructures which recognises the autonomy, independence and importance of culture and ideology.

Gramsci's concept of hegemony

Most commentators on Gramsci's work tend to mention the variable character of his use of the concept of hegemony, tracing its antecedents and going through the various uses Gramsci makes of it in different aspects of his writings, as well as noting its role in theories of political struggle.¹¹ These things, as important as they are, do not concern us directly here. Our concern is with the Marxist analysis of the mass media and popular culture. This centres on Gramsci's understanding of hegemony as a cultural and ideological means whereby the dominant groups in society, including fundamentally but not exclusively the ruling class, maintain their dominance by securing the 'spontaneous consent' of subordinate groups, including the working class, through the negotiated construction of a political and ideological consensus which incorporates both dominant and dominated groups.

According to an early exposition of Gramsci's ideas, his concept of hegemony entails the following: 'the hegemony of a political class meant for Gramsci that that class had succeeded in persuading the other classes of society to accept its own moral, political and cultural values. If the ruling class is successful, then this will involve the minimum use of force, as was the case with the successful liberal regimes of the nineteenth century' (Joll: 1977; p. 99). One of the most recent interpreters of Gramsci's work, one who usefully goes through the variations in the meaning of the concept, provides the following summary:

Gramsci uses the concept of hegemony to describe the various modes of social control available to the dominant social group. He distinguishes between *coercive control* which is manifest through direct force or the threat of force, and *consensual control* which arises when individuals 'willingly' or 'voluntarily' assimilate the world-view or hegemony of the dominant group; an assimilation which allows that group to be hegemonic.

(Ransome: 1992; p. 150)

The culture which prevails in a society at any particular point in time can be interpreted, from this perspective, as an outcome and embodiment of hegemony, of the 'consensual' acceptance by subordinate groups of the ideas, values and leadership of the dominant group. There is clearly a problem here in that the extent to which the subordinate groups genuinely consent to the hegemony of the dominant group is open to question. But Gramsci does contrast hegemony with coercion and force. Therefore, we can recognise how he introduces elements of consent and consensus missing from alternative Marxist theories of ideology and culture. It can be argued that Gramsci's theory suggests that subordinate groups accept the ideas, values and leadership of the dominant group not because they are physically or mentally induced to do so, nor because they are ideologically indoctrinated, but because they have reasons of their own. According to Gramsci, hegemony is secured, for example, because concessions are made by dominant to subordinate groups. The culture which is built around this hegemony will thus express in some way these interests of the subordinate groups.

Gramsci is not always clear on these points, but we can give some indication of his arguments. He sees hegemony as one aspect of social control arising out of social conflict. It is not a functional imperative of capitalism, but a set of consensual ideas arising out of, and serving to shape, class and other social conflicts:

the supremacy of a social group manifests itself in two ways, as 'domination' and as 'intellectual and moral leadership'. A social group dominates antagonistic groups, which it tends to 'liquidate', or subjugate perhaps even by armed force; it leads kindred and allied groups. A social group can, and indeed must, already exercise 'leadership' before winning governmental power (this indeed is one of the principal conditions for the winning of such power); it subsequently becomes dominant when it exercises power, but even if it holds it firmly in its grasp, it must continue to 'lead' as well.

(1971; pp. 57–58)

Leadership is crucial to hegemony for Gramsci, and this passage effectively captures what it entails, and why it is distinct from coercion as a form of social control. Hegemony expresses subordinate consent to the authority of the discourses of the dominant group in society.

Hegemony is accepted and works because, in a very broad sense, it is founded upon the granting of concessions to subordinate groups which do not pose a threat to the overall framework of domination. As Gramsci makes this point:

the fact of hegemony presupposes that account be taken of the interests and the tendencies of the groups over which hegemony is to be exercised, and that a certain compromise equilibrium should be formed – in other words, that the leading group should make sacrifices of an economic-corporate kind. But there is also no doubt that such sacrifices and such a compromise cannot touch the essential; for though hegemony is ethical-political, it must also be economic, must necessarily be based on the decisive function exercised by the leading group in the decisive nucleus of economic activity.

(ibid.; p. 161)

Gramsci here seems to suggest that the power of the dominant group ultimately derives from its position in the economy (its cornerstone is the bourgeois class), and that the concessions which underlie hegemony are primarily economic in character, for example welfare provisions or wage rises. But if we accept that hegemony is also about the battle for ideas, and the consent to dominant ideas, then it might be argued that it also includes concessions to the ideas and values of subordinate groups. The latter, far from merely colluding with dominant ideas, may find their own recognised in the prevailing hegemony. This would make sense of Gramsci's line of argument. If hegemony is seen to arise out of conflict, then we could expect the hegemonic compromises which resolve conflict, however temporarily, to express the issues and interests at stake.

This can be illustrated by the example of the police and crime series on British television in the mid-1970s.¹² It has been argued that these series formed part of an attempt by dominant groups to re-establish their hegemonic position through a 'law and order' moral panic. The prevailing hegemony of dominant groups in British society, based upon a type of social-democratic reformism, was beginning to break down under the strain of class, industrial and racial conflicts. As a result, dominant groups engaged in political, ideological and cultural struggles to restore their hegemony, which began to take a more authoritarian and populist direction. This meant that popular cultural forms, for example police and crime series like The Sweeney (1975-1978) or The Professionals (1977-1983), began to recognise popular concerns about increasing crime or the threat of crime, and social order, while emphasising the need for law and order to be re-established in society. In this way, hegemony describes the restoration of the political and cultural dominance of the most powerful groups as a reaction to popular aspirations in order to secure the consent of subordinate groups.

Hegemony arises out of the activities of certain institutions and groups within capitalist societies. Gramsci sees what he calls civil society as having the responsibility for the production, reproduction, and transformation of hegemony, while the state is responsible for the use of coercion. This is a fairly simple and direct equation whereby the state exercises repression and civil society exercises hegemony. While this distinction has been the subject of much debate, its influence on Althusser as an argument about the composition of the superstructure is fairly obvious. It means that, for Gramsci, popular culture and the mass media are subject to the production, reproduction and transformation of hegemony through the institutions of civil society which cover the areas of cultural production and consumption. Hegemony operates culturally and ideologically through the institutions of civil society which characterise mature liberal-democratic, capitalist societies. These institutions include education, the family, the church, the mass

media, popular culture, etc. Civil society is the way Gramsci locates the place of culture and ideology within societies, and hegemony is the way he tries to understand how they work. From a Gramscian perspective, popular culture and the mass media have to be interpreted and explained in terms of the concept of hegemony.

Another way of appreciating Gramsci's notion of civil society and the role played by hegemony is to look at what he has to say about political strategy. He draws a distinction, using a military analogy, between war of manoeuvre or movement and war of position. War of movement refers to a swift, frontal and direct attack on the enemy with the aim of winning quickly and decisively. This is comparable to insurrectionary political action. It describes the bolshevik revolution of 1917 which involved a war of movement against the political target provided by a centralised and dominant state power left unprotected by civil society. Hegemony in civil society was weak while the state was strong and highly visible, so a revolutionary war of movement against the state could be conducted. According to Gramsci, the liberal-democratic societies of western capitalism are different in that they have relatively weaker states and much more extensive and complicated civil societies which strengthen the hegemony of the dominant group. In this situation, a war of position rather than a war of movement becomes the strategy to be adopted by revolutionary socialist forces. This involves a long, protracted and uneven struggle over the hegemonic hold of the dominant group, and its eventual replacement by the hegemony of the subordinate groups aspiring to power and the radical transformation of society. A war of position is thus a war of retrenchment waged primarily across the institutions of civil society. It is a strategy which accepts the drawn out nature of the struggle, the probability of defeats and reversals, and the importance of the need for the struggle to be cultural and ideological as well as economic and political, delaying a war of movement until the battle for hegemony has begun to succeed.

According to Gramsci, the revolutionary forces have to take civil society before they take the state, and therefore have to build a coalition of oppositional groups united under a hegemonic banner which usurps the dominant or prevailing hegemony. Without this struggle for hegemony, all attempts to seize state power will be futile. The nature of civil society makes sure of this. As Gramsci writes of 'the most advanced states':

'civil society' has become a very complex structure and one which is resistant to the catastrophic 'incursions' of the immediate economic element (crises, depressions, etc.). The superstructures of civil society are like the trench-systems of modern warfare. In war it would sometimes happen that a fierce artillery attack seemed to have destroyed the enemy's entire defensive system, whereas in fact it had only destroyed the outer perimeter: and at the moment of their advance and attack the assailants would find themselves confronted by a line of defence which was still effective. The same thing happens in politics, during the great economic crises.

(ibid.; p. 235)

According to this perspective, popular culture can be interpreted in terms of the struggles over hegemony carried on within the institutions of civil society.

To finish this outline, a few more points need to be made about hegemony. The first is that hegemony is not a fixed and determinate set of ideas which have a constant function to perform. While clearly, for Gramsci, hegemony serves to secure the dominance of the most powerful classes and groups in society, and is seen when it is so far dominant as to colour even what is called 'common sense', it is none the less something which emerges out of social and class struggles which it, in turn, serves to shape and influence. Therefore its hold over subordinate groups can never be fully guaranteed in practice. Questions can be raised about the extent to which the use of the concept of hegemony in particular analyses can become a variant of the dominant ideology thesis, bringing it closer in effect to Althusser's theory, as well as to that put forward by the Frankfurt School. To be fair to the spirit of Gramsci's work and to the demands of exposition, it is perhaps best to think of hegemony as a contested and shifting set of ideas by means of which dominant groups strive to secure the consent of subordinate groups to their leadership, rather than as a consistent

and functional ideology working in the interests of a ruling class by indoctrinating subordinate groups.

Lastly, Gramsci sees hegemony as the result of the work carried out by intellectuals. In this sense, his theory suggests we conceive of the producers, distributors and interpreters of popular media culture as intellectuals engaged in the establishment of, and conflicts over, the prevailing hegemony, within the institutions of civil society. The work of these institutions relies on the roles carried out by intellectuals. Gramsci is using the term 'intellectuals' not in its restricted elitist sense to refer to great artists, major writers or renowned academics, but in a much broader occupational sense to refer to those charged with the production and dissemination of ideas and knowledge in general: 'all men are intellectuals ... but not all men have in society the function of intellectuals' (ibid.; p. 9). The function of an intellectual is derived from the occupational positions to be found particularly but not exclusively in the institutions of civil society, and is concerned with the production, distribution and interpretation of culture, ideas, knowledge, discourses, etc., which are related to hegemony. Not all intellectuals have the same power, nor are all intellectual tasks of equal weight. Some intellectuals may directly produce hegemonic ideas, others may merely elaborate them, while some others will carry out delegated tasks laid down by those with authority. But all those whose function is in some way to be an intellectual, that is to say those who predominantly work with ideas in some way (even if all work involves some level of intellectual activity), are concerned with hegemony and the role of the respective institutions in civil society. This is how a Gramscian perspective would understand the particular roles associated with the production, distribution, consumption and interpretation of popular culture within the modern mass media.

Conclusions: Marxism, Gramscian Marxism and popular culture

Let us return to the point at which we began our discussion of Gramsci. It may well be the case that the theory offered by Gramsci will prove the best way forward for the study of popular culture, especially if it is combined with the stress of the political economy approach on the importance of economic constraints. This is particularly true if this promise is allied with a desire to remain within a general Marxist framework which avoids economic determinism. As Storey puts it: 'neo-Gramscian hegemony theory at its best insists that there is a dialectic between the processes of production and the activities of consumption' (1993; p. 200). Gramscian theory therefore has the potential for this sort of analysis without the dogmatism, determinism and economism of other variants of Marxist theory, and it seems to offer the possibility of an approach grounded in concrete historical realities rather than speculative theoretical abstractions.

However, this does not mean that Gramsci's theory is not without its problems, and these, in my view, suggest that the analysis of popular culture and the mass media can now only be advanced by moving beyond a strictly Marxist framework.¹³ This perspective, as we have seen in this chapter, has provided a number of insights which need to be retained. But the problems which can be identified with Gramsci's theory also identify the limits of Marxism.

There are a number of secondary but still significant problems with Gramsci's theory that can be mentioned in passing. For example, there is the difficulty associated with clearly separating hegemony from coercion since hegemony can itself be coercive. Hegemony is still a form of domination, while coercion can be used in a hegemonic fashion. Force can be used against certain subordinate groups with the consent of other subordinate groups, which would presumably constitute a hegemonic use of coercion. Likewise, it is possible for coercion to be used in a legitimate or hegemonic way by agencies of the state. Moreover, is the fascist celebration of violence coercive or hegemonic, or indeed both? And does not the world of work, the sphere of economic production, rely upon both coercion and hegemony in order to operate effectively?

Linked to this is the problem of confining hegemony to civil society and coercion to the state. It is conceivable that Gramsci accepts that institutions in civil society can also act in a coercive manner, and state institutions in a hegemonic manner. But how does this enable us to analyse an institution like parliament which is central to liberal-democratic states and can order coercive acts to be performed, but which through its ceremonials and rituals, and its staging of democratic politics, equally serves to foster hegemony. Such an example tends to question not only the analytical but the empirical usefulness of the distinction between state and civil society, if not of that between hegemony and coercion.

There are, however, a number of more fundamental problems which need to be mentioned in closing this chapter. There is, first, the claim that Gramsci's theory represents merely another variant of the dominant ideology thesis (Abercrombie et al.: 1980). Much is made by Gramsci of the importance of conflict in the emergence of hegemony and its historical transformations. None the less, it usually turns out to be the case that in practice the dominant groups manage to acquire some form of hegemony to secure their rule. Hegemony may be the consequence of class conflict, but it is a consequence which continually favours one side of the struggle, the dominant group, at the expense of the other, the subordinate groups. The concept of hegemony sometimes seems to describe a series of football games in which both sides can play but only one side can win. The dominant group invariably wins out by gaining the acceptance of a new form of hegemony, while the potential for change appears to be highly limited short of a full-scale revolutionary struggle. As the argument proceeds, the importance of conflict and change gives way to the stultifying hold of hegemony over subordinate social groups. If hegemony ends up being about the continued re-assertion of the rule of the dominant groups in society, in which the ideas of the subordinate groups can make little headway, then we appear to have returned to a version of the ruling-class ideas model, a dominant ideology thesis.

Related to this is Gramsci's argument that social control and social order, the continued dominance of the most powerful groups in society, can only be secured by means of a dominant ideology. This is, of course, strictly speaking untrue, since Gramsci also recognises the importance of coercion in securing domination. However, he does seem to think that hegemony is a more potent form of social control. What such a theory neglects is that acquiescence with the prevailing order does not necessarily arise because people are indoctrinated or forced to acquiesce, nor because they spontaneously consent to, or believe in, a dominant ideology. People can accept the prevailing order because they are compelled to do so by devoting their time to 'making a living', or because they cannot conceive of another way of organising society, and therefore fatalistically accept the world as it is.¹⁴ This, moreover, assumes that the question why people should accept a particular social order is the only legitimate question to ask. It can be claimed that an equally legitimate question is why should people not accept a particular social order?

The concept of hegemony can be applied in the analysis of a wide range of social struggles. Although, in Gramsci's hands, the concept tends to be applied to class struggles, it has been welcomed because it can be applied to other arenas of conflict, and allow a number of different types of struggle to be linked together in a more general analysis. Yet what this sort of analysis entails is an explanation of culture and ideology as hegemony which traces it back to its social roots in the class struggle. There is nothing wrong in tracing the social roots and contexts of ideas and culture; this is, indeed, a part of what the sociology of popular culture is concerned with. But it does become problematic if it results in a form of class reductionism whereby all culture is explained by its relation to class struggle. This kind of reductionism neglects the specific character and autonomous effects of culture and ideas. It also tends to treat them in an absolutist manner to the extent that they must be seen to favour one class or another involved in struggle, usually the dominant one. It equally assumes that in principle all types of popular culture must have some form of functional relation to the class struggle.

However complicated and mediated the relationships between culture and class are argued to be, if culture is not accorded some real autonomy from class struggles then we are once again left with a reductionist form of analysis. Even if we wanted to argue that a class analysis of popular culture is important, this would not mean that class or some other form of social division is all we need to take into consideration. Nor would it mean that all forms of popular culture are readily understood in terms of other social structures and conflicts. Any reductionist analysis ignores not only crucial social factors other than the one it seeks to privilege, but the independence and influence of the phenomenon it is seeking to explain. A class-based analysis of culture such as that put forward by Gramsci runs these risks in the use it makes of the concept of hegemony.

If it can be argued that Gramsci's theory fails to avoid relying upon a version of economic or class reductionism, then to what extent can he be said to have resolved the problems encountered in constructing a Marxist theory of culture and ideology? It seems to me that the development of the analysis of popular culture and the mass media cannot proceed on the basis of a theory which still wants to be in some way distinctively Marxist. Despite the persuasive and compelling character of Gramsci's theory, its insights must remain limited if it confines itself to a Marxist framework. This is because the distinctively Marxist emphasis on economic determinism is sociologically limited, as I have argued. However, Gramsci, and adherents of Gramscian theory, have been accused of minimising the significance of economic factors like the sphere of material production, and paying too much attention to culture, and to the superstructure more generally. They have been found guilty of 'culturalism', of giving too much weight to cultural and ideological factors in their desire to avoid 'economism'.15 Culturalism is, of course, a problem because it deviates too far from the distinctively Marxist emphasis upon the economy and the mode of production. Yet it can be suggested that this deviation is necessary if the sociology of popular culture is to be developed, although it need not, and should not, proceed by ignoring the importance of economic structures. In fact, the limitations of Marxism begin to become apparent when we attempt to bring together economic, ideological and cultural factors in a sociology of popular culture.

Further reading

Abercrombie, N. et al. (1980) The Dominant Ideology Thesis, London, Allen and Unwin.

Anderson, P. (1979) Considerations on Western Marxism, London, Verso.

- Bennett, T. (1982) 'Theories of the media, theories of society', in M. Gurevitch et al. (eds), Culture, Society and the Media, London, Methuen.
- (1986) 'Introduction: "the turn to Gramsci", in T. Bennett et al. (eds), Popular Culture and Social Relations, Milton Keynes, Open University Press.
- Elster, J. (1986) An Introduction to Karl Marx, Cambridge, Cambridge University Press (chapter 9).
- Golding, P. and Murdock, G. (1991) 'Culture, communications and political economy', in J. Curran and M. Gurevitch (eds), *Mass Media and Society*, London, Edward Arnold.
- Hall, S. and Jacques, M. (eds) (1983) The Politics of Thatcherism, London, Lawrence and Wishart.
- Joll, J. (1977) Gramsci, London, Fontana.
- McLellan, D. (1986) Ideology, Milton Keynes, Open University Press.
- Murdock, G. (1993) 'Communications and the constitution of modernity', Media, Culture and Society, vol. 15.
- Simon, R. (1982) Gramsci's Political Thought: An Introduction, London, Lawrence and Wishart.
- Swingewood, A. (1991) A Short History of Sociological Thought, Basingstoke, Macmillan (second edition).

Feminism and popular culture

The feminist critique	180
Women and advertising	184
The feminist analysis of popular	
culture	189
Feminism and mass culture	189
Feminist theory and the critique	
of content analysis	191
Feminist theory, patriarchy and	
psychoanalysis	196
Feminist theory and the study of	
ideology	201
Feminist analysis, semiology and	
ideology	206
Feminist analysis, ideology and	
audiences	209
Conclusion	215

177

T HE INCREASE IN THE interest shown in popular cultural representations of women within cultural studies and the sociology of culture has been part of the more general resurgence of feminism and feminist theory. Feminism as an intellectual activity and a political strategy has a long history (Spender: 1983). But with respect to the issues raised by this book, of most interest is the emergence of the modern women's movement from the late 1950s onwards which has involved the analysis and critique of how and why popular culture and the mass media have dealt with women and their representations in an unfair, unjust and exploitative manner, within the context of a more general framework of gender inequality and oppression.¹

As we shall see below, as the argument develops, it is possible to suggest that there have been at least three strands of feminism which have been important: liberal feminism which criticises the unequal and exploitative employment and representation of women in the media and popular culture, and argues for remedial equal opportunities legislation to rectify this situation; radical feminism which sees the interests of men and women as being fundamentally and inevitably divergent, regards patriarchy or the control and repression of women by men as the most crucial historical form of social division and oppression, and argues for a strategy of female separatism; and socialist feminism which accepts this stress on patriarchy but tries to incorporate it into an analysis of capitalism, and argues for the radical transformation of the relations between the genders as an integral part of the emergence of a socialist society. More recently in the study of popular culture, these differences appear to have become blurred, alongside a move away from radical feminism. Nowadays, feminism seems to combine a more 'liberal' view of gender power structures, which conceives of the inequalities between the sexes as socially and culturally constructed phenomena, with an attempt to develop feminist analyses which involve both a less dismissive conception of the female audiences for popular culture, together with a theoretical framework which incorporates class, race, ethnicity and other important social divisions.²

The theories and perspectives I have considered so far in this book have tended either to be specific to the study of culture, like semiology or mass culture theory, or to embrace a more general and wide-ranging approach to social phenomena, like structuralism or Marxism. Feminism has more in common with the latter in the scale and range of the themes and problems it addresses. Indeed, it embodies a concern with the intellectual history of the study of popular culture as much as with the histories of many other areas of social scientific inquiry. This chapter will recognise this, insofar as it can, by tracing back, as many feminists have done, the feminist assessment of the body of work which can be included under the title of cultural studies or the sociology of popular culture. The feminist perspective has examined critically the other perspectives covered in this book. Thus it entails a critical history of the study of culture. In this chapter, I shall therefore consider feminism and popular culture in two related ways. First, I shall consider the feminist critique of popular culture and of the study of popular culture. Feminists have been critical of a number of things in this area, but a few in particular stand out. These include popular cultural representations which marginalise or stereotype women, the relative absence of women involved in cultural production and the relative neglect of women as members of the audience for popular culture. Feminists have been equally critical of the way in which the academic study of social and cultural phenomena has in turn furthered these processes by failing to take seriously or consider more fully the position of women and gender oppression. Academic studies, as much as popular culture itself, have excluded, ignored or trivialised women as a social category. They have, as a result, been opposed by feminists on political and intellectual grounds.

The critique has had as its target all those theories and perspectives which have colluded in this form of sexism. Feminism has found some of these approaches important and influential. Gamman and Marshment make the point in these terms: since the late seventies feminists have ... suggested that women's experience is subordinate to the categories and codes through which it is articulated. Here, feminist appropriations of Continental Marxism have been of particular significance: the work on 'common sense' and 'ideology' by Gramsci and Althusser, and psychoanalytic work on the acquisition of gender, have been employed by feminists to 'politicise everyday life – culture in the anthropological sense of the lived practices of a society' – and to problematise the culture's definition of femininity and masculinity.

(1988; p. 2; cf. C. Penley: 1988)

But while many feminist studies and arguments have made use of insights, methods and concepts derived from these approaches, such as the use of semiology to decode the sexism in apparently 'feminist' adverts, they have all been criticised for failing to come to terms with the analysis of women and gender. This critique has, in turn, led both to internal debates within feminism and to the development of feminist analyses of popular culture, and this is the second main area I wish to look at in this chapter. One interesting point about a number of these analyses is the fact that they have made telling criticisms of some of the theories we have considered in previous chapters, and they can be seen as advancing the criticisms already made. More generally, they can be used to highlight the character of feminist studies of popular culture, and the radical challenge posed by feminism to previous theories and perspectives on popular culture.

The feminist critique

A lot of the earlier work on women and popular culture concentrated upon what Tuchman has called the 'symbolic annihilation of women'.³ This refers to the way cultural production and media representations ignore, exclude, marginalise or trivialise women and their interests. Women are either absent, or represented (and we have to remember that popular culture's concern with women is often devoted entirely to their representation, how they look) in terms of stereotypes based upon sexual attractiveness and the performance of domestic labour. In short, women are 'symbolically annihilated' by the media through being absent, condemned or trivialised.

Cultural representations of women in the mass media are conceived of as working to support and continue the prevailing sexual division of labour, and orthodox conceptions of femininity and masculinity. The 'symbolic annihilation of women' practiced by the mass media serves to confirm that the roles of wife, mother and housewife, etc., are the fate of women in a patriarchal society. Women are socialised into performing these roles by cultural representations which attempt to make them appear to be the natural prerogative of women.⁴ Van Zoonen summarises these points as follows:

Numerous quantative content analyses have shown that women hardly appear in the mass media, be it depicted as wife, mother, daughter, girlfriend; as working in traditionally female jobs (secretary, nurse, receptionist); or as sex-object. Moreover, they are usually young and beautiful, but not very well educated. Experimental research done in the tradition of cognitive psychology tends to support the hypothesis that media act as socialization agents – along with the family – teaching children in particular their appropriate sex roles and symbolically rewarding them for appropriate behaviour. ... It is thought that media perpetuate sex role stereotypes because they reflect dominant social values and also because male media producers are influenced by these stereotypes.

(1991; pp. 35-36)

This summary also neatly captures the similarities between this line of thinking and other conceptions of dominant ideology we have encountered elsewhere in this book.

One of the most extensive statements of the argument that the mass media 'symbolically annihilate' women has been made by Tuchmann. She relates this notion to the 'reflection hypothesis' which suggests that the mass media reflect the dominant social values in a society. These concern, not the society as it really is, but its 'symbolic representation', how it would like to see itself. Tuchmann argues that if something is not represented in this affirmative manner it implies 'symbolic annihilation': 'either condemnation, trivialization, or "absence means symbolic annihilation" (1981; p. 169). With respect to the symbolic representation of women in the American media, she points out that although 'women are 51 per cent of the population and are well over 40 per cent of the labour force', 'relatively few women are portrayed' in this way: 'those working women who are portrayed are condemned. Others are trivialized: they are symbolized as child-like adornments who need to be protected or they are dismissed to the protective confines of the home. In sum, they are subject to symbolic annihilation' (ibid.; pp. 169-170). The reflection hypothesis argues the media have to reflect social values in order to attract audiences. Therefore, their search for a 'common denominator' to maximise audiences means that they 'engage in the symbolic annihilation of women by ignoring women at work and trivializing women through banishment to hearth and home' (ibid.; p. 183).

Surveying the evidence on America between the 1950s and the mid- to late 1970s, Tuchmann finds this argument to be especially true of popular television and the press. As as far as television is concerned, she discovers the following: that women are markedly under-represented while men tend to dominate programmes: that the men represented tend to be shown pursuing an occupation; that the few women who are shown working are portrayed as being ineffectual, and certainly not as competent as their male counterparts; and that 'more generally, women do not appear in the same professions as men: men are doctors, women, nurses; men are lawyers, women, secretaries; men work in corporations, women tend boutiques' (ibid.; p. 173). She continues: 'the portraval of incompetence extends from denigration through victimization and trivialization. When television women are involved in violence, unlike males, they are more likely to be victims than aggressors. Equally important, the pattern of women's involvement with television violence reveals approval of married women and condemnation of single and working women' (ibid.).

This symbolic annihilation of women is confirmed by the adverts shown on television. 'Analyses of television commercials support the reflection hypothesis. In voice-overs and one-sex (all male or all female) ads, commercials neglect or stereotype women. In their portrayal of women, the ads banish females to the role of housewife, mother, homemaker, and sex object, limiting the roles women may play in society' (ibid.; p. 175).

The press as well as women's magazines provide further evidence of the symbolic annihilation of women. However, women's magazines are not as directly responsible for this as most other areas of the media, because the more specialised and smaller scale of their audiences means that the reflection hypothesis does not so readily fit their case. It is true that research on women's magazines has 'found an emphasis on hearth and home and a denigration of the working woman'. But it is equally the case that 'such differences as do exist between working-class and middle-class magazines remain interesting ... for they indicate how much more the women's magazines may be responsive to their audience than television can be', the latter having to appeal to a much larger and more undifferentiated audience than the former (ibid.; pp. 176, 178 and 179). Their smaller audience also suggests that these magazines may be more responsive than popular television to changes in the social situation of women generally, and their readership in particular. According to Tuchmann, research has shown that magazines aimed at a predominantly working-class readership are more likely to show women at work, and as being independent and effective, than magazines aimed at a more middle-class readership. However, she insists this argument cannot be taken too far even if women's magazines (both middle class and working class) may be more likely to recognise the social changes experienced by women, including the emergence of the women's movement, than the other areas of the media she considers. She concludes: 'the image of women in the women's magazines is more responsive to change than is television's symbolic annihilation and rigid typecasting of women. The sex roles presented are less stereotyped, but a woman's role is still limited. A female child is always an eventual mother, not a future productive participant in the labour force' (ibid.; p. 181).

Therefore, in practice, this overall process has meant that men and women have been represented by the mass media in conformity with the cultural stereotypes which serve to reproduce traditional sex roles. Men are usually shown as being dominant, active, aggressive and authoritative, performing a variety of important and varied roles which often require professionalism. efficiency, rationality and strength to be carried out successfully. Women by contrast are usually shown as being subordinate, passive, submissive and marginal, performing a limited number of secondary and uninteresting tasks confined to their sexuality, their emotions and their domesticity. In portraying the sexes in these ways, the mass media confirm the natural character of sex roles and gender inequalities. The concern being voiced here is that this 'symbolic annihilation' means that women, their lives and their interests are not being accurately reflected by the mass media. Popular media culture does not show us women's real lives. The counterparts to the absence, condemnation and trivialisation of women are omission, bias and distortion on the part of the mass media. As with certain other perspectives we have come across, the claim being made is that popular culture offers a fantasy, surrogate world to its consumers, not the real world they actually live in. In order for the mass media to socialise people successfully into the reality of their sex roles it must not show them what these sex roles are really like. A number of questions are raised by this. If people are not shown the reality of their genders how can they be successfully performed in society? Why don't people conform to their stereotypes? And if they don't what use are the stereotypes?

Women and advertising

One of the main areas of popular culture which has attracted the attention of feminists has been advertising and its representation of women. As Baehr comments: 'from its very beginnings the Women's movement has responded critically, often angrily, to what it has rather loosely called "sexism in the media". Advertisements were an obvious first target and Betty Friedan devoted a large part of *The Feminine Mystique* to a content analysis of women's magazines and to a critique of advertising and market research techniques' (1981; p. 141). Sustained critical analysis carried out in these terms has unearthed the kind of things mentioned above about gender stereotypes. As Dyer notes: 'analysis of ads suggests that gender is routinely portrayed according to traditional cultural stereotypes: women are shown as very feminine, as "sex objects", as housewives, mothers, homemakers; and men in situations of authority and dominance over women' (1982; pp. 97–98).

We can get some idea of what is at issue here by looking at certain studies of the representation of women in advertising which suggest that things may not have changed that much since some of the earlier studies were carried out. Dyer cites a study from 1981 which surveyed 170 different television adverts. It

found that 66 per cent of the central figures in financial ads ... were men or 'voiced-over' by men. In all ads men were depicted as independent, whereas women were shown as dependent. Men were typically portrayed as 'having expertise and authority', as being objective and knowledgeable about the product; females were typically shown as consumers of products. Of the central figures shown in the home, 73 per cent were women and of the people who voiced no argument about the product, 63 per cent were women, ... Male voiceovers were used in 94 per cent of the sample of ads for body products, 83 per cent of home products and 80 per cent of food products. These figures confirm similar content analyses of ads on American TV.... TV commercials clearly portray sex-role stereotypes, and according to some researchers repeated exposure to such stereotypes must influence the learning of sex-role stereotypes. The British research suggests that advertisements are not even approximately accurate in reflecting the real nature of sex roles. In 1978, for instance, 41 per cent of all employees in the UK were women. In the sample of British ads women comprised a mere 13 per cent of central characters portrayed in paid employment.

(ibid.; pp. 108-109)

Dyer therefore concludes: 'the treatment of women in ads amounts to what an American researcher has called the 'symbolic annihilation' of women. In other words, ads reflect the dominant social values; women are not important, except in the home, and even there men know best, as the male voice-over for female products suggests' (ibid.; p. 109).

We can compare these findings with a more recent study which tends to come to similar conclusions. This is a content-analysis study of sexual stereotyping in British television advertising, based on a sample of 500 prime-time television adverts, and carried out by Cumberbatch for the Broadcasting Standards Council in 1990.5 It tends to show the continuation of the stereotyping we have already come across. There were twice as many men as women in the adverts; 89 per cent of the adverts used a male voice-over, even if the advert itself prominently featured women; the women featured in the adverts were usually younger and more attractive than the men - 34 per cent as against 11 per cent - while 1 in 3 of the women were judged to have 'model looks' as compared with 1 in 10 of the men; 50 per cent of the women were between 21 and 50 years of age compared with 30 per cent of the men, while 25 per cent of the women were over 30 years of age compared with 75 per cent of the men. Men were twice as likely to be shown in paid employment compared with women, and when shown at work it was depicted as being crucial to men's lives whereas 'relationships' were shown to be more important for women. Only 7 per cent of the sample showed women doing housework, but they were twice as likely to be shown washing and cleaning than men. Men were more likely to be shown cooking than women - 32 per cent as against 24 per cent - but in these cases the cooking was for a special occasion and/or demanded the use of particular skills, and was not portraved as a domestic chore. In the 31 per cent of cases in which men were shown doing housework, it was usually seen as being performed for friends, whereas when women did housework it was usually seen as being for their family, their partner or for themselves. Lastly, women were twice as likely to be depicted as both being married and receiving some type of sexual advance (presumably not in the same adverts) as compared with men.

This particular perspective, along with the use of content analysis as a research method, is associated by some feminist writers with what has come to be called liberal feminism. This type of feminism is said to be concerned with the way sex role stereotyping in the media reinforces it in the wider society. It argues that people are socialised into sex roles by such agencies as the mass media and the family. It demonstrates its case through content analyses, and demands more realistic representations of women in popular culture, as well as greater employment opportunities for women in the media industries. Van Zoonen describes it as follows: 'in liberal feminist discourse irrational prejudice and stereotypes about the supposedly natural role of women as wives and mothers account for the unequal position of women in society. General liberal principles of liberty and equality should apply to women as well' (1991; p. 35). Feminists have themselves become critical of this approach whilst not forgetting the advances it has made. There appear to be three major reasons why some schools of feminist thought have moved away from this position: the inadequacies of content analysis; the relative neglect of wider structures of economic, political and cultural power; and the absence of explanatory theories which can account for sex role stereotyping. As a result, feminists have turned to theories like semiology, structuralism, Marxism and psychoanalysis, as well as to theories of patriarchy.

We can illustrate these developments by remaining with the example of advertising. One of the apparently most significant changes which has been noted in this area has concerned the incorporation of 'feminist' demands and 'women's liberation politics' into advertising itself. This is something which, it is argued, a liberal feminism equipped only with a content analysis methodology, and the politics of equal opportunities, cannot adequately explain. Dyer notes this trend, which she sees as an aspect of the protective way advertising deals with criticism:

some advertisers, aware of the objections of the feminist movement to traditional images of women in ads, have incorporated the criticism into their ads, many of which now present an alternative stereotype of the cool, professional, liberated women.... Some agencies trying to accommodate new attitudes in their campaigns, often miss the point and equate 'liberation' with a type of aggressive sexuality and very unliberated coy sexiness.

(1982; pp. 185–186)

Similarly, Gill has shown how an advert, which uses a demand raised by the feminist movement – specifically in abortion campaigns ('a woman's right to choose') – as a slogan for a holiday for young people ('club 18–30'), would have to be judged to be 'feminist' on the basis of an atheoretical approach which relied upon content analysis. She argues that a more theoretically informed and qualitative approach, making use of ideas drawn from Marxism, structuralism and semiology, would readily reveal how the advert was really still rooted in a sexist conception of the role of women. She writes accordingly about her chosen example:

the language of the advert is militant and demanding, in keeping with the slogan. Traditional content analysis would register this, noting words like 'rights', 'choose', 'freedom', 'express herself' and 'without constraint'. A feminist researcher using content analysis may then conclude that this is an advert which affirms feminist ideas, one which embodies a 'positive image' of women. However, the advert might be interpreted quite differently by someone using a more qualitative and interpretive method of analysis. Looking at the text we can see that in this advert a woman's right to choose is being limited to choices about her individual style which, in turn, are reduced to a choice about what to consume (i.e. what holiday to book). The meaning of the slogan has been changed: what was essentially a collective political demand is reduced to an individual personal one, concerning which of the 51 18-30 resorts to visit. This transformation of meaning has turned the feminist idea that the 'personal is political' on its head - by reducing the political to personal choices.... Further detailed examination of the language used by the advert and the way the message is

structured might lead us to believe that it is an example of ... the co-option or incorporation of feminist images – which are used in such a way as to empty them of their progressive meaning.

(1988; p. 36)

This brief discussion of women and advertising has been intended to illustrate the feminist critique of popular culture, and some of the points at issue between different feminist approaches to its study. We now need to consider these points, and others, in more general terms.

The feminist analysis of popular culture

Feminism and mass culture

One way of appreciating the difference between the feminism we have looked at so far and the ones we shall discuss below, as well as the transition between feminist critiques and analyses of popular culture, is provided by Modleski's account of the relationship between gender and mass culture. Her account is a radical one since it goes beyond saying women have been 'annihilated' by popular culture and cultural studies to question the very language and assumptions in terms of which popular culture has been asscssed.

Modleski's general point is that gender is fundamentally significant for the study of popular culture, and has particular relevance for the concept of mass culture. This might now appear relatively uncontentious, but Modleski's argument refers us to the very categories with which we think about popular and mass culture. Her argument about gender is one which she suggests has rarely been acknowledged previously, and is contrasted with the view that gender is one additional dimension or aspect which has to be included to make the picture of popular culture more complete, one position among many, one point of opposition to mass culture which has not been taken into consideration before. For Modleski, the matter goes much deeper. She argues that 'our ways of thinking and feeling about mass culture are so intricately bound up with notions of the feminine that the need for a feminist critique becomes obvious at every level of the debate' (1986; p. 38). Her concern is with the way in which women have been held responsible for mass culture and its harmful effects, while men are seen as having the responsibility for high culture or art. Thus mass culture is identified with the feminine while high culture is identified with the masculine.

The case which Modleski has in mind is put forward by Douglas. This not only says that the work of nineteenth-century women writers is inferior to that of their male contemporaries, but holds women responsible for the emergence of mass culture. She thus quotes Douglas, who is writing about Harriet Beecher Stowe's novel *Uncle Tom's Cabin* and her character Little Eva, as follows:

Stowe's infantile heroine anticipates that exaltation of the average which is the trademark of mass culture ... she is ... the childish predecessor of Miss America, of 'Teen Angel', of the ubiquitous, everyday, wonderful girl about whom thousands of popular songs and movies have been made ... in a sense, my introduction to Little Eva and to the Victorian scenes, objects and sensibility of which she is suggestive was my introduction to consumerism. The pleasure Little Eva gave me provided historical and practical preparation for the equally indispensable and disquieting comforts of mass culture.

(ibid.; p. 40)

According to Modleski, the point here should be to find out why women are constrained to be concerned with consumption in patriarchal societies rather than blaming them for the rise of consumerism.

It is the kind of argument presented by Douglas, amongst others, which, for Modleski, 'has provided the historical preparation for the practice of countless critics who persist in equating femininity, consumption, and reading, on the one hand, and masculinity, production and writing on the other' (ibid.; p. 41). This also serves to expose 'the masculinist bias of much politicallyoriented criticism that adopts metaphors of production and consumption in order to differentiate between progressive and regressive activities of reading (or viewing, as the case may be)' (ibid.; p. 42).⁶ Thus Modleski shows how the very terms used to assess mass culture and subordinate it to high culture are derived from, and refer back to, the sexist constructions of femininity and masculinity to be found in the wider society. It is not merely a question, then, of adding in gender as another feature of popular culture, but of understanding and challenging the hierarchy of categories which elevates the masculine and subordinates the feminine in examining popular culture. In a way, the perspective Modleski is critical of operates with a set of oppositions which privileges the masculine and art at the expense of the feminine and mass culture:

Mass culture (popular culture)
Femininity
Consumption
Leisure
Emotion
Passivity
Reading

It can therefore be suggested, for example, that the fear expressed by high culture critics about the role of mass culture in making its audiences passive and vulnerable, and prone to consumerism, is equally a fear about the audience becoming feminine, indicating, for Modleski, how central gender is to our understanding of popular culture.

Feminist theory and the critique of content analysis

A key problem with the feminist perspective we considered in the first section arises from its view that the mass media should reflect reality, the reality of women's lives in a society which does not confer the same privileges upon women as it does upon men. But, as Van Zoonen asks, who can actually define this reality since

feminists themselves do not agree on its character for women? (1991; p. 42). The feminism she identifies as liberal feminism sees legislation and increased equality of opportunity as ways of undermining the 'unrealistic' portraval of women in popular culture. Other feminist arguments we shall look at take a different view. Van Zoonen cites the radical and socialist feminist perspectives as well as what she sees as a cultural studies feminist approach (ibid.; cf. Baehr: 1981; pp. 46-47). These argue that societies like our own are endemically sexist since they are rooted in patriarchal relations, and at best, remedial action, like equality of opportunities legislation, can only influence things at the margins. Gender inequalities and exploitation are much more systematic and qualitative than liberal feminism seems able to bargain for, and it is in these terms that the mass media have to be understood and explained. The media are not simply being devious in showing women in stereotypical roles, but have a far more basic role in helping to define and shape the fundamental meanings of femininity and masculinity. From this point of view, these are not identities which exist unambiguously elsewhere, and then come to be distorted by popular culture. They are, in part, constructed and reproduced through popular culture by the work of mass media institutions. Liberal feminism fails to appreciate these points because it is atheoretical, neglects the wider structures of patriarchal power and sticks to the findings unearthed by content analysis.

An important prerequisite for the development of alternative feminist theories has therefore been the critique of content analysis. While this method obviously has general relevance for research in the social sciences, it has tended to occupy a significant if not unique place in media and cultural studies. It is usefully defined by Dyer in the following terms:

the basic assumption of content analysis is that there is a relation between the frequency with which a certain item appears in a text/ad and the 'interest' or intentions of the producer on the one hand and on the other, the responses of the audience. What the text is all about or what the producer means by the text is 'hidden' in it and can be revealed by identifying and

192

counting significant textual features. Content analysis is usually confined to large-scale, objective and systematic surveys of manifest content using the counting of content items as the basis for later interpretation.

(1982; p. 108)

We have already seen the kind of results it can yield when used to analyse representations of women in advertising.

A number of feminist writers have been highly critical of this use of content analysis. These writers do not deny altogether the validity or the value of the findings it has given rise to, but rather wish to make clear its limitations.⁷ Let us look at a number of these criticisms. It is claimed that content analysis is atheoretical in that it is not linked to an explanatory theoretical framework, but is treated uncritically as a quantitative research method. The contrast being drawn here is with something like psychoanalysis in which a method (therapy) is linked to a theory of the human psyche (the Freudian notion of the subconscious). It is similarly thought to be atheoretical since it is not based upon an explanatory account of the relation between the popular cultural text being analysed and the social structural context in which it can be located, including, very importantly, its underlying power relations. According to Baehr, 'studies which describe sexist content cannot help us to understand the relationship between the content described and the social structures which produce it and within which it operates' (1981; p. 46).

This lack of theoretical discrimination is also evident in the way content analysis is said to emphasise quantity at the expense of quality. This is not completely true. For example, the study of television advertisements by Cumberbatch, cited above, was able to discriminate between the quantitative fact of more men than women being portrayed cooking, and the qualitative fact that this cooking was shown to be a skilled accomplishment for special occasions. None the less, content analysis does concentrate upon the differing numbers of men and women represented performing particular roles rather than asking questions about how and why representations occur in the ways they do. These questions can

FEMINISM

only be asked and answered in a theoretically informed manner which takes account of the structures of power between the genders.

This lack of qualitative discrimination is bound up with the failure of content-analysis based studies to distinguish between different levels of meaning. This line of criticism obviously owes much to the adoption of alternative theoretical frameworks like semiology or Marxism which argue that there are covert or hidden levels of meaning which lie behind and give rise to the overt or superficial meanings which content analysis deals with. The difficulties associated with this opposition between a quantative method and the study of overt meanings on the one hand (content analysis) and a qualitative method and the study of covert meanings on the other (semiology or structuralist analysis) is brought out well by Baehr. She writes:

for example, one woman newsreader reporting an item on 'militant bra-burning feminists' numerically equals one woman newsreader reporting on feminists' 'reasonable case for abortion on demand'. The method enumerates the visible form (i.e. both newsreaders are women) but leaves out the important question of the difference in the content presented. An increase in the number of female newsreaders here implies a change for the better. But as we already know that news coverage of women concentrates on their appearance. sexuality, etc. . . . more women reading the same old news simply reaffirms the very framework which reproduces sexism. That is not to say that more women should not be employed at all levels of media production, but it does suggest that content analysis as a methodology implicitly influences the kinds of questions asked and that the conclusions it draws may work against feminist interests.

(1981; p. 147)

This more qualitative evaluation of newsreading and female representations, informed by theories which stress the basic importance of covert meanings, rests upon a critique of content analysis, its politics and its research agenda. Not all feminists share Baehr's position. Muir argues, for example, that 'recent feminist debates have used psychoanalytic theory to explore why the "male gaze" is dominant in mainstream cinema. But there may be a more concrete (if related) explanation: that the masculine point of view is prevalent simply because men control the industry' (in Gamman and Marshment: 1988; p. 143). Content analysis can therefore be mobilised to support this position by quantifying the prevalence of the masculine point of view in popular culture, just as other types of statistical evidence can identify male control over the media industries.

However, the feminist critique of content analysis has not confined itself to the criticisms outlined so far. It has been claimed that content analysis can only, at best, provide a static picture of social and gender relations and representations of women and men. Again the problem is an explanatory one. While content analysis can give some idea of what gender representations look like at particular points in time, it fails to go beyond purely descriptive accounts. It is not designed to answer questions like where do cultural representations come from?; how do the different types of representation to be found in various areas of the media fit together?; and how and why do representations change over time? Without some kind of theory, it is difficult to begin to answer these questions. Content analysis rests upon the claims that media representations are coherent and uniform, not ambiguous or contradictory, and that the sex role stereotypes presented by the media are clear and consistent, not complex and open to varying interpretations.

Likewise, content analysis claims to be objective but depends upon the categories it defines to study media texts. The objectivity of the categories it uses can therefore be questioned. They may, for example, embody certain theoretical or political presuppositions which support its more general orientation but which, since they remain implicit and unstated, cannot be argued over. The choice of the categories with which content analysis works involves theoretical and political decisions. If these were to be made apparent they would often undermine the claims made to objectivity. Lastly, as we have already seen in our discussion of women and advertising, content analysis is ill-equipped to understand those instances in which popular media culture attempts to incorporate feminism, or to recognise the use of feminist claims and arguments for purposes which are at odds with the interests of feminism.

Feminist theory, patriarchy and psychoanalysis

The capacity of the mass media to reflect the reality of women's lives in patriarchal, capitalist societies is something which is important to the liberal feminist viewpoint, and can clearly be examined by a content analysis methodology. Content analysis can be used to show how cultural representations of women, say in advertising, distort the reality of women's lives, portraying a fantasy world rather than the one women actually live in. But as we have already indicated, feminists have questioned this view by asking who is to define the objective reality the media have to represent? They have pointed out that some cultural stereotypes may have their social equivalents or at least elements of them in the 'real' world (some advertisers, for example, aim their products at women because they are the main consumers of certain products), and have criticised the contention that cultural representations must either be real or unreal (the representations of women in soap operas, for example, might be difficult to understand if they are thought to be purely fictitious).

Underlying these differing methodological and analytical assumptions is a difference between, on the one hand, theories which take for granted the media's ability to reflect reality if ideological distortions are removed, and, on the other, theories which see the media and popular culture as playing a crucial part in the construction of reality. As we have seen, semiology, for example, does not necessarily deny that an objective reality exists, but it does insist that our knowledge of it is culturally generated by such things as language. These theoretical perspectives have been turned to by feminists both to criticise, without denying the value of, earlier feminist critiques and analyses, and to develop alternative theories and analyses of gender oppression and popular culture. For feminists adopting these theoretical strategies, reality cannot be taken for granted. It has to be theorised, and understood as something which is constructed, in very important respects, by cultural and ideological processes. It has therefore to be analysed by different theoretical perspectives drawn from structuralism, psychoanalysis and Marxism, and by more adequate concepts like patriarchy.

Responding critically to the cultural representations of the 'liberated' woman in adverts and police series, Baehr provides a succinct summary of these points, and points towards the adoption of alternative theories:

The fact that heroic women have supplemented heroic men on the screen involves us in more than just media headcounting. It brings us back to questions concerning the media's crucial role in the construction of meaning and in the re-construction and representation of feminism and feminist issues within patriarchal discourse.... The media are not transparent. They do not, and cannot, directly reflect the 'real' world any more than language can. To argue that they do . . . is to deny the whole process of mediation which comprises a set of structures and practices which produce an ideological effect on the material they organise. By relying on a behaviourist type of 'direct-effects' model of the media these studies present a simplistic, unidirectional and reductive connection between media and behaviour, by arguing that the media determine and directly affect how we see ourselves and how we behave 'as women' in society. . . . This approach mistakes the relationship between the media and their users as a causal one. It is not the media in themselves that determine what women are. Women are constructed outside the media as well, and it is their marginality in culture generally and in the media which contributes to their subordinated positions.

(1981; pp. 148-149)

Instead, attention needs to be given to 'the vital questions which explore the relationship between women's subordination in terms of their "economic" place in patriarchal relations under capitalism and the representation of those relations in the ideological domain which women inhabit and construct' (ibid.; p. 149).

This approach needs to recognise that 'much of the feminist contribution to the debate on the ideological role of the media in society draws its theoretical framework from the massive input of new theories from France', including semiology, structural linguistics, Althusser's Marxism and Lacanian psychoanalysis (ibid.; pp. 145–146). Thus:

a feminist analysis requires us to extend the study of the way the media operate in relation to the dominant bourgeois ideology to how they function within a patriarchal culture where 'preferred' meanings reside in a male discourse . . . the crucial question then becomes: how are media images and representations of 'femininity' constructed within patriarchal social and sexual relations of production and reproduction? (ibid.: p. 145)

This form of feminist analysis has involved the development of more theoretically informed perspectives and concepts which it would be useful to outline briefly. Patriarchy can be viewed as a social relationship in which men dominate, exploit and oppress women.8 As a concept it defines the unequal relations between the genders, although it has to take note of the fact that not all men or all women are equally advantaged or disadvantaged. Other structures of inequality like class and race need to be taken into consideration. Hartman has suggested 'we can usefully define patriarchy as a set of social relations between men, which have a material base, and which, though hierarchical, establish or create interdependence and solidarity among men that enable them to dominate women' (1979; p. 11). The concept of patriarchy refers to the unequal power relationship between men and women which serves as a key determinant of how women and men will be represented in popular culture, and of how they will respond to those representations. Patriarchy as a concept clearly has much wider implications, and has been the subject of much debate over how it is to be defined, and how important it is. But viewing it in

this way helps to clarify its role in feminist analyses of the media and popular culture.

One example of the role this idea has played in the development of feminist theory and analysis has concerned the way it has been combined with psychoanalytic theory to analyse how and why men look at female representations in contemporary popular culture, and the implications of this for the power men have over women. This argument is particularly identified with the work of Mulvey (1975). As Gamman and Marshment succintly summarise her case:

Mulvey's thesis states that visual pleasure in mainstream Hollywood cinema derives from and reproduces a structure of male looking/female to-be-looked-at-ness (whereby the spectator is invited to identify with a male gaze at an objectified female) which replicates the structure of unequal power relations between men and women. This pleasure, she concludes, must be disrupted in order to facilitate a feminist cinema.

(1988; p. 5)

However, Mulvey herself (1981) has subsequently expressed some reservations about the overly deterministic nature of this position, while it has more generally been criticised for ignoring both how women may subvert or negotiate the male gaze, and how popular culture also offers opportunities for women to 'gaze' at female protagonists. Moreover, it is argued that the psychoanalytic approach tends to reduce everything to gender, and thus neglects other crucial dimensions of power which affect patriarchal relations like class and race, and which subsequent feminist analyses have wished to incorporate into their theoretical frameworks.

Patriarchy is a concept and its meaning will vary to some extent according to the theoretical framework within which it is used. What has been called radical feminism conceives of it as referring to the all-embracing and universal domination of women by men, whereas socialist feminism, while it values patriarchy as a central explanatory factor, does also take account of other important systems of exploitation like class and race. Indeed, a general concern of socialist feminism has been how to reconcile analyses of patriarchy with analyses of capitalism. Van Zoonen, for example, defines radical and socialist feminism in these terms (cf. McIntosh: 1978). For her, radical feminism not only views patriarchy as the most basic and historically universal structure of oppression, akin to the economy or mode of production in Marxism, but can also interpret masculinity and femininity as innate biological characteristics of men and women. It argues that 'since mass media are in the hands of male owners and producers, they will operate to the benefit of patriarchal society.... the power of the media to affect men's behaviour towards women and women's perception of themselves is beyond discussion' (1991; p. 37). Radical feminism has focused much of its discussion of the media on the role of pornography, since some of its proponents regard this as the most graphic expression of the relation between patriarchy and popular culture.⁹

This theory is open to the criticisms we have already made of dominant ideology theories and ruling class models of ideology. It tends to obscure the complexity of the relations it analyses in three specific ways. First, there is no simple, direct and causal relationship between the media and its audience. Second, the media do not represent genders in a direct and uniform manner. And third, there is no necessary uniformity of interest amongst men on the one hand, and women, on the other, towards what is represented by the media. Also its exclusive concentration on patriarchy can be criticised because it ignores other significant structures of power like class. These arguments have led to the development of socialist feminism, which has retained concepts of patriarchy and patriarchal ideology, whilst rejecting their association with biological definitions of gender. For this and other perspectives emerging within the area of cultural studies, gender is socially and culturally constructed rather than biologically conditioned.

Unlike radical and liberal feminism, socialist feminism does not focus exclusively on gender to account for women's position, but attempts to incorporate an analysis of class and economic conditions of women as well ... more recently, socialist feminism has tried to incorporate other social divisions along the lines of ethnicity, sexual preference, age, physical ability since the experience of, for example, black, lesbian and single women did not fit nicely in the biased gender/class earlier model.

(ibid.; 1991; p. 38)

A problem for the socialist feminist perspective has been how to retain a theoretically coherent hold over all these crucial divisions, one which goes back to the debates in the 1970s over how to reconcile feminist and Marxist theory.¹⁰ The difficulty here concerns the development of a framework adequate enough to account for such a range of social inequalities. As it stands, this perspective is also open to either the economic reductionism of Marxism or the gender reductionism of patriarchal theories of society. Aligned with this, it can, like liberal and radical feminism, fall prey to a theory in which the mass media simply act as a conveyor belt for patriarchal ideology, and in which the female audience becomes merely a mass of passive consumers imbued with false consciousness. However, despite this affinity with Marxist conceptions of popular culture as a dominant ideology and thus with the difficulties it gives rise to, the debate over socialist feminism and the criticisms it has attracted has laid the ground for further feminist analyses of popular culture and the mass media, as well as for subsequent theoretical departures and innovations. Just as liberal feminism has been associated with a particular type of empirical study, so the turn to certain types of theory imported from the continent of Europe has been associated with important and influential studies which have developed feminist theory and the feminist analysis of popular culture.

Feminist theory and the study of ideology

A good example to consider in the light of what has been argued in the previous section is McRobbie's work on female youth subcultures and popular culture. No doubt this work is by now a bit dated, and it is clearly no longer representative of feminist analyses of popular culture.¹¹ However, it is a useful example to discuss for a number of reasons. It makes use of a number of different theoretical ideas, including semiological modes of analysis as well as concepts drawn from the work of Althusser and Gramsci, in order to account for its chosen subject matter. It is a familiar example, much discussed in the secondary literature. Likewise, it brings out very clearly the limitations of some of the ideas and approaches it uses, a critique which can be developed below by looking at other work and subsequent theoretical developments.

McRobbie's best known work has concerned the subcultures of young working-class girls, and has in particular concentrated on the ideology of the teenage girls' magazine *Jackie*. Her position has shifted somewhat since the original arguments were published, but the initial theoretical ideas which guided her research seem clear. In studying 'the way in which the girls experience the school, the family, and the youth club', she writes:

the assumption upon which this is based, is that each of these institutions attempts to mould and shape their subjects' lives in particular ways. One of their central functions is to reproduce the sexual division of labour so that girls come willingly to accept their subordinate status in society. This work is done primarily through ideologies which are rooted in and carried out in, the material practices specific to each of these institutions.

(1991a; p. 44)

This approach owes something to Althusser's theory of ideology, but even here McRobbie draws back from its full-blown determinism:

from the evidence of this piece of work, it can be argued that there is no mechanical acceptance of these ideologies on the part of the girls ... Althusser's claim that the ideological state apparatuses ensure 'subjection to the ruling ideology' is not so unproblematic ... the girls' existence within them and experience of them, was clearly more a matter of 'gentle' undermining, subtle redefinition and occasionally of outright confrontation.

(ibid.)

Of course, if ideologies do not work in the way they are supposed to, how can the sexual division of labour be reproduced? However, this does show how, for McRobbie, the specific effects of ideologies is a matter of empirical assessment as opposed to theoretical dogma.

In relation to this work, McRobbie has conducted an ideological analysis of Jackie. In keeping with what we have noted about her approach so far, McRobbie sees the function of the magazine as being to 'position' girls for their later roles as wives and mothers by means of the ideology of teenage or adolescent femininity it cultivates.¹² In contrast to the liberal feminist approach, the magazine is conceived of as a system of signs embodying this particular ideology which tries to secure the acceptance or 'consent' of young girls as individual 'subjects' to its specific codes and values. The magazine directly addresses a young female audience on the basis of a consumerism and a culture which defines female adolescence and which hides differences within this group arising from inequalities like class and race. It does its work in the realm of leisure time, defined as free time, time away from work, which, for McRobbie, is part of 'civil society', 'the sphere of the personal or private'. It is here that hegemony is sought after and secured. 'Teenage girls are subjected to an explicit attempt to win consent to the dominant order - in terms of femininity, leisure and consumption, i.e. at the level of culture' (ibid.; p. 87).

To fill in the detail of this argument that the magazine acts as a powerful ideological force, McRobbie turns to semiology to unearth the codes which constitute the ideology of female adolescence. This method is preferred to content analysis in line with the critique I discussed above. Despite it being new and hardly foolproof, semiology

has more to offer than traditional content analysis, because it is not solely concerned with the numerative *appearance* of the content, but with the messages which such contents signify. Magazines are specific signifying systems where particular messages are produced and articulated. Quantification is therefore rejected and replaced with understanding media messages as *structured wholes* ... semiological analysis proceeds by isolating sets of codes around which the message is constructed ... these codes constitute the 'rules' by which different meanings are produced and it is the identification and consideration of these in detail that provides the basis to the analysis.

(ibid.; p. 91)

This methodology, including its associated distinction between denotation and connotation, allows McRobbie to uncover the 'culture of femininity' which 'as part of the dominant ideology', 'has saturated' the lives of young girls, 'colouring the way they dress, the way they act and the way they talk to each other. This ideology is predicated upon their future roles as wives and mothers' (ibid.; p. 93). Thus, while she does not wish here, as well as in her later work, to see these young girls as the passive victims of a dominant ideology or the capitalist and patriarchal quest for hegemony, it is difficult to make sense of her analysis if the ideology of *Jackie* does not have the specific effect of determining the beliefs and behaviour of its readers.

Semiological analysis is thus used by McRobbie, in combination with ideas drawn from Althusser and Gramsci about the prevalence of a dominant ideology, to discover a number of codes in *Jackie* which serve to define its ideology of teenage femininity, and allow it to act as a powerful force on the lives of its readers. There are four such codes McRobbie chooses to identify, although she is quick to point out that these are by no means the only ones which can be identified.¹³ The first of these, and perhaps the most important, is the code of romance, also termed 'the moment of bliss' (ibid.; p. 94). This code involves 'the individual girl looking for romance', finding the 'right' boy, although it has to confront the problem that romance may not last. Hence:

the code of romance realises, but cannot accept, that the man can adore, love, 'cherish' and be sexually attracted to his girlfriend and simultaneously be 'aroused' by other girls. It is the recognition of this fact that sets all girls against each other, and forms the central theme in the picture stories.... No story ever ends with *two* girls alone together and enjoying each other's company.... They cancel out completely the possibility of any relationship other than the romantic one between girl and boy.

(ibid.; pp. 98-99, 101)

The second code is 'the code of personal life: the moments of anguish' (ibid.; p. 108), which concerns 'real life' difficulties and the 'problem' page in the magazine. The replies offered to readers tend to confirm and reinforce the ideology of adolescent femininity to be found elsewhere in the magazine (ibid.; p. 117). The third code is 'the fashion and beauty code' (ibid.), which instructs readers on how to look and dress in order to be able to fulfil the demands of this ideology, as well as being inducted into 'the sphere of feminine consumption' (ibid.; p. 125). Lastly, there is the code of pop music which involves stars and fans (ibid.). Her survey of these codes allows McRobbie to reach the following conclusion:

Jackie sets up, defines and focuses exclusively on 'the personal', locating it as the sphere of prime importance to the teenage girl. This world of the personal and of the emotions is an all-embracing totality, and by implication all else is of secondary interest. Romance, problems, fashion, beauty and pop all mark out the limits of the girl's feminine sphere. Jackie presents 'romantic individualism' as the ethos par excellence of the teenage girl. The Jackie girl is alone in her quest for love.... Female solidarity, or even just female friendship, has no real existence in the magazine.... This is ... a double-edged kind of individualism since, in relation to her boyfriend ... she has to be willing to give in to his demands, including his plans for the evening, and by implication, his plans for the rest of their lives.

(ibid.; p. 131)

Despite her desire not to pre-empt questions about how such an ideology may actually influence the actions and values of the magazine's readers, about 'how girls read *Jackie* and encounter its ideological force' (ibid.; pp. 131–132), McRobbie concludes with a

view of the relationship between popular culture and its audiences which seems to be common to theories of popular culture. This view is defined by the ideology of feminine adolescence, which, 'as it takes shape through the pages of *Jackie* is immensely powerful, especially if we consider it being absorbed, in its codified form, each week for several years at a time' (ibid.; p. 131). All audiences therefore inevitably succumb to the power of ideology.

Feminist analysis, semiology and ideology

I now want to consider some of the criticisms which can be made of McRobbie's study, and by implication of studies like it, partly to extend the critiques advanced above of semiological and Marxist theories of popular culture, and partly to chart the direction taken by feminist analyses of popular culture in the context of critical debates over the use of these theories in empirical studies. This critical overview concentrates upon two particular themes: the debate over the relative merits of semiological or contentanalysis approaches to the study of popular culture; and the relationship between ideology, popular culture and audiences.

It is evident, even in McRobbie's own study, that the value of content analysis cannot be so easily dismissed. At a number of points, claims are made which are as consistent with content analysis as they are with semiology. McRobbie makes it clear that she is using the latter rather than the former, but in talking about the problem page in *Jackie*, for example, she says 'it is boyfriend problems which occupy the dominant position', and that 'the stock response' of the advice offered by the writers of the page 'is to become more independent and thus more confident' (ibid.; p. 114). Now these claims are quantative as well as qualitative in character. They could have been enumerated, and could perhaps have been defined more precisely if content analysis had not been so readily dismissed.

In the critical comments made in chapter 3, I argued that despite its pretensions semiology has often been arbitrary in the conclusions it reaches. We can also find this in McRobbie's analysis. She wishes to suggest, for example, that the magazine's focus on the personal, the emotional and the individual makes everything else appear to be of secondary importance. The young girls it addresses thus have to compromise their individuality and independence by giving in to the wishes of their boyfriends over where to go for a night out, and hence over the course of the rest of their lives. This suggestion is made by McRobbie as if 'by implication'. It is not directly argued for in the text. Neither is it objectively validated by semiological analysis. But it is an inference drawn by the analyst as a result of her initial starting-point. It has therefore to remain an arbitrary judgement, the result of the analyst's ideological position, unless and until some more objective basis, including some empirically plausible basis, can be established.

This arbitrariness is particularly noticeable in the way semiological analysis prides itself upon discovering latent meanings lving behind, and hidden by, the surface qualities of the cultural text. Arbitrariness here takes two forms, one concerning the validity of this kind of distinction, and the other concerning the exaggerated significance attached to hidden, covert or latent meanings and messages. First, if both kinds of meaning - overt and covert, or denotative and connotative - can in fact be determined, a number of questions are raised. Why privilege one set of meanings over another? Why should the surface meaning be dismissed if it is the one most people recognise? Why presume that once the 'preferred' meaning is discovered, there are no more meanings to be found which are even more 'hidden'?¹⁴ How can meanings which are covert have more impact upon people's consciousness than meanings which are overt? If people are only aware of the latter, why are they so likely to be influenced by the former. All sorts of assumptions about influence are made by semiologists which they never really try to decode.

Second, critical questions can be raised about the significance semiology accords its interpretations of the hidden meanings it uncovers. These are supposed to be explanatory and objective but often turn out, on inspection, to be arbitrary and subjective. Barker brings this feature out very effectively in his critique of McRobbie's study. He notes, for example, McRobbie's claim that in order to make its ideology acceptable to its readers, *Jackie* makes itself entertaining and pleasurable to read. The surface meaning in this instance is that the magazine is 'fun' to read which is evident to McRobbie because of its 'lightness of tone ... which holds true right through the magazine particularly in the use of colour, graphics and advertisements. It asks to be read at a leisurely pace indicating that its subject matter is not wholly serious, and is certainly not "news"' (ibid.; p. 90). This quality serves to obscure the ideology which is at work in the magazine (but which can be uncovered by the semiological analysis of its codes), while it ensures that the target audience will actually read the magazine. But this quality can be interpreted in another way. As Barker asks: 'why shouldn't we take this [*Jackie*'s lightness of tone] as a hint from *Jackie* not to become too engrossed, to take its pronouncements with a pinch of salt? In other words, why should it not be a *modification* of the message?' (1989; p. 158). He continues:

this is a good example of semiology's becoming unassailable through making arbitrary distinctions, then declaring these arbitrary elements to have coded significance. Semiology requires this division of the surface features into those containing the ideology, and those which disguise it and act as transmission aids. There are no objective ways of deciding which is which. Therefore the method can only prove whatever the analyst 'knew in advance'. McRobbie knew that *Jackie* does not paint a feminist picture. Thus she was bound to discover in it an anti-feminist message.¹⁵

(ibid.; pp. 158–159)

In brief, without some more objectively grounded arguments, semiology is always likely to give rise to arbitrary interpretations.

Semiologists have responded to this with the idea that all cultural texts are polysemic.¹⁶ This means that texts contain a number of different messages, and are therefore open to a number of different interpretations. Semiological analyses are not intended to be objective, but merely try to tease out the variety of meanings to be discovered in the text. However, this not only undermines the validity of the conclusions semiology arrives at, but it has to come to terms with the fact that texts do not contain an infinite number of meanings, and are not open to an infinite number of interpreta-

tions. Objective criteria still need to be etablished in order to determine the limits which can be set on meanings and interpretations. In short, relativism is no answer. But, even more basic than this criticism is the fact that semiological studies like McRobbie's do claim to have arrived at valid and plausible conclusions.

We have seen how semiology is open to the criticism that it is ahistorical. McRobbie's study is no exception, and this is so despite its use of Marxist theory, and the criticism made of content analysis's failure to study history. Barker's own study of *Jackie* suggests that there have been significant changes in its treatment of things like romance, but McRobbie's position cannot entertain this possibility since the ideological work performed by the magazine could not otherwise be guaranteed. According to Barker,

from 1975 onwards there is a real decline in confidence in romance's possibilities ... this poses real problems for McRobbie's account. Recall that she saw in *Jackie* a monolithic ideology of real power, trapping girls into a false sisterhood of jealousy. Her sample (scattered through 1974–75) was her evidence of this. Her sample, though drawn without any reference to the history of *Jackie*, had to be treated as 'typical'; how else could she justify drawing such large implications about *Jackie*'s role in selling young girls the 'appropriate ideology of consumerist capitalism'.

(ibid.; pp. 178-179)

While raising questions about the value of McRobbie's study, these points also suggest that content analysis may have been too hastily dismissed. Certainly, semiology no longer seems able to fulfil its promise of providing a usable alternative. In addition to these criticisms, we now have to consider those which have involved the feminist analysis of the relationship between ideology, popular culture and the audience.

Feminist analysis, ideology and audiences

Perspectives and studies which rely upon methods and theories like semiology or Althusser's theory of ideology tend to take the view that ideology performs definite functions which clearly shape the attitudes and actions of those subject to its power. In McRobbie's study, ideology is seen to foster a culture of femininity amongst young working-class girls, which prepares them for their roles in later life as wives and mothers while encouraging their participation in consumer capitalism. This line of argument suggests that ideology will have the effects which the theory predicts. Otherwise, presumably people will not do the things they are supposed to be forced to do by ideology, like becoming wives and mothers. It is this argument I wish to examine critically since it begs a number of questions about the indispensable nature of ideology, and its influence over its subjects.

It is interesting that McRobbie affirms the need for the ideology she identifies to be necessary for the subject positions taken by young girls, irrespective of whether or not a magazine like Jackie is published. What is important is that the function of ideology is performed: 'of course, Jackie is not solely responsible for nuturing this ideology of femininity. Nor would such an ideology cease to exist if Jackie disappeared' (1991a; p. 83). However, a number of problems arise from this argument. First, it implies a straightforward functionalism by assuming that the function will inevitably be performed because it has to be performed. Second, it presumes that the ideology will find expression somewhere within popular culture because it is functionally necessary for its values to be inculcated into its target population. But if this is the case then why worry about the structure of the specific forms in which it finds expression, as semiology does, since these must merely act as an outlet for their ideological content. Popular cultural forms can make no difference if the ideology must be expressed in order to do its work. If they do make a difference, and affect and shape their ideological contents, then the functional effects of ideology cannot be guaranteed. Third, this argument tends to proceed on the assumption that only ideology can influence the ways people think and act, and neglects other factors which can shape the course of people's lives. Lastly, coming back again to the problem of history, if the ideology fostered by Jackie is so important then why have the sales of the magazine declined dramatically since the late 1970s

(ibid.; p. 170), and what other forms have been, and continue to be, capable of propagating this ideology?

As part of her general argument about the functional character of ideology, and as an indication of the uses of semiology in her study, McRobbie extends her analysis of the ideological role of *Jackie* to the nature of its appearance for its readers and potential readers. If its ideology is to be effective, it has to have a distinctive appearance for its readers in addition to its entertainment and fun values which we have already commented upon. In other words, it needs to appear as something which is natural and given, not something which is the result of a definite process of commodity production, nor something which is made for a profit. This is reminiscent of Barthes's idea that myths work by making what is ideological and historical appear to be natural and inevitable. McRobbie writes:

one of the most immediate and outstanding features of *Jackie* as it is displayed on bookstalls, newspaper stands and counters, up and down the country, is its ability to look 'natural'. It takes its place easily within that whole range of women's magazines which rarely change their format and which (despite new arrivals which quickly achieve this solidness if they are to succeed) always appear to have been there. Its existence is taken for granted. Yet this front obscures the 'artificiality' of the magazine, its 'productness' and its existence as a commodity. (ibid.; p. 92)

But as Barker asks, if this is the case, 'would it be hiding or revealing its existence-as-commodity more if the price were covered up?' (1989; p. 154). He argues that McRobbie mistakes the 'naturalness' of the magazine for its recognisable appearance which is not the same thing at all, and by no means hides the fact that the magazine is produced. Moreover, the magazine must struggle to hide its commodity status, since at some point its readers must actually fork out their money to buy it. Yet again, as Frazer indicates, the process whereby the magazine is produced is hardly that hidden from its readers. One of the participants in the discussion groups on *Jackie* which she studied remarked, 'I wonder who takes the pictures and who are the people?' (1987; p. 407). In fact, Frazer's study provides a very useful critique of McRobbie's study and the theory of ideology it relies upon, and it would be helpful for the concerns of this chapter if we discussed its arguments.¹⁷ What it does is raise some serious objections to this theory of ideology on both theoretical and empirical grounds. It presents 'some empirical data – the transcripts of discussion among seven groups of girls about a photo-story from *Jackie* magazine, and about *Jackie* and other girls magazines like it', which are 'used to underpin an argument about the use of the concept of 'ideology' in social theory and research' (ibid.).

Theoretically, the use of ideology as an explanatory concept is challenged for a number of reasons. First of all, ideology is taken to refer to a set of ideas which are false, misleading or distorting, and which can be contrasted with science which reveals the truth. For example, Marxist theories, such as the one put forward by Althusser, see ideology as the means by which the capitalist relations of production are reproduced, and contrast it with the truth expressed by Marxist science. There ought therefore to be a way of clearly and convincingly distinguishing between ideology and science but this is never made apparent. Second, in practice it is difficult if not impossible to equate the varied ideas and values that people normally hold with the coherent and unitary system of beliefs predicted by theories of ideology. Third, it is assumed by these theories that ideology itself exists within societies as a unitary system of belief, but it is difficult, when the topic is researched, to find examples of ideas which conform to the expectations of theories of ideology. Fourth, empirical research is not encouraged by the claim that ideology is hidden behind, and gives rise to, the ideas which can be found in societies and the beliefs which people hold. If ideology is such a phenomenon then to research it becomes a highly problematic task. This is not helped by the fact that the theorist often seems able to discern, intuitively, the ideology in question without doing any research, and without outlining the criteria by which it may be recognised and distinguished from superficial, non-ideological phenomena.

Frazer herself has no objection to the use of concepts in science which refer to unobservable entities, but she argues that

ideology as a concept is 'overly theoretical, in the sense that it is explanatorily unnecessary' (ibid.; p. 410). For her, the things that ideology is designed to explain, can be explained by 'concepts which are more concrete' (ibid.). At the heart of her critique of theories of ideology is her criticism of the supposition that ideology actually makes people think and behave in definite and distinct ways. Theories which use the concept of ideology, according to Frazer, tend to operate with a fairly crude model of causality. In this model, ideology determines the general set of cultural beliefs in a society, which in turn determine the beliefs and attitudes of the members of the society, which in turn finally determine how these people actually behave. It is this model, she argues, which is questioned by the empirical evidence. Ideology does not make people do things in the way the theory expects them to. The theory 'predicts that people will be more, or differently, affected by "ideology" than evidence actually shows they are' (ibid.).

Some of the best examples of this type of reasoning are those approaches, like semiology, which assume it is possible to infer the beliefs and actions of people from an analysis of the ideological content of the popular culture they consume. Once the analyst has determined the ideological meaning of a cultural 'text', then it must have this effect on its readers. For Frazer, this claim can be criticised, in the first instance, by asking whether texts do possess one valid and unitary meaning. Clearly, if it is claimed that texts are polysemic, then this must limit their ideological effectiveness. Second, it can be criticised by empirical research designed to find out if texts, even if they can be accorded a unitary meaning, do have ideological effects upon their readers. What, then, do her findings tell us about the young girls she spoke to in her research discussions and their reading of *Jackie*? And what does this tell us about the theory of ideology.

There are a number of points to be made here. First, Frazer argues that the young girls included in her research tended, on the whole, to read the magazine as fiction, distancing it from representations which might appear realistic. Second, these readers tended not to identify with the central characters in the stories, since 'these real readers were freer of the text than much theory implies' (ibid.; p. 417). Third, her analysis of the group discussions led her to the tentative conclusion that 'a self-conscious and reflexive approach to texts is a natural approach for teenage girls' (ibid.; p. 419). They were, after all, often highly critical of the magazine. Furthermore, they appreciated the type or genre of magazine in which *Jackie* could be placed, as well as its fictional character. And they were alive to the fact that it was a text which was produced, as the quote with which we introduced this study indicated, as opposed to a text which tried to appear natural (ibid.; p. 419).

These findings lead Frazer to discount the value of the theory of ideology, and to suggest another way of understanding how readers relate to popular cultural texts. Even if it were possible to determine the ideological meanings residing in these texts, Frazer's research questions the extent to which readers are influenced by these meanings, and certainly casts doubt on the more deterministic uses of the concept of ideology. Instead, Frazer wishes to use the concept of a discourse register in order to make sense of the relationship between readers and texts, or between audiences and popular culture. A discourse register is 'an institutionalized, situationally specific, culturally familiar, public, way of talking'. Frazer continues: 'my data suggest that the notion of a "discourse register" is invaluable in analysing talk - the talk of all the girls' groups I worked with is marked by frequent and sometimes quite dramatic shifts in register' (ibid.; p. 420). These registers both allow people to talk in specific situations and also limit what they can say. They have legitimate and illegitimate areas or contexts of use. They are also wide-ranging and diverse, and their use in social science does not aspire to discovering the unitary coherence of ideology. She writes: 'it's very clear from the transcripts of the groups' discussions that all the girls have a multiplicity of discourse registers available to use' (ibid.; p. 422), ranging from the problem page of teenage magazines, the tabloid press and the small group discussion to feminism. Discourse registers, unlike ideology, can be researched directly to ascertain 'the power of concrete conventions and registers of discourse to constrain and determine what is said and how it is said', including the assessment of 'the influence of popular culture' (ibid.; p. 424).

There are many valuable aspects to this approach, including its critique of deterministic theories of ideology, like semiology, Marxism and radical feminism, and its attempt to take seriously the task of empirically researching audiences for popular culture. However, it clearly cannot reject some of the issues raised by theories of ideology, even if it can successfully dispute their solutions. For a start, the use of the concept of discourse registers cannot really ignore the question of power, and this would be particularly difficult if the inspiration for the concept had been derived from Foucault's work. Using the concept of discourse registers may be valuable in questioning the argument that the power of ideas comes from the fact that they form a unitary and coherent ideology which serves the interests of the most powerful groups in society. None the less it cannot exclude these considerations completely. Particular discourse registers may indicate the power of certain groups to make them publicly available. Likewise, the relative lack of power of subordinate groups may mean they have to resort to the discourses of others. Where, after all, do discourse registers come from? Where do their sources lie, and under what conditions do they continue to be used? Who propagates them and who resists their propagation? Do discourse registers allow certain groups to exercise power and if so how? We might also ask if all discourse registers are of equal importance with respect to power relations or are some more important than others? If it were possible to construct a hierarchy of discourse registers based upon their importance as publicly available discourses, would this not be highly significant for the analysis of power relations? Not only is power crucial for understanding the history of discourse registers, it is equally crucial for determining why some discourse registers may be more significant than others (cf. Barker: 1989; pp. 251-253).

Conclusion

In this chapter I have not tried to present an exhaustive discussion of the feminist analysis of popular culture. Rather I have endeavoured to highlight some key arguments and studies in the development of this perspective in order to clarify some of the themes and issues it has covered, and to emphasise its general influence upon the study of popular culture. The chapter has also allowed us to see how theories and perspectives discussed in previous chapters have subsequently been used and criticised. As things stand at the moment, there is clearly a growing interest in the kinds of interests and studies represented by Frazer's work. Equally clear is the fact that a great deal of work is focused upon the theoretical issues and empirical problems associated with the general turn from structuralism, semiology and Marxism, to neo-hegemony theory and postmodernism.¹⁸ This is made apparent by Gamman and Marshment's definition of popular culture:

Popular culture is a site of struggle, where many of these meanings [of the power struggles over the meanings which are formed and circulate in society] are determined and debated. It is not enough to dismiss popular culture as merely serving the complementary systems of capitalism and patriarchy, peddling 'false consciousness' to the duped masses. It can also be seen as a site where meanings are contested and where dominant ideologies can be disturbed. Between the market and the ideologues, the financiers and the producers, the directors and the actors, the publishers and the writers, capitalists and workers, women and men, hetereosexual and homosexual, black and white, old and young – between what things mean, and how they mean, is a perpetual struggle for control.

(1988; p. 2)

The immediate outcome of this is evident in a number of ways. There is the emergence of 'populist' analyses based upon a notion of the recipient of popular culture as an 'active reader' or 'subversive consumer', which I shall discuss briefly in the conclusion. There is the apparent move away from text-based studies of popular culture towards more ethnographic studies (Moores: 1993; Stacey: 1994). There is the growing importance of the cultural studies approach to the analysis of gender which stresses

216

the following: the socially and culturally constructed and contested character of gender; the more powerful role of producers as opposed to consumers in the making of popular culture; the combination of textual analyses with ideas about the negotiated meanings of gender they entail; and the active reception practices of men and women which are conducted with reference to the unequal power relations between them (Van Zoonen: 1991; pp. 44–51).

The growth of a concern with the area of consumption within cultural studies has equally been a noticeable feature of recent feminist debates, and can be used to illustrate some of these points. In recent years, the view of women as passive consumers manipulated into desiring commodities and the luxuries of consumption by the culture industries has begun to be challenged by feminist theory and research. Within the context of the emergence of what has been termed 'cultural populism', it has been argued that this notion of the passive consumer undervalues the active role they play, the way their appreciation and interpretation of cultural consumption may diverge from that intended by the culture industries, as well as the fact that consumption cannot simply be understood as a process of subordination.

Consumption is a particularly important issue for feminists since women have often been defined as the main group of consumers by advertising, by capitalist industries and by much cultural theory. Challenges to this definition have thus been developed within cultural studies, though they do not necessarily share all the assumptions associated with cultural populism. Stacey, for example, in her study of the female audience for Hollywood cinema in Britain during the 1940s and 1950s, has no wish to underestimate the importance of cultural production. However, she presents a convincing argument to the effect that:

the meaning of femininity within cultural production ... is not synonymous with the uses and meanings of commodities to consumers. Following existing cultural studies work on consumption I shall suggest that women are subjects, as well as objects of cultural exchange, in ways that are not entirely reducible to subjection. . . . this work emphasises women's agency as consumers and highlights the contradictions of consumption for women.¹⁹

(1994; p. 185; cf. p. 176)

Thus consumption does not simply represent 'the power of hegemonic forces in the definition of woman's role as consumer', but rather 'is a site of negotiated meanings, of resistance and of appropriation as well as of subjection and exploitation' (ibid.; p. 187; cf. pp. 189 and 217–223).

Along with this concern with consumption, there is the related attempt to analyse gender in the context of other dimensions of power such as class and race, thereby building upon the foundations laid by socialist feminism (Skeggs: 1993). Last, but by no means least, there is the taking up of new theoretical departures like discourse analysis (Gill: 1993), post-structuralism and post-modernism. The use of post-structuralism, in particular the influence of Foucault's work on discourses and power, is again something I wish to take up briefly in the conclusion. I will deal with postmodernism in the next chapter, since it is a theoretical development which seems to have a lot to say about what is happening to popular culture in contemporary societies. We can see postmodernism as the theory of society and social change which is bound up with the philosophical and theoretical framework of post-structuralism.

Further reading

- Baehr, H. (1981) 'The impact of feminism on media studies just another commercial break?', in D. Spender (ed.), *Men's Studies Modified*, Oxford, Pergamon Press.
- Franklin, S., Lury, C. and Stacey, J. (1991) (eds) (1991) Off-centre: Feminism and Cultural Studies, London, Harper Collins (parts 1 and 2).
- Frazer, E. (1987) 'Teenage girls reading Jackie', Media, Culture and Society vol. 9.

Gamman, L. and Marshment, M. (eds) (1988) The Female Gaze: Women

as Viewers of Popular Culture, London, The Women's Press.

- Gill, R. (1993) 'Ideology, gender and popular radio: a discourse analytic approach', *Innovation* vol. 6, no. 3.
- McRobbie, A. (1991a) Feminism and Youth Culture, Basingstoke, Macmillan.
- Skeggs, B. (1993) 'Two minute brother: contestation through gender, "race" and sexuality', *Innovation* vol. 6, no. 3.
- Stacey, J. (1994) Star Gazing: Hollywood Cinema and Female Spectatorship, London, Routledge.
- Tuchman, G., et al. (eds) (1978) Hearth and Home: Images of Women in the Mass Media, New York, Oxford University Press.
- Van Zoonen, L. (1991) 'Feminist perspectives on the media', in J. Curran and M. Gurevitch (eds), *Mass Media and Society*, London, Edward Arnold.
- Winship, J. (1992) 'The impossibility of Best: enterprise meets domesticity in the practical women's magazines of the 1980s', in D. Strinati and S. Wagg (eds), Come On Down?: Popular Media Culture in Post-war Britain, London, Routledge.

Postmodernism and popular culture

What is postmodernism?	223
Culture and society	223
Art and popular culture	225
Confusions over time and space	226
The decline of metanarratives	227
Contemporary popular culture	
and postmodernism	228
Architecture	228
Cinema	229
Television	231
Advertising	232
Pop music	233
The emergence of postmodernism	235
Consumerism and media-saturation	235
New middle-class occupations	236
Personal and collective identities	238
The limits of postmodernism	239
	Culture and society Art and popular culture Confusions over time and space The decline of metanarratives Contemporary popular culture and postmodernism Architecture Cinema Television Advertising Pop music The emergence of postmodernism Consumerism and media-saturation New middle-class occupations Personal and collective identities

I N THIS CHAPTER I will look at the postmodernist analysis of contemporary popular culture. However, I shall alter the organisation of my discussion slightly from the one used in previous chapters in that I shall be more directly concerned with the empirical claims of postmodernism. There are a number of reasons for this. In the first place, postmodern theory, and its theoretical and philosophical underpinnings in post-structuralism, are relatively recent developments, and have not been as intellectually assimilated as the other theories I have looked at. This means that there are few sources which present clear and readable accounts of postmodern theory. Compounding this problem is the fact that what discussion there has been of postmodernism – and by now there has been a lot – has tended to be theoretical and abstract in character as well as difficult to understand. Compared with this theoretical output, relatively little has been said about postmodernism as an empirical or historical phenomenon.

It is clear that postmodernism has become an issue which has attracted increasing interest and attention in recent years. Judging simply by book titles published either using the term or its equivalents, or making clear their concern with postmodernism, this can readily be seen. The Books in Print index shows no book titles published on postmodernism between 1978 to 1981, but 14 published in 1988, 22 in 1989 and 29 in 1990. The Humanities Index shows no book titles or books on postmodernism published between 1980 and 1983, but a total of 241 appearing between 1987 and 1991.¹ This does not include books which are not specifically concerned with postmodernism but still discuss it, nor journal articles or coverage in the more popular media. Yet even here two major journals in the social and cultural sciences, Theory, Culture and Society and Screen, have devoted special issues to postmodernism,² while arts programmes have either considered the major themes raised by the debate or looked at specific areas such as architecture. Indeed, in the UK postmodernism has come to be a term commonly used in discussions about contemporary architecture.³

Despite all this, relatively little has been said about whether postmodernism is emerging in contemporary societies. The debate seems to have been much more involved with the theory of postmodernism rather than with its recognition as an empirical phenomenon. Relatively few writers appear to have asked the question, can we see postmodernism in the world around us? There has, in fact, been a tendency to assume that postmodernism has become widespread in modern societies. However, less attention has been devoted to demonstrating that this is the case.⁴ This has been matched, in turn, by the excessive attention given to the problem of defining the term itself.⁵

In this chapter, I shall look at postmodernist theory, and will consider the extent to which postmodernism can be identified empirically in modern societies, popular culture and the mass media being special areas of concern in the debate about postmodernism.⁶ This focus on the empirical identification of postmodernism means that the chapter will be organised in terms of the following questions: what is postmodernism?; can it be identified in contemporary popular media culture?; what are some of the reasons advanced for its emergence?; and what kind of critique can be developed of its claims and arguments?

What is postmodernism?

In order to identify postmodernism, the following – by no means exhaustive – set of points summarises some of the most salient features which writers about the phenomenon have chosen to emphasise.⁷ I realise that it represents something of a composite picture, but it is more than adequate for the purposes of this chapter.

The breakdown of the distinction between culture and society

First, postmodernism is said to describe the emergence of a social

order in which the importance and power of the mass media and popular culture means that they govern and shape all other forms of social relationships. The idea is that popular cultural signs and media images increasingly dominate our sense of reality, and the way we define ourselves and the world around us. It tries to come to terms with, and understand, a media-saturated society. The mass media, for example, were once thought of as holding up a mirror to, and thereby reflecting, a wider social reality. Now reality can only be defined by the surface reflections of this mirror. Society has become subsumed within the mass media. It is no longer even a question of distortion, since the term implies that there is a reality, outside the surface simulations of the media, which can be distorted, and this is precisely what is at issue according to postmodern theory.

This idea, in part, seems to emerge out of one of the directions taken by media and cultural theory. To put it simply, the liberal view argued that the media held up a mirror to, and thereby reflected in a fairly accurate manner, a wider social reality. The radical rejoinder to this insisted that this mirror distorted rather than reflected reality. Subsequently, a more abstract and conceptual media and cultural theory suggested that the media played some part in constructing our sense of social reality, and our sense of being a part of this reality (Curran *et al.*: 1982; Bennett: 1982). It is a relatively short step from this (and one which need not be taken) to the proposition that only the media can constitute our sense of reality. To return to the original metaphor, it is claimed that this mirror is now the only reality we have.

Moreover, linked to this is the notion that in the postmodern condition it becomes more difficult to distinguish the economy from popular culture. The realm of consumption – what we buy and what determines what we buy – is increasingly influenced by popular culture. Consumption is increasingly bound up with popular culture because popular culture increasingly determines consumption. For example, we watch more films because of the extended ownership of VCRs, while advertising, which makes increasing use of popular cultural references, plays a more important role in deciding what we will buy.

224

POSTMODERNISM

An emphasis on style at the expense of substance

A crucial implication of the first point is that in a postmodern world, surfaces and style become more important, and evoke in their turn a kind of 'designer ideology'. Or as Harvey puts it: 'images dominate narrative' (1989; pp. 347-348). The argument is that we increasingly consume images and signs for their own sake rather than for their 'usefulness' or for the deeper values they may symbolise. We consume images and signs precisely becaue they are images and signs, and disregard questions of utility and value. This is evident in popular culture itself where surface and style, what things look like, and playfulness and jokes, are said to predominate at the expense of content, substance and meaning. As a result, qualities like artistic merit, integrity, seriousness, authenticity, realism, intellectual depth and strong narratives tend to be undermined. Moreover, virtual reality computer graphics can allow people to experience various forms of reality at second hand. These surface simulations can therefore potentially replace their real-life counterparts.

The breakdown of the distinction between art and popular culture

If the first two points are accepted it follows that for postmodern culture anything can be turned into a joke, reference or quotation in its eclectic play of styles, simulations and surfaces. If popular cultural signs and media images are taking over in defining our sense of reality for us, and if this means that style takes precedence over content, then it becomes more difficult to maintain a meaningful distinction between art and popular culture. There are no longer any agreed and inviolable criteria which can serve to differentiate art from popular culture. Compare this with the fears of the mass culture critics that mass culture would eventually subvert high culture. The only difference seems to be that these critics were pessimistic about these developments, whereas some, but not all, postmodern theorists are by contrast optimistic. A good example of what postmodernist theory is getting at is provided by Andy Warhol's multi-imaged print of Leonardo Da Vinci's famous painting *The Mona Lisa*. This example of pop art echoes the argument we looked at above of Walter Benjamin's (1973), as well as an earlier jokey version of the same painting by Marcel Duchamp (McShine: 1989). The print shows that the uniqueness, the artistic aura, of the Mona Lisa is destroyed by its infinite reproducibility through the silk-screen printing technique employed by Warhol. Instead, it is turned into a joke – the print's title is 'Thirty are better than One'. This point is underlined by the fact that Warhol was renowned for his prints of famous popular cultural icons like Marilyn Monroe and Elvis Presley as well as of everyday consumer items like tins of Campbell's soup, Coca-Cola bottles and dollar bills.

One aspect of this process is that art becomes increasingly integrated into the economy both because it is used to encourage people to consume through the expanded role it plays in advertising, and because it becomes a commercial good in its own right. Another aspect is that postmodern popular culture refuses to respect the pretensions and distinctiveness of art. Therefore, the breakdown of the distinction between art and popular culture, as well as crossovers between the two, become more prevalent.

Confusions over time and space

It is argued here that contemporary and future compressions and focusing of time and space have led to increasing confusion and incoherence in our sense of space and time, in our maps of the places where we live, and our ideas about the times in terms of which we organise our lives. The title and the narratives of the *Back to the Future* films capture this point fairly well. The growing immediacy of global space and time resulting from the dominance of the mass media means that our previously unified and coherent ideas about space and time begin to be undermined, and become distorted and confused. Rapid international flows of capital, money, information and culture disrupt the linear unities of time, and the established distances of geographical

POSTMODERNISM

space. Because of the speed and scope of modern mass communications, and the relative ease and rapidity with which people and information can travel, time and space become less stable and comprehensible, and more confused and incoherent (Harvey: 1989, part 3).

Postmodern popular culture is seen to express these confusions and distortions. As such, it is less likely to reflect coherent senses of space or time. Some idea of this argument can be obtained by trying to identify the locations used in some pop videos, the linear narratives of some recent films or the times and spaces crossed in a typical evening of television viewing. In short, postmodern popular culture is a culture *sans frontières*, outside history.

The decline of metanarratives

The loss of a sense of history as a continuous, linear 'narrative', a clear sequence of events, is indicative of the argument that, in the postmodern world, metanarratives are in decline. This point about the decline of metanarratives arises out of the previous arguments we have noted. Metanarratives, examples of which include religion, science, art, modernism and Marxism, make absolute, universal and all-embracing claims to knowledge and truth. Postmodernist theory is highly sceptical about these metanarratives, and argues that they are increasingly open to criticism. In the postmodern world they are disintegrating, their validity and legitimacy are in decline. It is becoming increasingly difficult for people to organise and interpret their lives in the light of metanarratives of whatever kind. This argument would therefore include, for example, the declining significance of religion as a metanarrative in postmodern societies. Postmodernism has been particularly critical of the metanarrative of Marxism and its claim to absolute truth, as it has been of any theory which tries to read a pattern of progress into history.⁸

The consequence of this is that postmodernism rejects the claims of any theory to absolute knowledge, or of any social practice to universal validity. So, for example, on the one hand

POSTMODERNISM

there are movements in the natural or hard sciences away from deterministic and absolute metanarratives towards more contingent and probabilistic claims to the truth, while on the other hand people appear to be moving away from the metanarrative of lifelong, monogamous marriage towards a series of discrete if still monogamous 'relationships' (Harvey: 1989; p. 9; Lash and Urry: 1987; p. 298). The diverse, iconoclastic, referential and collage-like character of postmodern popular culture clearly draws inspiration from the decline of metanarratives.

Contemporary popular culture and postmodernism

I now want to look more closely at some examples of popular culture in order to see if the existence of postmodernism can be detected. Clearly, what follows is by no means systematic or exhaustive. It is necessarily selective and is meant to represent a search for certain elements and trends in popular culture with a view to providing a preliminary assessment of the problems I have posed. It should therefore clarify the nature of postmodernism.

Architecture

This is a particularly appropriate example to use since, during the twentieth century, groups of architects have identified themselves as 'modernist' or 'postmodernist'. These terms have subsequently been used to describe contemporary buildings.⁹ The argument here is that modernism, which first came to prominence in the 1920s, has based itself upon a radical rejection of all previous forms of architecture, and has insisted that buildings and architecture have to be created anew according to rational and scientific principles. Functionality and efficiency, high rise, streamlined, glass and concrete structures, and a disregard for the past and for context, have all become its hallmarks. It has sought to reflect, celebrate and entrench the dynamism of industrial modernity through the rational, scientific and technical construction of built space.

Postmodernism in architecture rejects this metanarrative. Its hallmarks are highly ornate, elaborately designed, contextualised and brightly coloured buildings, a stress on fictionality and playfulness, and the mixing of styles drawn from different historical periods in almost random and eclectic fashion. Postmodernism turns buildings into celebrations of style and surface, using architecture to make jokes about built space. Examples of this include Philip Johnson's Grandfather Clock shaped building for AT&T in New York, Charles Moore's Piazza Italia in New Orleans, or Richard Rogers's Lloyds building in the City of London. Rather than build or design according to rational, scientific principles, postmodern architecture is said to proceed according to the context in which the building is to be placed, and to mix together styles both classical (for example, Ancient Roman or Greek) and vernacular (popular cultural signs and icons). It embraces cultural definitions and the superiority of style, bringing together ideas and forms from different times and places. It also rejects the privileged metanarrative of modernist architecture; and the distinction between classical and modernist architecture as art. on the one hand, and vernacular architecture as popular culture, on the other. Las Vegas has therefore, for example, been seen as both an exemplar of and inspiration for postmodern architecture (Venturi et al.: 1977).

Cinema

Postmodernist arguments clearly concern the visual, and the most obvious films in which to look for signs of postmodernism are those which emphasise style, spectacle, special effects and images, at the expense of content, character, substance, narrative and social comment. Examples of this include films like *Dick Tracey* (1990) or 9½ Weeks (1986). But to look only at those films which deliberately avoid realism and sell themselves on their surface qualities can obscure some of the other things which are going on in contemporary cinema.¹⁰ The films directed and produced by Steven Spielberg and his associates, such as the *Indiana Jones* (1981, 1984 and 1989) and *Back to the Future* series (1985, 1989

and 1990), equally display elements of postmodernism since their major points of reference, and the sources they most frequently invoke, are earlier forms of popular culture such as cartoons, 'B' feature science-fiction films, and the Saturday morning, moviehouse, adventure series people of Spielberg's generation would have viewed in their youth. It is likewise argued that these films appear to stress spectacle and action through their use of sophisticated techniques and relentless pursuit sequences, rather than the complexities and nuances of clever plotting and character development. Sometimes it is suggested that the narrative demands of classical realism are being increasingly ignored by postmodern cinema. Moreover the Back To The Future series and other films like Brazil (1985) and Blue Velvet (1986) are said to be postmodern because of the way they are based on confusions over time and space. Others like Who Framed Roger Rabbit? (1988) can be seen to be postmodern because of their deliberate use of distinct (cultural and technical) genres: the cartoon strip and the detective story. Yet others like Body Heat (1981) can be claimed to be postmodern because they are parasitic on the cinema's past, recycling - in this example - the crime thriller of the 1940s. They thus engage in a kind of 'retro-nostalgia'. Related to this are films which recycle themselves in a number of sequels once the magic box office formula has been discovered, like the Rocky (1976, 1979, 1982, 1985 and 1990) or Rambo (1982, 1985 and 1988) films and the many other repeats which could be mentioned. This tendency is argued to be postmodern partly because it ignores the demands of artistic originality and novelty associated with modernism. None the less, it is argued to be postmodern mainly because it goes no further than recycling the recent past, making films which are merely imitations of other films rather than reflections of social reality.

A frequently cited example of the postmodern film is *Blade Runner* (1982) (Harvey: 1989, chapter 18; Instrell: 1992). Amongst the more noticeable characteristics of this film (which is about Los Angeles in the early part of the twenty-first century), we can note how its architectural look, or production design, clearly mixes styles from different periods. The buildings which house the major corporation have lighting characteristic of contemporary skyscrapers but the overall look of ancient temples, while the 'street talk' consists of words and phrases taken from a whole range of distinct languages. These architectural and linguistic confusions can be said to contribute to an elusive sense of time since we appear to be in the past, the present and the future at the same time. It is a science fiction film which is not obviously futuristic in its design. This effect is accentuated in two ways. First, the 'non-human humans' in the film are not mechanical robots but 'replicants', almost perfect simulations of human beings. Second, the genre of the film is not clear.¹¹ It has been defined as a science fiction film, but it is also a detective film. Its story unfolds as a detective story, the hero has many of the character traits we associate with the 'tough-guy' policeman or private investigator, and his voice-over, which relates the investigation, draws upon the idioms and tone of film noir.

Television

One way of considering television, in the context of the arguments of this chapter, is to view it as a postmodern medium in its own right. Television's regular daily and night-time flows of images and information, bring together bits and pieces from elsewhere, constructing its sequences of programmes on the basis of collage techniques and surface simulations. Equally, there are a number of instructive examples of television programmes which can be used to assess the emergence of postmodernism. For the sake of clarity, I shall confine myself here to one of these examples, the police and crime series *Miami Vice* (1985–1990), although its distinguishing features may be found elsewhere.¹² There are many other examples of television programmes which can be used to assess the claims of postmodernist theory, such as the surreal cult series *Twin Peaks* (1990–1991) and *Wild Palms* (1993).

One of the most important claims made about *Miami Vice* has concerned its reliance upon style and surface. Commentators have noted how it emphasised its visuals and imagery, pointing to the overall look and ambience which the series managed to

achieve. For example, its executive producer, Michael Mann - who subsequently went on to produce the even more 'hyper-real' Crime Story (1989) - when asked once about the main rule he worked to when making the programme, is reputed to have replied, 'no earth tones'.13 The series was carefully designed visually in terms of colour, locations and camera work. When it first came on in America, one critical reponse was to suggest it didn't conform to normal television. This refers to the way it seemed more in keeping with the grander stylistic and adventurous conventions of cinema rather than the cosy, intimate and more 'realistic' routines of television. It was also noticeably different from more seemingly realistic police series like Hill Street Blues (1981-1989). It has also been compared with film noir. This visual appeal was as crucial to the series as the designer clothes worn by its detectives heroes. and the imaginative day and night-time images of Miami. The visual pleasures derived from style and 'look' - locations, settings, people, clothes, interiors, the city - were a crucial motivation in the making and appreciation of the series. The use of an obtrusive pop and rock music sound track added to these pleasures, representing something of a departure for the police and crime series. More than this, it did not so much reject narrative as such, but rather parodied and stylised the established conventions of the genre, while abounding with self-conscious references to popular culture. For example, the conventions of the gangster film were often parodied, while one episode was a more or less straightforward remake of the western High Noon (1952).

Advertising

This example is drawn from television advertising, and is used to see if it is possible to exemplify further the emergence of postmodernism in contemporary popular culture. The argument here is that advertisements used to tell us how valuable and useful a product was. Now, however, they say less about the product directly, and are more concerned with sending up or parodying advertising itself by citing other adverts, by using references drawn from popular culture and by self-consciously making clear their status as advertisements. This argument recognises that advertising is always involved in selling things to people, but suggests that these features distinguish those elements of postmodernism which can be found in contemporary television advertising.

Advertising has, of course, always been seen as a superficial exercise, more involved with surface and style than anything else. But the point at issue is the changing content and tone of advertising, the move away from the simple and direct selling of a product on the basis of its value to the consumer, whatever the visual style and trick effects used. Although the intention is still to sell, it is contended that nowadays the postmodern effect is achieved by seemingly overt efforts within advertising to undermine this purpose. Once Guinness was supposed to be good for us. Now all we see is an actor, in some obscure setting, drinking a glass of Guinness without any positive suggestions being made as to why we should follow suit. Postmodern adverts are more concerned with the cultural representations of the advert than any qualities the product advertised may have in the outside world, a trend in keeping with the supposed collapse of 'reality' into popular culture. The stylish look of advertisements, their clever quotations from popular culture and art, their minisagas, their concern with the surfaces of things, their jokey quips at the expense of advertising itself, their self-conscious revelation of the nature of advertisements as media constructions, and their blatant recycling of the past, are all said to be indicative of the emergence of postmodernism in television advertising.

Pop music

From the point of view of postmodern theory, the recent history of popular music can be seen to be marked by a trend towards the overt and explicit mixing of styles and genres of music in very direct and self-conscious ways.¹⁴ This has ranged from the straightforward remixing of already recorded songs from the same or different eras on the same record, to the quoting and 'tasting' of distinct musics, sounds and instruments in order to create new sub- and pan-cultural identities. Jive Bunny and the Master Mixers, with their eclectic succession of pop and rock 'n' roll records, are the best example of the former, while the mixing and collage-like constructions of reggae sound systems, rap, house and hip hop are amongst the best examples of the latter. It is also necessary to include in this category the so-called 'art rock' musical innovations and mixing of styles associated with groups like Talking Heads, and performers like Laurie Anderson, together with the self-conscious 'reinvention of disco' by the Pet Shop Boys.

Whatever the respective musical and political merits of these new departures, or the scale of their influence, they can be argued to be postmodern. They are concerned with collage, pastiche and quotation, with the mixing of styles which remain musically and historically distinct, with the random and selective pasting together of different musics and styles, with the rejection of divisions between serious and fun or pop music and with the attack on the notion of rock as a serious artistic music which merits the high cultural accolade of the respectful concert (a trend identified with punk). By contrast, 'modernist' popular music can be understood as an attempt to fashion new and distinct forms out of previous styles. So what was distinctive about rock 'n' roll, for example, was not the fact that it, too, borrowed from and based itself upon already existing musical styles, but that it used these styles to construct something new. Rock 'n' roll, as is commonly suggested, arose out of the cross-cutting influences exerted by country and western, on the one hand, and urban rhythm 'n' blues, on the other. The result was not, it is argued, a postmodern amalgam in which country and rhythm 'n' blues stayed recognisably the same, but a novel and original fusion called rock 'n' roll. Similarly with soul music. This is said to have arisen out of the coming together of gospel and blues within black American culture. Yet again the consequence was said to be something strikingly new and different, not a sound which maintained the relatively separate identities of gospel and blues. Put very simply and crudely the argument about the transition between modernism and postmodernism in pop music can be seen to be associated with the movement from rock 'n' roll in the late 1950s, and the Beatles

and Tamla Motown in the 1960s, to Jive Bunny, Music Mixing and 'art rock' and 'straight' pop in the 1980s.

The emergence of postmodernism

So far I have tried to outline what is meant by the term postmodernism, and have shown how elements of it may be found in some leading examples of popular media culture. Just how extensive and general these indications are, however, is something which has to be questioned, as I shall argue in my conclusion. Before that we need to look at another aspect of postmodern theory. This concerns its understanding of the social and historical conditions under which postmodernism emerges.¹⁵ This is bound up with the defining features of postmodernism, and should allow us to clarify further the arguments associated with this theory.

Consumerism and media-saturation

Postmodernism has links with some long-standing ideas about the scale and effects of consumerism and media-saturation as central aspects of the modern development of industrial, capitalist societies. One illustration of this is the attempt to account for the emergence of postmodernism in terms of the argument that during the twentieth century the economic needs of capitalism have shifted from production to consumption. This suggests that once the major need of capitalist societies was to establish their conditions of production. The machines and factories for the manufacturing of goods had to be built and continually updated; heavy industries concerned with basic materials, like iron and steel, and energy, had to be fostered; the infrastructure of a capitalist economy - roads, rail, communications, education, a welfare state, etc. - had to be laid down; and the work force had to be taught the 'work ethic', the discipline required by industrial labour. All this meant that consumption had to be sacrificed to the needs of production.

Once a fully functioning system of capitalist production has been established, however, the need for consumption to grow begins to emerge, and then people need to acquire a leisure or consumer ethic in addition to a work ethic. Now it would be simple-minded to suggest that consumption is only a fairly recent development in the history of capitalism or that the problems of capitalist production have necessarily been resolved. But the point being made is that in an advanced capitalist society like Britain. the need for people to consume has become as important, if not strategically more important, than the need for people to produce. Increased affluence and leisure-time, and the ability of significant sections of the working class to engage in certain types of conspicuous consumption, have in their turn served to accentuate this process. Hence, the growth of consumer credit, the expansion of agencies like advertising, marketing, design and public relations, encouraging people to consume, and the emergence of a postmodern popular culture which celebrates consumerism, hedonism and style.

In this process the media obviously become more important. The rise of modern forms of mass communications, and the associated proliferation of popular media culture, therefore become central to the explanatory framework of postmodern theory. What is inferred from this is that the mass media have become so central to communication and information flows within and between modern societies (and consequently the popular culture they broadcast and promote has come increasingly to define and channel everyday life in these societies) that they, along with consumerism, have given rise to the characteristic features of postmodernism described above. The world, it is argued, will increasingly consist of media screens and popular cultural images – TVs, VDUs, videos, computers, computer games, personal stereos, adverts, theme parks, shopping malls, 'fictitious capital' or credit – which are part and parcel of the trends towards postmodern popular culture.

New middle-class occupations and consumer markets

Consumerism and media-saturation have been conceived of as overly abstract processes with their own autonomous logics, but they can be given some social grounding if changes in the class and occupational structures are taken into consideration.¹⁶ This means it can be argued that the increasing importance of consumption and the media in modern societies has given rise to new occupations (or changed the role and character of older ones) involved with the need to encourage people to consume, more frequently, a greater number and variety of commodities. The idea here is that some groups have to be held responsible for producing postmodernism, however unaware they may be about what they are doing. Hence it can be suggested that certain 'postmodern' occupations have emerged which function to develop and promote postmodern popular culture. These occupations involve the construction of postmodernism. They are claimed to be both creating and manipulating or playing with cultural symbols and media images so as to encourage and extend consumerism. This argument tries to account for the growing importance of occupations like advertising, marketing, design, architecture, journalism and television production, others like accountancy and finance associated with increased consumer credit, and those like social work, therapists of one kind or another, teachers, lecturers and so on, associated with the definition and selling of notions of psychological and personal fulfilment and growth. All these occupations are said to be among the most important in determining the taste patterns for the rest of the society. They exert an important influence over other people's life-styles, and values or ideologies (while expressing their own as well).

These new middle-class occupations, which cater for the variety of consumer markets already existing or in the process of being formed, are crucial to the development of a postmodern popular culture. They entail being conversant with the media and popular culture, both of which have to be used and manipulated in order for the appropriate occupational work to be carried out. This is further linked to the proposition that the cultural ideologies and identities of these occupational groups are becoming increasingly postmodern. At least, certain significant sections within these groups can be described in this way. Both the nature of the work they carry out and the need to distinguish themselves as a status group from others in the hierarchy of taste can be seen

POSTMODERNISM

as being conducive to their elaboration of a postmodern ideology and life-style. Their quest for cultural power leads them towards postmodernism and away from the cultures of other classes, such as the high culture of the traditional middle-class intelligentsia.¹⁷

The erosion of collective and personal identities

The interpretation of identity, be it personal or collective, has become a crucial issue in the debates raised by postmodern theory.¹⁸ The specific claims that have been made about identity in these debates furnish us with another set of reasons for the emergence of postmodernism. The overall case that can be examined here does not claim that a simple process of decline has occurred but that a limited and dependable set of coherent identities have begun to fragment into a diverse and unstable series of competing identities. The erosion of once secure collective identities has led to the increasing fragmentation of personal identities. It is argued that we have witnessed the gradual disappearance of traditional and highly valued frames of reference in terms of which people could define themselves and their place in society, and so feel relatively secure in their personal and collective identities. These traditional sources of identity - social class, the extended and nuclear family, local communities, the 'neighbourhood', religion, trade unions, the nation state - are said to be in decline as a result of tendencies in modern capitalism like increasingly rapid and wide-scale rates of social change. 'Economic globalisation', for example, the tendency for investment, production, marketing and distribution to take place on an international basis above and beyond the nation state or the local community, is seen as an important reason for the gradual erosion of these traditional sources of identity. Transnational economic processes erode the significance of local and national industries and, thereby, the occupational, communal and familial identities they could once sustain.

This argument then goes on to suggest that these problems are exacerbated because no comparable and viable forms emerge which can take the place of traditional sources of identity. No new institutions or beliefs arise to give people a secure and coherent sense of themselves, the times in which they live and their place in society. Those features of contemporary societies which are novel or which represent the prominence of previously secondary trends, like the demands of consumerism or watching television, are not thought to offer satisfactory and worthwhile alternatives. In fact, they encourage the features associated with postmodernism. Consumerism by its very nature is seen to foster a self-centred individualism which disrupts the possibilities for solid and stable identities. Television has similar effects because it is both individualistic and universal. People relate to television purely as individual viewers cut off from wider and more genuine social ties, while television relates back to people as individual and anonymous members of an abstract and universal audience. In both cases, the wider collectivities to which people might belong, and the legitimate ideas in which they might believe, tend to be ignored, eroded or fragmented. Neither consumerism nor television form genuine sources of identity and belief, but since there are no dependable alternatives, popular culture and the mass media come to serve as the only frames of reference available for the construction of collective and personal identities.

The limits of postmodernism

In assessing the emergence of postmodernism within contemporary popular culture I have not been able to present an extensive survey, but it is clearly possible to find examples which clarify the claims of postmodernist theory. I now want to question these claims. There are two ways in which I shall try to do this: one will be to take a critical look at some of the central arguments of postmodern theory; the other will be to examine critically the claims it makes about a particular area of popular culture.

First of all, the idea that the mass media take over 'reality' clearly exaggerates their importance. The mass media are important, but not that important. This assertion sometimes seems to be more in keeping with an ideology of the media which arises from the interests of those working in, and controlling, the media. It has less to commend it as a serious analysis in view of its failure to identify the precise character of this importance, and to provide empirical grounds for the claims it makes. It also ignores the point that other factors, like work and the family, contribute to the construction of 'reality'. The related idea that popular media culture regulates consumption rests upon unsubstantiated assumptions about people's behaviour as consumers. Equally, it fails to recognise how useful the commodities are which people buy, and neglects the fact that the ability to consume is restricted by economic and cultural inequalities. Moreover, the notion that 'reality' has imploded inside the media such that it can only be defined by the media is equally questionable. Most people would probably still be able to distinguish between the 'reality' created by the media, and that which exists elsewhere. Of course, if reality has really 'imploded' into the media, how would we know it has happened? We could only rely on the media to tell us that it had. but why should we trust them?

Those theorists who think postmodernism is emerging seem to be echoing many of the anxieties and fears expressed much earlier by mass culture and Frankfurt School critics.¹⁹ This is evident in a number of the arguments put forward by postmodern theory. For example, the ideas that collective and personal identities are being eroded, that modern popular culture is a trash culture, that art is under threat and that the enlarged role of the mass media allows them to exercise a powerful ideological influence over their audiences, all provide clear evidence for this point: neither are cultural pessimism, and concern over working class consumption, anything new; nor is the implied distinction between a modernist past when the world was a better place to live in, and the postmodern present and future when things can only go on getting worse and worse. Not only is too much significance given to consumerism and the power of media like television, but the claims that are made are rarely substantiated by any evidence. In addition, little attention is given to such things as the nature of people's daily lives, popular attitudes towards consumption, the continuity of identities and the possibility of alternative identities emerging in the course of time.

Another major difficulty with postmodernism lies in its assumption that metanarratives are in decline. In the first place, what is postmodernism, after all, if it is not another metanarrative? It presents a definite view of knowledge and its acquisition, together with a general account of the significant changes it sees occurring in modern societies. It presumes to tell us something true about the world, and knows why it is able to do this. It is therefore difficult to see why postmodernism should not be thought of as a metanarrative. If it is indeed another metanarrative, how can they be in decline? It could be suggested that postmodernism is the last of the metanarratives. But would it be possible to argue this except on the basis of another metanarrative since it involves making a claim to know something? It would seem that, far from metanarratives being in decline, they are something we cannot do without. However, because postmodernism has to be regarded as a metanarrative despite its protestations, it does not follow that we are justified in continuing to think in terms of established metanarratives like Marxism and modernism.

It is apparent that developments in technology and communications have had significant effects on the speed with which information, images and people can be transported around the world. They are therefore in line with postmodernist claims about space and time. As a result, the sense that people now have of time and space must have changed when compared with previous generations. But again the opportunities to experience these changes may be unequally distributed. They may be more available to some classes and occupational groups as opposed to others. Moreover, why should these changes be qualitatively distinct from those associated with the invention of the aeroplane and the cinema? We need to know about the history within which these changes can be understood, and not succumb to a surprisingly positivistic faith in technology. If we are going to talk about changes then we must presumably engage in some kind of historical evaluation. Another reason to be sceptical of the claims of postmodern theory is the fact that the effects of these dramatic changes in time and space upon people's lives remain relatively unexamined, the changes in people's consciousness

POSTMODERNISM

seemingly being assumed to follow automatically from technological changes.

Postmodernist claims about the breakdown of the distinction between art and popular culture have a certain plausibility, particularly since they seem to relate to the practices and ideologies of certain occupational groups. However, these claims appear to be largely confined to these groups. There are, in fact, a number of difficulties with the idea that such a breakdown is occurring. First, if art and popular culture can still be distinguished from each other, then how far can the breakdown be said to have gone? Second, postmodern culture has been distinguished from other types of culture. Therefore the possibility of using criteria to distinguish between cultural products does not disappear with postmodernism. If we take the postmodern argument at face value, the potential for cultural discrimination must remain under postmodernism. Otherwise, how can postmodernism be distinguished from other types of culture? Third, the postmodern popular culture produced by certain occupational groups within the cultural industries is clearly not just concerned with a celebratory populism or a know-nothing relativism. The quotes and references that are part of this process are meant to appeal to those 'clever' enough to spot the source of the quote or reference. Rather than dismantling the hierarchy of aesthetic and cultural taste, postmodernism erects a new one, placing itself at the top. Lastly, it can be argued that most people do discriminate in their cultural consumption and appreciation, even if they do not do so in order to conform with the demands of the hierarchy of art and mass culture, or of postmodernism.

If we look at the examples of popular culture I discussed briefly above, there appear to be changes in the direction of postmodernism, most notably in the areas of architecture and advertising. However, it is difficult to apply this conclusion equally to all areas of popular culture. In particular, its relevance to an account of changes in the cinema is limited, and I shall conclude by looking briefly at this example. No doubt there are aspects of contemporary cinema which can be called postmodern, but a number of significant problems emerge if the history of cinema is taken into consideration.²⁰ The changes which can be called postmodern, described above, either are not as novel as is claimed or are simply misunderstood.

Popular cinema has always been concerned with presenting spectacle to a large audience. From its very early days, cinema appealed to its audience on the basis of the spectacular events it could bring to the screen. To say that postmodernism is concerned with spectacle is to forget this history and to misconstrue the nature of cinema. Obviously, the spectacles screened today are different, in terms of what can be achieved, from those at the turn of the century. None the less, given these different technical and cultural contexts, there is no reason to suppose that one era has been more concerned with spectacle than another. Furthermore, stories remain an important aspect of the appeal of contemporary cinema. The Back to the Future films may exemplify postmodern claims about confusions over time and space but they are equally held together by strong and complex narratives. Likewise, a spectacular film like Blade Runner has a story about the misguided attempts by science to replicate human life, and the tragic fates its 'replicants' suffer, a theme which goes back to Mary Shelley's Frankenstein novel.

From the postmodern point of view, contemporary cinema is seen to be indulging in nostalgia, living off its past, ransacking it for ideas, recycling its images and plots and cleverly citing it in self-conscious postmodern parodies. This view also implies that postmodern popular culture is identifiable by its self-conscious awareness of its status as a cultural product. Yet again, this exaggerates the novelty of these kinds of developments and misconstrues their character and their history. The repeat and the sequel have been part of the way cinema has worked from its earliest stages. Initially it made use of other forms of popular culture like the stage, the newspaper and the novel, and very soon these media fed off each other for ideas and stories. As it grew, cinema remade films that had been made before. For example, that model of narrative realism The Maltese Falcon (1941) was in fact the third film to be made from Hammett's original novel, while between 1908 and 1920 six film versions of Robert Louis Stevenson's Dr.

POSTMODERNISM

Jekyll and Mr Hyde were released (Maltin: 1991; Wood: 1988). Similarly, the history of cinema throws up numerous examples of the film sequel, including those which involved a whole series of repeats. The Sherlock Holmes (1922–1985), Tarzan (1918–1989) and Thin Man (1934–1947) series are obvious examples, but a cursory survey will reveal a number of other cases (Maltin: 1991). Similarly, King Kong (1933) spawned Son of Kong (1933), and Mighty Joe Young (1949). Moreover, it can be cited as an example of a film which reflects self-consciously upon its status as a cultural product, due to the way it deals directly with filmmaking and spectacle (Kawin: 1986).

Insofar as it is possible to generalise, film genres can be said to depend upon a delicate blend of repetition and surprise. As Neale has argued, the historically variable character of genres, the mixing together of genres, the difficulty of allocating particular films to specific genres, together with the confused or hybrid nature of film genres as a whole, are all features to be found throughout the history of cinema rather than being unique to recent films (Neale: 1990). Similarly, the parody of genres has a much longer history than is allowed for by postmodern theory, as does the period film which tries to reconstruct an earlier period of history in a highly stylised manner. Westerns and gangster films readily come to mind as relevant examples in this context. Neither is what postmodern theory has to say about nostalgia films, those films said to be parasitic on the past history of cinema, that convincing.²¹ There are clearly films which can be called nostalgia films. But many films which are evaluated in this way seem to be more importantly concerned with reinventing and reviving genres, and establishing their contemporary relevance, rather than repeating what has gone before. For example, Body Heat (1981) is sometimes seen as a nostalgia film but, far from merely recycling the past, it is a film which tries to update cinematic images and motifs about sex, desire and fate.

This discussion has tried to indicate some of the difficulties confronted by postmodernism and its interpretation of modern cinema. The signs of postmodernism to be detected in certain areas of contemporary popular culture may well be quite partial and

POSTMODERNISM

specific. It is reasonable to suppose that an examination of other areas will reveal problems similar to those arising from my brief survey of cinema. While it cannot be dismissed completely, postmodernism seems subject to severe theoretical and empirical limitations. It is certainly inadequate as a basis for developing a sociology of popular culture.

Further reading

- Boyne, R. and Rattansi, A. (eds) (1990) Postmodernism and Society, Basingstoke, Macmillan.
- Collins, J. (1992) 'Postmodernism and television', in R. Allen (ed.), *Channels of Discourse, Reassembled*, London, Routledge (second edition).
- Connor, S. (1989) Postmodernist Culture, Oxford, Basil Blackwell.
- Featherstone, M. (1991) Consumer Culture and Postmodernism, London, Sage.
- Fiske, J. (1991) 'Postmodernism and television', in J. Curran and M. Gurevitch (eds), *Mass Media and Society*, London, Edward Arnold.
- Gitlin, T. (1989) 'Postmodernism: roots and politics', in I. Angus and S. Jhally (eds), *Cultural Politics in Contemporary America*, New York and London, Routledge.
- Harvey, D. (1989) The Condition of Postmodernity, Oxford, Basil Blackwell.
- Hebdige, D. (1988) Hiding in the Light: On Images and Things, London, Routledge (part 4).
- Jameson, F. (1991) Postmodernism, London and New York, Verso.
- Lash, S. (1990) *The Sociology of Postmodernism*, London and New York, Routledge.
- ----- and Urry, J. (1987) *The End of Organized Capitalism*, Cambridge, Polity Press (pp. 285-300).
- Strinati, D. (1993) 'The big nothing?: contemporary culture and the emergence of postmodernism', *Innovation* vol. 6, no. 3.

Chapter 7

Conclusions

Discourse and popular culture	249
The 'dialogical' approach to	
popular culture	252
Cultural populism	255

247

N THIS BOOK I have presented a critical exposition of some I leading theories and perspectives on the study of popular culture. The theories and perspectives I have covered include mass culture theory, the Frankfurt School's analysis of the culture industry, structuralism and semiology, contemporary Marxism (in terms of its political economy, structuralist and culturalist variants), feminism and, lastly, postmodernism. In outlining these approaches, I have tried to indicate what they have had to say about the analysis of popular culture, as well as bringing to light some of the problems and criticisms they have had to confront. In presenting these theories in this way there is a sense in which they can be seen as being historically related to each other. Mass culture theory and the Frankfurt School represent some of the earliest efforts to get to grips with the modern media and popular culture, and they have been succeeded by some highly generalised theoretical analyses, such as structuralism and Marxism, as well as by some perspectives which have also endeavoured to be more empirical, like feminism. Now we are faced with postmodernism which sometimes seems to set itself against both systematic theory and empirical research. But it would be oversimplistic to view these theories in this light. While there is something in what I have said, the fact is that at the moment there are a number of perspectives on popular culture in circulation. This suggests that we cannot think in terms of a simple historical progression. At present, feminism, Gramscian Marxism or neohegemony theory and Marxist political economy, amongst others, are participants in the debate on the appropriate ways of analysing popular culture and the mass media. Postmodernism is not the only one we have to contend with. This book has aimed to say something about how we have arrived at this situation.

In view of this variety, one way of proceeding would be to draw together aspects of these different approaches in order to produce a more adequate perspective on popular culture.

CONCLUSIONS

However, this is not my intention. To do justice to this task would require a more lengthy and substantial discussion than I have the time or the space for here. It is, none the less, possible to make some concluding comments by looking at a number of more recent theoretical developments which, since they indicate some of the future directions of popular cultural study, have some interest and importance for the themes of this book.

Discourse and popular culture

I have already discussed postmodernism, and have only mentioned post-structuralism in passing, mainly because it has not been that directly involved in the analysis of popular culture. However, there are one or two signs that theorists and researchers working in this area may be turning to the ideas of the post-structuralists for new ways of thinking about and explaining popular culture. In particular, the work of Foucault (1926–1984), the French poststructuralist philosopher, sociologist and historian of knowledge, whose ideas are central to the critique of structuralism and Marxism, may be used for this purpose, and we can consider briefly one study to indicate the arguments involved in this perspective.¹

Foucault's ideas have become increasingly influential in the social sciences. So far, their influence has been felt in such diverse areas as criminology, law and social control, the sociology of health and medicine, the study of sexuality, education, bureaucracy and epistemology. Their effect is much less evident in the sociology of popular culture and the mass media. However, one study which can indicate what the application of post-structuralism to this area might involve is Ang's attempt to use Foucault's notion of discourse to analyse the audience.² For Foucault, discourses are particular ways of organising knowledge in the context of serving specific types of power relationships.

Ang's analysis concentrates upon institutional discourses about television audiences. These audiences do not exist naturally, nor can they be taken for granted. Rather they are constructed by particular discourses which seek to know them in order to exert power over them. For example, advertisers define audiences as consumers, and gather knowledge about their purchasing habits, because they want to sell to them. However, because audiences are constructed in this manner by the combination of knowledge and power within these discourses, it does not mean that real audiences will behave in the way predicted. Audiences can also be understood by the way they resist the discursive powers which try to construct them in ways which suit those powers.

Basing her critique upon Foucault's ideas, Ang writes:

in Foucault's work ... we find a ... detailed emphasis upon the way in which power and knowledge are intertwined through concrete discursive practices - that is, situated practices of functional language use and meaning production. In these discursive practices, elusive fields of reality are transformed into discrete objects to be known and controlled at the same time. But this can only happen in specific, powerladen institutional contexts, that delimit the boundaries of what can actually be said. More concretely, it is only in and through the discourses that express the institutional point of view that the dispersed realities of audiencehood come to be known through the single, unitary concept of 'television audience'.... But what should be stressed is that the move towards more scientific ways of knowing the audience within television institutions is not simply a sign of progress from ignorance to knowledge ... Rather, what is at stake here is a politics of knowledge. In the way television institutions know the audience, epistemological issues are instrumental to political ones: empirical information about the audience such as delivered by audience measurement could become so important only because it produces a kind of truth that is more suitable to meet a basic need of the institutions: the need to control.

(1991; pp. 8 and 10)

Ang therefore considers how the major television institutions involved in the organisation, production and communication of programmes operate to control their audiences by treating them as objects of discourses. They construct and produce knowledge about their audiences in order to control them in line with their institutional requirements. The ideas and habits of which television watching is composed are so complex and varied that they have to be defined by the discourses of television institutions if they are to be controlled. The domination of these discourses, according to Ang, has meant that the real or ordinary television audience has not figured as prominently as it should have in analyses and discussions of watching television. These discourses speak on behalf of, but not for, the television audience. By exposing the discourses of the audience developed by the powerful television institutions. discourses which have also influenced academic studies of the audience, she hopes to shift attention back to the ordinary television viewer. To achieve this, it is necessary for research to look at 'the social world of actual audiences', and 'to develop forms of knowledge about television audiencehood that move away from those informed by the institutional point of view' (ibid.; p. 12).

This understanding of how media organisations operate contrasts with the way Marxism conceives of them as either channels for a dominant ideology or expressions of the demands of profitability. In Ang's analysis, they work according to a much more general drive to exercise power, although in practice there is no reason why it cannot incorporate the arguments of other approaches. Ang substantiates her argument by examining commercial and public service television in America and Europe. However, her use of the concept of power remains vague and abstract, and this is a problem with the Foucauldian concept more generally. If television institutions seek to control audiences by discursive forms of knowledge, what are the particular reasons which make them do this? Is there a universal drive to exercise power which characterises all institutions? Or are there more specific social and historical reasons to explain why this should happen? Although Ang does provide evidence of the latter, a theory of this process still needs to suggest the interests which motivate power. Similarly, why should the power of institutions be resisted? What are the interests which motivate resistance to discursive power?

Moreover, there is a tendency for this approach to see everything as being discursively constructed, a problem made more acute by the notorious imprecision of the concept of discourse itself. In this logic we seem to end up with nothing but discourses. The realities of power are then dissolved into discourses. For example, Ang suggests that to confront the institutional construction of audiences it is necessary to consider 'the social world of actual audiences'. However, this is, in its turn, another discursive construction, although preferable to the former: 'we cannot presume to be speaking with the authentic voice of the "real audience", because there is no such thing' (ibid.; p. 165).

We cannot, of course, speak for an authentic audience, but there must be audiences somewhere outside discourses. If the institutional discourses of television audiences are empirically inadequate, how can we know this except by claiming to know why they are inadequate? We don't have to refer to other discursive constructions but to the process of acquiring empirical knowledge. Ang accepts that institutional and academic knowledge about audiences is not completely useless (for example, ibid.; p. 11), but how can this claim be substantiated if all knowledge is discursively constructed and we can never produce knowledge about real audiences? In fact, the claim which is made can only be based upon some criterion which can distinguish between knowledge which is more useful from that which is less useful. Furthermore, is Ang presenting us with just another discourse or knowledge which will make us think differently about audiences?

The 'dialogical' approach to popular culture

Barker has also alluded to the potential offered by Foucault's notion of discourse (as 'a specific expression of knowledge as power, as in the way children are "defined" by intelligence and aptitude tests' (1989; p. 220)) for media and cultural studies. He writes of Foucault: 'his way of thinking about power has great potential, and has opened the way to new kinds of research' (ibid.; p. 213). This is because his concept of power concerns 'the way we can be turned into objects to be studied. Our talk becomes a

CONCLUSIONS

symptom, our dreams, thoughts, and sensations become the property of "experts". That is power. It is not to deny that there are forms of direct physical control, punishment, armies, police forces. But the first and most common form of power lies in these linkings of power/knowledge' (ibid.). However, Barker's mentors are Volosinov and Propp rather than Foucault. He presents an extensive empirical and critical account of theories which have tried to analyse comics as a form of popular culture. As a result of the failings he notes in these other theories, he puts forward an approach to popular culture which owes much, as he acknowledges, to Volosinov's notion of dialogical analysis.³

The objective of Barker's book is to develop a theory of ideology which does not contain the deficiencies of previous theories, and which can provide an adequate basis for the analysis of comics. To this end, he combines Volosinov's dialogical approach and Propp's emphasis on the importance of narrative forms into an elaborate conceptual framework (ibid.; chapter 12).⁴ His argument has much in common with that put forward by Frazer (1987), although, rather than turning to discourse analysis, he prefers to retain the concept of ideology. Accordingly, he suggests we can understand comics in terms of a 'contract' between the reader and the text, which is based on a dialogue between them. The meaning of the text arises from this social relationship. A good impression of Barker's argument can be gained from the following:

A 'contract' involves an agreement that a text will talk to us in ways we recognise. It will enter into a dialogue with us. And that dialogue, with its dependable elements and form, will relate to some aspect of our lives in our society.... I have been illustrating the way specific comics offer a contract to some aspect of the social lives of their readers.... It is from this that I want to formulate the central hypotheses of the book: (1) that the media are only capable of exerting power over audiences to the extent that there is a 'contract' between texts and audiences, which relates to some specifiable aspect(s) of the audience's social lives; and (2) the breadth and direction of the influence is a function of those socially constituted features of the audiences lives, and comes out of the fulfilment of the contract; (3) the power of 'ideology' therefore is not of some single kind, but varies entirely – from rational to emotional, from private to public, from 'harmless' to 'harmful' – according to the nature of the 'contract'... if all comics, all media, involve a dialogue between text and reader, then to study one side without implicitly assuming the other, would be like listening to one end of a telephone conversation without thinking about the other person's part ... we need to understand ideology as dialogical. (ibid.; p. 261)

Thus Barker bases his analysis of popular culture on the use of the concept of 'dialogue', formulated initially by Volosinov to develop a theory of language and ideology.

This promises to be a relatively sophisticated way of approaching the study of the relationship between texts and readers. It endeavours to overcome the difficulties confronted by previous theories of ideology, and seems capable of encouraging empirical research in this area. However, referring back to our earlier discussion of Foucault, we might ask what part power has to play in the forming of contracts between texts and audiences. Can this relationship be regarded as a reasonably equal one? Or if not, what are the bases of the inequalities within which it is formed? No doubt Barker's notion of the contract is a useful way of understanding the relationship of audiences to popular culture. It does not dismiss them as 'cultural dopes', nor does it lapse into a celebration of their freedom to choose whatever culture they want. But it does need to say more about how the contract is formed and transformed by wider power relations. Related to this is a problem regarding the role of production. Texts are not usually produced by readers, but are the result of specific processes of cultural production. What, then, do these processes contribute to the dialogue between text and audience? In fact Barker stresses the importance of studying the production histories of cultural forms which 'summarise the interactions of producers (their

254

purposes, institutional structures, external constraints, relations with creators, writers, artists, etc.), their audiences (traditions of reading, definitions of the medium, etc.) through which the form is produced and reproduced' (ibid.; p. 275). Moreover, his book contains accounts of the production histories of a number of comics. So what role do they play in the dialogues and contracts in terms of which he wishes to analyse popular culture? If his emphases upon the significance of production histories, the structures and transformations of cultural forms and 'the social characteristics of the audience' (ibid.), are taken together with the concept of the contract between text and readers, then his argument is clearly more substantial and wide-ranging than those offered by either Foucauldian or dialogical theories.

Cultural populism

This is defined by McGuigan as follows: 'cultural populism is the intellectual assumption, made by some students of popular culture, that the symbolic experiences and practices of ordinary people are more important analytically and politically than Culture with a capital C' (1992; p. 4). In fact, McGuigan's book of the same name, is part of a recent critical backlash against the emergence of a populist approach to the analysis of popular culture. He complains about 'a discernable narrowing of vision in cultural studies. exemplified by the drift into an uncritical populist mode of interpretation. I support the wish to understand and value everyday meanings, but, alone, such a wish produces inadequate explanations of the material life situations and power relations that shape the mediated experiences of ordinary people' (ibid.; p. 244). For McGuigan, populism understands popular cultural forms as an expression of the interests, experiences and values of ordinary people, and this is precisely what is wrong with it. It becomes an uncritical endorsement rather than a critical dissection of popular culture.

Populism argues that popular culture cannot be understood as a culture which is imposed upon the thoughts and actions of people. Whether this imposition is said to result from the demands

of capitalist production and consumption for profits and markets, from the needs of capitalism or patriarchy for ideological control. from the interests of a bourgeois class, from the playing out of the class struggle or from the dictates of an universal mental structure. it is none the less inadequate as a way of understanding popular culture. According to populism, popular culture cannot be understood unless it is viewed, not as an imposition, but as a more or less genuine expression of the voice of the people. The critical response to the mass culture critics' condemnation of the Americanisation of British culture can be cited as an example of populism. From this point of view, the attempt to wrest something positive from American popular culture is not to be dismissed as a slavish and misguided imitation of American life, but welcomed as the assertion of pleasure and creativity in a culture which allows popular participation and celebration for ordinary people. That American popular culture is popular with the British working class is no reason to disregard it, or to write it off as the imposition of economic and ideological power. This dismissive attack can safely be left in the hands of middle-class intellectuals. In the eyes of populists, these intellectuals don't realise that not only do they have an inadequate explanation, since it does not take into consideration the wishes and desires of the people, but the very fact that it is associated with intellectuals is reason enough to be suspicious about its status as an argument.

One of the problems with cultural populism, for McGuigan, is that it has become an increasingly influential perspective on the study of popular culture. He sees it exemplified by some of the work of the Centre for Contemporary Cultural Studies at Birmingham University on youth subcultures and popular television, as well as by the ideas of Fiske,⁵ whose views are often taken as perfect illustrations of the claims and limitations of populism (ibid.; pp. 70–75 and chapters 3 and 4). The target of McGuigan's critique is thus:

an uncritical populist drift in contemporary cultural studies ... [in which] ordinary people use the symbolic resources available to them under present conditions for meaningful

CONCLUSIONS

activity ... thus, emancipatory projects to liberate people from their alleged entrapment, whether they know they are entrapped or not, are called into question.... Economic exploitation, racism, gender and sexual oppression, to name but a few, exist, but the exploited, estranged and oppressed cope ... very well ... making valid sense of the world and obtaining grateful pleasure from what they receive.

(ibid.; p. 171)

Although he makes a number of criticisms of this perspective, McGuigan's main complaints concern its neglect of the 'macroprocesses of political economy', its failure to 'account for *both* ordinary people's everyday culture *and* its material construction by powerful forces beyond the immediate comprehension and control of ordinary people', and its complicity with 'economic liberalism's concept of "consumer sovereignty"' (ibid.; pp. 172, 175 and 176; for a similar critique, see Golding and Murdock: 1991; p. 28).

Interestingly enough, the theories I have focused on in this book tend not to take a populist position on the role of the audience in their explanations of popular culture. Whether it is defined as a political strategy or as an analysis of culture, populism has a long history, as my critique of mass culture theory's attack on Americanisation showed. Yet it is difficult to find in the major theories of popular culture an explicit statement of the populist approach. Even semiology, which is argued to have played a part in the development of the Birmingham Centre's cultural populism, says the audience takes for granted the cultural signs which surround it and fails to perceive the ideological work they are doing.⁶ Populism has clearly figured in the ideologies of the producers of popular culture as a way of justifying what they produce - 'giving people what they want' - and it can equally be an ideology of audiences (Ang: 1989). This perhaps suggests that populism is more important as an ideology than it is as a theory. But what it also indicates is that populism could have been expected to emerge as a means of understanding popular culture, even if it has to face the problems that critics have brought to light. In view of the generally dismissive tone of much cultural theory towards the popular audience, it is no

CONCLUSIONS

surprise that some writers have been prompted to recognise its significance. I have no wish to excuse its weaknesses, but a populist appraisal can act as a corrective to the elitism to be found in other perspectives.

Ironically enough, populism represents a mirror image of elitism, and this shows up its critical failings. It is basically an overreaction to the elitism of theories of popular culture. Whereas these theories have often seen audiences as full of passive unthinking dupes, open to manipulation and ideological control by the mass media and the culture it spreads, populism has turned this around. seeing audiences as self-conscious, active subversives, exploiting media culture for their own ends, and resisting and reinterpreting messages circulated by cultural producers. Whereas elitism has patronised the audience by calling it stupid, populism has patronised the audience by calling it subversive. Populism has still presumed to speak on behalf of, not to, the audience. If the elitist conception of the audience is wrong then so is the populist one. and for similar reasons. They both operate in terms of unfounded caricatures, and without an adequate empirical and historical appreciation of the social and cultural nature of audiences. In this respect Barker's notion of a contract between text and readers represents a step forward.⁷ It takes the problem seriously as one which requires both conceptual refinement and empirical research, and does not merely continue to stress the importance of political economy. Admittedly, the latter is important, but how does saying it is get us any further in understanding the popular audience? It is possible to think of the popularity of popular culture as a real sociological problem, without thereby becoming a populist.

Another aspect of this problem is the way it has prevented a proper account of consumption from entering into the theoretical debates about popular culture. There has been a tendency in the critical backlash to populism to equate it with consumption. So any attempt to understand the role of consumption in determining forms of popular culture comes to be regarded as another example of populism, and is therefore dismissed. This is particularly characteristic of the political economy perspective, and is clearly justified by some of the more extreme statements of the populist position. But by concentrating upon those writers who see consumption as a type of populist subversion, exponents of this critique tend to neglect authors like Bourdieu (1984) and Miller (1987) (cf. Campbell (1987), Moorhouse (1991) and Stacey (1994)), who discuss consumption in a theoretically and empirically informed manner which is neither populist nor one to reduce consumption to the economy and production. As Miller notes, for example, remarking upon the critique of consumption to be found in modern social theories like postmodernism:

these global approaches almost always move from an attack on contemporary material culture as trivial or inauthentic to an implied (though rarely explicit) denigration of the mass of the population whose culture this is. By contrast, the analysis of particular domains of consumption . . . allows for a more sensitive discrimination between those elements of consumption which appear to generate close social relations and social groupings (such as those among children and neighbourhoods) and those which, by analogy with the critique of ideology, appear to act to prevent sections of the population from representing their interests, and to suppress any expression of those perspectives which might help to develop such interests.

(1987; p. 16; cf. p. 10)

Moreover, the concept of consumption is a concept derived from economics, as well as one borrowed by populists, and it would be interesting to see how it would fit into the political economy approach.⁸ In fact the social sciences have shown relatively little interest in the process of cultural and material consumption (ibid.; p. 7). In this respect, Bourdieu's work (1984) is particularly important since it is based upon an approach which deliberately links processes of cultural consumption with processes of cultural production.⁹

The argument that the major determinant of popular culture is the need for the cultural industries to make a profit is not just a statement about production, or about how and why cultural goods are produced. It is also a statement about consumption, or about

how and why the goods produced make a profit by finding large enough markets. The analysis of popular culture requires an emphasis on both, particularly since it is doubtful whether power and control over production by themselves are sufficient to determine patterns of cultural consumption. Furthermore, if we were to study a specific form of popular cultural production, we might well find that patterns of consumption are an important influence on what gets produced. The forms of popular culture consumed by audiences, the reasons for their consumption and the difficulty in predicting the precise patterns this will take, make the consumption of popular culture an important theoretical and empirical problem. These reasons, rather than an abstract will to power, may well explain why television institutions, in Ang's terms (1991), produce discourses about their audiences. It is their lack of knowledge about the patterns of consumption of their audiences which gives rise to these discourses.

The critique of populism is likewise based upon the argument that people only have a limited understanding of the wider social forces and power relations which shape their thoughts and actions. In principle, this is a plausible suggestion, though it could also be applied to those who theorise and study popular culture and the mass media. Equally, it does raise questions about the specifically popular nature of popular culture. Popular taste may be able to do nothing about the earth moving around the sun, but it can't be separated from the determination of the popularity of cultural forms.

Further reading

Ang, I. (1991) Desperately Seeking the Audience, London, Routledge.

Barker, M. (1989) Comics: Ideology, Power and the Critics, Manchester, Manchester University Press.

Barrett, M. (1991) The Politics of Truth, Cambridge, Polity Press.

Bourdieu, P. (1984) Distinction, London, Routledge.

---- (1993) The Field of Cultural Production, Cambridge, Polity Press, (part 1).

260

McGuigan, J. (1992) Cultural Populism, London, Routledge.

- Miller, D. (1987) Material Culture and Mass Consumption, Oxford, Basil Blackwell.
- Robbins, D. (1991) The Work of Pierre Bourdieu, Milton Keynes, Open University Press.
- Stacey, J. (1994) Star Gazing: Hollywood Cinema and Female Spectatorship, London, Routledge.
- Stam, R. (1988) 'Mikhail Bakhtin and left cultural critique', in E. Ann Kaplan (ed.), *Postmodernism and its Discontents*, London and New York, Verso.

Notes

- 1 Some idea of the scale of contemporary popular media culture is given by the fact that 98 per cent of homes in Britain now have a television set while almost two-thirds have a video recorder (the *Guardian*, 20 September 1991), and that, on average, every member of the population watched over 26 hours of television a week in 1992 (BFI: 1993; p. 50).
- 2 For assessments of the nature of international media and cultural inequalities see Sreberny-Mohammadi (1991) and Drummond and Paterson (1986; part 1).
- 3 On audience research see, for example, Lewis (1990), Morley (1991) and (1992), Moores (1993), Stacey (1994) and Walkerdine (1986).
- 4 There is also Storey's book whose aims and approach are more in keeping with this book. See Storey (1993).
- 5 For discussions of this idea, see Abercrombie *et al.* (1980), Hill (1990) and Abercrombie (1990).

NOTES

1 Mass culture and popular culture

1 The sources for these points are Burke (1978) and Williams (1976), which have already been referred to in the main text.

2 The sources for the mass culture debate are equally relevant to my discussion of mass society theory and the critiques of both mass society and mass culture theory. Amongst the most useful sources are the following: Bennett (1982), MacDonald (1957), Brookeman (1984), Frith (1983), Rosenberg and White (1957), Eliot (1979), Hoggart (1958), F.R. Leavis (1930), Q.D. Leavis (1932), Williams (1963), Johnson (1979), Ang (1989), Modleski (1986a) and Strinati (1992a).

3 This was particularly true for the Frankfurt School, which is discussed in the next chapter.

4 For one of the best accounts of Hollywood cinema see Bordwell *et al.* (1988).

- 5 For a comparison of liberal and totalitarian political regimes see Bendix (1969), Kornhauser (1960) and Bennett (1982). On the relation between intellectuals and mass culture see Ross (1989) and Turner (1992).
- 6 As Bennett (1982; p. 32) has commented: 'The range and diversity of the theorists who are normally regarded as having contributed to the development of mass society theory is forbidding. We have thus, to name but a few, cultural theorists such as Matthew Arnold, T.S. Eliot, Friedrich Nietzsche and Ortega y Gasset; political theorists such as John Stuart Mill and Alexis de Tocqueville; the students of crowd or mass psychology from Gustave le Bon to Wilheim Reich and Hannah Arendt; and, finally, such representatives of the Italian school of sociology as Vilfredo Pareto and Gaetano Mosca.' Together with the works cited in note 2 above, for other sources on mass society theory see Giner (1976), Kornhauser (1960), Swingewood (1977), Bell (1965) and Shils (1957) and (1962).
- 7 This quote is taken from MacDonald (1957), an article which is drawn upon extensively in this chapter in order to exemplify mass society and mass culture theory. It should, however, be noted, as Ross (1989; pp. 52–53) points out, that MacDonald produced a number of versions of this essay as his views changed over time.
- 8 For the main sources on mass culture theory, and the subsequent critique, see notes 2 and 6 above.
- 9 For interesting accounts of the work of F.R. Leavis and Q.D. Leavis

see Mulhern (1981) and Sansom (1992).

- 10 The main sources used for the discussion of Americanisation are as follows: Strinati (1992a), Hebdige (1988), Webster (1988), Bigsby (1975), Morley and Robins (1989), and Hoggart (1958).
- 11 According to the English subtitles to Wenders' film *Kings of the Road* (1976), the actual phrase used is 'the yanks colonised our subconscious'.
- 12 The actor who played the gangster hero in Scarface was in fact Paul Muni.
- 13 Harry Palmer is the name given to the working-class spy hero in the films made from Deighton's novels, *The Ipcress File* (1965), *Funeral in Berlin* (1967) and *Billion Dollar Brain* (1967). (According to Michael Caine, who played the character in the films, he coined the name himself: the *Guardian*, 17 August 1994; the hero is not named in the novels.) Much of Hammett's detective fiction is also characterised by his trait of not giving a name to his detective hero.
- 14 The process of standardisation is discussed more fully in the next chapter on the Frankfurt School.
- 15 See A. Collins (1993), who has extended Ang's distinction to include an ideology of entertainment which is still populist but which sees no reason why it should be defensive about its cultural tastes and preferences.
- 16 Nor is this meant to imply that the tradition of ethnographic research on audiences can be ignored (see, for example, Moores (1993) and note 3 above). But it is to suggest that much theory has not incorporated this research into its arguments.

2 The Frankfurt School and the culture industry

- 1 See, for example, Caughie (1991), Gendron (1986), Modleski (1986b) and Murdock and Golding (1977; p. 18).
- 2 For example, Benjamin had fled to Paris in the 1930s, and was then forced to flee France by the advance of the German army in 1940. On the point of entering Spain on his way to America, but worried about the possibility of escape, he committed suicide in the same year.
- 3 An important source for my discussion of the Frankfurt School has been Adorno (1991; especially chapters 1 and 3). Other sources I have found useful are as follows: Bennett (1982), Craib (1984;

chapter 11), Gendron (1986), Jay (1973; chapter 6), Slater (1977; chapter 5), Bottomore (1989: chapter 2), Swingewood (1991; pp. 283–290), Horkheimer and Adorno (1973; originally published in 1944), Abercrombie *et al.* (1980), Held (1980; chapter 3), Larrain (1979; pp. 200–210), Eagleton (1991; pp. 125–136), Thompson (1990; pp. 97–109), Brookeman (1984; chapter 8), Dant (1991; pp. 87–98) and Marcuse (1972).

- 4 For discussions of Marx's theory of commodity fetishism in addition to those to be found in the texts cited in the previous note (in particular, Eagleton, Held and Larrain) see Elster (1985; pp. 95–99) and Mepham (1979).
- 5 Of all of his work it is Marcuse (1972) which is by far the most relevant for the concerns of this chapter.
- 6 For a short historical account of Doo-Wop see Hansen (1981).
- 7 The critique advanced in the main text draws upon the sources cited in note 3 above.
- 8 For relevant accounts of genre, see Neale (1980) and (1990), Cook (1985), Berger (1992), Palmer (1991; chapter 7) and Krutnik (1991; chapter 1).
- 9 On this view of the audience, see chapter 5 below and note 3 to the Introduction.
- 10 For examples of this argument see Palmer (1988) and Messenger Davies (1989).
- 11 For a perceptive discussion of the 'debate' between Adorno and Benjamin, see Wolin (1994; chapter 6).
- 12 The limitations of Benjamin's case concern the problems raised by Adorno in his debate with Benjamin. See Wolin (ibid.).

3 Structuralism, semiology and popular culture

- 1 A very useful source on Saussure is Culler (1976). See also Saussure (1974). I am well aware of other developments in semiology (Hawkes: 1977), as well as other comparable thinkers like Durkheim (1858–1917) and Freud (1856–1939), but Saussure's work forms a particularly illustrative case to discuss in the context of this chapter.
- 2 Some of these problems are assessed by Culler. See Culler (1976; pp. 79–89 and chapter 4).
- 3 For this discussion, apart from the works of Lévi-Strauss cited in the

main text, I have relied on the following sources: Leach (1970), Hawkes (1977), Sperber (1979), Badcock (1975), Craib (1984; chapter 7), Swingewood (1991; chapter 11), Barker (1989; pp. 147–159), Wright (1975) and Woollacott (1982).

- 4 One famous sociological study which uses the distinction between the sacred and the profane to define religion and to analyse totemism was carried out by Durkheim (1915).
- 5 For his popular novels see Eco (1983) and (1990). It can be suggested that, compared with Eco, Bennett and Woollacott (1987) provide a more convincing and comprehensive analysis of James Bond.
- 6 However, see also Lévi-Strauss (1963; p. 282), where he stresses the need to take seriously a culture's 'home-made' models of itself.
- 7 Bennett and Woollacott are themselves prone to this usage, rather than reverting to a more consistent sociological vocabularly. Furthermore, Eco similarly distinguishes between 'smart' and 'naive' readers (Eco: 1990b).
- 8 Apart from the works by Barthes cited in the main text, I have relied upon the following sources: Culler (1983), Sturrock (1979), Barthes (1967), (1977) and (1983), Woollacott (1982), Hawkes (1977), Dyer (1982; chapter 6), Fiske and Hartley (1978), Craib (1984; chapter 7), Wright (1975), Barker (1989; pp. 124–128), Rylance (1994) and Williamson (1978). See also Masterman (1984) for an indication of Barthes's influence.
- 9 In fact, Barthes here appears to clarify something which would have otherwise remained implicit. See Barthes (1968; section 4).
- 10 The sources for this critique are to be found in note 3 above. Leach (1970) is particularly useful in this context.
- 11 The sources for this critique are to be found in note 8 above. See also Moorhouse (1991; pp. 7–9).
- 12 For his development of this idea of polysemy see Barthes (1977; pp. 15–51); cf. Fiske (1989a).
- 13 For a full discussion of the encoding-decoding model, see Hall (1980); cf. Morley (1980). For an effective critique of this model, see Wren-Lewis (1983).
- 14 For an example of a study which combines semiological and ideological forms of analysis, see Hebdige (1979). Some writers like McGuigan (1992; pp. 91, 96–97, and 100–107), and Moores (1993; pp. 134–138) have tended to see this study as holding to a populist conception of the consumers of popular culture, in that for

Hebdige – subculture represents a subversive rearrangement by its adherents of codes and signs to be found elsewhere in popular culture, including the realm of dominant ideas and symbols. However, it seems to me that this is an inference drawn by the analyst in terms of the dictates of semiological and ideological analysis, rather than an explanation which takes account of the actual interpretations and preferences of these consumers. It is worth quoting Cohen on this point: 'I sometimes have a sense of working-class kids suffering an awful triple fate. First, their actual career prospects are grim enough; then their predicament is used, shaped and turned to financial profit by the same interests which created it; and then – the final irony – they find themselves patronized in the latest vocabulary imported from the Left Bank' (1980; p. xxyiji).

4 Marxism, political economy and ideology

- 1 Although it obviously counts as a school of Marxist theory, I have confined my discussion of the Frankfurt School to a separate chapter for a number of reasons. First, it represents an earlier attempt to develop a Marxist theory of culture and ideology than the variants of western Marxism considered in this chapter which have had a similar objective in view. Second, it employs a distinctive usage of Marx's theory of commodity fetishism. Third, it thus appears both to be more distinct from other Marxist approaches and to share a lot in common with mass culture theory. These reasons, however, should not allow us to exaggerate the extent of these differences.
- 2 The literature on this is massive. Apart from the work of Marx cited in the main text, some useful secondary sources are as follows: McLellan (1986; chapter 2), Elster (1985) and (1986; chapter 9), Larrain (1979; chapter 2), Eagleton (1991; chapter 3), Dant (1991; chapter 4), Barrett (1991; part 1), Thompson (1990; pp. 33-44), Swingewood (1991; pp. 72-80) and Mepham (1979).
- ³ I am using this work as an example of a contemporary Marxist account which is explicitly based upon the explanatory priority Marxist theory accords to the economy. Other examples which could have been used include media imperialism. See, for example, Drummond and Paterson (1986; part 1), Mattelart *et al.* (1984) and Tomlinson (1991; chapter 2). For an interesting exchange on the political economy approach, see Budd and Steineman (1989) and

Fiske (1989a). It is fair to point out that Murdock and Golding have altered their position since the mid-1970s. See Golding and Murdock (1991), which is discussed briefly in the main text. See also Murdock (1993) which sets out arguments I find it difficult to disagree with.

- 4 The difficulties in dealing with a phenomenon like language in terms of the base-superstructure model are instructive. Language covers the whole range of 'levels' from biology to pure, immaterial utterances. How is it possible to decide which is the most important?
- Apart from the work of Althusser cited in the main text, the sources I have relied on are as follows: Althusser (1969) and (1970), Anderson (1979), Craib (1984; chapters 8 and 9), McLellan (1986; chapter 3), Bennett (1982) and (1979; pp. 112–123), Barrett (1991; chapter 5), Larrain (1979; pp. 154–164), Eagleton (1991; pp. 136–158), Swingewood (1991; pp. 306–311), Dant (1991; pp. 76–85), Cormack (1992; chapter 1) and Abercrombie et al. (1980).
- 6 For an example of this, see Centre for Contemporary Cultural Studies (1978). It is also worth consulting issues of *Screen* for the mid-1970s.
- 7 The sources used for this critique are cited in note 5 above.
- Apart from Gramsci (1971), which is cited in the main text, particularly useful texts on Gramsci are Bennett (1986), and Simon (1982). Other useful sources are as follows: Anderson (1979) and (1976–1977), Joll (1977; chapters 8 and 9), Ransome (1992), Williams (1977; pp. 108–114), Swingewood (1991; pp. 205–214), Eagleton (1991; pp. 112–123), Barrett (1991; chapter 4), Cormack (1992; chapter 1), Buci-Glucksmann (1980) and Abercrombie *et al.* (1980).
- 9 For examples of this see Hall *et al.* (1978) and Hall and Jacques (1983).
- 10 For biographical information on Gramsci see Fiori (1973), Joll (1977), Buci-Glucksmann (1980), Simon (1982) and Ransome (1992).
- 11 For useful discussions of Gramsci's concept of hegemony, apart from his own writings, see the sources cited in note 8 above, in particular Anderson (1976–1977), Simon (1982), Buci-Glucksmann (1980) and Williams (1977).
- 12 For discussions of this topic see Clarke (1986) and (1992). For other examples of the application of Gramsci's concept of hegemony to popular television, see Seiter (1986) and Gitlin (1994).

- 13 The sources for a critical assessment of Gramsci's writings are to be found in note 8 above, in particular Anderson (1976–1977) and Abercrombie *et al.* (1980), but it is noticeable that there is a relative lack of critical commentaries on his work in the secondary literature.
- 14 For an interesting account of fatalism and social theory, see Lockwood (1982).
- 15 For assessments of culturalism (along with structuralism) and its relation to the importance of Gramsci's work for the study of popular culture, see Bennett (1986) and Hall (1981).

5 Feminism and popular culture

- 1 Examples of this literature include Greer (1971), de Beauvoir (1972), Mitchell (1975), Spender (1980) and Friedan (1963), the last being particularly important from the point of view of media and cultural studies.
- 2 For discussions of different types of feminism and feminist analysis see Van Zoonen (1991), McIntosh (1978) and Lengermann and Niebrugge-Brantley (1992).
- 3 For a full statement of what this approach entails, see Tuchman (1978).
- 4 We have already seen this argument put forward by Barthes in the chapter on structuralism and semiology.
- 5 The source for this is the Guardian, 21 November 1990, p. 6.
- 6 Books written by women are 'readerly' because they do not demand any 'work' to be performed by their readers. They are therefore easy to 'consume', and therefore easy to 'write'. The stress placed upon the importance of production as opposed to consumption is a feature of other theories of popular culture like Marxism.
- 7 I have here relied upon Baehr (1981) and Gill (1988).
- 8 For some important discussions of patriarchy, see Kuhn and Wolpe (1978), Hartman (1979), Walby (1990) and Barrett (1988).
- 9 For sources on the pornography debate see Dworkin (1980), Seaton (1986), Benn (1986) and Ross (1989; chapter 6).
- 10 For a discussion of the debate between Marxism and feminism see Sargent (1981).
- 11 The source for this is McRobbie's essay '*Jackie* magazine: romantic individualism and the teenage girl', in McRobbie (1991a; originally

270

published in 1978). However, McRobbie has since retracted much of the substance of this argument. See her later essay '*Jackie* and *Just Seventeen*: girls' comics and magazines in the 1980s', in ibid.

- 12 The concept of 'positioning' is very similar to Althusser's concept of 'interpellation'.
- 13 It could, of course, be claimed that from a semiological point of view, codes like these could be invented *ad nauseum*, there being no rational, objective or empirical criteria to limit the choice apart from the limits of the text itself.
- 14 This method could presumably be used to generate 'hidden' meanings *ad infinitem*, the only stopping point being the preferred ideological reading of the analyst.
- 1.5 On the basis of his own study of the magazine and its storics, Barker also questions the empirical validity of McRobbie's conclusions, in particular her claim that *Jackie* discourages female friendships in favour of boyfriends and marriage. Barker (1989; pp. 157, 179–181 and 247–249).
- 16 See note 12 to chapter 3, above.
- 17 For a more extended discussion of the issues raised by Frazer's article, see Stacey (1994).
- 18 On these developments and their implications, see McRobbie (1991b) and (1993).
- 19 The studies Stacey has in mind are: Winship (1981), Partington (1991) and Nava (1992). Stacey's own study (1994) is an equally important example of this approach, as is Winship (1992).

6 Postmodernism and popular culture

- 1 A version of this chapter has appeared in *Innovation* vol. 6, no. 3, 1993.
- 2 See Screen vol. 28, no. 2, 1987, and Theory, Culture and Society vol. 5, nos 2–3, 1988.
- 3 See, for example, the *London Evening Standard Magazine*, September 1989.
- 4 Good examples of this are Denzin (1991) and Jameson (1991).
- 5 One convenient indication of this is the way in which the concept of 'postmodernism' in the title of Jameson's original article on this theme (1984) has attracted much more attention that the other equally problematic terms it contained, namely 'late' capitalism, and

cultural 'logic'.

6 Featherstone (1988), for example, has related the discussion of postmodernism to the more general debate about the overall shape and direction of industrial, capitalist societies.

7 Among the sources used for this discussion, apart from those cited in notes 2 and 4 above, see the following: Harvey (1989; especially part 1), Gitlin (1989), Lash and Urry (1987; pp. 285–300), Hebdige (1988; part 4), Boyne and Rattansi (1990), Lash (1990), Collins (1989), Connor (1989), Docherty (1993), Jencks (1986), Twitchell (1992), Pfeil (1985), Hutcheon (1989), Lyotard (1984) and Baudrillard (1988). On Baudrillard see Gane (1991a) and (1991b). I have found Gitlin, and Lash and Urry particularly helpful in providing an initial orientation and an organisational structure for my discussion of postmodernism, and Harvey and Connor very useful in filling in more of the substance and detail.

8 I do not have the space here to present an extensive account of modernism (see, however, the section on architecture below), although it is obviously relevant to any consideration of postmodernism. For assessments of modernism see the sources cited in note 7, particularly Harvey (1989), Lash and Urry (1987), Lash (1990) and Gitlin (1989). See also Murdock (1993).

9 For discussions of modernist and postmodernist architecture see, for example, Jencks (1984) and (1986), Portoghesi (1982) and (1983) and Venturi *et al.* (1977).

10 Among the sources consulted for this section see, Lash and Urry (1987), Harvey (1989), Corrigan (1991), Baudrillard (1987), Denzin (1991) and Jameson (1991; chapter 9). For further details of the films discussed see the relevant issues of the Monthly Film Bulletin and Sight & Sound.

11 This refers to the original film which went on theatrical release, and not the so-called director's cut which came out in 1992.

- 12 For a general consideration of this area see Connor (1989; chapter 6), Collins (1992) and Fiske (1991). For assessments of *Miami Vice*, see Butler (1985) and Fiske (1987; pp. 255–262).
- 13 There is no actual source for this quote other than my own memory, but a comparable quote can be found in Butler (1985; p. 133).
- 14 For discussions of postmodernism and popular music see Connor (1989; pp. 185–190), Hebdige (1987) and (1988; part 4) and Stratton (1989); cf. Laing (1985; chapter 1).
- 15 In considering the reasons for the emergence of postmodernism I

have used those sources cited in note 7 above. For some evidence on media-saturation see note 1 to the Introduction.

- 16 In the considerable literature on postmodernism this has received less than its fair share of attention. See, however, Gitlin (1989), Lash and Urry (1987), Harvey (1989; p. 348; cf. p. 290), Lash (1990) and Pfeil (1985). See also Bourdieu (1984) and Featherstone (1991; especially chapter 2); cf. Collins (1993) and Frith and Savage (1993).
- 17 It has to be said that, in the light of what we know at the moment, these claims remain highly speculative. But see Bourdieu (1984) and Miller (1987).
- 18 See, for example, Harvey (1989; pp. 86–87), Lash and Urry (1987), and Gitlin (1989). For post-structuralist views on identity see Sarup (1988).
- 19 On mass culture theory and the Frankfurt School see the respective chapters in the main text.
- 20 I have relied upon a number of sources for this assessment. These include historical studies of Hollywood cinema like Kerr (1986), Bordwell *et al.* (1988), Balio (1985) and Neale (1985), as well as reference books and film guides, in particular Maltin (1991). It would be instructive if the claims of postmodernist theory could be subject to a similar kind of critical assessment in other areas of popular media culture.
- 21 This is particularly the case with Jameson's arguments. See Jameson (1991; chapter 9).

7 Conclusions

- 1 For discussions and assessments of Foucault's work, see Foucault (1980), Barrett (1991; chapters 6 and 7), Rabinow (1984), Ritzer (1992; pp. 507–515), Smart (1983) and (1988) and Dant (1991; pp. 120–134). It should be noted that Foucault's ideas, as with post-structuralism more generally, have developed in critical opposition to structuralism and Marxism.
- 2 For other examples of discourse analysis which are derived from differing notions of discourse, see Frazer (1987), Gill (1993) and Fairclough (1989).
- 3 Volosinov also appears to go by the name of Bakhtin, and there seems to be some confusion in the literature on this. For discussions

of the work of Bakhtin (Volosinov) and its relevance for the study of culture, see Stam (1988) and (1989), Morson (1986) and Morson and Emerson (1989).

- 4 Note that Barker sees a number of similarities between the ideas of Bakhtin (Volosinov) and Propp (1989; pp. 274–275); cf. Wright (1975).
- 5 For a possible example of this see Fiske (1989b). However, Fiske (1989a) and (1991) suggest that this may be an oversimplification of his views.
- 6 For example, there is Cohen's (1980) critique of Hebdige's (1979) semiologically inspired study of youth subcultures, which is referred to in note 14 to chapter 3, above.
- 7 For another example of a more sophisticated empirical and historical approach to the study of audiences, see Allen (1990).
- 8 Miller's arguments could be applied to a number of the theories discussed in this book.
- 9 For detailed and interesting discussions of Bourdieu's work, see Robbins (1991), Jenkins (1992) and Garnham and Williams (1986).

Bibliography

- Abercrombie, N. (1990) 'Popular culture and ideological effects', in N. Abercrombie, S. Hill and B. S. Turner (eds), *Dominant Ideologies*, London, Allen and Unwin.
- Adorno, T. (1991) The Culture Industry, London, Routledge.
- Allcn, R. (1990) 'From exhibition to reception: reflections on the audience in film history', *Screen* vol. 31, no. 4.
- Althusser, L. (1969) For Marx, Harmondsworth, Penguin. (1971) Lenin and Philosophy and Other Essays, London, New Left Books.
- ------ and Balibar, E. (1970) *Reading Capital*, London, New Left Books.
- Anderson, P. (1976–77) 'The antinomies of Antonio Gramsci', New Left Review no. 100.
- ——(1979) Considerations on Western Marxism, London, Verso.
- Ang, I. (1989) Watching Dallas, London, Routledge.

(1991) Desperately Seeking the Audience, London, Routledge.

Arnold, M. (1932) Culture and Anarchy, Cambridge, Cambridge University Press.

- Badcock, C. (1975) Lévi-Strauss: Structuralism and Sociological Theory, London, Hutchinson.
- Baehr, H. (1981) 'The impact of feminism on media studies just another commercial break?', in D. Spender (ed.), *Men's Studies Modified*, Oxford, Pergamon Press.
- Balio, T. (ed.) (1985) *The Hollywood Film Industry*, Madison, University of Wisconsin Press.

Barker, M. (1989) Comics: Ideology, Power and the Critics, Manchester, Manchester University Press.

Barrett, M. (1988) Women's Oppression Today, London, Verso.

- Barthes, R. (1967) Writing Degree Zero, London, Cape (originally published in 1953).
- ------ (1968) *Elements of Semiology*, New York, Hill and Wang (originally published in 1964).
- ------ (1973) *Mythologies*, London, Paladin Books (originally published in 1957).
- (1977) Image-Music-Text, London, Fontana.
- ----- (1983) Barthes: Selected Writings, ed. S. Sontag, London, Fontana.
- ------ (1988) The Semiotic Challenge, Oxford, Blackwell.
- Baudrillard, J. (1987) The Evil Demon of Images, Sydney, Power Publications.
- (1988) Selected Writings, ed. M. Poster, Cambridge, Polity Press.

Beauvoir, S. de (1972) The Second Sex, Harmondsworth, Penguin.

- Bell, D. (1965) 'America as a mass society: a critique', in *The End of Ideology*, New York, Free Press (revised edition).
- Bendix, R. (1969) Nation Building and Citizenship, New York, Anchor Books.
- Benjamin, W. (1973) 'The work of art in the age of mechanical reproduction', in *Illuminations*, London, Fontana.
- Benn, M. (1986) 'Campaigning against pornography', in J. Curran, J. Ecclestone, G. Oakley and A. Richardson (eds), *Bending Reality: The State of the Media*, London, Pluto Press.
- Bennett, T. (1979) Formalism and Marxism, London and New York, Methuen.
- (1982) 'Theories of the media, theories of society', in M. Gurevitch,
 T. Bennett, J. Curran and J. Woollacott (eds), *Culture, Society and*

⁽¹⁹⁹¹⁾ The Politics of Truth, Cambridge, Polity Press.

the Media, London, Methuen.

- (1986) 'Introduction: "the turn to Gramsci", in T. Bennett, C. Mercer and J. Woollacott (eds), *Popular Culture and Social Relations*, Milton Keynes, Open University Press.
- ------ and Woollacott, J. (1987) Bond and Beyond: The Political Career of a Popular Hero, Basingstoke, Macmillan.
- Berger, A. (1992) Popular Culture Genres: Theories and Texts, London, Sage.
- BFI (1993) British Film Institute: Film and Television Handbook 1994, London, British Film Institute.
- Bigsby, C. (ed.) (1975) *Superculture*, Bowling Green, Ohio, Bowling Green University Press.
- Booker, C. (1969) The Neophiliacs: A Study of the Revolution in English Life in the Fifties and Sixties, London, Collins.
- Bordwell, D., Staiger, J. and Thompson, K. (1988) The Classical Hollywood Cinema, London, Routledge.
- Bottomore, T. (1989) The Frankfurt School, London, Routledge.
- Bourdieu, P. (1984) Distinction, London, Routledge.
- (1993) The Field of Cultural Production, Cambridge, Polity Press.
- Boyne, R. and Rattansi, A. (eds) (1990) Postmodernism and Society, Basingstoke, Macmillan.
- Brookeman, C. (1984) American Culture and Society since the 1930s, London and Basingstoke, Macmillan.
- Buci-Glucksmann, C. (1980) Gramsci and the State, London, Lawrence and Wishart.
- Budd, M. and Steineman, C. (1989) 'Television, cultural studies and the "blind spot", in G. Burns and R. Thompson (eds), *Television Studies: Textual Analysis*, New York, Praeger.
- Bullock, A. and Stallybrass, O. (eds) (1977) The Fontana Dictionary of Modern Thought, London, Fontana.
- Burke, P. (1978) Popular Culture in Early Modern Europe, London, Temple Smith.
- Butler, J. (1985) 'Miami Vice: the legacy of film noir', *Journal of Popular Film and Television*, Fall issue.
- Campbell, C. (1987) The Romantic Ethic and the Spirit of Modern Consumerism, Oxford, Basil Blackwell.
- Caughie, J. (1991) 'Adorno's reproach: repetition, difference and television genre', *Screen* vol. 32, no. 2.
- Centre for Contemporary Cultural Studies (1978) On Ideology, London, Hutchinson.

Chandler, R. (1980) Pearls are a Nuisance, London, Pan Books.

- Clarke, A. (1986) 'This is not the boy scouts: television police series and definitions of law and order', in T. Bennett, C. Mercer and J. Woollacott (eds), *Popular Culture and Social Relations*, Milton Keynes, Open University Press.
 - (1992) "You're nicked!": television police series and the fictional representation of law and order', in D. Strinati and S. Wagg (eds), *Come On Down?: Popular Media Culture in Post-war Britain*, London, Routledge.

Cohen, P. (1980) Folk Devils and Moral Panics: The Creation of the Mods and Rockers, Oxford, Martin Robertson (second edition).

Collins, A. (1993) 'Intellectuals, power and quality television', *Cultural Studies* vol. 7, no. 1.

Collins, J. (1989) Uncommon Cultures: Popular Culture and Postmodernism, New York and London, Routledge.

----(1992) 'Postmodernism and television', in R. Allen (ed.), *Channels* of *Discourse*, *Reassembled*, London, Routledge (second edition).

Connor, S. (1989) Postmodernist Culture, Oxford, Basil Blackwell.

Cook, P. (ed.) (1985) The Cinema Book, London, British Film Institute.

Cormack, M. (1992) Ideology, London, Batsford.

Corrigan, T. (1991) A Cinema Without Walls, London, Routledge.

Craib, I. (1984) Modern Social Theory, London and New York, Harvester Wheatsheaf.

Culler, J. (1976) Saussure, London, Fontana.

(1983) Barthes, London, Fontana.

- Curran, J., Gurevitch, M. and Woollacott, J. (1982) 'The study of the media: theoretical approaches', in M. Gurevitch *et al.* (eds), *Culture, Society and the Media*, London, Methuen.
- Curran, J. and Gurevitch, M. (eds) (1991) Mass Media and Society, London, Edward Arnold.

Denning, M. (1987) Cover Stories: Narrative and Ideology in the British Spy Thriller, London and New York, Routledge and Kegan Paul.

- Denzin, N. (1991) Images of Postmodern Society: Social Theory and Contemporary Cinema, London, Sage.
- DiMaggio, P. (1986) 'Cultural entrepreneurship in nineteenth century Boston: the creation of an organizational base for high culture

Dant, T. (1991) Knowledge, Ideology and Discourse, London and New York, Routledge.

Deighton, L. (1978) *The Ipcress File*, London, Triad Granada (originally published in 1962).

in America', in R. Collins , J. Curran, N. Garnham, P. Scannell,

P. Schlesinger and C. Sparks (eds), Media, Culture and Society: A Critical Reader, London, Sage Publications.

- Docherty, T. (1993) Postmodernism: A Reader, New York and London, Harvester Wheatsheaf.
- Drummond, P. and Paterson, R. (eds) (1986) Television in Transition, London, British Film Institute.
- Durkheim, E. (1915) The Elementary Forms of the Religious Life, London, George Allen and Unwin.
- Dworkin, A. (1980) 'Pornography and grief', in L. Lederer (ed.), Take Back The Night, New York, William Morrow.
- Dyer, G. (1982) Advertising as Communication, London and New York, Methuen.
- Dyer, R. (1973) Light Entertainment, London, British Film Institute.
- Eagleton, T. (1991) Ideology: An Introduction, London and New York, Verso.
- Eco, U. (1979) 'The narrative structure in Fleming', in *The Role of the Reader*, Bloomington, Indiana, University of Indiana Press.
- ----- (1983) The Name of the Rose, London, Secker and Warburg.
- (1990a) Foucault's Pendulum, London, Pan Books.
- (1990b) The Limits of Interpretation, Bloomington, Indiana, University of Indiana Press.
- Eliot, T.S. (1979) Notes towards the Definition of Culture, London, Faber and Faber.
- Elster, J. (1985) *Making Sense of Marx*, Cambridge, Cambridge University Press.
- —— (1986) An Introduction to Karl Marx, Cambridge, Cambridge University Press.
- Fairclough, N. (1989) Language and Power, London and New York, Longman.
- Featherstone, M. (1988) 'In pursuit of the postmodern', *Theory*, *Culture* and Society vol. 5, nos 2-3.

(1991) Consumer Culture and Postmodernism, London, Sage.

- Fiori, G. (1973) Antonio Gramsci: Life of a Revolutionary, New York, Schocken Books.
- Fiske, J. (1987) Television Culture, London and New York, Methuen.

(1989b) Understanding Popular Culture, Boston and London,

Unwin Hyman.

- (1991) 'Postmodernism and television', in J. Curran and M. Gurevitch (eds), *Mass Media and Society*, London, Edward Arnold.
- and Hartley, J. (1978) *Reading Television*, London and New York, Methuen.
- Foucault, M. (1980) Power/Knowledge: Selected Interviews and other Writings 1972–1977, ed. C. Gordon, New York, Harvester Wheatsheaf.
- Franklin, S., Lury, C. and Stacey, J. (eds) (1991) Off-centre: Feminism and Cultural Studies, London, HarperCollins.
- Frazer, E. (1987) 'Teenage girls reading Jackie', Media, Culture and Society vol. 9.
- Friedan, B. (1963) The Feminine Mystique, Harmondsworth, Penguin.
- Frith, S. (1983) Sound Effects: Youth, Leisure and the Politics of Rock, London, Constable.
 - and Savage, J. (1993) 'Pearls and swine: the intellectuals and the mass media', *New Left Review* no. 198.
- Gamman, L. and Marshment, M. (eds) (1988) The Female Gaze: Women as Viewers of Popular Culture, London, The Women's Press.
- Gane, M. (1991a) Baudrillard: Critical and Fatal Theory, London, Routledge.
 - (1991b) Baudrillard's Bestiary: Baudrillard and Culture, London, Routledge.
- Garnham, N. and Williams, R. (1986) 'Pierre Bourdieu and the sociology of culture; an introduction', in R. Collins, J. Curran, N. Garnham, P. Scannell, P. Schlesinger and C. Sparks (eds), *Media, Culture and Society: A Critical Reader*, London, Sage Publications.
- Gendron, B. (1986) 'Theodor Adorno meets the Cadillacs', in T. Modleski (ed.), *Studies in Entertainment*, Bloomington, Indiana, Indiana University Press.
- Gill, R. (1988) 'Altered images?: women in the media', Social Studies Review vol. 4, no. 1.
- (1993) 'Ideology, gender and popular radio: a discourse analytic approach', *Innovation* vol. 6, no. 3.
- Giner, S. (1976) Mass Society, London, Martin Robertson.
- Gitlin, T. (1989) 'Postmodernism: roots and politics', in I. Angus and S. Jhally (eds), *Cultural Politics in Contemporary America*, New York and London, Routledge.
- ------(1994) 'Prime time ideology; the hegemonic process in television entertainment', in H. Newcomb (ed.), *Television: The Critical View*,

New York and Oxford, Oxford University Press (fifth edition).

- Golding, P. and Murdock, G. (1991) 'Culture, communications and political economy', in J. Curran and M. Gurevitch (eds), *Mass Media and Society*, London, Edward Arnold.
- Goldthorpe, J., Lockwood, D., Bechhofer, F. and Platt, J. (1969) The Affluent Worker in the Class Structure, Cambridge, Cambridge University Press.
- Gramsci, A. (1971) Selections From the Prison Notebooks, London, Lawrence and Wishart.
- Greer, G. (1971) The Female Eunuch, New York, McGraw-Hill.
- Gurevitch, M., Bennett, T., Curran, J. and Woollacott, J. (eds) (1982) Culture, Society and the Media, London, Methuen.
- Hall, S. (1980) 'Encoding/Decoding', in S. Hall, D. Hobson, A. Lowe and P. Willis (eds), *Culture, Media, Language*, London, Hutchinson.
- ——(1981) 'Cultural studies: two paradigms', in T. Bennett *et al.* (eds), *Culture, Ideology and Social Process*, Milton Keynes, Open University Press.
- ----- Critcher, C., Jefferson, T., Clarke, J. and Roberts, B. (1978) Policing the Crisis: Mugging, the State and Law and Order, London, Macmillan.

- Hansen, B. (1981) 'Doo-Wop', in J. Miller (ed.) (1981) The Rolling Stone Illustrated History of Rock and Roll, London, Pan Books.
- Hartman, H. (1979) 'The unhappy marriage of Marxism and feminism', Capital and Class Summer issue; reprinted in L. Sargent (ed.), Women and Revolution: A Discussion of the Unhappy Marriage of Marxism and Feminism, London, Pluto Press, 1981.
- Harvey, D. (1989) The Condition of Postmodernity, Oxford, Basil Blackwell.
- Hawkes, T. (1977) Structuralism and Semiotics, London, Methuen.
- Hebdige, D. (1979) Sub-culture: The Meaning of Style, London, Methuen.
- —— (1987) Cut 'n' Mix: Culture, Identity and Caribbean Music, London, Routledge.
- ------ (1988) Hiding in the Light: On Images and Things, London, Routledge.
- Held, D. (1980) Introduction to Critical Theory, London, Hutchinson.
- Hill, S. (1990) 'Britain: the dominant ideology thesis after a decade', in

N. Abercrombie, S. Hill and B.S. Turner (eds), Dominant Ideologies, London, Unwin Hyman.

Hoggart, R. (1958) The Uses of Literacy, Harmondsworth, Penguin.

Horkheimer, M. and Adorno, T. (1973) *Dialectic of Enlightenment*, London, Allen Lane (originally published in 1944).

Hutcheon, L. (1989) The Politics of Postmodernism, London, Routledge. Instrell, R. (1992) 'Blade Runner: the economic shaping of a film', in

J. Orr and C. Nicholson (eds), *Cinema and Fiction*, Edinburgh, Edinburgh University Press.

Jameson, F. (1984) 'Postmodernism, or the cultural logic of late capitalism', New Left Review, no. 146.

----(1991) Postmodernism, London and New York, Verso.

Jay, M. (1973) The Dialectical Imagination, London, Heinemann.

Jencks, C. (1984) The Language of Post-modern Architecture, London, Academy Editions.

-(1986) What is Post-modernism?, London, Academy Editions.

Jenkins, R. (1992) Pierre Bourdieu, London and New York, Routledge.

Johnson, L. (1979) The Cultural Critics, London, Routledge and Kegan Paul.

Joll, J. (1977) Gramsci, London, Fontana.

Kawin, B. (1986) 'Children of the light', in B. Grant (ed.), Film Genre Reader, Austin, University of Texas Press.

Kerr, P. (ed.) (1986) The Hollywood Film Industry, London and New York, Routledge and Kegan Paul.

Kornhauser, W. (1960) *The Politics of Mass Society*, London, Routledge and Kegan Paul.

Krutnik, F. (1991) In a Lonely Street: Film Noir, Genre, Masculinity, London and New York, Routledge.

Kuhn, A. and Wolpe, A.M. (eds) (1978) Feminism and Materialism, London, Routledge and Kegan Paul.

Laing, D. (1985) One Chord Wonders, Milton Keynes, Open University Press.

Larrain, J. (1979) The Concept of Ideology, London, Hutchinson.

Lash, S. (1990) The Sociology of Postmodernism, London and New York, Routledge.

Lash, S. and Urry, J. (1987) The End of Organized Capitalism, Cambridge, Polity Press.

Leach, E. (1970) Lévi-Strauss, London, Fontana.

Leavis, F.R. (1930) Mass Civilization and Minority Culture, London, Minority Press.

Leavis, Q.D. (1932) Fiction and The Reading Public, London, Chatto and Windus.

Le Carré, J. (1975) *Tinker Tailor Soldier Spy*, London and Sydney, Pan Books (originally published in 1974).

Lengermann, P. and Niebrugge-Brantley, J. (1992) 'Contemporary feminist theory', in G. Ritzer, *Sociological Theory*, New York, McGraw-Hill Inc. (third edition).

Levine, L. (1988) High Brow/Low Brow: The Emergence of Cultural Hierarchy In America, Cambridge, Mass., Harvard University Press.

Lévi-Strauss, C. (1963) *Structural Anthropology*, New York and London, Basic Books.

----- (1969) Totemism, Harmondsworth, Penguin.

(1970) The Raw and the Cooked, London, Cape.

(1977) Structural Anthropology, vol. 2, London, Allen Lane.

Lewis, J. (1990) 'Are you receiving me?', in A. Goodwin and G. Whannel (eds), *Understanding Television*, London and New York, Routledge.

Lockwood, D. (1982) 'Fatalism: Durkheim's hidden theory of order', in A. Giddens and G. Mackenzie (eds), *Social Class and the Division* of *Labour*, Cambridge, Cambridge University Press.

Lowenthal, L. (1957) 'Historical perspectives of popular culture', in B. Rosenberg and D. White (eds) Mass Culture, Glencoe, Free Press.

MacDonald, D. (1957) 'A theory of mass culture', in B. Rosenberg and D. White (eds) *Mass Culture*, Glencoe, Free Press.

McGuigan, J. (1992) Cultural Populism, London, Routledge.

McIntosh, M. (1978) 'The state and the oppression of women', in A. Kuhn and A.M. Wolpe (eds) *Feminism and Materialism*, London, Routledge and Kegan Paul.

McLellan, D. (1986) Ideology, Milton Keynes, Open University Press.

McRobbie, A. (1991a) Feminism and Youth Culture, Basingstoke, Macmillan.

—— (1991b) 'New times in cultural studies', New Formations 13, Spring issue.

(1993) 'Cultural studies for the 1990s', Innovation vol. 6, no. 3.

McShine, K. (1989) Andy Warhol: A Retrospective, New York, Museum of Modern Art.

Maltin, L. (1991) Movie and Video Guide 1992, London, Penguin Books. Marcuse, H. (1972) One Dimensional Man, London, Abacus.

Lyotard, J-F. (1984) *The Postmodern Condition*, Manchester, Manchester University Press.

Marx, K. (1963) Selected Writings in Sociology and Social Philosophy, ed. T. Bottomore and M. Rubel, Harmondsworth, Penguin.

- Masterman, L. (ed.) (1984) Television Mythologies: Stars, Shows and Signs, London, Comedia.
- Mattelart, A., Delacourt, X. and Mattelart, M. (1984) International Image Markets, London, Comedia.
- Mepham, J. (1979) 'The theory of ideology in *Capital*', in J. Mepham and D. Ruben (eds), *Issues in Marxist Philosophy*, vol. 3, Brighton, Harvester Press.
- Merquior, J. (1985) Foucault, London, Fontana.
- Messenger Davies, M. (1989) Television is Good for Your Kids, London, Hilary Shipman.
- Miller, D. (1987) Material Culture and Mass Consumption, Oxford, Basil Blackwell.
- Mitchell, J. (1975) Psychoanalysis and Feminism, Harmondsworth, Penguin.
- Modleski, T. (1986a) 'Femininity as mas(s)querade: a feminist approach to mass culture', in C. MacCabe (ed.), *High Theory/Low Culture*, Manchester, Manchester University Press.
 - ----- (ed.) (1986b) Studies in Entertainment, Bloomington, Indiana, Indiana University Press.
- Moores, S. (1993) Interpreting Audiences, London, Sage Publications.
- Moorhouse, H. (1991) Driving Ambitions: An Analysis of the American Hot Rod Enthusiasm, Manchester, Manchester University Press.
- Morley, D. (1980) The Nationwide Audience, London, British Film Institute.
- (1991) 'Where the global meets the local: notes from the sitting room', *Screen* vol. 32, no. 1.
- (1992) Television, Audiences and Cultural Studies, London and New York, Routledge.
- and Robins, K. (1989) 'Spaces of identity: communications technologies and the reconfiguration of Europe', *Screen* vol. 30, no. 4.
- Morson, G. (ed.) (1986) Bakhtin: Essays and Dialogues on his Work, Chicago, Chicago University Press.
- ----- and Emerson, C. (eds) (1989) *Rethinking Bakhtin: Extensions and Challenges*, Evanston, North Western University Press.

Mulhern, F. (1981) The Moment of Scrutiny, London, Verso.

Mulvey, L. (1975) 'Visual pleasure and narrative cinema', *Screen* vol. 16, no. 3.

— (1981) 'Afterthoughts on "visual pleasure and narrative cinema" inspired by *Duel in the Sun*', *Framework* Summer issue; reprinted in L. Mulvey, *Visual and Other Pleasures*, Basingstoke, Macmillan.

- Murdock, G. (1993) 'Communications and the constitution of modernity', *Media*, *Culture and Society*, vol. 15.

Nava, M. (1992) Changing Cultures, London, Sage.

- Neale, S. (1980) Genre, London, British Film Institute.
- ----- (1985) Cinema and Technology, London, Macmillan.
- (1990) 'A question of genre', Screen vol. 31, no. 1.
- Orwell, G. (1957) Inside the Whale and Other Essays, Harmondsworth, Penguin.
- (1965) The Decline of the English Murder and Other Essays, Harmondsworth, Penguin.
- Palmer, P. (1988) 'The social nature of children's television viewing', inP. Drummond and R. Paterson (eds), *Television and its Audience*,London, British Film Institute.
- ------ (1991) Potboilers: Methods, Concepts and Case Studies in Popular Fiction, London and New York, Routledge.
- Partington, A. (1991) 'Melodrama's gendered audience', in S. Franklin, C. Lury and J. Stacey (eds), Off-centre: Feminism and Cultural Studies, London, Harper Collins.
- Penley, C. (1988) 'Introduction. The lady doesn't vanish: Feminism and film theory', in *Feminism and Film Theory*, New York and London, Routledge and the British Film Institute.
- Pfeil, F. (1985) 'Makin' flippy-floppy: postmodernism and the baby-boom PMC', in M. Davis (ed.), *The Year Left: An American Socialist Yearbook 1985*, London, Verso.
- Portoghesi, P. (1982) After Modern Architecture, New York, Rizzoli. ——(1983) Postmodern Architecture, New York, Rizzoli.
- (1905) I Ostinodern Themtecture, New Tork, Rizzoli.
- Rabinow, P. (ed.) (1984) The Foucault Reader, London, Penguin.
- Radway, J. (1987) Reading the Romance: Women, Patriarchy and Popular Literature, London, Verso.
- Ransome, P. (1992) Antonio Gramsci: A New Introduction, New York and London, Harvester Wheatsheaf.
- Reisman, D., Glazer, N. and Dewney, R. (1961) The Lonely Crowd: A Study of the Changing American Character, New Haven, Conn., Yale University Press (abridged edition).

- Ritzer, G. (1992) Sociological Theory, New York, McGraw-Hill Inc. (third edition).
- Robbins, D. (1991) The Work of Pierre Bourdieu, Milton Keynes, Open University Press.
- Rosenberg, B. and White, D. (eds) (1957) Mass Culture, Glencoe, Free Press.
- Ross, A. (1989) No Respect: Intellectuals and Popular Culture, New York and London, Routledge.
- Ross Muir, A. (1988) 'The status of women working in film and television', in L. Gamman and M. Marshment (eds), *The Femal Gaze: Women as Viewers of Popular Culture*, London, The Women's Press.
- Rylance, R. (1994) Roland Barthes, New York and London, Harvester Wheatsheaf.
- Sansom, A. (1992) F.R. Leavis, New York and London, Harvester Wheatsheaf.
- Sargent, L. (ed.) (1981) Women and Revolution: A Discussion of the Unhappy Marriage of Marxism and Feminism, London, Pluto Press.
- Sarup, M. (1988) An Introductory Guide to Post-structuralism and Postmodernism, New York and London, Harvester Wheatsheaf.
- Saussure, F. de (1974) Course in General Linguistics, London, Fontana (originally published in English in 1959).
- Seaton, J. (1986) 'Pornography annoys', in J. Curran, J. Ecclestone, G. Oakley and A. Richardson (eds), *Bending Reality: The State of the Media*, London, Pluto Press.
- Seiter, E. (1986) 'The hegemony of leisure: Aaron Spelling presents Hotel', in P. Drummond and R. Paterson (eds), *Television in Transition*, London, British Film Institute.
- Shils, E. (1957) 'Daydreams and nightmares: reflections on the criticism of mass culture', *The Sewanee Review* vol. 65, no. 4.
- Shils, E. (1962) 'The theory of mass society', Diogenes 39.
- Simon, R. (1982) Gramsci's Political Thought: An Introduction, London, Lawrence and Wishart.
- Skeggs, B. (1993) 'Two minute brother: Contestation through gender, "race" and sexuality', *Innovation* vol. 6, no. 3.
- Slater, P. (1977) Origin and Significance of the Frankfurt School, London, Routledge and Kegan Paul.
- Smart, B. (1983) Foucault, Marxism and Critique, London, Routledge and Kegan Paul.
 - (1988) Michel Foucault, London, Routledge.

- Spender, D. (1980) Man Made Language, London, Routledge and Kegan Paul.
- Spender, D. (ed.) (1983) Feminist Theorists: Three Centuries of Key Women Thinkers, New York, Random House.
- Sperber, D. (1979) 'Claude Lévi-Strauss', in J. Sturrock (ed.), Structuralism and Since, Oxford, Oxford University Press.
- Sreberny-Mohammadi, A. (1991) 'The global and the local in international communications', in J. Curran and M. Gurevitch (eds), *Mass Media and Society*, London, Edward Arnold.
- Stacey, J. (1994) Star Gazing: Hollywood Cinema and Female Spectatorship, London, Routledge.
- Stam, R. (1988) 'Mikhail Bakhtin and left cultural critique', in E. Ann Kaplan (ed.), *Postmodernism and its Discontents*, London and New York, Verso.
- —— (1989) Subversive Pleasures: Bakhtin, Cultural Criticism and Film, Baltimore, Johns Hopkins University Press.
- Storey, J. (1993) An Introductory Guide to Cultural Theory and Popular Culture, New York and London, Harvester Wheatsheaf.
- Stratton, J. (1989) 'Beyond art: postmodernism and the case of popular music', *Theory, Culture and Society* vol. 6.
- Strinati, D. (1992a) 'The taste of America: Americanization and popular culture in Britain', in D. Strinati and S. Wagg (eds), Come on Down?: Popular Media Culture in Post-war Britain, London, Routledge.
- ----- (1992b) 'Postmodernism and popular culture', Sociology Review vol. 1, no. 4.
- ----- (1993) 'The big nothing?: contemporary culture and the emergence of postmodernism', *Innovation* vol. 6, no. 3.
- Sturrock, J. (ed.) (1979) Structuralism and Since, Oxford, Oxford University Press.

Swingewood, A. (1977) The Myth of Mass Culture, London, Macmillan.

- -----(1991) A Short History of Sociological Thought, Basingstoke, Macmillan (second edition).
- Thompson, J.B. (1990) Ideology and Modern Culture, Cambridge, Polity Press.
- Tomlinson, J. (1991) Cultural Imperialism, London, Pinter Publishers.
- Tuchman, G. (1981) 'The symbolic annihilation of women by the mass media', in S. Cohen and J. Young (eds), *The Manufacture of News*,

London, Constable (revised edition).

- Tuchman, G., et al. (eds) (1988) Hearth And Home: Images of Women in the Mass Media, New York, Oxford University Press.
- Turner, B. (1992) 'Ideology and utopia in the formation of an intelligentsia: reflections on the English cultural conduit', *Theory*, *Culture and Society* vol. 9.
- Turner, G. (1990) British Cultural Studies: An Introduction, Boston, Mass., Unwin Hyman.
- Twitchell, J. (1992) Carnival Culture: The Trashing of Taste in America, New York, Columbia University Press.
- Van Zoonen, L. (1991) 'Feminist perspectives on the media', in J. Curran and M. Gurevitch (eds), *Mass Media and Society*, London, Edward Arnold.
- Venturi, R., Scott-Brown, D. and Izenhour, S. (1977) Learning from Las Vegas, Cambridge, Mass., MIT Press.
- Walby, S. (1990) Theorizing Patriarchy, Oxford, Basil Blackwell.

Walkerdine, V. (1986) 'Video replay: families, films and fantasy', in V. Burgin, J. Donald and C. Kaplan (eds), Formations of Fantasy, London and New York, Methuen.

Webster, D. (1988) Looka Yonder: The Imaginary America of Populist Culture, London, Routledge.

- White, J. (1986) The Worst Street in North London, London, Routledge and Kegan Paul.
- Williams, R. (1963) Culture and Society 1780-1950, Harmondsworth, Penguin.
 - -----(1976) Keywords: A Vocabulary of Culture and Society, London, Fontana.

(1977) Marxism and Literature, Oxford and New York, Oxford University Press.

- Williamson, J. (1978) Decoding Advertisements: Ideology and Meaning in Advertising, London and Boston, Marion Boyars.
- Winship, J. (1981) 'Woman becomes an "individual" femininity and consumption in women's magazines 1954–1969', stencilled paper no. 65, Centre for Contemporary Cultural Studies, University of Birmingham, 1981.
 - (1992) 'The impossibility of *Best*: enterprise meets domesticity in the practical women's magazines of the 1980s', in D. Strinati and S. Wagg (eds), Come On Down?: Popular Media Culture in Postwar Britain, London, Routledge.

Wolin, R. (1994) Walter Benjamin: An Aesthetic of Redemption, Berkeley

and Los Angeles, University of California Press (second edition).

- Wood, G. (1988) 'Horror film', in W. Gehring (ed.), Handbook of American Film Genres, New York, Greenwood Press.
- Woollacott, J., 'Messages and meanings', in M. Gurevitch et al. (eds), Culture, Society and the Media, London, Methuen.
- Worpole, K. (1983) Dockers and Detectives: Popular Reading, Popular Writing, London, Verso.
- Wren-Lewis, J. (1983) 'The encoding/decoding model: criticisms and redevelopments for research on decoding', *Media*, *Culture and Society* vol. 5.
- Wright, W. (1975) Six-guns and Society: A Structural Study of the Western, Berkeley, University of California Press.

Index

Abercrombie, N. 77, 173'active reader' 216 Adorno, Theodor 52–9, 61-79 passim, 81, 83, 137 - 8advertising 38, 48; in magazines 124-5; postmodernism and 224, 226, 232-3, 242; on television 40, 183, 193, 232-3; women and 40, 180, 183, 184-9, 193, 196, 197, 217 affluence 59, 60 Althusser, L. 160, 162-3, 168, 170, 180, 198, 202, 204, 209, 212; economic determinism/ ideology 155-9; Marxism 52, 130, 155-6; theory of ideology 130, 146-55 Americanisation 256, 257; critique of mass culture theory 31-8; and mass

culture 7, 11, 21–31, 47 - 8Anderson, Laurie 234 Anderson, P. 162, 164 Ang, I. 37, 42, 47-8, 249-52, 257, 260 anthropology 96, 101 architecture 222-3, 228-9, 242 Arnold, M. 23 art 4, 8-12 passim, 18-19, 27, 190-1; mass culture theory 38, 42, 45, 47; mechanical reproduction 82-5; popular culture and (distinction) 38, 225 - 6'art rock' 234, 235 atomisation 6-7, 11 audiences: cultural populism 49, 217, 255-60; feminist analysis 191, 200, 209-17; Frankfurt School 64, 66-8, 77-8; Marxist approach 144,

145; mass culture critics 38, 41–2, 46, 48–9; mass culture debate 10–21; objects of discourse 249–52, 260; reflection hypothesis 181–2, 183; regressive listening 67–8, 74, 76, 78, 79; structuralist approach 102, 104–7, 127; -text contract 253–4, 258; *see also* consumer; consumerism; consumption authenticity (style/taste) 42–3, 44, 65

- avantgardism 18, 19, 20–1, 42, 46, 65, 70, 75–6
- Back to the Future (films) 226, 229-30, 243
- Baehr, H. 184, 192, 193, 194-5
- Bakhtin (Volosinov) 253, 254
- Barker, M. 207–8, 209, 211, 215, 252–5, 258
- Barthes, R. 211; mythology 108–10, 112–19, 123–5, 127; semiology 91, 119, 123–8; semiology and popular culture 108–19; structuralism 109–10; writing (French classical) 110–12
- base-superstructure model 132-6, 137, 143, 148-52, 156-7
- BBC 139-40
- Beatles 71, 234
- belief systems 212
- Benjamin, Walter 4, 226; critique of Frankfurt School 53, 81–5
- Bennett, T. 107, 108, 160, 224
- binary oppositions (in structuralism) 97-9, 102-7, 122
- Blade Runner (film) 230, 243
- Blue Velvet (film) 230
- Body Heat (film) 230, 244
- bolshevik revolution 164, 169
- Bond novels 102-8
- Booker, C. 30
- books 15-18, 20, 22-7 *passim*, 32-3, 35-7, 41, 102-8
- Bourdieu, Pierre 33, 76, 259

bourgeois class 117-18, 163-4, 167, 256 bourgeois hegemony 111, 163-4 bourgeois ideology 116-19, 127-8, 198 Brazil (film) 230 Broadcasting Standards Council 186 Buci-Glucksmann, C. 164 Bullock, A. 89 Burgess, Guy 36 Burke, P. 2 Cadillacs (in Adorno's theory) 69-74 Campbell, C. 259 Capital (Marx) 134-5 capital-labour relations 60, 149-51 capitalism 22, 216, 235-6, 256; base-superstructure model 132-6, 137, 143, 148-52, 156-7; commodity fetishism 3, 56-8, 60-1, 63, 65-6, 75, 130, 132; Frankfurt School analysis 53-61, 63, 65-6, 68-9, 75-7, 80-1; Marxism and 130-8, 143, 148-52, 156-7, 163, 168; modern 53-6, 58-61; see also industrialisation cartoons 230 Centre for Contemporary Cultural Studies 156, 160, 256, 257 Chandler, R. 32 cinema 4, 5, 108; Frankfurt School 53, 63, 69, 77-8; Hollywood system 11, 18, 19, 42, 53, 63, 69, 199, 217; mass culture theory 33, 42, 44, 46–7; postmodernist 229-31, 242-5; silent films 18, 42; sound films 18, 83, 84–5 citizenship (political) 7-8 civil society 132, 133, 168-71, 172, 203 class 111, 130-1; base-superstructure model 132-6, 137, 143, 148-52, 156-7; bourgeois

- class 117-18, 163-4, 167, 256;
- media ownership/control
- 137-41; middle-class 183,
- 236-8, 256; power 144, 145,
- 146, 154; sociology of 137;
- struggle 148, 158-9, 163-4,
- 170, 173–4, 256; *see also* ruling class; working class
- classical music 65–6, 68, 70, 72–3, 76, 77
- classical style (writing) 108, 110–12, 115
- codes 92, 109–10, 123, 205–5; decoding 88, 106, 107–8, 127; encoding 127
- coercion 151–2, 165–7, 168, 172–3
- collective consciousness 97
- collective identities 238-9, 240
- Collins, J. 38, 40–1
- comics (analysis of) 253-5
- commercialisation of culture 2, 3, 4, 11, 82
- commodity fetishism 3, 56–8, 60, 61, 63, 65–6, 75, 130, 132
- communication fetishism 3, 56–8, 60, 61, 63, 65–6, 75, 130, 132
- communication activities 143-4
- communication industries 138, 139, 140, 144
- communications, modernism and 145–6
- concept, signified as 114-15
- conflict 133, 166-8, 173, 174-5
- conformity (in culture industry) 63–4
- connotation 116, 125–6, 128, 204, 207
- consensual control 165-6, 167
- consumer 78–9, 216–18; sovereignty 257
- consumer goods 79-80
- consumerism 141, 237, 239, 240; feminist approach 190–1, 203, 210; Frankfurt School 59–61; mass culture theory 30, 38–40, 48; media-saturation 235–6

consumption 41-2, 49, 72, 224,

- 258-60; feminism and 190-1,
- 217-18; mass 21, 22, 82
- content analysis: critique of
 - 191-6, 203, 206, 209; television advertisements 186-7, 188
- contract (audience-text) 253-4, 258
- control: consensual 165–6, 167; of mass media 137–41, 144, 146; social 3, 55, 59, 62, 165–7, 173–4; of television audience 249–52
- core-periphery approach 70, 72-3, 77-8
- Craib, I. 54
- crime/police series (television) 168, 197, 230, 231-2
- crime novel 25-6, 28, 32-4
- Crime Story (television series) 232
- culturalism 175
- cultural populism 49, 217, 255-60
- cultural production 137–44, 155, 168, 179–80, 217, 254, 259–60
- cultural products 127, 139, 141, 242–4
- cultural representation 233; of women 179-84, 195-7
- cultural standards 44, 45-7
- cultural studies approach 192, 216–17
- culture: commercialisation of 2, 3, 4, 11, 82; industry 55–6, 58, 60–76, 217; nature and (totemism) 97–9, 122–3; society and 223–4; sociology of 33, 175, 178–9, 245, 249; structuralism and myth 94–101; *see also* mass culture; mass culture (and popular culture); mass culture theory; popular culture
- Culture and Anarchy (Arnold) 23
- Cumberbatch, G. 186, 193 Curran, J. 224
- *Dallas* (television series) 37, 47–8 decoding 88, 106, 107–8, 127 Deighton, Len 35–6

democracy 7-8, 9, 22, 23, 31, 45, 46 Denning, M. 108 denotation 116, 125, 204, 207 detective stories 168, 197, 230, 231 - 2diachronic analysis 93-4, 121 diachronic standardisation 71-2, 73 - 4Dialectic of Enlightenment (Horkheimer) 62 dialogical approach 252-5 Dick Tracey (film) 229 DiMaggio, P. 46 direct-effects model 197 discourse: analysis 218; popular culture and 249-52, 260; register 214, 215 Dr Jekyll and Mr Hyde (Stevenson) 243 dominant ideology thesis 77, 251; feminism 181, 198, 200-1, 204, 216; Marxism 130-2, 137-8, 141, 145, 152, 165-6, 169-70, 173 - 4Doo-Wop music 69-74 Douglas, A. 190 Duchamp, Marcel 226 Dyer, G. 185-6, 187-8, 192-3 Eco, Umberto 102-8 economic determinism 134-6, 139, 143, 146-9, 155-60, 162-3, 172, 175 economic globalisation 238 economic reductionism 145, 174-5, 201 economism 148, 163, 164, 172, 175education 7-8, 20, 22 educational state apparatus 157-9 Eisenstein, Sergei 46 Elements of Semiology (Barthes) 116 - 17elitism/elite culture 258; Frankfurt School 52, 76, 77, 78; mass culture theory 9–10, 15–17,

20-1, 38-41, 44-6; see also

high culture encoding 127 Engels, Friedrich 147 Englishness 27 enlightenment 54-5, 60 Equalizer, The (television series) 41 equal opportunities legislation 178, 192 essentialism 148 exchange value 57-8, 61, 75 Fairclough, N. 95 false consciousness 201, 216 false needs 59, 60-1, 64, 79-80, 81 fascism 4, 5, 55-6, 164, 172 fashion and beauty code 205 Feminine Mystique, The (Friedan) 184 - 5feminism 38, 52, 78, 88, 248; and mass culture 189-91 feminism and popular culture 178-9; conclusion 215-18; feminist analysis 189-215; feminist critique 180-9 feminist analysis: critique of content analysis 191-6; ideology and audience 209-15; mass culture 189-91; semiology and ideology 206-9 feminist critique 46-7, 180-3; women and advertising 184-9 feminist theory: critique of content analysis 191-6; patriarchy and psychoanalysis 196-201; study of ideology 201-15 femininity 180, 181, 190-2, 198, 200, 203, 204, 205, 210 film noir 231, 232 films see cinema Fiske, J. 256 Fleming, Ian (Bond novels) 102-8 folk art 18 folk culture 3, 4, 8, 9-10, 12, 15, 19, 21, 38, 42-3, 45 folk music 77 form, signifier as 114-15

- For Marx (Althusser) 153
- Foucault, M. 215, 218, 249–50, 252, 253, 254
- Frankenstein (Shelley) 243
- Frankfurt School 19, 46, 52, 88, 105, 137, 170, 240, 248; commodity fetishism 56–8, 130; critical assessment 74–85; critique (Benjamin) 81–5; culture industry 61–74; origins 53–6; theory of modern capitalism 58–61
- Frazer, E. 211-14, 216, 253
- freedom, false needs and 61
- French classicism 108, 110–12, 115
- French imperialism 114, 115, 116
- French Revolution 163
- Friedan, Betty 184-5
- Frith, S. 14, 30
- functional artefacts 71-2, 73, 77
- functionalism 157-9, 160, 210-11
- Gamman, L. 179, 195, 199, 216
- gender: inequalities 184, 192, 198; oppression 178–9, 196, 200; power structures 178; reductionism 201; relations 180, 189, 195, 216–17; stereotypes 179, 181, 183, 185; *see also* men; women
- Gendron, B. 70-4, 76, 77
- genres (emergence) 72-4, 77-8
- German Ideology, The (Marx)
- 131-2, 133-4, 138, 140-1
- Gill, R. 188–9, 218
- 'golden age' ideology 43-4
- Golding, P. 74, 132, 133, 134–5, 137–40, 142–6, 257
- Goldthorpe, J. 79-80
- Gosse, Edmund 22
- Gramsci, A. 147, 159, 180, 202, 204; concept of hegemony 130, 151, 160–1, 163–75; Marxism 52, 155–6, 160–5, 171–5, 248 Guinness advertisements 233

Hammett, Dashiell 243

- Hartman, H. 198
- Harvey, David 225, 227, 228, 230
- Hebdige, D. 24, 27-8, 30, 33-7
- hegemony 131; Gramsci's concept 130, 151, 160–1, 163–75
- Herder, Johann Gottfried 2
- hierarchical relationships 45-7
- high culture 2, 10, 15, 17–19, 21, 39, 44, 45, 47, 78, 190, 191;
 - see also elitism/elite culture
- Hill Street Blues (television series) 2.32
- Hitchcock, Alfred 46
- Hoggart, R. 27-31, 34, 37
- Hollywood 11, 18, 19, 42, 53, 63, 69, 199, 217
- homogeneity criteria 40-1, 95
- 'hook' (in music) 65, 66-7
- Horkheimer, M. 53, 54, 62
- Hornung, E.W. 26
- human agency (role) 121-2, 162
- Huxley, T.H. 31–2
- ideological role (popular culture) 3-4
- ideological state agencies 151-2
- ideology 105, 253–4; Althusser 146–59; base–superstructure model 132–6, 137, 143, 148–52, 156–7; bourgeois
 - 116-19, 127-8, 198; dominant
 - see dominant ideology thesis;
 - feminist theory 201–15; Marx
 - and 127, 130–55; of mass culture 48; of the past 43–4,
 - 45–6; of populism 37, 48;
 - 'specific effectivity' of 149, 155,
 - 157, 158
- 'Ideology and Ideological State Apparatuses' (Althusser) 149
- Indiana Jones (films) 229
- individualisation process 63, 66, 72
- industrialisation 3, 5–6, 8, 9, 10–11, 45, 82
- industrial production 4, 6, 10, 11–12

inequality 59 infantilism (of regressive listener) 67, 74, 78, 79 Instnell, R. 230 intellectuals (role) 171 intertextuality 107–8 *Ipcress File, The* (Deighton) 35–6 *Jackie* (magazine) 202–9, 210–14 James Bond novels 102–8

Jameson, F. 38 jazz 46, 66 'jitterbugs' 67 Jive Bunny and the Master Mixers 233–4, 235 Johnson, L. 23–4, 25, 31, 38, 44 Johnson, Paul 13–14 Johnson, Philip 229 Joll, J. 165

'juke-box boys' 28, 29, 30, 34-5

Kawin, B. 244 King Kong (films) 244 kinship 97, 120 knowledge: dialogical analysis 252–3; discourse analysis 249,

252–3; discourse analysis 249, 250–1, 252; power and 48, 252–5

- labour: capital relations 60, 149–51; power 150–1; sexual division of 181, 184, 185–6, 202, 203
- Lacanian psychoanalysis 198

language 113, 121; of Frankfurt School 74, 75; meta-language 113; structural linguistics 88, 89–74

langue 90, 94, 92, 93, 94-6

Lash, S. 228

- Leavis, F.R. 24, 38, 43-4, 46
- Leavis, Q.D. 15–18, 19–20, 22, 32, 41
- Le Carré, John 36-7
- leisure industries 140
- Lenin, Vladimir 147, 164
- Leonardo da Vinci 226
- Lévi-Strauss, C. 89, 95-101, 102,

105, 119-23 Levine, L. 46 liberal democracies 4, 5, 164, 168, 169, 173 liberal feminism 178, 187, 192, 196, 200, 203 linear narratives 227 linguistics, structural 88, 89-94 literature 15-18, 20, 22-7 passim, 32-3, 35-7, 41, 102-8 Lowenthal, L. 2 MacDonald, D. 10, 13, 14, 15, 16, 18–19, 20, 42, 46 McGuigan, J. 255-7 McIntosh, M. 200 Maclean, Donald 36 McRobbie, A. 161, 201–12 McShine, K. 226 magazines 126, 183; advertisements in 124-5; ideological analysis (Jackie) 202-9, 210-14 'male gaze' 195, 199 Maltese Falcon, The (film) 243 Maltin, L. 243-4 Mann, Michael 232 Marcuse, Herbert 53, 54, 59, 60, 79-80 Marshment, M. 179, 195, 199, 216Marx, Karl 56-8, 59, 147; ideology and 130-55 Marxism 38, 81, 88, 249, 251; Althusser 52, 130, 155–9; feminism and 180, 187-8, 194, 197, 201, 206, 209, 212, 215-16; Frankfurt School 52, 55-9, 81; Gramsci 52, 130, 160-75, 248; ideology 130-55; meta-narrative 227, 241; political economy 136-46; semiology and 117, 126-7 Marxism (political economy and ideology): economic determinism 52, 155-9; hegemony (Gramsci) 165-71; Marx and

ideology 130-55; popular

culture 52, 160-5; theoretical

problems 171–5

- masculinity 180, 181, 190–2, 200
- mass consumption 21, 22, 82
- mass culture 225, 256; feminism and 189-91
- mass culture (and popular culture): Americanisation 21–38; critique of theory 38–49; mass culture debate 10–21; mass society and 5–10; social significance of 2–5
- mass culture theory 52, 248, 257; critique of 38–49; critique of (and Americanisation) 31–8
- mass media 226, 239–40; Marxist analysis 137–41, 143–6, 152, 155, 159, 165, 169, 175; representation of women 179–84, 192–3, 195, 196, 197, 200
- mass production 4, 6, 10–12, 19, 21, 22, 24, 66, 82
- mass propaganda 5, 8
- mass society theory 5–10, 11–13, 21, 24; *see also* atomisation; industrialisation
- material production (base-superstructure model) 132-3, 175
- Max Headroom (television series) 41
- meaning 113–15, 117, 121–2, 124–5, 207–9
- mechanical reproduction of art 82–5
- media: ownership/control 137–41; representation of women 179–84 *passim*; saturation 235–6; *see also* mass media
- mediatory social organisations 6-7
- men: male gaze 195, 199; masculinity 180, 181, 190-2, 200; novelists 116-19
- mental structure 120–1, 122–3, 256
- meta-language 113
- metanarratives 145, 227-9, 241
- Miami Vice (television series)

- 231-2
- middle class 183, 256; occupations 236-8
- Mighty Joe Young (film) 244
- 'milk bars' 28, 29, 30-1
- Miller, D. 259
- modern capitalism 53, 54, 55-6, 58-61
- modernism 19, 145–6, 227–9, 234, 241
- modernity 31, 228
- Modleski, T. 47, 78, 189–91
- Mona Lisa (multi-imaged print) 226
- money (commodity fetishism) 56-8, 60
- monopoly capitalism 59, 61
- Montaigne, Michel de 2
- Moore, Charles 229
- Moores, S. 216
- Moorhouse, H. 259
- moral values 6-7
- Muir, A. 195
- Mulvey, L. 199
- Murdock, G. 74, 132–5, 137–40, 142–6, 257
- music 13–14, 40, 43, 56; Adorno's theory 52, 57–8, 64–74, 75, 137; classical 65–6, 68, 70, 72–3, 76, 77; culture industry and 53, 64–74; postmodernism 233–5
- myth 120, 211; popular culture (Barthes) 112–19, 123–5, 127; structuralism and culture 94–101
- Mythologies (Barthes) 108–10, 112–16, 117–19
- national culture 27
- nature, culture and 97-9, 122-3
- Nazi Germany 5, 53-4, 82
- Neale, S. 244
- needs: false 59, 60-1, 64, 79-80, 81; real 60-1, 64, 79-80, 81
- 'negative consensus' 27-8
- news/newsreaders 194
- 91/2 Weeks (film) 229

No Orchids for Miss Blandish 25 - 6nostalgia films 244 novelists 116-19

occupations, new middle-class 236 - 8

- Oedipus myths 99–100, 101, 120 Orwell, George 25-8, 32
- ownership of mass media 137-41. 144, 146
- parole 90, 91, 93, 94-6
- Pascal, Blaise 2
- Passeron, J.-C. 28
- passive consumers 217
- patriarchy 178, 181, 190, 192, 216, 256; psychoanalysis and 187, 196-201
- Penley, C. 180
- personal identities 238-9, 240
- personal life, code of 205
- Pet Shop Boys 234
- Philby, Kim 36
- photography 83, 114, 118-19
- police/crime series (television) 168, 197, 230, 231-2
- political citizenship 7-8
- political economy 70, 257, 258-9; limits of 142-6; Marxism and 130, 132-3, 136-46, 149, 172
- politics 46, 118, 161-2, 165
- popular culture: art and 225-6; Barthes and semiology 108-19; contemporary 228-35; dialogical approach 252-5; discourse and 249-52; feminism see feminism and popular culture; Marxism and (Gramsci) 160-5, 171-5; mass culture and see mass culture (and popular culture); myths and 112-16; postmodernism and see postmodernism; recent theoretical developments 248-60; social significance 2-5
- popular music 40, 43, 56; Adorno's theory 52, 57–8,

64-74, 75, 137; code of 205; culture industry and 53, 64-74; postmodernism in 233-5; on television shows 13-14

- populism 216; cultural 49, 217, 255-60; ideology of 37, 48
- pornography 108, 200
- positioning' girls (media role) 203
- post-structuralism 218, 222, 249
- postmodernism 38, 52, 216, 218, 222, 248, 249, 259; contemporary culture and 228-35; emergence of 235-9; identification 223-8; limits 239-45 poverty 59
- power 8-9, 42, 64-5, 95, 153, 156; dialogical approach 252-5; discursive 249-52; of ideology 253-4; knowledge and 48,
 - 252-5; relations 46-7, 112, 118, 193-4, 198-9, 215-16,
 - 217, 254, 255, 260
- press 182, 183
- production relations 132-6, 137, 143, 148-52, 157-8
- Professionals, The (television series) 168
- profit 10, 62, 77, 126, 144, 251, 2.59
- Propp, V. 253
- pseudo-individualisation 65, 66, 68, 70, 77
- psychoanalysis 193, 195;
- patriarchy and 187, 196-201

public sector broadcasting 139-40

radical feminism 178, 192, 200, 215

- radio 4, 5, 44, 140
- 'Raffles' (Hornung) 26
- Rambo (films) 230
- Ransome, P. 166
- rationality 31, 54, 55, 228-9
- real/true needs 60-1, 64, 79-80, 81
- reality: material 109-10; objective 196-7; postmodernist 239-40;

social 224, 230; virtual 225 reflection hypothesis 181-2, 183 regressive listening 67-8, 74, 76, 78, 79 Reisman, David 13 relative autonomy 148-9, 150, 156, 157, 158 religion 82, 227 Renaissance 82 ritual role of art 82, 83 Rocky (films) 230 Rogers, Richard 229 romance, code of 204-5 romantic individualism 205 ruling class 130-2, 137-8, 144-6, 151, 153, 159, 165, 170, 173, 200 St Elsewhere (television series) 41 Saussure, Ferdinand de 89-94, 95,

- 96, 109, 112, 121 science 31–2, 54, 55, 147–8, 212, 228–9
- science fiction 230-1
- Screen (journal) 156, 222
- semiology 52, 70, 88, 248, 257; Barthes 123–8; Barthes and popular culture 108–19; Barthes and structuralism 109–10; feminist theory 187–8, 194, 196, 203–4, 206–9, 213, 215–16; Marxist theory 137, 156; Saussurean linguistics 88, 91–2, 94; and structuralism (key
- problems) 119–28
- 'sequential logic' 141
- sexism 179-80, 184, 188, 191, 192, 193
- sexual division of labour 181, 184, 185-6, 202, 203
- Shelley, Mary 243
- Sherlock Holmes (films) 244
- 'shiny barbarism' 28-9
- signification 89, 110, 112,
 - 114-15, 125
- signified/signifier 88, 91–2, 98, 112–15, 116
- signs 88-94, 109-10, 112-14,

- 116, 123-4, 125-7, 205, 225
- silent films 18, 42
- Skeggs, B. 218
- soap operas 37, 40-1, 47-8, 196
- social change 9, 45, 54, 94, 95,
- 148–9, 183, 218, 238
- social class see class
- social conflict 133, 166–8, 173, 174–5
- social control 3, 55, 59, 62,
- 165-7, 173-4
- social reality 224, 230
- social relations of production: base-superstructure model 132-6, 137, 143, 148-52,
 - 157-8; commodity fetishism 3, 56-8, 60, 61, 63, 65-6
- socialisation process 154, 181, 184
- socialism 56, 59, 81
- socialist feminism 178, 192, 199–201, 218
- socialist revolution 55, 162, 163-4, 169
- society: base-superstructure model 132–6, 137, 143, 148–50; culture and 223–4; *see also* mass society theory
- sociology: of class 137; of culture 33, 175, 178, 179, 245, 249
- Son of Kong (film) 244
- sound films 18, 83, 84-5
- 'sound image' 91, 92
- space and time (postmodern confusions) 226–7, 230, 241, 243
- 'specific effectivity' of ideology 149, 155, 157, 158
- Spender, D. 178
- Spielberg, Steven 229–30
- spy novels 35-7, 102-8
- Stacey, J. 216, 217-18
- Stallybrass, O. 89
- standardisation 40–1, 62–3, 65–6, 70, 77, 95; diachronic 71, 72, 73–4; synchronic 71
- stereotypes of women 179, 181, 183, 185-6, 187, 188, 192,

195

- Stevenson, Robert Louis 243
- Storey, J. 161, 172
- Stowe, Harriet Beecher 190
- Structural Anthropology (Lévi-Strauss) 99-100
- structuralism 38, 52, 88–9, 156, 248, 249; binary oppositions 97, 98–9, 102–7, 122; culture and myth 94–101; feminist theory 187–8, 194, 197, 216; James Bond novels 102–8; Lévi-Strauss 119–23; semiology and 109–10, 119–28
- structuralism (semiology and popular culture) 88; Barthes 108–19; culture and myth 94–101; James Bond novels 102–8; semiology and (key problems) 119–28; structural linguistics 89–94
- structuralist Marxism 146–55, 160
- structural linguistics 88, 89-94
- style 225; authenticity 42–3, 44, 65; pseudo-individualisation 65, 66, 68, 70, 77
- subcultures 34-7, 201-12, 256
- substance 225; content analysis 186-8, 191-6, 203, 206, 209
- 'subversive consumer' 216
- Sweeney, The (television series) 168
- 'symbolic annihilation' of women 180–3, 184, 186, 189
- symbolic representation of women 182
- synchronic analysis 93-4, 121
- synchronic standardisation 71

Talking Heads 234

- Tamla Motown 235
- Tarzan (films) 244
- taste 42-3, 44, 45, 49, 65
- television 13–14, 44, 140, 260; advertisements 40, 193, 232–3; audience (discourse analysis) 249–52; crime series 168, 197,

- 230, 231–2; postmodernism 231–3, 239, 240; soaps 37, 40–1, 47–8, 196; women and 182–3, 193 text-audience contract 253–4, 258
- textual artefacts 71–2, 73, 77 Thatcherism 160
- theatre 42
- Theory, Culture and Society (journal) 222
- Thin Man (films) 244
- third world countries 60
- time and space (postmodern confusions) 226–7, 230, 241, 243
- Tinker, Tailor, Soldier, Spy (Le Carré) 36–7
- Tocqueville, Alexis de 23
- totalitarian societies 5, 53, 56, 103
- totemism 97-9, 120, 122-3
- tourism 108
- Trilling, Lionel 23
- Tuchman, G. 180, 181-3
- Twin Peaks (television series) 231
- Uncle Tom's Cabin (Stowe) 190 urbanisation 5, 6, 8, 9, 11 Urry, J. 228 Uses of Literacy, The (Hoggart) 28 use value 57, 58

Van Zoonen, L. 181, 187, 191–2, 200, 217 Venturi, R. 229 virtual reality 225 Volosinov (Bakhtin) 253, 254

war of movement/position 169 Warhol, Andy 226 waste/waste production 59 Webster, D. 23, 24, 28, 34 Wenders, Wim 30 White, J. 33 Who Framed Roger Rabbit? (film) 230 Wild Palms (television series) 231

- Williams, R. 2–3, 135
 Williamson, J. 124–5
 women: advertisements and 40, 180, 183, 184–9, 193, 196, 197, 217; cultural representation 179–84, 195–7; femininity 180, 181, 190–2, 198, 200, 203–5, 210; stereotypes 179, 181, 183, 185–6, 187, 188, 192, 195; 'symbolic annihilation' 180–3, 184, 186, 189; writers 116–19, 190; see also feminism; feminism and popular culture
 Wood, G. 243
- Woollacott, J. 107, 108

- work ethic 235, 236
- working class 27, 31, 33, 59–60, 77, 80–1, 132, 165, 183, 236, 240; class struggle 148, 158–9, 163–4, 170, 173–4, 256; socialist revolution 55, 162, 163–4, 169; youth 28–9, 34–5
- Worpole, K. 32-3
- writing (French classical style) 108, 110–12, 115
- Writing Degree Zero (Barthes) 108, 110-12
- youth, subcultures 201–12, 256; working class 28–9, 34–5